台北 電影節 **26**th **2024**
6.21——7.6
TAIPEI FILM FESTIVAL

指導單位

主辦單位

 台北電影節 TAIPEI FILM FESTIVAL

協辦單位

公益財團法人 日本台灣交流協會 Japan-Taiwan Exchange Association　　GOETHE INSTITUT

主要合作夥伴

anue fund 鉅亨買基金　T+W TAIWAN PLUS Taiwan to the World

特別贊助

 SONY Cinema Line　MONTBLANC　 Lipton　 CONVERSE　 左岸咖啡館　雨映青年短片大賽

特別合作夥伴

Uber　SOTETSU GRAND FRÉSA TAIPEI XIMEN　　 中華民國電影導演協會 Directors Guild of Taiwan

贊助單位

 JANDAN TAIPEI　M·A·C　TRIPOLOGY × T.H. TREAS HUNTER　Lapo FOR PERSONAL STYLE　Flux Kérastase PARIS　L'ORÉAL PROFESSIONNEL PARIS　BM BLACK MICA　Hairplexx DUBAI

HOLOHOLO 十億國際　旋轉牧馬 MERRY GO ROUND　PLAN.B STUDIO SELF PHOTO STUDIO　小美 SHAOMEI　YAYOI やよい軒　初耘　啤酒肚釀製 BEER BELLY BREWING　Y THE YUAN　傢@作 CANA & SELECTS

花影　とどけ、梅のちから。 CHOYA Good-Island　果嶼 citizen M　LAITEST 萊潔　mini matters　in Pairs in Pairs, my socks　THE SINGLETON.　CANDY POPPY　台北時代寓所 HOTEL RESONANCE TAIPEI

从 HOMEHOTEL　STAY COOL　璞韻　StreetVoice 街聲　派歌　臺北表演藝術中心 TAIPEI PERFORMING ARTS CENTER　臺北藝術節 TAIPEI ARTS FESTIVAL

gomaji 懂生活的好麻吉　QSearch　Vilson　米森 HOUSUKI·舒希

合作單位

博客來　滾石文化　廣告 AdM　OPENTIX 兩廳院文化生活　BUREAU FRANÇAIS DE TAIPEI 法國在台協會　加拿大 CANADA

媒體協力

SUPER MEDIA　LINE TODAY　TRAVEER 大人的美好時光 LUXE　釀電影　Bella　美麗佳人 marie claire　鏡　LaVie

場地協力

中山堂 TAIPEI ZHONGSHAN HALL　VIESHOW CINEMAS　光點華山 SPOT　SMAJO 小馬廄　RENO STUDIOS 再現影像　中影股份有限公司 Central Motion Picture Co.

技術協力

宗宸

後期協力

FULL SHINE 福格數位製作 DCP PRODUCTION　E 遠東譯像 FAR EAST TRANSVIDEO　TIMELINE STUDIO　好多聲音 FORGOOD SOUND　赫儀聲音製作 HZALYZER. SOUND　意象影像 iVIEW PROCESS　大鐵人 Tetsujin Post Production

器材協力

旋轉牧馬 MERRY GO ROUND　聖云 LIGHTING　SONY Cinema Line

製播單位

華視 CTS 中華電視公司 chinese television system

目次 CONTENTS

局長序

2024年是台北建城140週年，也是台北電影節舉辦的第26個年頭。140年來，台北城市的地景面貌與人文精神迭代更新，電影呈現與記錄了這個城市的樣貌，也滋潤了市民的藝術涵養。

在睽違多年後，今年台北電影節再次推出「焦點城市」單元，精選了布達佩斯這座城市作為年度主題，除了向市民介紹布達佩斯的電影藝術與美學，也希望透過電影的相遇，加深台北與布達佩斯之間的文化交流，展現不同城市的電影敘事和文化風貌。

這不僅是一場電影的盛會，也是一次文化的對話和心靈的交融，我們期待藉此加深觀眾對於電影藝術的感知，激發對不同生活方式的好奇與探索。這些由遠至近的電影作品，透過銀幕上的城市故事，將世界帶入台北，也將台北的熱情推向世界，不僅讓觀眾在戲院裡環遊世界，更使台北電影節成為一處全球故事交匯的場所，彰顯了台北作為一座國際化都市的文化自信和開放姿態。

我們熱切邀請每位電影的愛好者，無論您是站在鎂光燈下的明星，還是在幕後辛勤工作的電影英雄，抑或是每一位熱情的影迷，攜手參與這場充滿魅力和感動的電影慶典。讓我們一起見證電影如何超越語言和文化的障礙，連結我們所有人的情感，共同慶祝這份屬於我們的藝術盛事。

蔡詩萍
臺北市政府文化局局長
財團法人台北市文化基金會執行長

Foreword from the Director General

2024 marks the 140th anniversary of the completion of the Taipei City Walls and the 26th edition of the Taipei Film Festival. Over 140 years, Taipei City's urban landscape and humanistic spirit have undergone iterative changes. Film has both presented and documented the city's landscape, and enriched the artistic cultivation of its citizens.

Following an absence of many years, the "City in Focus" section returns to the Taipei Film Festival with Budapest as the annual theme. Apart from introducing Budapest's film art and aesthetics to the public, we also hope to deepen cultural exchanges between Taipei and Budapest through cinema, showcasing the storytelling and cultural styles of films from different cities.

This is not only a prestigious film event but also a cultural dialogue and spiritual communion. We hope to use this opportunity to deepen the audience's awareness of the art of cinema and inspire curiosity and exploration of different lifestyles. These films, from far and near, through urban stories on the screen, bring the world to Taipei and propel Taipei's passion to the world. They not only let audiences travel around the world in theaters but also make Taipei Film Festival a global melting pot of stories, highlighting Taipei's cultural confidence and openness as an international city.

We warmly invite every film enthusiast, whether you are a star standing under the spotlight or a hardworking film hero working behind the scenes, as well as every passionate movie fan, to join us in this enchanting and moving celebration of cinema. Let us bear witness to how film transcends language and cultural barriers, connect our emotions, and jointly celebrate this art event that belongs to all of us.

TSAI Shih-ping
Director General
Department of Cultural Affairs, Taipei City Government

Chief Executive Officer
Taipei Culture Foundation

主席序

原本是幾件互相無關的事情。

今年初，擔任了兩部電影的監製，不約而同地，兩位首部長片導演都跟我搖頭嘆氣，「拍電影和單純美好的創作沒有關係」。也是今年初，我重讀喬瑟夫・坎伯的神話學著作《千面英雄》和克里斯多夫・佛格勒的編劇書《作家之路》，英雄旅程的結構，起點是面對守門人，跨越第一道門檻。上週接獲台北電影節「新導演長片工作坊」詢問擔任顧問的可能性，於是這幾件看似無關的事情在腦袋中產生了關連，關連或許就是台北電影節。

對於代代繼起的電影人而言，台北電影節多年來不就一直處於接壤地帶——想像中拍電影的美好桃花源，和實際上拍電影的滾滾紅塵？不就一直扮演著神話中英雄旅程第一道門檻的守門人，或提供錦囊妙法寶的歡迎，或青面獠牙的試煉，冀望英雄心意已決、準備充分，可以上路展開旅程？

台北電影節今年將與文化部首度合作辦理「新導演長片工作坊」，而與國際接軌的常設單元「國際新導演競賽」則將邁入第20年；受電影學生歡迎，初探實務的「電影正發生」，今年由過去的美術、配樂、表演，外擴至攝影；影展單元「焦點城市」帶來遙遠的布達佩斯。在單純的創作桃花源之外，電影紅塵的確廣闊又複雜多變。或許未來，台北電影節可以從第一道門檻的概念出發，規劃更多活動，因活動可以累積知識和經驗，即為過關第一道門檻，想密笈。

我們第一道門檻見。

易智言
台北電影節主席

Foreword from the Festival President

It started off as several unrelated matters.

At the beginning of the year, I served as an executive producer on two different films. Coincidentally, both debut feature directors sighed as they said to me: "Filmmaking has nothing to do with pure and beautiful creativity." Also at the start of the year, I re-read Joseph Campbell's monomyth work *The Hero with a Thousand Faces* and Christopher Vogler's screenwriting book *The Writer's Journey*. The structure of the hero's journey begins with entering the first threshold guarded by gatekeepers. Last week, I received an inquiry from Taipei Film Festival about the possibility of serving as a consultant for its "New Director Workshop". These several unrelated matters thus became linked in my mind, and perhaps that link is Taipei Film Festival.

For generations of filmmakers, hasn't Taipei Film Festival always been positioned at the borderland between the imagined paradise of filmmaking and the actual hustle and bustle of filmmaking? Hasn't it always played the role of gatekeeper of the first threshold in the mythological hero's journey, providing valuable guidance or daunting trials, in the hope that the hero is determined and sufficiently prepared to commence the journey?

This year, Taipei Film Festival and the Ministry of Culture are collaborating to deliver the "New Director Workshop"; the long-lasting "International New Talent Competition", the festival's global connection, is entering its 20th year; "In Progress", the popular section among film students, is expanding from its past exploration art direction, music, and performance to cinematography this year; and the "City in Focus" section brings us faraway Budapest. Beyond the paradise of pure creativity, the world of filmmaking is indeed vast, complex, and ever-changing. Perhaps in the future, Taipei Film Festival can plan even more activities through the first threshold concept, because activities can accumulate knowledge and experience, serving as the key to crossing the threshold.

Let's meet at the first threshold.

YEE Chih-yen
President of Taipei Film Festival

台北電影節 × anue fund 鉅亨買基金

看好電影
買好基金

鉅亨買基金　生活不擔心

加入鉅亨買基金即享終身0手續費

鉅亨證券投資顧問股份有限公司 ｜ 113金管投顧新字第003號 ｜ 公司地址：台北市信義區松仁路89號18樓B室

服務專線：(02)2720-8126 ｜ 服務時間：09:00-17:00 ｜ 客服信箱：cs@anuegroup.com.tw

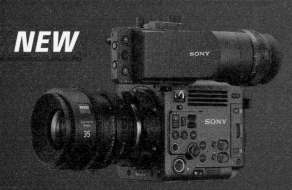

世界首映
World
Premiere

乒乓男孩
Doubles Match

冠宇和黃軒是自小玩伴，不僅就讀同一小學，也同樣對桌球產生濃厚興趣。他們不怕辛苦拼命練習，誓言做一個打遍天下無敵手的最強雙打搭檔。然而，刻苦練習的他們，實力卻越發懸殊，雙打組合屢嘗敗績，信任開始產生嫌隙。在母親的安排下，黃軒被迫送去城市獲得更好的體育資源，組合就此拆散，友情漸行漸遠。隨著錦標賽選拔展開，自小熟悉的拍檔即將成為球桌彼端的對手，兩人苦練許久的必勝絕技，也將在此一拍定輸贏。

有別於《老大人》的溫情刻畫，導演洪伯豪挑戰自我，嘗試熱血運動題材，將鏡頭轉向桌球場上的一來一回，正手拉、反手擰，毫無冷場精彩呈現。現實同為桌球選手的彭裕愷和李星緯，將精湛球技和演技發揮淋漓，亦敵亦友的友情令人揪心。金獎演員群徐若瑄、鄭人碩、施名帥、魏蔓等眾星傾情加入，為今年盛夏打出一記勝負正反拍。

Hu Guan-yu is passionate about table tennis. He trains with his best friend Huang Xuan, hoping to make the Olympic national team. When a new coach arrives, the team's atmosphere shifts, and they gradually drift apart. A year later, Guan-yu wins the junior national team qualifier. His opponent in the final: Huang Xuan.

開幕片
OPENING FILM

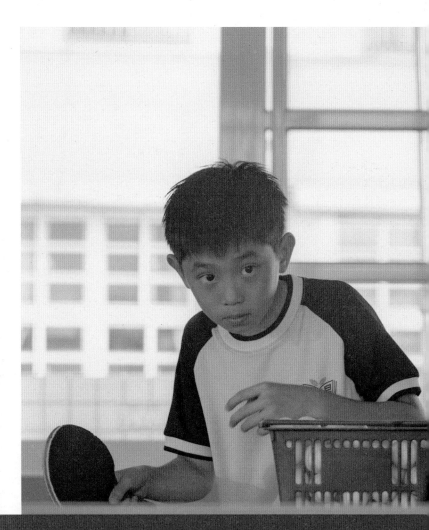

DIRECTOR
洪伯豪 HUNG Po-hao

PRODUCER
唐在揚 David TANG
梁宏志 Eric LIANG

SCREENPLAY
游文興 YU Wen-hsing

CINEMATOGRAPHER
周以文 CHOU I-wen

EDITOR
林雍益 Ian LIN

MUSIC
李銘杰 Rockid LEE

SOUND
杜篤之 TU Duu-chih
吳書瑤 WU Shu-yao

CAST
徐若瑄 Vivian HSU
鄭人碩 Rexen CHENG
施名帥 SHIH Ming-shuai
彭裕愷 Benjamin PENG
李星緯 Lucas LEE

PRINT SOURCE
嘉揚電影有限公司
RISE PICTURES CO., LTD.

洪伯豪，1978年出生，畢業於臺南藝術大學音像紀錄研究所。曾參與多部電影作品，擔任副導演一職，執導的多部短片和影集皆斬獲佳績。2018年，以首部劇情長片《老大人》榮獲台北電影獎最佳劇情長片等四項大獎，《乒乓男孩》為其最新作品。

HUNG Po-hao's debut feature, *Dad's Suit*, received four awards at the 2019 Taipei Film Awards. In recent years, he has directed several TV series, such as *Wake Up 2*, *A Thousand Goodnights*, and *Trinity of Shadows*.

Doubles Match

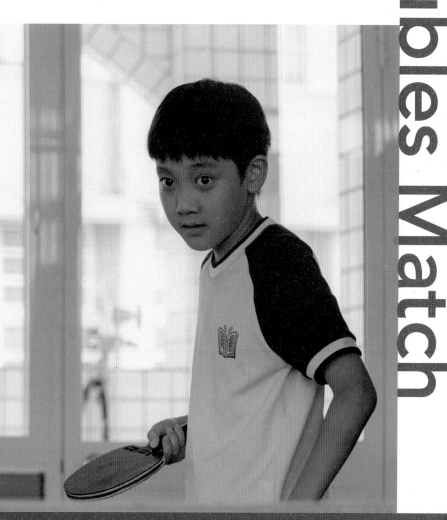

06.21 FRI 19:00 中山堂 TZH ★

南韓 South Korea｜2023｜DCP｜Color｜116min

非普通家族

A Normal Family

一個是為錢辯護的王牌律師，一個是為信念救人的正直醫生，因為擺脫不了兄弟的血緣羈絆，不得不以定期的奢華晚餐，維持貌似和平的兩家情誼。直到一個漫長的夜，他們正值青春期的兒女犯下了無可彌補的過錯，作為家長的他們也瞬間變成被謊言牽著走的小丑。到底要埋葬，還是自首？當晚餐話題逐漸失控，站在天平兩端的他們，掀起了激烈交鋒，殊不知一不小心，便放出了心底的野獸。

改編自荷蘭作家荷曼·柯赫的暢銷小說，許秦豪一反溫煦風格的冰寒新作，以有條不紊的類型敘事，揭露韓國階級社會中的教育扭曲，深挖親情牽扯下的角色雙面與道德底線。出乎意料的終極翻轉，引人直擊深不見底的人性深淵。全片陣容堅實，集結薛景求、張東健、金喜愛等人狂飆演技，在體面的杯盤之下，上演暗潮洶湧的交鋒戲碼。

Jae-wan is a materialistic criminal defense lawyer who has no problem defending murderers. His younger brother is Jae-gyu, a morally adept and warm pediatrician. They meet once a month with their wives for dinner. One day, security camera footage of a teenage boy and a girl beating a homeless man to death goes viral. The police begin their investigation, but since the perpetrators' faces weren't shown, the case goes nowhere. But having seen the footage, Jae-gyu's wife Yeon-kyung and Jae-wan's wife Ji-su uncover a shocking secret.

閉幕片

CLOSING FILM

DIRECTOR
許秦豪 HUR Jin-ho
PRODUCER
KIM Won-kuk
SCREENPLAY
PARK Eun-kyo
PARK Joon-seok
CINEMATOGRAPHER
GO Rak-sun
EDITOR
KIM Hyung-joo
MUSIC
CHO Sung-woo
SOUND
PARK Yong-ki (IMS Studio)
CAST
薛景求 SUL Kyung-gu
張東健 JANG Dong-gun
金喜愛 KIM Hee-ae
秀賢 Claudia KIM
PRINT SOURCE
網銀國際影視股份有限公司
Wanin International Visual Enterprise, Ltd.

許秦豪，韓國導演，1963年生。1998年以首部劇情長片《八月照相館》一舉拿下青龍獎、大鐘獎最佳新導演獎，奠定作者風格；2001年，再以《春逝》角逐鹿特丹影展，並獲東京影展藝術貢獻特別獎，在國際影壇嶄露頭角。早期以拍攝愛情電影見長，有「情感大師」之稱，而後嘗試拍攝多部中韓合製作品，近年則將類型觸角伸向史詩、時代、傳記等題材。《非普通家族》為其最新力作。

HUR Jin-ho was born in 1963 and graduated from the Korean Academy of Film Arts. All his feature films, *Christmas in August* (1998), *One Fine Spring Day* (2001), *April Snow* (2005), *Happiness* (2007) and *A Good Rain Knows* (2009) are variations on his favorite theme: love.

▌ 2024 棕櫚泉影展 Palm Springs IFF
▌ 2023 新加坡影展 Singapore IFF
▌ 2023 多倫多影展 Toronto IFF

A Normal Family

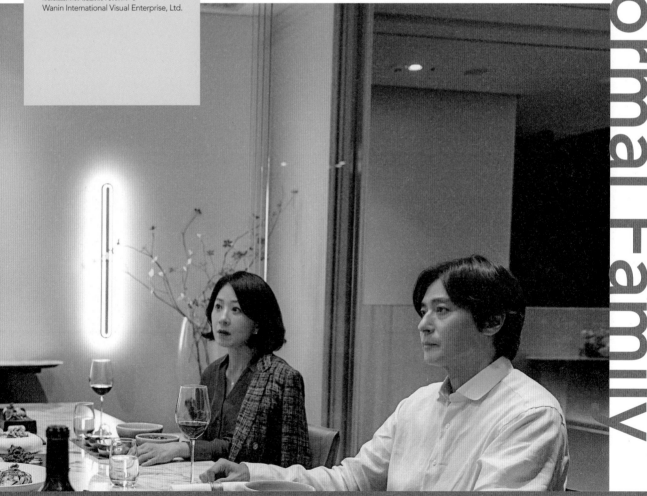

06.30 SUN 19:00 中山堂 TZH ★

MONTBLANC

100 Years of Meisterstück.
Written and directed by Wes Anderson.

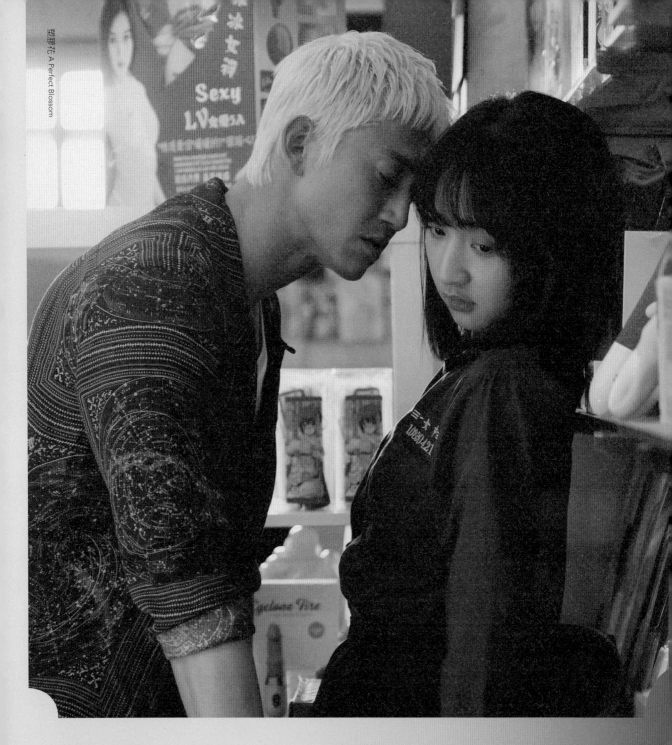

星光首映
GALA PRESENTATIONS

星光熠熠的放映現場，與影人近距離面對面，台北電影節集結國內外話題強片與劇集作品。從大師蔡明亮的「行者」新篇章，到最強台灣話題劇集，還有隨片登台的日本強檔電影，都將在中山堂隆重呈現。

Come face to face with film stars at the dazzling Gala Presentations, where Taipei Film Festival brings together the most topical domestic and international films and series. From the latest entry in Tsai Ming-liang's *Walker* series to a hotly discussed Taiwanese drama series and a major Japanese film, these highly anticipated works will all be making their grand premieres at Zhongshan Hall.

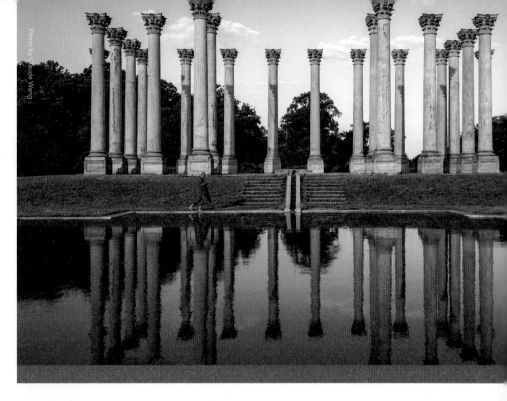

蔡明亮，創作生涯11部劇情長片皆入選世界三大影展，更連續五次獲得國際影評人費比西獎；2009年作品《臉》成為羅浮宮首度典藏電影，創下藝術電影的標竿與典範。近年作品頻繁跨足藝術圈，積極推動「美術館院線」與「作者的觀看方式」，開創新的觀影經驗，與過度商業化的電影市場體系抗衡。

TSAI Ming-liang's debut feature, *Rebels of the Neon God*, premiered at Berlinale in 1992. His sophomore film, *Vive L'amour* (1994), won the Golden Lion at Venice, while *The River* (1996) won the Jury Prize at Berlinale. All of his feature films have been selected by the world's top three film festivals, winning five FIPRESCI Prizes.

無所住
Abiding Nowhere

台灣、美國 Taiwan, USA │ 2024 │ DCP │ Color │ 79min

DIRECTOR
蔡明亮 TSAI Ming-liang
PRODUCER
王雲霖 Claude WANG
CINEMATOGRAPHER, EDITOR
張鍾元 CHANG Jhong-yuan
SOUND
林子翔 LIN Zi-xiang
CAST
李康生 LEE Kang-sheng
亞儂・弘尚希
Anong HOUNGHEUANGSY
PRINT SOURCE
汯呄霖電影有限公司
Homegreen Films Co., Ltd.

蔡明亮「行者」系列緩步12年，邁入第十篇章。行者踏上美國疆土，慢行於溪流樹林、城區街巷，行過華盛頓紀念碑、華府聯合車站；緩步藝術殿堂，與平行時空裡亞儂的生活日常，看似無干，又像對倒。行者步履不停，行者無疆，《無所住》以緩慢與美國的彼時、與大銀幕前的觀者進行一場對話和冥想，述說一首無邊無際，關於時間和萬物的祝禱詩。

歡慶建館百週年，美國史密森尼國家亞洲藝術博物館邀請蔡明亮寫下「行者」新頁。繼2014年《西遊》獲選柏林影展電影大觀單元閉幕片後，行者系列時隔十年再返柏林特別放映單元。片名取自《金剛經》之「無所住而生其心」，蔡明亮再次超越影像疆界，隨心所欲，化電影為譯經，以影像揭義，遁入玄妙之境界，展現高超道行。

The 10th film in the *Walker* series takes place in Washington DC. Two lonely souls on separate journeys, sometimes crossing paths but never once meeting. Nothing happens between them. There is no story. Their walking journeys are like a meditative prayer of heart and soul.

▌ 2024 哥本哈根紀錄片影展 CPH:DOX
▌ 2024 香港電影節 Hong Kong IFF
▌ 2024 柏林影展 Berlinale

06.23 SUN 19:00 信義 HYC 11 ★ │ 06.30 SUN 10:30 信義 HYC 11

森達也，日本當代重要的紀錄片導演、作家。1956年生於廣島縣吳市。1998年根據對奧姆真理教的採訪，完成首部紀錄長片《A》，2001年完成續篇《A2》。曾以著作《A3》獲第33屆講談社紀實文學獎。擅長處理極具爭議的社會案件，透過電影鬆動已被定型的世界，對世人認知的現實提出犀利的探問。

MORI Tatsuya is a Japanese documentary filmmaker born in 1956. His first documentary feature, A, which focuses on the Tokyo subway sarin attack of 1995, was theatrically released in 1998. It was invited to many overseas film festivals, such as Berlinale, and drew significant attention worldwide.

DIRECTOR
森達也 MORI Tatsuya
PRODUCER
小林三四郎 KOBAYASHI Sanshiro
SCREENPLAY
荒井晴彥 ARAI Haruhiko
CINEMATOGRAPHER
桑原正 KUWABARA Tadashi
EDITOR
洲崎千恵子 SUZAKI Chieko
MUSIC
鈴木慶一 SUZUKI Keiichi
SOUND
齊藤綠 SAITO Midori
森山貴之 MORIYAMA Takayuki
岩波昌志 IWANAMI Masashi
CAST
井浦新 IURA Arata
田中麗奈 TANAKA Rena
永山瑛太 NAGAYAMA Eita
東出昌大 HIGASHIDE Masahiro
PRINT SOURCE
UZUMASA, Inc.

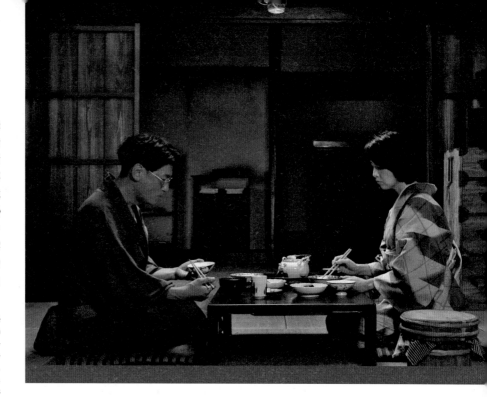

福田村事件
September 1923

日本 Japan｜2023｜DCP｜Color｜137min

1923年9月，關東大地震重創東京，因天災而起的虛假謠言四起，當地民眾對於朝鮮人的惡意眼光撲面而來。某日，一組賣藥商隊攜家帶眷，從日本香川出發行商，行經關東村落時，偶遇孤身於街頭販賣糖果的朝鮮女孩，商隊的領袖出於善意伸出援手，卻意外因口音而招致村民誤認為朝鮮人，百名民眾隨即展開獵巫行動，對商隊成員們虐打殘殺。在側旁觀的是剛從朝鮮京城歸國的日本夫婦，儘管平日裡受到村民的尊崇，此時卻也束手無策，最終釀成一起因種族衝突而起的人間悲劇。

本片由井浦新、田中麗奈、永山瑛太、東出昌大主演，緣起於一篇為事件受害者立碑的報導，日本重量級紀錄片導演森達也首度以劇情敘事形式，勾勒日本官方長期忽視、史稱「福田村事件」的暴力事件。出於對悲劇的始末、集體恐懼如何助長排他行徑的好奇，這起暴力事件成為森達也探索人性幽微之處的起點。

On September 1st, 1923, an extreme quake strikes Japan's Kanto region, destroying property and killing many innocent lives. With martial law imposed following the disaster, false rumors about Koreans looting and preparing to initiate a riot begin to spread rapidly to towns and villages in the region, eventually reaching Fukuda Village. A local newspaper scrambles to verify the rumors but cannot clarify the truth.

Taking advantage of the turmoil, the Kameido police station secretly starts suppressing socialists. And on September 6th, the piling coincidences, anxiety, and fear spark a tragic incident that would later be buried in history.

▇ 2023 釜山影展新潮流競賽大獎 New Currents Award, Busan IFF

06.29 SAT 15:50 中山堂 TZH ★｜06.30 SUN 13:40 信義 HYC 10 ★

鄭雅之，臺北藝術大學電影創作學系畢業，新銳電影導演，曾入選金馬電影學院。短片《悄悄》、《SWIN》、《浮陽》獲金穗獎肯定，也於國內影展放映。《塑膠花》是她編導的第一部台灣影集。

Makayla CHENG Ya-chih is an emerging director. An alumna of the Golden Horse Film Academy, her short films have screened at the Busan IFF, Tokyo IFF, Taipei FF, and Shanghai IFF. *A Perfect Blossom* is her debut Taiwanese drama series.

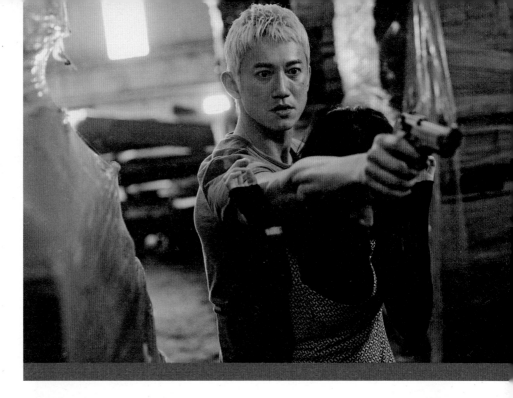

塑膠花（第1-3集）
A Perfect Blossom (Ep. 1-3)

世界首映
World Premiere

台灣 Taiwan｜2024｜DCP｜Color｜107min

富家千金耍叛逆，亡命之徒走走天涯！少女是溫室栽培的花朵，想掙脫拜金母的束縛，嚮往愛情渴求自由，卻勾搭上冷酷兇殘的金髮更生人。原以為是對浪漫的亡命鴛鴦，誰知道逗陣搶銀行變「真・擄人勒贖」。逃命列車越過越多人，粉紅泡泡漸褪色，愛情卻不減半分，社會現實冷漠疏離，少女終究要登大人。現代社會的「家」在何方？大叔與少女如何反抗並非自己選擇的生存狀態？他們又能否把愛蔓延到荒漠裡？

金馬影帝吳慷仁再度挑戰自我，詮釋具暴力傾向的更生人；金鐘新人李沐飾演性格分裂的上流千金，表面是可愛的學霸乖乖女，私下卻有著充滿暗黑情慾的一面。此外，高捷、陽靚、林鶴軒、馬志翔、葉全真等實力派演員集結，影集充滿台味的美漫人物設定，加上MV質感的流暢運鏡與剪接，逐漸梳理出角色的神祕背景，搭配迷離冷調的電子音樂，試圖打造全新的公路愛情台劇新風貌。

Seventeen-year-old Yen Na-na lives a cynical and boring life. While setting up a badger game to mess with her teacher, she unintentionally encounters 35-year-old drug dealer Kim Chin, who just got out of prison. It is love at first sight. Returning to his old trade, Kim Chin gets busted in a former drug dealer deal and is wanted by police again. The lovestruck Na-na volunteers to carry a bomb and pretends to be a hostage so they can rob a bank and escape together. However, the robbery exposes why Kim Chin was imprisoned in the first place, turning the love birds against each other.

DIRECTOR
鄭雅之 Makayla CHENG Ya-chih
CHIEF EXECUTIVE PRODUCER
唐才智 Alex DONG
EXECUTIVE PRODUCER
謝國豪 Kevin TSE
周銓 Sarso CHOU
SCREENPLAY
陳怡儒 Stefanie CHAN
鄭雅之 Makayla CHENG Ya-chih
CINEMATOGRAPHER
趙冠衡 CHAO Kuan-heng
李麟 Ling LEE
EDITOR
曾宇健 TSANG Yu-kin
MUSIC
侯志堅 Chris HOU
SOUND
江宜真 CHIANG Yi-chen
謝青�940 HSIEH Ching-chun
CAST
吳慷仁 Kangren WU
李沐 Moon LEE
高捷 Jack KAO
陽靚 Zin YANG
林鶴軒 LIN He-xuan
PRINT SOURCE
抓馬文化股份有限公司
DRAMA CULTURE COMPANY LIMITED

06.23 SUN 13:30 中山堂 TZH ▲ ★

孫介珩，台北人，中山大學政治研究所畢業，看不見電影工作室創辦人。2016年以紀錄片《海風下》入選新北市紀錄片獎；2018年以劇情短片《乾兒子》、《番茄》同時入圍金穗獎最佳劇情片；2020年以短片《第一鮪》獲金穗獎最佳編劇，並入圍台北電影獎最佳短片、男配角。

SUN Chieh-heng majored in history in college and political science in graduate school. He has been engaged in academic research and marine conservation, and chooses to tell stories through film.

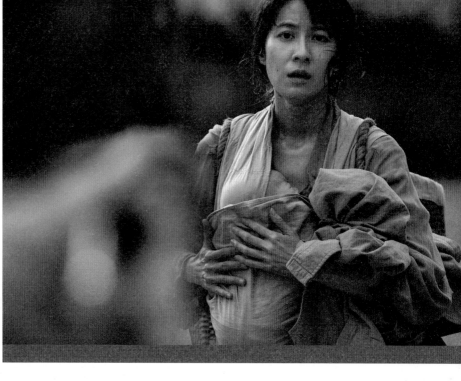

聽海湧（第1-2集）
Three Tears in Borneo (Ep.1-2)

台灣 Taiwan｜2024｜DCP｜Color｜108min

DIRECTOR
孫介珩 SUN Chieh-heng
PRODUCER
林佳儒 Inch LIN
湯昇榮 Phil TANG
孫介珩 SUN Chieh-heng
SCREENPLAY
蔡雨氛 TSAI Yu-fen
CINEMATOGRAPHER
王淳宇 Danny WANG
EDITOR
高鳴晟 KAO Ming-sheng
MUSIC
福多瑪 Thomas FORGUENNE
SOUND
張喆泓 CHANG Che-hung
CAST
吳翰林 Han WU
黃冠智 HUANG Guan-zhi
朱宥丞 JHU Yu-cheng
施名帥 SHIH Ming-shuai
連俞涵 Harriet LIEN Yu-han
周厚安 Andrew CHAU
PRINT SOURCE
財團法人公共電視文化事業基金會
Public Television Service Foundation

二戰期間，北婆羅洲一處日本戰俘營，三個情同手足的台籍日本兵在此擔任戰俘監視員。他們接受日籍軍官指揮，看管同盟國戰俘，終戰前夕卻被捲進一樁冷血屠殺案。二戰結束日本戰敗，同盟國軍事法庭要調查屠殺案件，台籍日本兵被中華民國領事控為主謀，日本辯護律師團卻不將他們當作首要救援對象，戰爭的瘋狂讓台灣人淪為孤兒。屠殺真相到底為何？回家鄉聽海浪真的只能是一場幻夢嗎？

首部以台灣人視角，刻劃人性情感與國族糾葛的二戰歷史影集。年輕實力演員黃冠智、吳翰林、朱宥丞飾演台籍戰俘監視員，赴日受訓一個月，台日雙語和考究的服裝場景，如實還原異鄉戰場上，受日本殖民壓迫的台灣人困境。題材新穎的歷史劇，更像一則以古喻今的國族寓言，道盡台灣人夾在日本、中國，以及國際列強間的複雜認同與矛盾情感。

During World War II, A-yuan, a monitor of prisoner-of-war in Borneo, is involved in a massacre. As the suspect, he realizes the nature of war as he reveals the truth.

▌2024 法國里爾 Series Mania 劇集展 Series Mania

06.27 THU 19:00 中山堂 TZH ★

莊絢維，臺北藝術大學電影創作研究所畢業。影視作品橫跨電影和劇集，包括《濁流》、《人面魚：紅衣小女孩外傳》等，皆獲國內外獎項肯定。

David CHUANG graduated from the Department of Filmmaking of NTUA and Vancouver Film School. His works span film and TV, and include *Upstream* and *The Tag-Along: The Devil Fish*.

陳冠仲，投身影視製作十餘年，並參與多部類型片。曾以《洛西・布拉西》獲金穗獎最佳劇情片、音效配樂。與莊絢維合導的影集《逆局》，榮獲2022年金鐘獎戲劇節目最佳導演。

With over a decade of experience in film and TV production, **CHEN Kuan-chung** won the Golden Bell Award for Best Directing for a TV Series for *Danger Zone* in 2022.

DIRECTOR
莊絢維 David CHUANG
陳冠仲 CHEN Kuan-chung
CHIEF PRODUCER
湯昇榮 Phil TANG
EXECUTIVE PRODUCER
曾瀚賢 TSENG Han-hsien
SCREENPLAY
陳承佑 CHEN Cheng-yu
CINEMATOGRAPHER
趙冠衡 Eric CHAO
仉春霖 CHANG Chun-lin
EDITOR
林雍益 Ian LIN
施博瀚 SHIH Po-han
MUSIC DIRECTOR
李銘杰 Rockid LEE
MUSIC
CHEER
林昀駿 Troy LIN
CAST
張孝全 CHANG Hsiao-chuan
許瑋甯 HSU Wei-ning
王識賢 WANG Shih-hsien
蘇慧倫 Tarcy SU
藤岡靛 Dean FUJIOKA
李沐 Moon LEE
劉俊謙 Terrance LAU Chun-him
張再興 CHANG Tsai-hsing
PRINT SOURCE
Netflix Pte. Ltd.

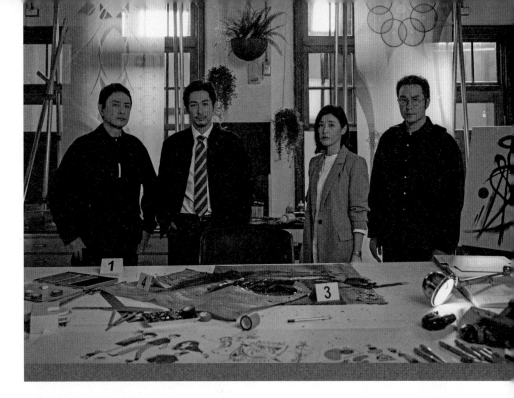
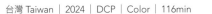
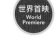

誰是被害者：第2季（第1-2集）
The Victims' Game: Season 2 (Ep. 1-2)

世界首映
World Premiere

台灣 Taiwan ｜ 2024 ｜ DCP ｜ Color ｜ 116min

前鑑識官方毅任迎接女兒江曉孟離開觀護所，父女倆和從嗜血記者轉職基金會公關的徐海茵一同展開新生活，卻身陷一連串的死亡事件。所有疑點，都將頭號嫌疑人指向方毅任。案件更牽起一件15年前他經手的情殺案，恩師林景瑞聲譽同樣遭到質疑。為了還自己清白，方毅任必須和刑警趙承寬以及法醫薛欣寧合作查明真相，否則他將再一次失去與曉孟的家。當細節抽絲剝繭，謎題是否得以解開，而神祕圖騰又能否引領眾人迎來正義的曙光。

繼第一季的熱議好評，金獎團隊再次聯手打造全新第二季，不但有原班人馬張孝全、許瑋甯、李沐延續親情關係線，更加上日港男神藤岡靛、劉俊謙跨刀卡司陣容，眾人聯手偵破一件件兇殺謎團，當邪惡勢力步步進逼，誰才是真正的被害者？

Former investigator Fang Yi-jen and reporter-turned-public relations manager Hsu Hai-yin start a new life with his daughter Chiang Hsiao-meng. However, Fang is embroiled in a series of deaths, becoming a prime suspect. The incidents link back to a murder case he responded to 15 years ago. Prosecutor Chang Keng-ha doubts Fang and his mentor Lin Ching-jui's integrity. Fang collaborates with Detective Chao Cheng-kuan and forensic examiner Hsueh Hsin-ning to uncover the truth and prove his innocence, or he risks losing his relationship with Chiang once again.

06.21 FRI 13:00 中山堂 TZH ★

SURPRISE FILM

2024 ｜ DCP ｜ Color ｜ ? min

驚　以為你都知道

喜　其實萬萬想不到

場　電影看完都沒猜到

這是一部沒有吸毒、搶劫、綁架、殺人、血腥的限制級電影。

06.22 SAT 13:50 中山堂 TZH ★

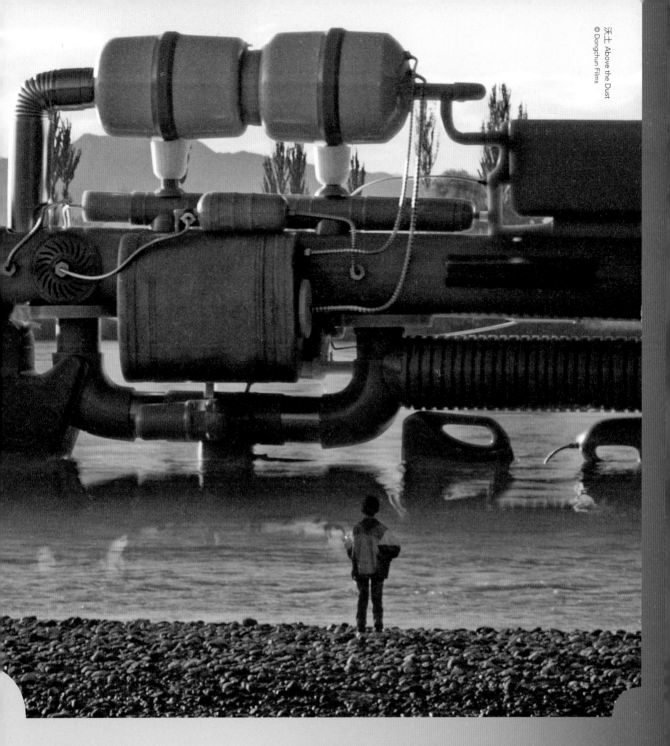

特別放映
SPECIAL SCREENINGS

現場配樂營造的全新觀影體驗，雙競賽評審團主席隨片登台，帶來精彩的大師講堂，給影迷最深入的電影觀點。還有闔家觀賞的親子作品，小影迷與電影的邂逅就從台北電影節開始。

Featuring the fresh new cinematic experience of live scoring, on-stage presentations by the jury presidents of both competitions, as well as exciting masterclasses, the Special Screenings section offers film buffs the most insightful perspectives on cinema. There are also child-friendly films for the whole family to enjoy, making Taipei Film Festival the gateway for young cinephiles to discover the world of movies.

© Seiji Shibuya

石橋英子，日本音樂家，音樂風格充滿有機及實驗特質，除了常以創作歌手、即興演奏家身分，與吉姆・歐洛克等知名音樂人合作演出外，亦常為展覽、劇場和影視作品編寫配樂，並以《在車上》、《邪惡根本不存在》獲亞洲電影大獎最佳原創音樂獎，《GIFT》為她與濱口竜介再次合作的創作計畫。

ISHIBASHI Eiko is a Japanese multi-instrumentalist whose work has ranged from acclaimed singer-songwriter albums to scores for film, television, theater and exhibitions. For scoring *Drive My Car*, she won Discovery of the Year at the World Soundtrack Awards and Best Original Music at the Asian Film Awards.

濱口竜介，1978 年生，2015年以《歡樂時光》獲盧卡諾影展特別提及開始嶄露頭角，後更以《睡著也好醒來也罷》、《在車上》接續闖入坎城主競賽，後者更拿下最佳劇本獎與奧斯卡最佳國際影片，亦曾以《偶然與想像》拿下柏林影展評審團大獎。

HAMAGUCHI Ryusuke started garnering international recognition with his 2008 graduate film *Passion*. His film *Wheel of Fortune and Fantasy* (2021) won the Silver Bear Grand Jury Prize at Berlinale. *Drive My Car* (2021) won Best Screenplay at Cannes and Best International Feature Film at the Academy Awards.

© Shuhei Kojima

GIFT：配樂場

PRINT SOURCE NEOPA Inc. × Fictive LLC

GIFT: A Film by Ryusuke Hamaguchi × Live Score by Eiko Ishibashi

日本 Japan｜2023｜DCP｜Color｜74min

應曾合作《在車上》配樂的音樂家石橋英子之邀，濱口竜介首次為現場音樂演出創作影像，他前往石橋工作室附近的八岳火山群地區進行取材與拍攝。面對當地空靈壯觀的自然地景，以及蓬勃發展的觀光產業，濱口決定聚焦人與自然關係的多面性和複雜性，在環境保護、土地開發等道德爭議表象背後，開拓出一部宛若深林迷宮的自然懸疑奇片。

本作故事背景與《邪惡根本不存在》相同，然而，透過類似默片的剪輯手法和字卡呈現，濱口不僅紮實呈現劇情架構，更成功為音樂保留了完整的聲音空間。相對已填入對白血肉的劇情片版本，本作更多了一份紀錄片般的寫實氣韻與想像空間，令石橋英子優美脫俗的樂句更顯蕩氣迴腸，成就了一場只有在演出現場才能完整呈現創作概念的獨特視聽饗宴。

Gift is Hamaguchi Ryusuke's companion piece to *Evil Does Not Exist*, developed in collaboration with music composer Ishibashi Eiko, who previously scored his Oscar-winning film *Drive My Car*.

Gift preserves the story of *Evil Does Not Exist*, but is presented as a silent film with title cards and the live accompaniment of Ishibashi's score, performed in person by the composer herself. Compared to the original version filled with dialogue, this remix adds a documentary-like realism and imaginative space that allows Ishibashi's graceful and transcendent music to resonate more profoundly, resulting in a unique audiovisual feast and new kind of cinematic experience.

▮ 2024 香港電影節 Hong Kong IFF
▮ 2023 東京 FILMeX影展 TOKYO FILMeX

06.29 SAT 20:00 中山堂 TZH ♫

邪惡根本不存在
Evil Does Not Exist

PRINT SOURCE 東昊影業有限公司 Andrew Film Co., Ltd.

日本 Japan｜2023｜DCP｜Color｜106min

東京近郊的寧靜山村中,中年喪偶的巧與女兒相依為命。替村民打雜為生的巧,熟稔山林裡的一切,自然之道是他謀生的工具、生活的信仰,更是他育女的原則。某日,一對陌生男女代表開發公司前來遊說村民,希望能在村子的水源處打造一座豪華露營地。面對家園可能迎來的劇變,巧維持著一貫的寡言,冷眼凝視著事態的發展……。

繼獲獎無數的鉅作《在車上》後,濱口竜介再次與音樂家石橋英子合作,並將原為應石橋現場演出量身打造的影像計畫,擴張為一部概念完整,且在敘事手法及題材格局上皆再度自我突破的大作。擅長架構都會男女的言語迷障,進而精準描摹情感與關係氛圍的濱口,這回將鏡頭對準冥冥自然,以悠然詩意的步調,穿越善惡與城鄉等人間價值,揮灑出一幅兼具寫實靈魂與迷幻氣質的天道圖卷。

Takumi and his daughter Hana live in Mizubiki Village, close to Tokyo. Like generations before them, they live a modest life. One day, the village becomes aware of a plan to build a glamping site near Takumi's house, offering city residents an "escape" to nature. When company representatives from Tokyo arrive in the village, it becomes clear that the project will have a negative impact on the local water supply, causing unrest. The agency's mismatched intentions endanger both the ecological balance of the plateau and their way of life, with an aftermath that affects Takumi's life deeply.

▌2024 亞洲電影大獎最佳影片、原創音樂 Best Film, Best Original Music, Asian Film Awards
▌2023 倫敦影展最佳影片 Best Film, BFI London FF
▌2023 威尼斯影展評審團大獎、國際影評人費比西獎 Grand Jury Prize, FIPRESCI Prize, Venice FF

06.28 FRI 18:10 信義 HYC 10 ★

DIRECTOR
濱口竜介 HAMAGUCHI Ryusuke
PRODUCER
高田聰 TAKATA Satoshi
SCREENPLAY
濱口竜介 HAMAGUCHI Ryusuke
石橋英子 ISHIBASHI Eiko
CINEMATOGRAPHER
北川喜雄 KITAGAWA Yoshio
EDITOR
濱口竜介 HAMAGUCHI Ryusuke
山崎梓 YAMAZAKI Azusa
MUSIC
石橋英子 ISHIBASHI Eiko
SOUND
松野泉 MATSUNO Izumi
CAST
大美賀均 OMIKA Hitoshi
西川玲 NISHIKAWA Ryo
小坂竜士 KOSAKA Ryuji
渋谷采郁 SHIBUTANI Ayaka
菊池葉月 KIKUCHI Hazuki
三浦博之 MIURA Hiroyuki

王小帥，1966年生於上海。首部作品《冬春的日子》即獲BBC選為影史百部佳片之一，後更以《十七歲的單車》、《青紅》、《左右》等作品多次入選三大影展，獲獎無數，亦曾獲法國文化部頒發文學藝術騎士勳章。

WANG Xiaoshuai is a pioneer of Chinese independent cinema who has directed 15 films in 30 years. *In Love We Trust* (2008) won the Berlinale Silver Bear for Best Screenplay, *Beijing Bicycle* (2001) won the Grand Jury Silver Bear at Berlinale, and *Shanghai Dreams* (2005) won the Jury Prize at Cannes.

DIRECTOR, SCREENPLAY
王小帥 WANG Xiaoshuai
PRODUCER
劉璇 LIU Xuan
CINEMATOGRAPHER
KIM Hyun-seok
EDITOR
Ruben VAN DER HAMMEN
MUSIC
Juho NURMELA
Ella VAN DER WOUDE
SOUND
Michel SCHÖPPING
CAST
歐陽文鑫 OUYANG Wenxin
咏梅 Yong Mei
祖峯 ZU Feng
PRINT SOURCE
The Match Factory

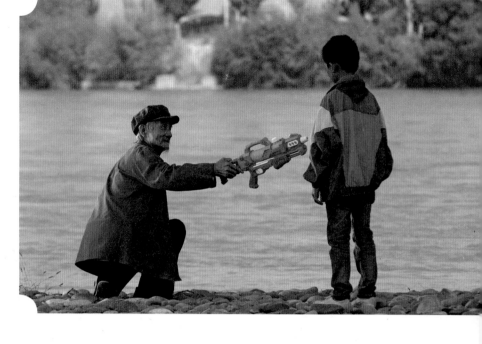

沃土
Above the Dust

亞洲首映 Asian Premiere

中國、荷蘭 China, The Netherlands｜2024｜DCP｜Color｜123min

黃土荒村生存不易，十歲男孩沃土的父親出外打工，留下他與爺爺、媽媽和妹妹在老家簡樸度日。羨慕同學們都有酷炫的水槍，沃土總盼著父親回家能記得給他帶上一把，卻總是失望。自知不久人世的爺爺向他保證，當他成為鬼魂，一定會設法滿足乖孫的願望。爺爺離世後，沃土果真在夢中遇見爺爺，然而，爺爺穿越生死時空所帶回來的訊息，卻意外給家人們帶來了一場風暴⋯⋯。

中國第六代名導王小帥繼《地久天長》後，改編李師江短篇小說〈爺爺的鬼把戲〉的鄉土大作。延續「家園三部曲」，透過兒童視角凝視農村變遷。層層套疊蒼茫現實與奇幻夢境，穿越半世紀的過去與現在，王小帥再次忠實描繪常民歷史記憶，深切傳達出對斯土斯民的鄉愁情感及真摯關懷。

Ten-year-old Wo Tu dreams of having a water pistol like other boys in his village. Even though his father promised, he fails to bring one from the city. But there is one hope for Wo Tu: his dying grandfather assures he'll grant him the wish as a ghost. After his death, the old man visits the boy in his dreams, initiating a treasure hunt. Soon, the limits between reality and dream, past and present, become more and more blurred. A portrait of the profound love for the land, across three generations of a family in modern Chinese rural life.

▌2024 柏林影展 Berlinale

06.22 SAT 11:00 華山 SHC 1 ｜ 06.26 WED 18:50 信義 HYC 10 ★ ｜ 07.01 MON 15:00 華山 SHC 1

陳果，1959年生於廣東，十歲移居香港。1997年以《香港製造》打響名號後，陸續以《去年煙花特別多》、《細路祥》所組成的「香港三部曲」，以及由《榴槤飄飄》、《香港有個荷里活》、《三夫》組成的「妓女三部曲」屢獲大獎肯定。

Fruit CHAN is a Hong Kong film director and independent film producer. His 1997 film *Made in Hong Kong* won the Special Jury Prize at Locarno, as well as Best Director at both the Hong Kong Film Awards and Golden Horse Awards.

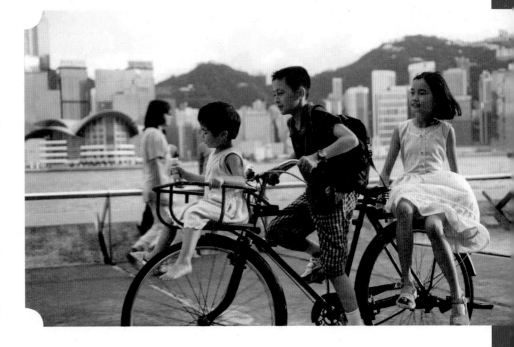

細路祥
Little Cheung

香港 Hong Kong｜1999｜DCP｜Color｜117min

本片為珍貴膠卷數位化版本，影像與聲音留有原膠卷片況。

The film is digitized from rare archive materials. This unrestored version contains defects and imperfections from the original film.

八歲男孩祥仔時常幫居裡的茶餐廳送外賣，因機靈可愛的個性而廣獲街坊喜愛，時常獲得小費打賞。某天，一位背景神祕的小女孩前來店裡應徵幫手，雖然立刻被祥爸趕走，好奇女孩來歷的祥仔卻暗中追了上去，並以小費利潤和女孩建立起合夥關係。當大人們正為主權移交而未雨綢繆，孩子們則仍沉浸在兩小無猜的世界中，不知自己的生活即將迎來巨大的改變。

香港名導陳果以兒童的純真視角凝視無奈現實，鏡頭深入九龍市井，每個場景及情節皆乘載著濃厚的人情趣味和世代記憶，呈現老香港的世代鄉愁之餘，也見證著九七前後政治及社會的時局變遷。緊接在《香港製造》、《去年煙花特別多》之後，本片為陳果成名代表作「香港三部曲」完美收尾，打敗《花樣年華》奪下當屆金馬獎最佳原著劇本。

Wise nine-year-old Little Cheung often spends time with his mahjong-loving grandmother and works as a delivery boy at the restaurant run by his father. He also befriends Fan, the daughter of illegal Chinese immigrants. Their days of innocence and simplicity are interrupted, though, as Fan's family is found out and Cheung unexpectedly learns that he has an estranged older brother and immediately sets out on a journey to find his lost sibling.

DIRECTOR, SCREENPLAY
陳果 Fruit CHAN
PRODUCER
陳偉揚 Kenny CHAN
江玲玲 Irene KONG
CINEMATOGRAPHER
林華全 LAM Wah Chuen（HKSC）
EDITOR
田十八 TIN Sam Fat
MUSIC
林華全 LAM Wah Chuen
朱慶祥 CHU Hing Cheung
SOUND
聶基榮 NIP Kei Wing
CAST
姚月明 YIU Yuet Ming
麥惠芬 MAK Wai Fan
麥雪雯 MAK Suet Man
PRINT SOURCE
Nicetop Independent Limited.

▎ 2000 金馬獎最佳原著劇本、新演員 Best Original Screenplay, Best New Performer, Golden Horse Awards
▎ 2000 盧卡諾影展新電影銀豹獎、藝術電影獎特別提及 Silver Leopard for New Cinema, Cicae Award - Special Mention, Locarno FF

06.22 SAT 19:30 中山堂 TZH ｜ 07.02 TUE 19:00 信義 HYC 10 ★

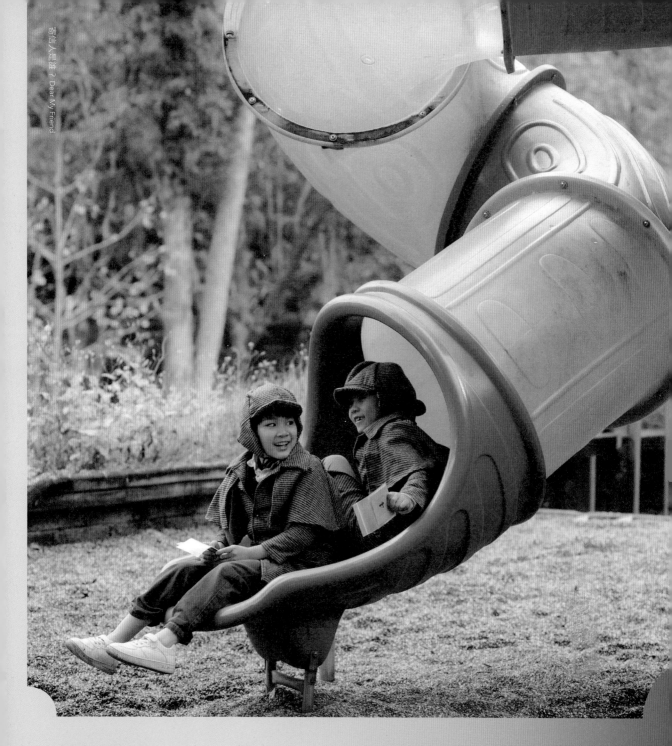

特別放映：
親子場
SPECIAL SCREENINGS:
FILMS FOR KIDS

屬於孩子們的故事，和大小演員齊聚中山堂，在大銀幕上
體驗不同的人生，用為下一世代量身打造的本土影視作品，
為孩子帶來一場難忘的影展初體驗。

These are stories that belong to children. Join actors both young
and old at Zhongshan Hall to experience diverse life stories on the
big screen. Featuring locally produced works specifically aimed at
the next generation, this segment offers children an unforgettable
maiden film festival experience.

李權洋，世新大學廣播電視電影學系、臺灣藝術大學電影學系碩士畢業。作品多以生活為題，導演風格寫實細膩。以執導電視劇《鏡子森林》入圍金鐘戲劇節目導演獎，並以短片《銅板少年》獲夏威夷影展最佳短片及金穗獎優等。執導作品包括短片《阿嬤的放屁車》及兒少奇幻影集《百味小廚神》。

LI Chuan-yang's directorial debut came in 2016 with the short *Coin Boy*, which earned numerous domestic and international nominations and awards. He is also a Golden Bell Award-nominated TV series director. An alumnus of the Golden Horse Film Academy, he was honored as the Huashan Emerging Director of the Year.

DIRECTOR
李權洋 LI Chuan-yang
PRODUCER
卡斯特 Caster WANG
陳厚廷 Vincent CHEN
SCREENPLAY
陳芳齊 CHEN Fang-chi
CINEMATOGRAPHER
楊大慶 Claude YANG
劉世文 Wen LAU
EDITOR
林姿妤 LIN Tzu-yu
MUSIC, SOUND
吉米林音樂工作室 JLMxSTUDIO
CAST
謝以樂 I-LE
鄒暟雲 Calvin TSOU
陳寧樂（胖球）Elena CHEN
陳馨妃（斯拉）Sofia CHEN
朱頭皮 PIG HEAD SKIN
PRINT SOURCE
財團法人公共電視文化事業基金會
Public Television Service Foundation

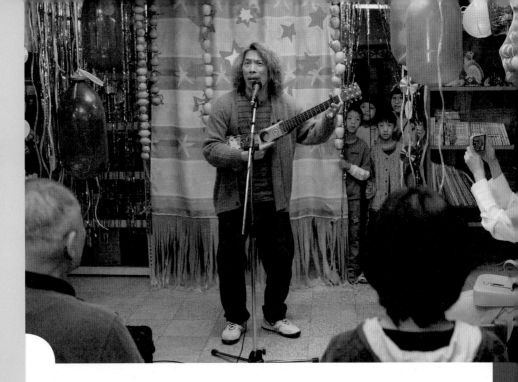

什麼都沒有雜貨店（第1-4集）
The Grocery Store of Nothing (Ep. 1-4)

世界首映
World Premiere

台灣 Taiwan ｜ 2024 ｜ DCP ｜ Color ｜ 58min

從台北搬到鄉下投靠阿公的小傑，來到了一間喜旺來商號，發現雜貨店裡什麼都沒有，只有他熱情古怪的嬉皮老闆阿公，和一群莫名其妙成天窩在雜貨店的小鬼頭：被寄養在雜貨店的野孩子阿樂、最愛被問「為什麼」的知識宅姊姊，和活潑調皮的貪吃鬼妹妹。作風老派的阿公，有閒就當外送員，沒閒就當誠實商店，雜貨店成了孩子們暫時遠離大人囉唆的避風港，吵吵鬧鬧成了沒有血緣的另類一家人。

改編自兒童文學作家王宇清同名作品，由音樂鬼才朱頭皮飾演雜貨店靈魂人物「旺伯」，最重要的兒童主角則由在網路擁有高人氣的療癒系歌手胖球和親妹妹斯拉、新銳童星謝以樂、鄒暟雲擔綱，並由擅長兒少戲劇題材的導演李權洋執導，是台灣首見的兒童情境喜劇。

A situational comedy tailored for children, reminiscent of a youthful rendition of *Friends*. The story follows Jay, an urbanite kid of Taipei, who is compelled to move to a remote small town and reside with his eccentric grandfather Wangbo in a peculiar grocery store. There, he encounters his lively yet unkempt roommate A-Le, the mischievous Xiao Ke who loves to feast, and the rational girl with a mind for science, Da Ke.

06.22 SAT 10:00 中山堂 TZH ★

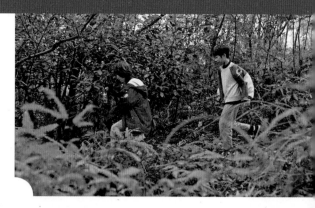

寄信人是誰？

Dear My Friend

台灣 Taiwan｜2024｜DCP｜Color｜14min

世界首映
World
Premiere

一封神祕的匿名信宣告偷走了偵探團的放大鏡，偵探團的小吉必須和好友阿順聯手解謎，找出寄信人以及被偷走的放大鏡。

台灣電影中少見的兒童偵探形象，透過解謎的快感，帶領孩子們去探究追尋，揮灑對生活的熱忱及好奇，並見證孩提時代的珍貴友情。

A detective team receives a mysterious anonymous letter claiming the sender stole their magnifying glass, along with a riddle. Lucky and his friend John embark on a journey from the classroom to the playground, finally reaching the field where they discover the last clue has been taken by the school bully.

DIRECTOR, SCREENPLAY
游美茵 YOU Mei-yin
PRODUCER
李妤芊 LEE Yu-chien
CINEMATOGRAPHER
黃聖鈞 HUANG Sheng-chun
MUSIC
蘇煜 Herry
SOUND
陳凱喆 Buzzkai
ANIMATOR
李永傑 LEE Yung-chieh
CAST
佘昀宸 SHE Yun-chen
陳秉佑 CHEN Bing-you
吳上善 Sam WU
PRINT SOURCE
財團法人富邦文教基金會 兒童節目人才孵育計畫
Fubon Cultural and Educational Foundation momo mini Incubator

游美茵，就讀於臺灣藝術大學影音創作與數位媒體產業研究所，具影片剪輯、圖像後製、媒體採訪寫作等技能。短片《非常規跑者》入選公視學生劇展。

YOU Mei-yin is skilled in video editing, graphic post-production, and media articles. She interned at Sky Films Entertainment Co. in 2020, where she participated in media promotion for films.

秘密森林少年

Boy in the Secret Forest

台灣 Taiwan｜2024｜DCP｜Color｜16min

世界首映
World
Premiere

今年冬天，男孩變得很奇怪，會莫名其妙在學校發脾氣，放學後也不跟同學玩了，大家似乎都知道原因，卻沒有人敢去接近他。放學後，男孩又來到森林深處，那裡有他最快樂也最憂傷的祕密。

以細膩的鏡頭語言堆疊出男孩的情緒流動，呈現難得一見的男孩銀幕形象，引領出穿越生長與消亡的動人生命體會。

This winter, the boy has become very strange. He bursts out in anger, throws random tantrums, and refuses to play with his classmates. Everyone seems to know the reason, but no one is brave enough to approach him. After school, the boy retreats deep into the forest. There lies his happiest and saddest secret...

DIRECTOR, SCREENPLAY
曾子晏 TSENG Tzu-yen
PRODUCER
林芃蕙 LIN Peng-hui
CINEMATOGRAPHER
陳群智 CHEN Chun-chih
EDITOR
楊融 YANG Rong
MUSIC
何佳容 HO Chia-jung
SOUND
梁惠宣 LIANG Hui-xuan
CAST
葉詠晨 Stanley YE
姜仁 KANG In
謝喬安 Joshua HSIEH
PRINT SOURCE
財團法人富邦文教基金會 兒童節目人才孵育計畫
Fubon Cultural and Educational Foundation momo mini Incubator

曾子晏，1997年生，台南人，目前就讀於臺灣藝術大學電影學系研究所，盼透過創作探尋事物之所以發生的意義。

TSENG Tzu-yen was born in Tainan, Taiwan and is currently pursuing a Master of Film at NTUA, aiming to explore the meaning of all things through her creative work.

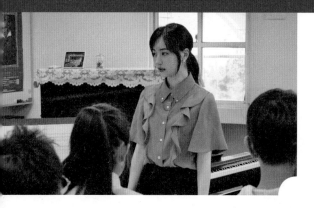

屁孩不屁孩
WHO FARTS!

台灣 Taiwan｜2024｜DCP｜Color｜14min

阿傑有個小困擾，就是一緊張就想放屁，而且屁又臭又響。即將在合唱團表演負責領唱的他，必須在表演日之前找到能「止屁」的運氣。

精心設計的喜劇結構，孩子的勇氣和樂天，讓令人煩惱的屁事，成為天馬行空的一首歌。飾演音樂老師的黑嘉嘉，在片中再次展現渾然天成的喜劇氣質。

Ajie has a little problem: when he is nervous, he farts; they are stinky and loud. When tasked with being the "note starter" of the choir, he must seek a solution. As the final performance draws near, can Ajie conquer his nerves and complete his mission?

DIRECTOR, EDITOR
陳詩芸 CHEN Shih-yun
PRODUCER
陳韋亘 CHEN Wei-san
SCREENPLAY
陳詩芸 CHEN Shih-yun
陳韋亘 CHEN Wei-san
CINEMATOGRAPHER
洪瑲宏 HONG Ciang-hong
SOUND
王姿雅 WANG Tzu-ya
ANIMATOR
李永傑 LEE Yung-chieh
CAST
黑嘉嘉 Joanne MISSINGHAM
楊承軒 YANG Cheng-xuan
賴建岱 LAI Chien-tai
PRINT SOURCE
財團法人富邦文教基金會 兒童節目人才孵育計劃
Fubon Cultural and Educational Foundation momo mini Incubator

陳詩芸，臺灣藝術大學電影學系、臺南藝術大學音像紀錄研究所畢業。創作橫跨劇情片與紀錄片，曾入圍金穗獎及台灣女性影展。現為日光影像工作室有限公司導演。

CHEN Shih-yun graduated from the Department of Motion Picture of TNUA. Her works have been selected for the Golden Harvest Awards and Women Make Waves. She is currently a director at Sunlight Image Studio Co., Ltd.

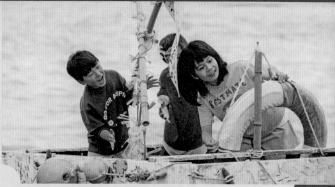

我們，海一起！
Together by the Sea

台灣 Taiwan｜2024｜DCP｜Color｜11min

從小夢想當船長的悅悅，與她的玩伴屎蛋與黑目仔，偷偷計劃合力打造一艘木船，準備在好友屎蛋搬離漁村前，實現揚帆出海的冒險之旅。然而，造船與出海的計畫卻考驗著三人的友誼。

小小的漁村，不是困住孩子夢想的所在，遼闊的大海，為孩子們賦予了真正的能量。

Joy, a fishing village girl who dreams of becoming a captain, and her friends Smelly and Beans always fantasize about the vast sea beyond the breakwaters. They secretly plan to build a small boat together during winter vacation, aiming for an adventurous voyage before Smelly leaves the village.

DIRECTOR, SCREENPLAY
洪佩岑 HUNG Pei-tsen
PRODUCER
洪佩岑 HUNG Pei-tsen
邱鼎豪 CHIU Ting-hao
CINEMATOGRAPHER
謝升竑 HSIEH Sheng-hung
EDITOR
陳泫 CHEN Hung
MUSIC
莊伯荀 Sid CHUANG
SOUND
黃永年 Eddie HUANG
王子柔 WANG Tzu-jou
曹禹辰 TSAO Yu-chen
CAST
林芃希 LIN Peng-hsi
鄒暟澐 ZOU Kai-yun
黃宥凱 HUANG You-kai
PRINT SOURCE
財團法人富邦文教基金會 兒童節目人才孵育計劃
Fubon Cultural and Educational Foundation momo mini Incubator

洪佩岑，臺灣藝術大學電影學系畢業，輔修戲劇系。目前為導演、編劇，也從事電影選角工作。成長於靠海農村，鍾情本土故事，以及海洋與兒少題材的創作。

HUNG Pei-tsen graduated from NTUA's Department of Motion Picture. She is currently a director, screenwriter, and casting agent. She grew up by the sea and enjoys local stories as well as ocean and youth themes.

06.23 SAT 11:20 中山堂 TZH ★

廣角台灣
TAIWAN PANORAMA

聚焦台灣電影工作者別樣的創作視角，從劇情長片、紀錄片到短片，利用不同題材、類型與創意，打開關於人、關於土地更廣闊的視野。

Centered around the distinct creative perspectives of Taiwanese filmmakers, from feature films to documentaries to short films, utilizing different themes, genres and creativity to broaden our horizons regarding people and the land.

世界首映
World Premiere

愛作歹
Silent Sparks

台灣 Taiwan｜2024｜DCP｜Color｜78min

朱平，世新大學廣電系畢業，首部短片《粗工阿全》即獲好評，《降河洄游》更入圍金鐘獎最佳電視電影，並獲男主角與男配角獎。《愛作歹》是他最新力作。

CHU Ping graduated from the Department of Radio, Television and Film at Shih Hsin University. His short film *Undercurrent* was nominated for Best Television Film and won Best Actor and Best Supporting Actor in a Mini-series or Television Film at the 2022 Golden Bell Awards. *Silent Sparks* is his feature debut.

耿直又聽話的飽仔，專為大哥「處理」各種事情，扛下身為小弟的風險，再向老大拿安家費貼補家計。飽仔的仙姑媽媽總是念他：「早知道細漢就別讓王爺幫你算出兄弟命，現在整天在惹麻煩。」但在他心裡，還藏了一個祕密——他心心念念上次進去的時候，特別好好「照顧」他的學長咪幾。當咪幾出獄，期待重逢的飽仔卻發現自己被冷落，青春勃發而無處出口的蕩漾春心，變得比什麼黑道歹路、輩分道義，都更難按耐……。

導演朱平挑戰以長片規格，細密地鋪陳在陽剛、壓抑的江湖人際中，伏流的同志情慾。全片鏡頭穩而慢，光線自然而情調滿滿，黃冠智、施名帥兩代本土男星貢獻洗鍊演技，在社會的暗角掩埋七情六慾。比起打打殺殺的生活，「你為什麼在躲我？」是一樁更難嚥下的心靈危機。

Earnest and obedient, Pao helps his gangster boss "handle" all kinds of matters, constantly putting himself at risk in return for a bit of money to help with the family expenses. But deep down, Pao harbors a secret — he has feelings for Jimmy, the prisoner who took "special care" of him the last time he was incarcerated. When Jimmy is released from prison, Pao is excited for their reunion, only to find himself neglected, rendering his pent-up desires more difficult to control than any underworld loyalties or obligations.

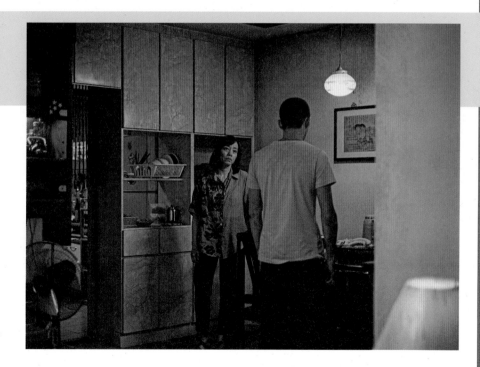

DIRECTOR, SCREENPLAY, EDITOR
朱平 CHU Ping
PRODUCER
王姿元 WANG Tzu-yuan
CINEMATOGRAPHER
黃語宥 HUANG Yu-yu
MUSIC
吳宗諺 Joe WU
SOUND
蔡瀚陞 TSAI Han-sheng
CAST
黃冠智 HUANG Guan-zhi
施名帥 SHIH Ming-shuai
PRINT SOURCE
財團法人公共電視文化事業基金會
Public Television Service Foundation

06.24 MON 18:40 信義 HYC 11 ★

種土
Soul of Soil

台灣 Taiwan｜2024｜DCP｜Color｜143min

顏蘭權，1965年生於高雄，東吳大學哲學、社會學系雙學位畢業，英國雪菲爾哈倫大學電視電影製作碩士。1999年因921地震開啟紀錄片創作生涯，作品多聚焦台灣在地題材，與莊益增共同執導之代表作《無米樂》、《牽阮的手》獲台北電影獎百萬首獎、台灣國際紀錄片影展台灣獎首獎等。

YEN Lan-chuan pursued graduate studies in filmmaking at the Northern Media School of Sheffield Hallam University. She spent three years to make the documentary *9/21 Earthquake Journal*.

30歲的阿仁，在科技大腦的右側偷偷挖隧道，36歲的阿仁，在朦朧的亮光中，看到台灣的「土」，看到崑濱伯「坐禪」（做田）的辛苦，毅然決然放棄科技業美好的未來，憑著熱血嘗試將垃圾化做堆肥讓土復活。已近耳順的安和哥向自然取經，帶著家人以有機農法種土養地，農活既是生活形式，也是生命態度。天地運行，大道無形也無情，理想與現實的拉鋸間，兩位農民一老一少，一靜一動，交錯彼此生命的春夏秋冬。

時隔20年，號稱「比《無米樂》還難拍」的新作《種土》終於問世，顏蘭權再次長期蹲點，記錄對土地一片至誠的性情中人，找來陳明章配樂、楊大正獻唱，娓娓道出農民的辛酸血淚與人生哲學。

極度寫實、極度真摯，喜形於色對比老僧入定，被攝者截然不同的性格與選擇，引領他們走上不同道路──種下土壤，究竟是希望，還是憨人的夢想？

Something is wrong with the "soil", rendering farmers unable to make money. Enthusiastic middle-aged farmer A-Ren switches to the tech industry, aiming to revive the soil by turning garbage into compost, with his family reluctantly supporting his dream. Meanwhile, An-he, who is nearing retirement, leads his family to cultivate the land using organic farming methods. Farming becomes not only a way of life but also an attitude towards life. As the cycles of nature unfold between the tug-of-war of ideals versus reality, two farmers — one old, one young; one calm, one energetic — will intersect amid the changing seasons of life.

DIRECTOR
顏蘭權 YEN Lan-chuan
PRODUCER
顏蘭權 YEN Lan-chuan
廖錦桂 Jin LIAO
CINEMATOGRAPHER
莊益增 Cres CHUANG
顏蘭權 YEN Lan-chuan
EDITOR
廖慶松 LIAO Ching-sung
MUSIC
陳明章 CHEN Ming-chang
楊亞歷 A-lîkilûnn
翁士凡 LaFa WENG
SOUND
周震 CHOU Cheng
PRINT SOURCE
牽猴子股份有限公司
Activator Co., Ltd.

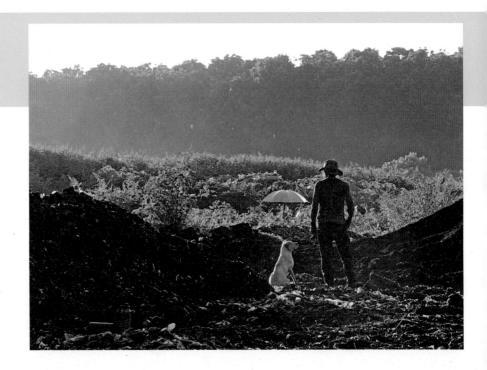

06.30 SUN 13:00 信義 HYC 11 ★

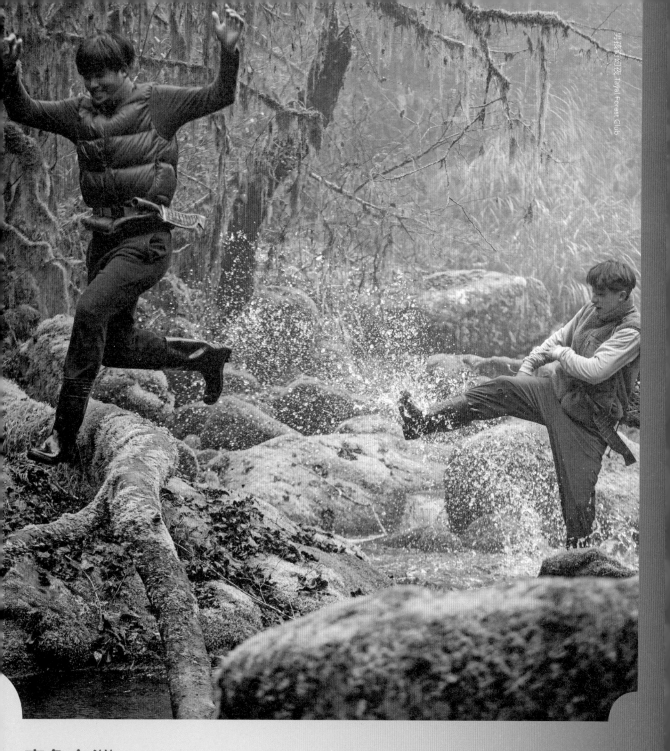

男孩子的夜 Tayal Forest Club

廣角台灣：
台灣短 SHOW
TAIWAN PANORAMA:
TAIWAN SHORTS

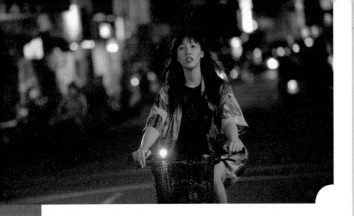

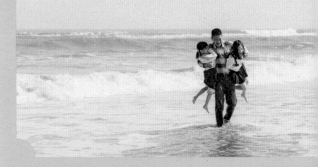

別離的季節
Separation Season

台灣、捷克 Taiwan, Czech Republic｜2024｜DCP｜Color｜28min

世界首映
World Premiere

畢業的季節即將來臨，俞婷從泳池回到租屋處，整天都沒有堂妹怡蓁的消息。好不容易打通手機閒聊幾句，出門騎腳踏車想接她回去，街上竟下起滂沱大雨。濕透的俞婷對著電話那頭發脾氣，卻沒想到她再也沒機會說對不起。怡蓁的輕生牽動著家人的情緒，有些人震驚悲痛不已、有些人仍然一意孤行。在處理繁複後事之餘，俞婷自己又該如何面對這場突如其來的別離？

In June, a graduation month, college graduate Ting experiences a sudden separation from her close cousin Jane. During a series of rituals, Ting tries to defend Jane's choice against their family and seeks an answer to Jane's suicide and their lives.

說謊也沒關係
It's Perfectly Okay to Lie

台灣 Taiwan｜2023｜DCP｜Color｜15min

亞洲首映
Asian Premiere

一對年幼姊妹瞞著母親，計劃一場與父親同行的久違祕密旅行，一車三人興奮前往祕密基地。然而幸福的海邊時光短暫如泡影，當父親說出這場「出國旅行」的目的地，一直默默觀察著父親的十歲姊姊也被迫作出最艱難的決定。導演取材個人童年經歷，以細膩筆觸勾勒少女心事，擁抱每一個不得不提早長大的早慧心靈。

When Hui's absentee father suddenly reappears, Hui and her little sister are filled with joy. However, when he announces their upcoming journey abroad, Hui knows she is forced to reveal his mental illness. At age 10, she chooses to act naive, shielding his dignity.

DIRECTOR
李怡慧 LEE I-hui
PRODUCER
陳斯婷 Estela Valdivieso CHEN
吳秀瑩 Hazel WU
SCREENPLAY
李怡慧 LEE I-hui
吳佳葦 WU Jia-wei
CINEMATOGRAPHER
鍾艾 CHUNG Ai
EDITOR
韋齊修 Nick VAKY
蔡孟馨 TSAI Meng-hsin
MUSIC
蔡宜均 TSAI Yi-chun
SOUND
呂海荼 Hyphen LU
CAST
賴雨霏 LAI Yu-fei
陳克勤 CHEN Ko-chin
廖宇墨 LIAO Yu-mo
PRINT SOURCE
綺影映畫有限公司
Serendipity Films Ltd.

李怡慧，畢業於臺灣大學歷史系，曾就讀美國紐約哥倫比亞大學電影系，入選2020年金馬電影學院。短片作品包括《初潮》、《蜜月旅行》與《黑風箏》等。

LEE I-hui is trained in science, history, and film art. She explores various styles through her short films, her themes always echoing her thoughts about how one's life relates to others, society and the world.

▌ 2024 雪梨短片影展 Sydney Short FF
▌ 2023 芝加哥兒童影展 Chicago Int. Children's FF
▌ 2023 義大利Giffoni兒童影展 Giffoni FF

DIRECTOR, SCREENPLAY
林誼如 LIN I-ju
PRODUCER
陳彥翰 Startle CHEN
CINEMATOGRAPHER
Tei LEE
EDITOR
陳韶君 CHEN Shao-chun
MUSIC
蔡宜均 TSAI Yi-chun
SOUND
胡序嵩 Sidney HU
CAST
王渝萱 WANG Yu-xuan
黃稚玲 HUANG Chi-ling
洪都拉斯 Honduras
張詩盈 Winnie CHANG
黃采儀 HUANG Tsai-yi
PRINT SOURCE
內容物數位電影製作有限公司
Content Digital Film Co., Ltd.

林誼如，1992年生於台北，臺灣大學社會系畢業，於布拉格表演藝術學院電影電視學院攻讀導演碩士。2019年首部執導短片作品《踮腳尖》入選柏林影展新世代兒童單元，《別離的季節》為其最新作品。

LIN I-ju was born in 1992 in Taipei. She is currently pursuing her MFA in directing at FAMU in Prague, with a full scholarship from Taiwan's Ministry of Education.

Her debut short *Tiptoe*, was selected to Berlinale's Generation Kplus Competition in 2019.

廣角台灣・台灣短 SHOW I

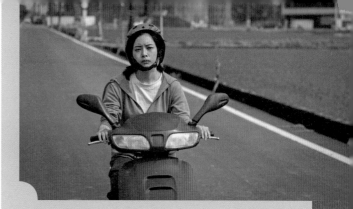

母雞
The Hen

台灣 Taiwan ｜ 2024 ｜ DCP ｜ Color ｜ 22min

新婚的文儀把工作辭了，跟老公搬回鄉下學養雞，同住的婆婆小心翼翼地在她能理解的範圍內不「虐待媳婦」，但生活習慣、環境禮俗畢竟難改，婆媳共處一室，關係箭在弦上。本片借重主角陳又瑄鮮亮、充滿穿透力的氣場，演繹在這座島上發生過千百萬次，女人踏入婚姻變成「母雞」的困境。時代看似進步，在沒有自己的生活空間，就只能是氧氣稀缺的日子。

Amidst the scorching rural countryside, among the neighbors, her mother-in-law, and the sound of chickens. Chen Wen-yi is the new one in town, a wife, a daughter-in-law, and perhaps in the future, a mother. However, will there finally be a moment when she can purely be herself?

紅翅膀
A Long Walk

台灣 Taiwan ｜ 2024 ｜ DCP ｜ Color ｜ 23min

小青的酒鬼阿公死了，今天辦告別式，從小和阿嬤一起承受精神霸凌的她，才不想參加那些又哭又喊的法事。但看著阿嬤目送夫婿的淚眼，她萬般不懂，就像她始終想不透：為什麼阿嬤不離開這裡？導演蔡季珉繼續挖掘少女對大人世界人情世故的茫然，主演游珈瑄穩穩扛起沉靜的爆發力，阿嬤黃淑芳的告白同樣動人，兩代女子在父權壓迫下互相扶持的路，真摯感人。

Ching's grandpa passed away. Though her grandma insists on staying at home for the funeral, the girl tries to take her away in her own way.

DIRECTOR, SCREENPLAY
陳亮廷 CHEN Liang-ting
PRODUCER
黃瀞瑩 HUANG Jing-ying
張麗怡 CHANG Li-i
CINEMATOGRAPHER
黃怡婷 HUANG Yi-ting
EDITOR
陳亮廷 CHEN Liang-ting
陳浤 CHEN Hung
MUSIC
盧卡．博納柯爾西
Luca BONACCORSI
SOUND
蕭子堯 SHIAO Zi-yao
CAST
陳又瑄 CHEN Yu-hsuan
陳雅慧 CHEN Ya-hui
林禹緒 LIN Yu-hsu
PRINT SOURCE
陳亮廷 CHEN Liang-ting

陳亮廷，臺灣藝術大學電影學系碩士。曾以短片《兩場葬禮》拿下金穗獎學生組最佳導演。

CHEN Liang-ting holds an MFA of Motion Picture from NTUA. His expertise encompasses directing, cinematography, and editing. His short film *Two Funerals* was nominated at the 2019 Golden Bell Awards and won Best Director and Best Cinematography in the Student Slate of the 2020 Golden Harvest Awards.

DIRECTOR, SCREENPLAY
蔡季珉 TSAI Chi-min
PRODUCER
吳信毅 Sinye WU
CINEMATOGRAPHER
楊大慶 Claude YANG
EDITOR
吳霽千 WU Chi-chien
蔡季珉 TSAI Chi-min
MUSIC
蘇妤涵 Miranda SU
SOUND
康銪倫 Allen KANG
CAST
游珈瑄 YU Chia-hsuan
黃淑芳 HUANG Su-fan
PRINT SOURCE
蔡季珉 TSAI Chi-min

蔡季珉，出生於台灣台中市，臺灣藝術大學廣播電視學系雙主修電影系畢業。作品多關注女性處境，2019年短片作品《同款的路》入選台灣國際女性影展。現為自由影像工作者。

TSAI Chi-min was born in Taiwan in 1995 and graduated from the Department of Motion Picture of NTUA. She focuses on women's issues in her films.

廣角台灣：台灣短 SHOW I

06.22 SAT 16:50 中山堂 TZH ★ ｜ 06.29 SAT 13:50 信義 HYC 11 ★

屍落人間
Sprout to Death

世界首映
World Premiere

台灣 Taiwan｜2024｜DCP｜Color｜25min

他斷手歪頭，而她悉心接納——殭屍與他的女神心繫彼此，無奈卻總是走不到一塊兒（或兩塊）。劉冠廷演出最文青的殭屍，揮灑著寫意的油畫、跳著出浴的現代舞，和謝欣穎談上一段跨物種的不了情，蔡明修、劉品言亦同台飆戲。導演李亞峰延續對邊緣族群的關注，以及對奇幻類型的語彙拼貼，在超現實的時空裡繼續探索愛、慾望與歸屬感。

A zombie fearing his gradual decay immerses himself daily in formaldehyde. He relies on reading and painting to maintain a sense of freshness in body, mind, and spirit. Initially hoping to survive in society through his artistic talents, he never encounters any opportunities until one day, he secures a job at a flower shop.

第八大道
Eighth Avenue

亞洲首映
Asian Premiere

台灣、美國 Taiwan, USA｜2024｜DCP｜Color｜12min

紐約布魯克林的第八大道，有著世上數一數二大的中國城街區，暱稱「畢卡索」的白人男子在此打著油漆工，默默觀察工班裡的華裔長輩與青年、各自喜愛的文化與態度日常。本片為赴美攻讀電影的導演洪冬人最新短片，以底片記錄移民生活圈的樣貌，疏離但不冰冷，好奇而不帶批判。林強跨刀製作的音樂更是意象滿滿。

Eighth Avenue portrays a mysterious Caucasian guy, Picasso, finding solace in Brooklyn.

DIRECTOR, SCREENPLAY
李亞峰 LI Ya-feng
PRODUCER
吳容宸 Edison WU
CINEMATOGRAPHER
林志朋 LIN Chih-peng
EDITOR
李棟全 Wenders LI
SOUND
莊智凱 Adam CHUNG
CAST
劉冠廷 LIU Kuan-ting
謝欣穎 HSIEH Hsin-ying
蔡明修 TSAI Ming-hsiu
劉品言 Esther LIU
PRINT SOURCE
雀喜娛樂事業有限公司
Chelsea Entertainment

李亞峰，台灣導演、編劇。2018年以自編自導的公視學生劇展《停車格》入圍金鐘獎及金穗獎，2022年再次以電視電影《無常日常》入圍金鐘獎。

LI Ya-feng majored in communication arts and has served as a director, cinematographer, editor, planner, and scriptwriter. In 2018, he was nominated at the Golden Bell Awards and participated in various international film festivals. In 2022, he founded Story Emporium Cultural Enterprise Co. to expand local cultural and humanistic creations.

DIRECTOR, SCREENPLAY, EDITOR
洪冬人 HONG Dong-ren
PRODUCER
仁青卓嘎 Rinchen DROLKAR
CINEMATOGRAPHER
陸曉矇 LU Xiaomeng
MUSIC
林強 LIM Giong
SOUND
趙人僑 CHAO Jen-chun
CAST
Rider LASKIN
姜珊 JIANG Shan
Frank LIU
藤枝英成 FUJIEDA Hidenari
PRINT SOURCE
洪冬人 HONG Dong-ren

洪冬人，台灣導演、剪接、攝影師，在台、美創作多部短片。2014年以短片《小溪邊的沙灘》入圍金穗獎；剪接作品《阿莉芙》於東京影展首映，該片入圍2017年金馬獎。

HONG Dong-ren is a Taiwanese filmmaker with a diverse background in shorts, documentaries, and features.

His previous short film, *Cornered Rat*, received the Silver Award of the International Golden Short Film Awards in Taiwan and was selected for multiple international festivals.

■ 2024 漢堡華語影像展 Chinese FF Hamburg

慾仙慾死
Euphoria

台灣 Taiwan｜2023｜DCP｜Color｜19min

男人將她的偷情對象殺了，她看著他收拾，提醒要用專用垃圾袋，否則會被管委會罰錢；她幫忙棄屍，卻覺得自己才是兇手，究竟殺人的是她的慾望，還是男人的自尊？或其實是她殺死了男人的自尊？她不懂為什麼事情最後變這樣，想著這次會不一樣，但結果卻沒變……這一切無解謎團如海浪，一波波襲來，而她只能張開自己，用身體去承受。

As nightfall casts shadows on their secrets, the woman schemes under the shroud of darkness, returning to the house to share her clandestine plans with her partner in crime. Yet, an otherworldly aura permeates the air, revealing the lovers' true selves and dropping cryptic hints about the mysterious male corpse.

DIRECTOR, SCREENPLAY
邱孝尊 CHIU Hsiao-tsun
PRODUCER
林君翰 LIN Chun-han
CINEMATOGRAPHER
蔡維隆 TSAI Wei-long
EDITOR
顏秉盈 YEN Ping-ying
MUSIC
歐布 Ohno
SOUND
林晉德 LIN Jin-de
CAST
許允晨 HSU Yun-chen
沈宥齊 SHEN You-qi
PRINT SOURCE
邱孝尊 CHIU Hsiao-tsun

邱孝尊，藝名邱昊奇，台灣演員、舞者、導演。出道十多年演出數十部長、短影視作品與廣告、MV，近年開始以導演身分創作。

CHIU Hsiao-tsun began his career as an actor in the TV series *You Light Up My Star* and has starred in many feature and short films, as well as commercials and music videos over the past decade. He aims to weave his life experiences into compelling stories. *Euphoria* is his first short film.

▌2023 韓國短片影展最佳短片
Best Short Film, Korea ISFF

男孩奇幻夜
Tayal Forest Club

台灣 Taiwan｜2024｜DCP｜Color｜19min

泰雅男孩尤幹放假回鄉，和玩伴一起上山卻迷了路，遇見神祕的醉翁，度過被營火照料的夜晚。在平地求學所受的苦，以及家庭破碎的遺憾，都在這個被祖靈擁抱的夜晚過後，有了新的意義。金馬獎最佳導演陳潔瑤在紀錄片《泰雅巴萊》、劇情片《哈勇家》之後，三度與她的最佳男主角張祖鈞合作，記下部落男孩面對環境變遷、族群流變的掙扎與歸屬。

Bullied at school and weighed down at home by his dad's drinking, Yukan is eager to escape it all. When his best friend, Watan, invites him on a hike, a physically and emotionally bruised Yukan grabs his machete and the two boys head into the woods.

DIRECTOR
陳潔瑤 Laha Mebow
PRODUCER
陳怡辰 CHEN Yi-chen
SCREENPLAY
陳潔瑤 Laha Mebow
梁元梅 Yayut Icyang
CINEMATOGRAPHER
廖敬堯 LIAO Ching-yao
EDITOR
陳建志 CHEN Chien-chih
MUSIC
保卜・巴督路 Baobu Badulu
SOUND
Mike MCAULIFFE
CAST
張祖鈞 Yukan Losing
陳宇 Buya Watan
呂春相 Kesi Silan
PRINT SOURCE
A Nia Tero and Upstander Project Production

陳潔瑤，宜蘭南澳泰雅族人，作品多為原住民題材，長片《不一樣的月光》、《只要我長大》皆獲多項獎項，並以《哈勇家》成為史上首位獲金馬獎最佳導演的女性原住民導演。

Laha Mebow became the first Taiwanese woman and first indigenous filmmaker to win Best Director at Golden Horse Awards for her 2022 film *Gaga*. Her 2016 feature *Hang in There, Kids!* won five Taipei Film Awards, including Best Narrative Feature and the Grand Prize.

▌2024 雪梨影展 Sydney FF

06.23 SUN 16:40 中山堂 TZH ★ ｜ 06.29 SAT 16:30 信義 HYC 11 ★

TAIWAN PANORAMA: TAIWAN SHORTS II

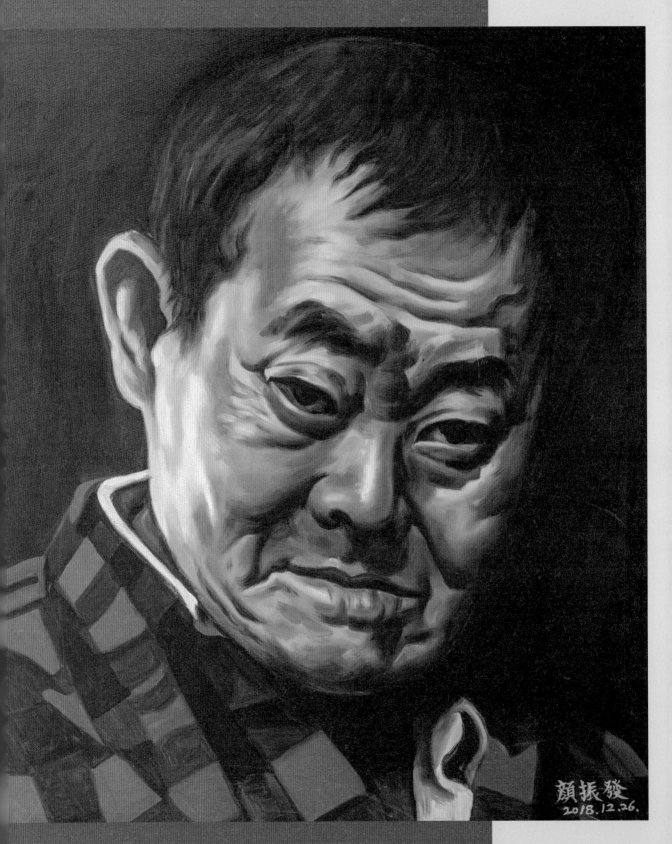

顏振發
2018.12.26.

▼ 1953年生，台南下營人，目前擔任全美戲院電影手繪看板首席畫師，為台灣最後一位仍為戲院服務的手繪看板師傅，而全美戲院也成為全台碩果僅存、保留手繪看板傳統的老戲院。從18歲開始在台南延平戲院向陳峰永師傅學習繪製電影手繪看板後，終生從未轉職，累積50多年的職業生涯，畫遍台灣經典電影、好萊塢賣座大片、黃金時代的港片等。

從2013年開始，顏振發為保存與傳承手繪技藝，開設「手繪看板文創研習營」，也透過異業委託合作進行文化推廣，最著名案例為參與2018年Gucci於台北永康街的城市藝術牆計畫。他先後登上英國《BBC》、日本《NHK》與美國《美聯社》、《紐約時報》等國際主流媒體，並於2018年獲頒台南市卓越市民的殊榮、2024年榮獲台北電影節卓越貢獻獎。

顏振發
YAN Jhen-fa

▶ YAN Jhen-fa was born in 1953 in Tainan's Xiaying District. He currently serves as the chief billboard painter of Chuan Mei Theater, making him Taiwan's last remaining hand-painted billboard artist working for a cinema. Chuan Mei Theater is also one of Taiwan's few remaining old cinemas that has preserved the tradition of hand-painted billboards. At age 18, he began learning the craft of hand-painting film billboards from Chen Feng-yong at Tainan's Yanping Theater, and has remained in the profession ever since. With a career spanning over 50 years, he has painted billboards for classic Taiwanese films, Hollywood blockbusters, and Hong Kong films during its golden age.

Starting from 2013, he has been dedicated to preserving and passing down his hand-painting techniques, establishing the "Hand-Painted Movie Billboard Workshop" and engaging in cultural promotion through cross-industry collaborations. The most famous example was participating in Gucci's urban art wall project on Taipei's Yongkang Street in 2018. He has been featured in international mainstream media such as the BBC, NHK, Associated Press, and The New York Times. He was honored as an Outstanding Citizen of Tainan City in 2018, and is the winner of Taipei Film Festival's 2024 Outstanding Contribution Award.

卓越貢獻獎展

時間｜06.21-07.06
地點｜臺北市中山堂廣場

一生都在繪製電影看板的顏振發師傅，特別為2024台北電影節「非常演員」繪製各自知名的角色，用自己獨特的觀察力、調色與筆觸，呼應著自己與電影密不可分的人生。

1953

下營紅甲里出生，甲中中庄仔人，與前輩藝術家兼工藝師顏水龍來自同一庄——土角厝。家中有五個小孩，父母在市場工作。

Born in Hongjia Village, Xiaying District, Tainan City, the same village as Taiwanese painter and sculptor Yen Shui-long. He is one of five children to parents who worked at the markets.

1965-1966

小學畢業後，考上新營的興國國中，但在初中就讀一年卻因為身體不適而申請休學，之後就不再就學。

Enrolled in Xinying's Hsing Kuo Junior High School after graduating elementary school, but took a leave of absence due to poor health after only one year and never returned to school.

1959-1965

就讀下營甲中小學，會到下營鎮上的大新戲院看電影，並臨摹報紙上的電影廣告。

Attended Xiaying Chia Chung Elementary School. Would go watch movies at Xiaying's Ta Hsin Theater and copy film advertisements in the newspaper.

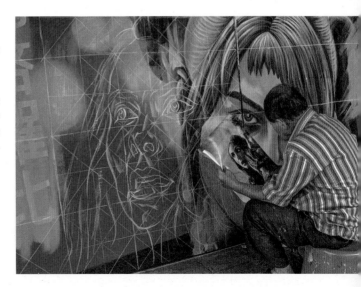

1971

來到台南市內投靠姑姑，在她的朋友介紹下到延平戲院向陳峰永師傅拜師學藝，終於一圓兒時繪圖夢想。

Moved to Tainan City to live with his aunt, whose friend introduced him to be an apprentice under billboard painter Chen Feng-yong at Yanping Theater, finally fulfilling his childhood dream of becoming an artist.

1966-1970

經由親戚引介，前往台北學做西裝一個月，後來適應不良又輾轉到高雄學做車床，但雙手差點被車床機械輾壓，所幸虛驚一場！

Through the introduction of relatives, went to learn suit tailoring in Taipei, but did not adapt well. A month later, moved to Kaohsiung to learn how to make lathes, but hands were nearly crushed by machinery.

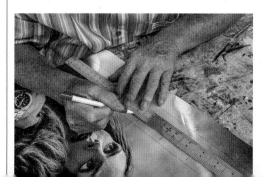

1973

畫了人生第一個電影手繪看板，電影是《丹麥嬌娃》。

Painted his first movie billboard, for the film *Sexy Girls of Denmark*.

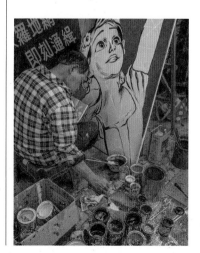

1973-1976

展開軍旅生涯，從金馬離島、新北淡水一路到桃園雙連坡、台中成功嶺等地到處支援。

Began his military service, providing support in Kinmen and Matsu offshore, from Tamsui in New Taipei to Shuanglianpo in Taoyuan, and Chenggongling in Taichung.

1977-1980

在朋友引介下至屏東潮州新山戲院工作，繪製看板三年，曾在25歲時遭遇瓶頸。

Began working at Hsin Shan Theater in Pingtung's Chaozhou Township through the introduction of a friend. After painting billboards for three years, experienced a career bottleneck at age 25.

1981

在屏東磨了三年歲月後，回到台南「電影里」。同樣追隨師父陳峰永，師徒的大本營從延平戲院轉移至中國城戲院。

After three years in Pingtung, returned to Tainan's "Movie Alley" and resumed working under Chen Feng-yong, with master and apprentice relocating their base from Yanping Theater to Chinatown Theater.

1981-1995

因師父陳峰永退休，慢慢爬上首席位子。同個時間點，全美戲院與中國城戲院正熱烈爭奪台南市二輪戲院龍頭。

Following Chen Feng-yong's retirement, gradually climbed to the position of chief billboard painter. Meanwhile, Chuan Mei Theater and Chinatown Theater fiercely competed to be the top second-run cinema in Tainan.

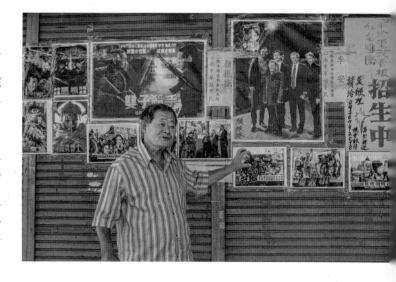

2013

為保存與傳承手繪技藝，開設「手繪看板文創研習營」持續至今，並且舉辦「油畫直說－顏振發油畫個展」。

To preserve and pass on the art of hand-painted billboards, founded the "Hand-Painted Movie Billboard Workshop", which remains active to this day. Also staged a solo oil painting exhibition.

2000

2000年前後，應全美戲院吳義垣老闆邀請，開始於全美戲院服務。

Around 2000, began working at Chuan Mei Theater at the invitation of owner Wu I-yuan.

2010

名主持人Janet隨旅遊生活頻道《瘋台灣》節目團隊，一起向他拜師學畫，就此成為鎂光燈追逐的焦點，先後登上多個國際主流媒體。

Became the focus of media attention after TV host Janet Hsieh approached him to learn billboard painting on *Fun Taiwan*, leading to subsequent coverage by international mainstream media.

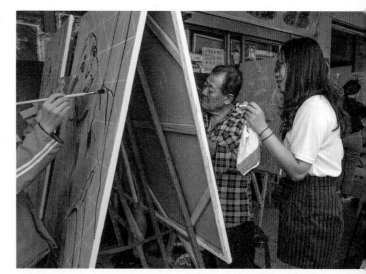

2021

由影評人王振愷執筆，出版《大井頭畫海報：顏振發與電影手繪看板》為其一生立傳。

Film critic Wang Jhen-kai wrote and published *Yan Jhen-fa and His Hand-painted Movie Billboards*, a biography of his life.

2019

參與台南市美術館「將藝術掛在心上：掛畫的生活美學」聯展，隔年參與有章藝術博物館大臺北雙年展「真實世界」。

Participated in Tainan Art Museum's "Keep Art in Mind - The Art in Daily Life" exhibition. The year after, participated in the "Authentic World" 2020 Greater Taipei Biennial of Contemporary Arts at Yo-Chang Art Museum.

2024

榮獲台北電影節卓越貢獻獎。

Recipient of Taipei Film Festival's Outstanding Contribution Award.

2020

疫情嚴峻期間，繪製「防疫五月天」巨幅帆布致贈陳時中部長；隔年完成全長16.4公尺，寬5.5公尺的「全球抗疫」巨型手繪看板，懸掛於全美戲院外牆，引發關注。

During the height of the COVID-19 pandemic, painted a giant canvas with the words "Pandemic Prevention Mayday" as a gift to then-Minister of Health and Welfare, Chen Shih-chung. The year after, attracted attention for completing a 16.4m x 5.5m giant billboard with the words "Taiwan Can Help Fight the Global Pandemic", which was hung on the exterior wall of Chuan Mei Theater.

2018

參與Gucci於台北永康街的城市藝術牆計畫，同年底獲頒台南市卓越市民榮譽。

Participated in Gucci's urban art wall project on Taipei's Yongkang Street. At the end of the year, honored as an Outstanding Citizen of Tainan City.

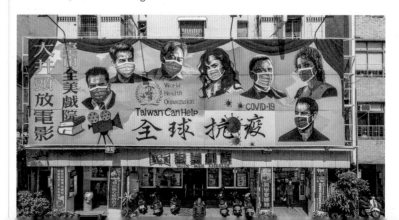

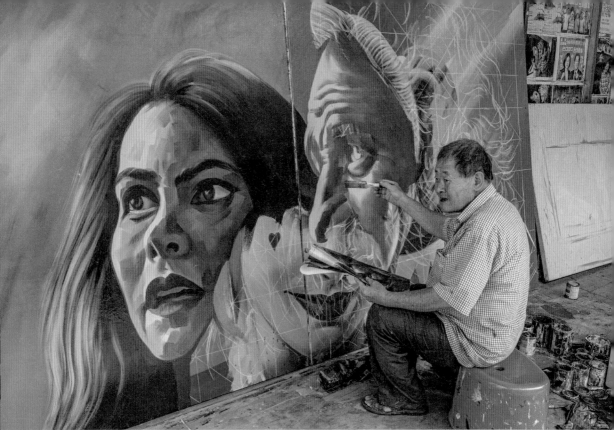

看板背後的職人精神

顏振發師傅的手繪電影人生

文——王振愷（影評人）

「我要一直畫到青暝看不到為止！」——顏振發

▶我們都對侯孝賢導演改編自黃春明文學作品《兒子的大玩偶》（1983）中的「三明治人」印象深刻，主角將自己裝扮成小丑、穿上五彩服飾、套上樂宮戲院的手繪海報與場次表，遊走小鎮宣傳正在熱映的電影。同樣在侯氏作品《戀戀風塵》（1986）裡，主角阿遠從九份到台北討生活，他時常闖入大稻埕第一戲院，與擔任看板畫師的好友阿春搭伙聚會。

時空跳接至2003年，蔡明亮導演的《不散》裡，即將歇業的福和大戲院外牆懸掛著《龍門客棧》（1967）手繪電影海報，後台暗巷裡棄置了多幅看板，彷彿已被遺忘許久。這些在正片之外被忽略的元素，其實記錄了日治時期電影被引入台灣，從映演宣傳機制放射出來包括報紙廣告、電影海報、本事簡介、踩街放送等視覺現代性產物，但來到當代，許多傳統已經消逝。

其中從日文「かんばん」直翻而來、在台語唸作「扛棒」（khang-páng）的廣告看板，已成為台灣熟悉的庶民語彙。目前在島內還保存有手繪看板文化的電影院僅剩台南全美戲院，這些懸掛在戲院立面的一幅幅巨型招牌，全都出自顏振發師傅（1953-）之手，他已畫了50年之久。

顏振發師傅從學徒到出師的歷程

青年的顏振發就跟《戀戀風塵》裡的阿春一樣，從下營農村來到台南市區找頭路，透過姑姑朋友的引介，前往延平戲院（日治時期為宮古座、現今為台南真善美戲院），在首席看板畫師——陳峰永（1944-2002）門下學習。看板業界分成學徒、半籠師、大師三個階段，學徒通常要花「三年四個月」才能出師，沒想到顏振發「以戲院為家」的加倍努力下，待在延平戲院一年後就提早等到上陣的機會。

1973年，顏振發畫了人生第一幅電影手繪看板，那是邵氏出品、呂奇導演的《丹麥嬌娃》。1970到1990年代間是台南市區戲院的黃金年代，顏振發畫遍最熱門的武俠片、功夫片與黑幫片等香港類型電影，描繪過李小龍、姜大衛、周星馳等不同世代華語片明星的肖像，也訓練出紮實的基礎功。當時映演業正處於戰國時代，競爭激烈，而看板畫師們在這個戰場上也各據山頭、自擁地盤。

晉升首席，文創風潮下的手繪看板

不過隨時代變遷，彩色電視、第四台、錄影帶、VCD、DVD衝擊著電影院的生存，千禧年後連鎖影城、網際網路與盜版拷貝崛起，更加快老戲院的倒閉潮。手繪看板畫師與戲院是命運共同體，顏振發看著獨棟戲院從興盛到衰亡，畫師們也逐漸失去根據地。雪上加霜的是，電腦排版與數位印刷等技術的普及，讓手繪看板幾乎被新科技取代，勞動需求更加限縮，畫師們只能退休、轉行。

危機就是轉機，當師父陳峰永退休、身旁的同事們紛紛退出江湖，顏振發反而得到更多執業的機會。2000年前後，他在全美戲院第一代老闆——吳義垣先生（1929-2020）誠摯地邀請下，接手這裡的首席看板畫師位置。後來的故事我們都熟悉，伴隨文創風潮，全美戲院逐漸轉型為一間充滿故事的老戲院，就此開始，顏師傅成為國內外媒體爭相報導的「國寶級畫師」。他也時常受邀參與具規模的委託創作，並開辦「手繪看板研習課程」，期望傳承這份手藝給後輩。

顏振發師傅清楚鎂光燈的閃耀是一時的，每天還是盡責地來到全美戲院對面騎樓工作室趕工。他的雙手仍如少年般有力，緊握著畫筆和油漆，將電影、廣告、美術與手工藝集結在看板上，已畫遍數千部電影。微微駝背的他靜默地站在比人還高的看板前，右膝著地、席地而坐，一手握著一張A3大小、數位影印的電影海報，上頭滿是原子筆打好的方正格子；另一隻手緊握著粉筆，慢條斯理地打底、畫框，沉浸在手繪的世界裡，這個景象早已成為台南重要的人文風景。

把繪畫視為人生伴侶的顏師傅終生未婚，一人吃飽全家飽，過著如苦行僧般的修行生活，每天圍繞在看板與戲院過活。目前密集趕工二至三天，每天早上從開工一路畫到傍晚時分，就能完成一幅全美戲院外牆的巨幅看板。

上工前，顏師傅會先在全美戲院對面的騎樓下，張開他的小桌子開始吃早午餐，餐桌上常常是煮到軟爛的牛肉湯、虱目魚湯配肉燥飯，相當在地的台南味；下工後，他騎著機車，從戲院出發前往小北夜市包便當，然後他會走到一間老字號果汁攤，一口氣請老闆幫他打上三杯不同口味的果汁，作為犒賞自己一整天辛勞的小確幸。

薛西弗斯神話般的職人精神

畫電影的人得時時刻刻與自己身心交戰，長年使用油漆，除了得忍受顏料嗆鼻的氣味，還有慢性揮發性氣體侵蝕著他們的呼吸道。工作時，身體姿勢得配合看板高低，時而站立、時而久蹲，長時間手握畫筆、舉上拿下，手腕扭傷、五十肩、駝背等問題皆造成身體不同部位的痠痛。除了肉身的折磨，手繪看板更常使用的是靈魂之眼，畫作越美麗越侵蝕視力，顏師傅就因為長時間專注而導致眼睛過度使用。多年前，醫生發現他的視網膜嚴重毀損，最後靠雷射修補救回他的左眼，但右眼目前已幾近全盲。

他的職人生涯宛如一則薛西弗斯神話，全美戲院的看板是重複使用的，當懸掛在外牆的電影下檔，看板會隨之撤下，顏師傅必須重新塗上灰漆，如同橡皮擦般，一次次把舊有的海報刷掉再畫。顏師父就像是薛西弗斯，將巨石推上山頂後又無情地滾回山下，永無止盡、徒勞無功。

顏振發師傅的人生奉獻給電影產業最末端的廣告招牌，是戲院觀眾面對上映電影的第一眼，但在戲尾的工作人員名單中卻永遠不會出現自己的名字，不過他站在銀幕的彼端，確確實實參與了其中環節。顏師傅永遠不知道未來要手繪的電影會是什麼？未知帶領著他一幅畫過一幅，他說要畫到雙手拿不起筆、眼睛看不見這個世界為止！

The Master Behind the Billboard:

The Hand-Painted Film Life of Yan Jhen-fa

Written by WANG Jhen-kai (Film critic)　Translated by Howard SHIH

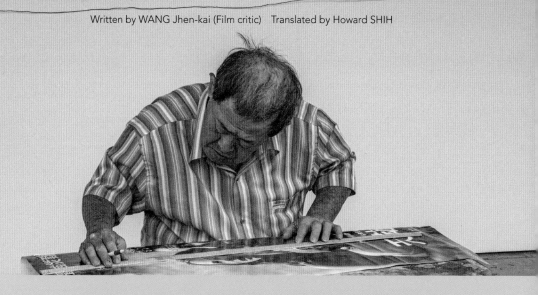

"I will keep painting until I can no longer see!" — Yan Jhen-fa

▶ The eponymous protagonist of *The Sandwich Man* (1983), Hou Hsiao-hsien's adaptation of Huang Chun-ming's literary work, left a deep impression on all of us. In the film, he dresses up as a clown in colorful costumes, wandering around town carrying hand-painted posters and session times to promote movies showing at Legong Theater. Similarly, in Hou's *Dust in the Wind* (1986), the protagonist Ah-yuan moves from Jiufen to Taipei to make a living, and often sneaks into the First Theater in Dadaocheng to meet with this friend A-chun, who works as a billboard painter.

Fast forward to 2003, the year of Tsai Ming-liang's *Goodbye, Dragon Inn*, where the soon-to-be-closed Fuhe Grand Theatre has hand-painted posters of *Dragon Inn* (1967) hanging on its exterior. Many discarded billboards lie in the back alley, seemingly long forgotten. These overlooked elements outside the main storyline actually document the introduction of film to Taiwan during the Japanese colonial era. The products of visual modernity that radiated from promotional mechanisms included newspaper advertisements, movie posters, synopsis leaflets, and street broadcasts, though many of these traditions have vanished in contemporary times.

The pronunciation of "billboard" in Taiwanese Hokkien— "khang-pán"—is derived directly from the Japanese word "kanban" and has become a familiar colloquialism in Taiwan. Currently, the only remaining cinema in Taiwan that has preserved its hand-painted billboard culture is Chuan Mei Theater in Tainan. The giant billboards hanging on the theater's façade all come from the hands of Yan Jhen-fa, who has been painting them for 50 years.

Yan Jhen-fa's journey from apprentice to master

Just like A-chun in *Dust in the Wind*, Yan Jhen-fa traveled from a rural district (Xiaying) to downtown Tainan in search of work. Through the introduction of his aunt's friend, he headed to Yanping Theater (known as Miyakoza during the Japanese colonial era and Wonderful Theatre today) to learn the craft under chief billboard painter Chen Feng-yong (1944-2002). The billboard industry was divided into three stages: apprentice, semi-master, and master. Apprentices usually took "three years and four months" to become a master, but Yan, who considered the cinema his home and worked extra hard, got the opportunity to step up after just one year at Yanping Theater.

In 1973, Yan painted his first film billboard for the Shaw Brothers' production of *Sexy Girls of Denmark*, directed by Lui Kei. The period between the 1970s to 1990s was a golden age for movie theaters in downtown Tainan. Yan painted billboards for the most popular wuxia, kung fu, and gangster films from Hong Kong at the time. He has depicted portraits of different generations of Sinophone movie stars, including Bruce Lee, David Chiang, and Stephen Chow, which developed his solid fundamental skills. Back then, the cinema industry was in a "warring states" phase marked by fierce competition, and billboard painters were also staking their claims and territories on the battlefield.

Promotion to chief billboard painter amid the cultural and creative industries trend

As times changed, the survival of cinemas became impacted by color televisions, the "fourth channel" (underground cable), videotapes, VCDs, and DVDs. After the turn of the millennium, the rise of chain theaters, the internet, and pirating further accelerated the decline of old cinemas. The fate of billboard painters is tied to that of cinemas; Yan Jhen-fa bore witness to the rise and fall of independent cinemas as artists gradually lost their bases of operation. Adding insult to injury was the widespread use of computer typesetting and digital printing, which almost completely replaced hand-painted billboards. This further reduction in demand for their services meant that billboard painters could only retire or change careers.

A crisis can be a turning point. When Chen Feng-yong retired, many colleagues around him also left the industry, leaving Yan with more opportunities to practice his craft. Around 2000, the first-generation owner of Chuan Mei Theater, Mr. Wu I-yuan (1929-2020), gave him a genuine offer to take over as chief billboard painter. We are all familiar with what happened after this. Along with the rise of the cultural and creative industries trend, Chuan Mei Theater gradually transformed into an old cinema full of stories. From then on, "Master Yan Jhen-fa" has become a "national treasure-level artist" covered enthusiastically by both domestic and international media. He is often invited to participate in large-scale commissioned projects, and also founded the "Hand-Painted Movie Billboard Workshop" in the hopes of passing down his craft to future generations.

A life that revolves around billboards and the cinema

Yan Jhen-fa knows very well that the spotlight is fleeting. Every day, he still dutifully heads in to work at his studio in the arcade across the road from Chuan Mei Theater. With hands that have remained as strong as they were in his youth, he grips his brush and the paint tightly as he brings film, advertising, art, and craftsmanship together on his billboards. To date, he has painted billboards for thousands of movies. Slightly hunched, he stands silently in front of a billboard taller than himself, before lowering his right knee to the ground. He then sits down, holding in one hand an A3-sized, digitally printed movie poster covered in square grids drawn with a ballpoint pen; tightly held in the other hand is a piece of chalk, meticulously preparing the background and frames. This image of him completely immersed in the world of hand-painting has long become an important part of Tainan's cultural landscape.

Yan, who views painting as his lifelong companion, has never married. He eats alone, living a solitary life of practice like a monk, his days revolving around billboards and the cinema. These days, with just two or three days of intensive work from morning to dusk, he can complete a giant billboard for the external wall of Chuan Mei Theater.

Before going to work, Yan would first open up a small table under the arcade opposite Chuan Mei Theater and start eating his brunch. The meal would often be very local Tainan cuisine, like slow-cooked tender beef soup or milkfish soup with braised pork rice. After work, he would ride his scooter from the cinema to Xiaobei Night Market to grab a bento box, then walk to an old-fashioned juice stand, where he would ask the owner to make him three different juices to reward himself for a hard-day's work.

A Sisyphean work ethic

Those who paint movie billboards are constantly battling their own bodies and minds. They use paint year after year, enduring not only the pungent smell but also the volatile gases chronically eroding their respiratory systems. While working, they must adapt their posture to the height of the board, requiring them to sometimes stand, sometimes crouch for long periods while moving a brush up and down. This can lead to wrist sprains, frozen shoulders, and hunched backs, causing soreness and pains in various parts of the body. Besides the physical torment, hand-painting billboards is also extremely taxing on the eyes — the more beautiful the artwork, the more it erodes the artist's vision. Yan's eyes have been overused due to long periods of concentration. Many years ago, doctors discovered that he had severely damaged retinas. His left eye was salvaged by laser eye surgery, but his right eye is now almost completely blind.

His career is like the myth of Sisyphus. Chuan Mei Theater's billboards are reused. Every time a film finishes its run, its billboard is taken down from the wall, and Yan must repaint it with gray paint, like using an eraser, brushing away the old poster so it can be repainted, over and over again. Yan is like Sisyphus, pushing the boulder up to the mountaintop, only to see it mercilessly roll back down, never-ending and always in vain.

Yan Jhen-fa has dedicated his life to the advertising billboards that lie at the very bottom of the film industry. They are the first thing cinema-goers see when they go to the movies, but his name will never appear in a film's end credits. Yet, standing on the other side of the screen, he is undeniably involved in the process. Yan never knows what film poster he will have to paint next. The unknown continues to lead him from one painting to another. He says he will keep painting until his hands can no longer hold a brush, and his eyes can no longer see this world! ◆

屋簷下沒有煙硝 Who Do I Belong To

國際新導演競賽
INTERNATIONAL NEW TALENT COMPETITION

台灣唯一的國際電影劇情長片競賽，從 90 國、388 件報名作品中精心挑選十部新銳佳作角逐大獎。滑冰男孩的舞動人生、拳王東山再起、母親千里尋子、戰爭的創傷，還有機密研究的幕後陰謀，各國創作者以精采敘事技巧、創作觀點與形式風格，訴說著他們的故事。

Taiwan's only international feature film competition, where 10 outstanding new works selected from 388 submissions across 90 countries vie for major prizes. From the moving story of an ice-skating boy, to the comeback of a boxing champion, a mother's thousand-mile search for her child, the trauma of war, and the clandestine conspiracies behind classified research, these filmmakers from around the world employ captivating narrative techniques, creative viewpoints, and stylistic forms to tell their stories.

王小帥 WANG Xiaoshuai

評審團主席 Jury President

導演、編劇、製片人,中國獨立電影先鋒人物,憑藉其強烈的個人風格、對人性的深切關注,以及堅持不懈的獨立創作精神,在過去30餘年的職業生涯中執導了15部電影長片。他的作品跨越了不同歷史時期,揭示了普通中國人在非常時期的創傷,先後獲得柏林影展銀熊獎、坎城影展評審團獎、亞洲電影大獎最佳導演等諸多重要獎項。

Director, writer, producer. Wang Xiaoshuai is one of the very few masters who remains true to his art in spite of rampant commercialism in the Chinese film industry, directing 15 feature films over the past three decades. By virtue of his strong personal style, deep concern for humanity, and diligent independent way of filmmaking, his works have garnered international acclaim, winning Silver Bear Awards at Berlinale, the Jury Prize at Cannes, and Best Director at the Asian Film Awards, among other prestigious accolades.

柯震東 Kai KO

2011年以出道作《那些年,我們一起追的女孩》一舉榮獲金馬獎最佳新演員,知名度大開。2016年以《再見瓦城》實力派表演首度角逐金馬影帝,後以《月老》榮獲2022年台北電影獎最佳男主角,並於同年轉戰導演,首部長片《黑的教育》入圍金馬獎最佳新導演,並入選2023年台北電影節國際新導演競賽,多元創作才華備受矚目。

Kai Ko shot to fame in 2011 by winning the Golden Horse Award for Best New Performer for his debut performance in *You Are the Apple of My Eye*. In 2016, he earned a Golden Horse Award nomination for Best Leading Actor for *The Road to Mandalay*, before winning Best Actor at the 2022 Taipei Film Awards for *Till We Meet Again*. In the same year, he attracted considerable attention for his diverse talents when he transitioned to directing with his debut feature, *Bad Education*, which earned him a nomination for Best New Director at the Golden Horse Awards and was selected for the International New Talent Competition of the 2023 Taipei Film Festival.

林清心 Cheng-sim LIM

聖賽巴斯提安影展美國與東亞區域選片人、China Onscreen Biennial 藝術總監。曾擔任加州大學洛杉磯分校電影暨電視檔案館、美國蓋蒂研究所，以及動態影像博物館（MoMI）等機構的客座策展人。擁有30年策展資歷的她，致力於在美國推廣來自亞洲、中東及拉丁美洲藝術家的創作，其影像作品也曾於美國公共電視台及美國紐約現代藝術博物館等地展出。

Cheng-sim Lim is a Los Angeles-based film curator and delegate for the San Sebastian International Film Festival in Spain. Her curatorial work over 30 years, including as Co-Head of Programming at the UCLA Film & Television Archive and Artistic Director of the China Onscreen Biennial, has built audiences and appreciation for the works of non-Western filmmakers in the US. She has curated film retrospectives, such as *Heroic Grace: The Chinese Martial Arts* series, that have toured North America and Europe to critical acclaim.

Photo: Jules Hmaloko

陳潔瑤 Laha Mebow

台灣首位電影長片原住民女導演。作品多聚焦於原住民族人文關懷與生命樣貌，善以細膩手法捕捉素人自然演出。長片《只要我長大》獲2016台北電影節「百萬首獎」與最佳劇情長片等五項大獎，並代表台灣角逐2017年奧斯卡最佳外語片。近期作品《哈勇家》獲2022年金馬獎最佳導演、新加坡影展最佳導演，以及2023年台北電影獎最佳劇情片等多個國內外獎項肯定。

Laha Mebow is Taiwan's first female indigenous feature film director. Her second feature film, *Hang in There, Kids!*, was selected as Taiwan's entry for Best Foreign Language Film at the 89th Academy Awards, and won five awards including Best Narrative Feature, Best Director, and the Grand Prize at the 2016 Taipei Film Awards. For her third feature film, *Gaga*, she won Best Director at the 2022 Golden Horse Awards, Best Director - Asian Feature Film at the 2022 Singapore International Film Festival, and Best Narrative Feature at the 2023 Taipei Film Awards.

定井勇二 SADAI Yuji

日本 Bitters End 創辦人暨電影製片，致力於發行藝術院線作品，並曾製作多部膾炙人口的日本電影，包含山下敦弘執導的《琳達！琳達！》，以及擒下2022年奧斯卡最佳國際影片、由濱口竜介執導的《在車上》等長片，更曾與奉俊昊、米歇·龔德里、李歐·卡霍三位知名導演共同合作，製作以東京為故事背景的三段式電影《東京狂想曲》。

Sadai Yuji began his career in the film industry in 1989. In 1994, he established Bitters End, one of the most active art house distribution and production companies in Japan. He has produced and co-produced films including *Linda Linda Linda* (Yamashita Nobuhiro), *Tokyo!* (Bong Joon-ho, Michel Gondry, Leos Carax), *Cut* (Amir Naderi), *Touch of Sin* (Jia Zhangke), *Daguerrotype* (Kurosawa Kiyoshi), *Asako I&II* (Hamaguchi Ryusuke) and *One Second Ahead, One Second Behind* (Nobuhiro). Bitters End also has released works by critically acclaimed directors including Jean-Pierre and Luc Dardenne, Otar Iosseliani, Fatih Akin, Bela Tarr, Nuri Bilge Ceylan, and Mikhael Hers.

Photo by LIU Chen-Hsiang

Photo by Crystal Pan

彭紫惠，藝術家、導演。2015年起就讀西班牙瓦倫西亞理工大學藝術創作研究所，臺灣藝術大學美術系畢業。創作多從媒材本質思考出發，過去展覽散見於西班牙、英國與台灣。《春行》是其首部長片。

王品文，導演，台灣政治大學新聞系、美國羅耀拉瑪麗蒙特大學電影製作研究所畢業。短片作品包括《我們之間》、《記憶迴廊》、《軍犬》等，《春行》是其首部長片。

PENG Tzu-hui is a Taiwanese artist and filmmaker. Her solo exhibitions include *Independent Land* (2012), *On the Verge* (2019), and *Transformation of the Universe* (2023). Her debut feature, *A Journey in Spring*, won the Silver Shell for Best Director at San Sebastian in 2023.

WANG Ping-wen has directed the short films *Between Us* (2014), *Labyrinth* (2016) and *Military Dog* (2019). She is an alumnus of the Produire au Sud Taipei Workshop 2018 and Talent Tokyo 2019. Her debut feature, *A Journey in Spring*, won the Silver Shell for Best Director at San Sebastian in 2023.

06.23 SUN 19:00 中山堂 TZH ★ | 06.27 THU 13:20 信義 HYC 11

春行

A Journey in Spring

台灣 Taiwan｜2023｜DCP｜Color｜90min

家裡的漏水止不了，老夫妻的日常相罵也沒完沒了。拌嘴、嫌棄、叮囑，這是跛腳男人欽福和逞強女人秀緻的日常，從城裡五金行走回山上老屋的路總是漫長，只是吵完了會相依擦藥，跌倒了也會相扶逗笑。老倆口在台北近郊相依為命，等著時間慢慢走，看似無盼無求，直到某日，死亡悄悄降臨小屋。當離家已久的兒子再度敲響家門，一直獨守著祕密的欽福，也將迎來一個潮濕又綿長的春季。

台灣女性雙導演以影像作畫，採用超16mm膠卷拍攝，以寫實的筆觸與徐緩的基調，細膩捕捉生命的悄然隕落，揭示平凡生活的悲喜起滅，希冀在過去與現在的輾轉間，為觀眾召喚一處心靈淨土。喜翔與楊貴媚獻上淬煉昇華的動人對手戲，藍葦華、陳佳穗、張書偉助陣演出，高捷驚喜客串，看見平淡深沉的愛在日常翻湧。

An old man with a limp, Khim-hok, has depended on his wife over the years. They live in an old house on the urban fringe of Taipei. After his wife suddenly passes away, Khim-hok covers it up and goes on living a seemingly peaceful life. But their long-estranged son and his new partner suddenly appear, so Khim-hok has to face his wife's death when the end finally comes.

DIRECTOR
彭紫惠 PENG Tzu-hui
王品文 WANG Ping-wen
PRODUCER
王品文 WANG Ping-wen
彭紫惠 PENG Tzu-hui
SCREENPLAY
余易勳 YU Yi-hsun
CINEMATOGRAPHER
加藤陽介 KATO Yosuke
蘇偉鍵 SOU Wai Kin
EDITOR
彭紫惠 PENG Tzu-hui
MUSIC
彭炫瑞 PENG Hsun-ting
SOUND
澎葉生 Yannick DAUBY
CAST
喜翔 KING Jieh-wen
楊貴媚 YANG Kuei-mei
藍葦華 LAN Wei-hua
張書偉 CHANG Shu-wei
陳佳穗 CHEN Chia-sui
高捷 Jack KAO
PRINT SOURCE
王品文 WANG Ping-wen
彭紫惠 PENG Tzu-hui

▌ 2024 香港電影節國際影評人費比西獎、新秀電影（華語）競賽最佳男演員
FIPRESCI Prize, Best Actor, Young Cinema Competition (Chinese Language) , Hong Kong IFF
▌ 2023 新加坡影展銀幕獎最佳表演獎、最佳劇本獎 Silver Screen Award for Best Performance, Best Screenplay, Singapore IFF
▌ 2023 聖賽巴斯提安影展最佳導演銀貝殼獎 Silver Shell for Best Director, San Sebastian IFF

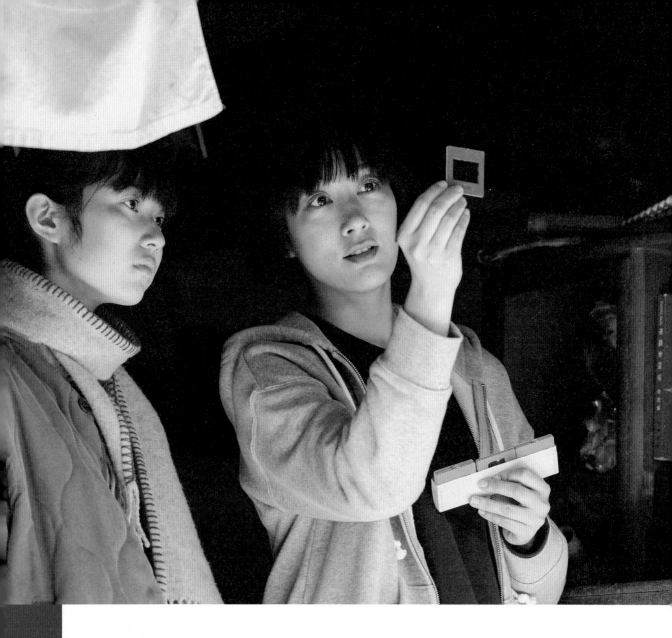

村瀨大智，1997 年生於日本滋賀縣，畢業於京都藝術大學，其畢業作《Roll》（2020）入選奈良影展學生競賽單元，榮獲觀眾獎肯定，《霧之淵》是他的第二部長片作品。

MURASE Daichi was born and raised in Shiga Prefecture, Japan. When he was 19, he directed his first short film, *Forget But*, which screened at Cannes in 2019. His graduation film, *Roll*, was nominated in the Student Film category at the Nara IFF and won the Audience Award.

霧之淵

Beyond the Fog

日本 Japan ｜ 2023 ｜ DCP ｜ Color ｜ 83min

奈良山區的小鎮，女孩靜靜望向蒼鬱巒峰。雲霧彼端，杳無人煙的山屋靜靜被塵世遺忘在立入禁止的深山。曾經遊客如織的小鎮，如今卻商旅蕭瑟。女孩家中經營的旅社傳承數代榮景，如今只剩幽深簷廊見證往昔。女孩父親獨自離鄉，剩下母親和年邁爺爺撐起旅店。某日，爺爺出了門便連日音訊全無，留下頓失方向的母女，以及命運未卜的旅店。

河瀨直美監製，新銳導演村瀨大智身兼編劇，以奈良縣川上村為背景，於歷史悠久的老舖旅館實境拍攝。在地攝影師百百武細膩掌鏡，透過長鏡頭凝視，每一幀山村即景，彷如光影鑿刻的靜物畫。亮眼新人三宅朱莉，搭配經典卡司水川麻美、三浦誠己、堀田真三，共譜一首饒富餘韻的生命之詩。

In a quiet hamlet hidden in the remote mountains of Japan that was once lively with hikers and shops, we meet Ihika, a 12-year-old born into a family that has run an inn for generations. Her father has been living apart for a few years. Saki, Ihika's mother who married into this family, has been managing the inn with Shige, her father-in-law. One day, Shige disappears. As the inn's survival is threatened, a time of change is coming for Ihika's family.

DIRECTOR, SCREENPLAY
村瀨大智 MURASE Daichi
PRODUCER
YOSHIOKA Aiko Flores
CINEMATOGRAPHER
百百武 DODO Takeshi
EDITOR
唯野浩平 TADANO Kohei
MUSIC
梅村和史 UMEMURA Kazufumi
SOUND
森英司 MORI Eiji
CAST
三宅朱莉 MIYAKE Shuri
水川麻美 MIZUKAWA Asami
三浦誠己 MIURA Masaki
堀田眞三 HOTTA Shinzo
PRINT SOURCE
奈良國際影展
Nara International Film Festival

▍2023 釜山影展 Busan IFF
▍2023 聖賽巴斯提安影展 San Sebastian IFF

 林見捷，導演、編劇、剪輯和製片人，畢業於華中科技大學生物信息與技術專業，後赴紐約大學Tisch藝術學院學習電影製作。首部長片《家庭簡史》即入選日舞影展世界電影劇情片競賽單元，並入選柏林影展大觀單元。

After obtaining a degree in bioinformatics, **LIN Jianjie**'s passion for deciphering human existence led him to filmmaking. He received his MFA from NYU Tisch School of the Arts. His short films *A Visit* (2015) and *Gu* (2017) screened at many international film festivals. *Brief History of a Family* is his feature debut.

06.22 SAT 13:20 信義 HYC 10 | 06.26 WED 13:30 信義 HYC 10 | 06.30 SUN 11:00 華山 SHC 1

家庭簡史
Brief History of a Family

中國、法國、丹麥、卡達 China, France, Denmark, Qatar ｜ 2024 ｜ DCP ｜ Color ｜ 100min

遭遇霸凌受傷的高中青年嚴碩，意外與家境優渥的同學塗偉結緣，開始經常到塗偉家中造訪。乖巧懂事、勤奮向學的嚴碩，很快獲得了塗偉父母的喜愛，知道他來自單親家庭，且長期承受父親家暴之後，塗偉父母對他的疼惜與照顧更是日益加倍。這一切看在原本恃寵而驕的塗偉眼中，十分不是滋味，兩人的矛盾與衝突漸漸醞釀，每晚餐桌上的氛圍也產生了微妙的化學變化⋯⋯。

「那些充滿笑臉的全家福照背後，每個人是怎麼想的？」抱著對此的好奇，新銳導演林見捷首部長片作品即闖入柏林影展，以冷冽的鏡頭語言與美術設計，精緻演繹詭譎張力滿點的懸疑親情劇場。主修生物出身的導演，以細胞隱喻，為電影注入特殊氛圍，用顯微鏡頭凝視當代中國一胎化中產家庭的不安現實，以及高壓升學環境的「內捲」景觀。

A middle-class family's fate becomes intertwined with their only son's enigmatic new friend in post one-child policy China, putting unspoken secrets, unmet expectations, and untended emotions under the microscope.

DIRECTOR, SCREENPLAY
林見捷 LIN Jianjie
PRODUCER
樓瑩 LOU Ying
鄭玥 ZHENG Yue
王衣文 WANG Yiwen
CINEMATOGRAPHER
張嘉昊 ZHANG Jiahao
EDITOR
Per K. KIRKEGAARD
MUSIC
Toke Brorson ODIN
SOUND
Margot TESTEMALE
Jacques PEDERSEN
CAST
祖峯 ZU Feng
郭柯宇 GUO Keyu
孫浠倫 SUN Xilun
林沐然 LIN Muran
PRINT SOURCE
Films Boutique

▌ 2024 香港電影節 Hong Kong IFF
▌ 2024 柏林影展 Berlinale
▌ 2024 日舞影展 Sundance FF

迪米崔・莫伊謝夫，生於1983年，曾於2005至2011年在地方電視台的設計推廣部門工作，2013年畢業於莫斯科Wordshop傳播學院。於2011年起陸續製作多部短片，《異星感應》為其首部劇情長片。

Dmitry MOISEEV worked on regional television between 2005 and 2011. In 2013, he graduated from the Wordshop Academy of Communications in Moscow with a degree in Video Directing. *Encounters* is his debut feature film.

06.24 MON 13:50 信義 HYC 10 | 06.26 WED 19:40 華山 SHC 1 | 06.29 SAT 11:00 華山 SHC 1

異星感應
Encounters

俄羅斯 Russia ｜ 2023 ｜ DCP ｜ Color ｜ 105min

來自異星的飛船多年前降臨地球各地，外星訪客看似毫無敵意，來訪目的卻始終不明，科學家更發現它們分泌的特殊液體，疑似能讓人類延年益壽，吸引各方覬覦。一名護士前往俄羅斯蕭條小鎮的機密實驗所，協助照顧虛弱的外星人，隨著多次接觸，她的身體不僅開始出現異樣，她的私心意圖和實驗所的祕密，以及外星人的真相也逐漸揭曉。

新銳導演迪米崔·莫伊謝夫以俄羅斯「克什特姆矮人」的外星傳聞為靈感，捨棄華麗炫目的特效技術，透過偽紀錄片的新聞影像、詭異的生物造型和陰鬱凋零的市景，建構出真實又陌生的科幻世界。在第三類接觸的題材包裹下，反思人性慾望貪婪下的種族、科學與信仰衝突。宛如俄羅斯版的《第九禁區》，卻也在黑暗中隱隱散發橫跨宇宙物種的善意光芒。

Former nurse Nina, looking after a feeble alien, starts opposing a group of corrupt officials, who are bullying the alien and extracting a valuable substance from them. When she contacts the alien, Nina learns the truth about the extraterrestrial beings, which completely changes her life.

▌ 2024 北京電影節 Beijing IFF
▌ 2023 俄羅斯馬亞克影展 Mayak FF

DIRECTOR, SCREENPLAY, EDITOR
迪米崔·莫伊謝夫 Dmitry MOISEEV
PRODUCER
Ruben DISHDISHYAN
Narek MARTIROSYAN
CINEMATOGRAPHER
Daniil FOMICHEV
SOUND
Alexey BADYGOV
Shamil MALAEV
CAST
Irina SALIKOVA
Sergey GILEV
Alexey YARMILKO
Dmitry VOROBYEV
PRINT SOURCE
Festagent

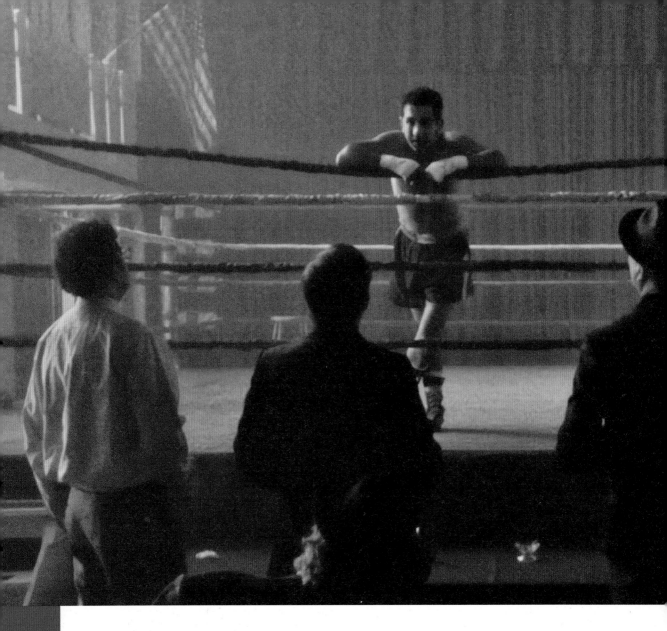

羅伯‧克洛德尼，導演、編劇、資深攝影，於紐約視覺藝術學院任教。2013年執導影集《Frankie Cooks》獲紐約艾美獎，2022年攝影作品《所有的美麗與血淚》獲威尼斯影展金獅獎，《拳王佩普的第232個發薪日》為其首部執導長片。

Robert KOLODNY is a director, writer and cinematographer based in New York. In 2019, he was invited to be a fellow of newportFILM's inaugural Documentary Cinematography Lab. In 2022, DOC NYC named him one of its 40 Under 40 Filmmakers. His feature debut, *The Featherweight*, premiered at the 80th Venice IFF.

06.22 SAT 19:10 信義 HYC 10 ★ | 06.24 MON 13:10 信義 HYC 11 ★ | 06.30 SUN 21:10 信義 HYC 11

拳王佩普的第232個發薪日
The Featherweight

美國 USA｜2023｜DCP｜Color｜100min

威力‧佩普，最偉大的羽量級拳擊手，1959年退休，220勝紀錄無人能破。六年過後回到家鄉，42歲的他一心想復出擂台重溫冠軍輝煌，劇組獲得許可貼身記錄日常，聽他述說傳奇過往，和現任妻子共度美好時光，對手和媒體紛紛讚揚，雖然生活不如以往，父親昏迷躺在加護病房，兒子叛逆處處針對反抗，教練認為復出決定魯莽，家中經濟更是需要幫忙，威力卻依然緊抓著往日榮光不放，這背水一戰的鐘聲究竟能不能被他敲響？

金獎攝影羅伯‧克洛德尼首部執導長片，以真假難辨的偽紀錄手法，重寫美國拳擊手威力‧佩普的復出歷程。大量晃動的手持攝影、顆粒飽滿的底片質感，打破第四道牆的對話訪談，純熟影像技術與眾多性格角色，再現美國六〇年代社會乃至於個人的惶惶不安。在真實與虛構的縫隙中填補血淚，在自尊和自卑的反覆中擺盪起落，只要決心足夠，必能重頭來過。

Set in the mid-1960s, *The Featherweight* presents a gripping chapter in the true-life story of Italian-American boxer Willie Pep — the winningest fighter of all time— who, down and out in his mid-40s and with his personal life in shambles, decides to make a return to the ring, at which point a documentary camera crew enters his life. Painstakingly researched and constructed, the film is a visceral portrait of the discontents of 20th-century American masculinity, fame, and self-perception.

▌2024 克里夫蘭影展 Cleveland IFF
▌2023 威尼斯影展 Venice FF

DIRECTOR
羅伯‧克洛德尼 Robert KOLODNY
PRODUCER
Steve LOFF
James MADIO
Bennett ELLIOTT
Robert GREENE
SCREENPLAY
Steve LOFF
CINEMATOGRAPHER
Adam KOLODNY
EDITOR
Robert GREENE
MUSIC
Retail Space
SOUND
Max COOKE
CAST
James MADIO
Ruby WOLF
Ron LIVINGSTON
Stephen LANG
Lawrence GILLIARD Jr.
Keir GILCHRIST
Shari ALBERT
PRINT SOURCE
Pep Films LLC

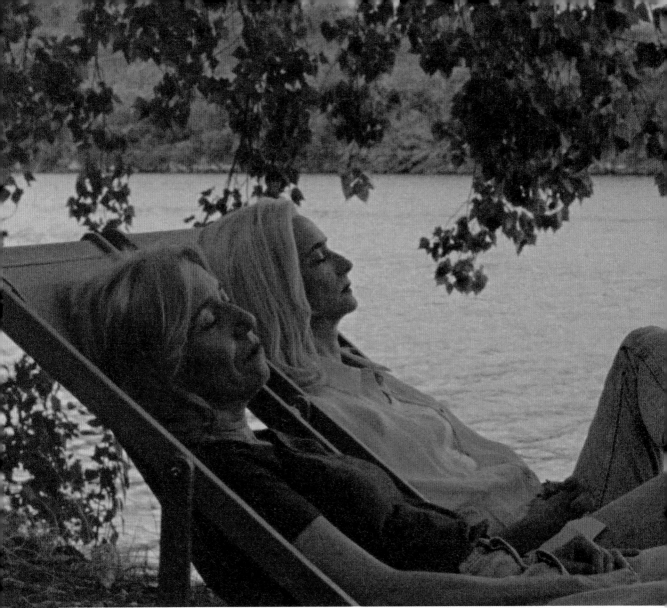

© sobretododenoche

© sobretododenoche

維克多·伊利亞特，1976年出生於西班牙畢爾包，導演暨影展節目策展人。2005年成立自己的電影公司Cajaconcosasdentro，作品常與表演藝術家合作，2015年起任聖賽巴斯提安影展選片人，《夜晚尤其是》為其首部劇情長片。

Víctor IRIARTE, born in Bilbao, Spain in 1976, is an artist, filmmaker, and film programmer. *Foremost by Night* is his first feature fiction film.

06.22 SAT 16:10 信義 HYC 10 ★ | 06.25 TUE 13:10 信義 HYC 11 ★ | 06.30 SUN 11:20 信義 HYC 10

夜晚尤其是
Foremost by Night

西班牙、葡萄牙、法國 Spain, Portugal, France｜2023｜DCP｜Color｜109min

女人的手指在地圖上移動著，槍枝藏進書中扉頁，畫外音指引著行走路徑與方向，「一步、兩步、三步、四步，轉彎」——一場復仇犯罪即將展開。一個被奪走親生骨肉的母親精密計劃尋找兒子，從西班牙至葡萄牙，直至遇見養母與男孩，深夜，書信，指尖勾勒路線，三人聯手欲「偷」回原屬於他們的東西。

以西班牙佛朗哥政權時期發生的嬰兒失竊現象為靈感，《夜晚尤其是》以黑色電影外衣包裝一個母愛尋親的故事。導演大膽融合多種類型元素，從黑色、犯罪，乃至公路電影。片段運用遮罩畫面，並以大量畫外音呈現第一人稱角色心理，也強調了女性作為敘述主體的存在。她、她和他，他們在歷史上彷彿「被消失」的鬼魅，但透過這些書信，身體的移動，以及手的觸摸，他們便無所不在。

When Vera was young, she wasn't able to take care of her son and gave him up for adoption. Years later, when she tried to find him, the institutions told her that her file did not exist. She has continued to look for him ever since.

When Cora was young, her doctor told her that she could not have children. Cora has dedicated her life to teaching piano lessons and caring for her adopted son, Egoz, about to turn 18.

Now, the paths of these three characters are about to cross and change their lives forever.

▍2023 芝加哥影展 Chicago IFF
▍2023 倫敦影展 BFI London FF
▍2023 威尼斯影展威尼斯日 Venice Days, Venice FF

DIRECTOR
維克多‧伊利亞特 Víctor IRIARTE
PRODUCER
Andrea QUERALT
Valérie DELPIERRE
Isa CAMPO
Isaki LACUESTA
Tamara GARCÍA
Katixa SILVA
維克多‧伊利亞特 Víctor IRIARTE
SCREENPLAY
Isa CAMPO
Andrea QUERALT
維克多‧伊利亞特 Víctor IRIARTE
CINEMATOGRAPHER
Pablo PALOMA
EDITOR
Ana PFAFF
MUSIC
Maite ARROITAJAUREGI
SOUND
Alazne AMEZTOY
CAST
Lola DUEÑAS
Ana TORRENT
Manuel EGOZKUE
PRINT SOURCE
Alpha Violet

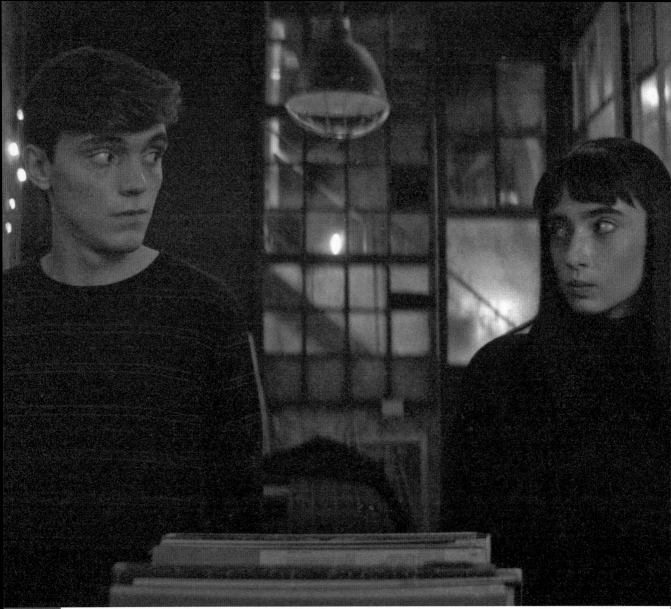

© Pavlin_Shawn

© Ulysse Del Drago

亞希安・路易一塞茲，導演、編劇，出生於加拿大魁北克。2016年拍攝首部短片《Wild Skin》即入圍加拿大影視獎；2018年以短片《Little Waves》獲選多倫多影展「加拿大年度十佳」；2021年短片作品《流星劃過的愛情》亦獲魁北克電影獎最佳實境短片獎提名。本片為她首部電影長片。

Ariane LOUIS-SEIZE is a Canadian filmmaker from Quebec. Her sultry, stylish coming-of-age study *Little Waves* was named one of Canada's Top Ten Shorts in 2018.

06.24 MON 16:00 信義 HYC 11 | 06.26 WED 12:40 信義 HYC 11 | 06.29 SAT 18:50 信義 HYC 11

人道主義吸血鬼徵求自願獻身者

Humanist Vampire Seeking Consenting Suicidal Person

加拿大 Canada｜2023｜DCP｜Color｜91min

出生吸血鬼家族的女孩莎夏，自小就被父母發現她的獠牙發展遲緩、害怕血腥暴力場面，且對作為食物的人類過度富有同理心；長大後，憂心的父母斷絕家中血援，要她向能手表姊學習自力更生。仍然不願野蠻捕殺無辜的她，找到一個折衷方法：混進自殺傾向人士互助會，搜尋生無可戀的對象。她在互助會認識了一個內向憂鬱、在學校遭受霸凌的男孩，兩人一拍即合，男孩相信自己可以死得比活著更有意義，但在奉獻熱血性命之前，莎夏堅持要陪他一一完成死前的願望清單……。

性格邊緣並有著小眾愛好的少男少女，奇幻迷魅的光影色彩，六〇年代抒情金曲定調全片復古美學，披著暗夜版《去X的世界末日》的外皮，卻有著小清新正能量的故事內核。與旁人格格不入的青春心靈，在遇見彼此後，終於找到了自己。

Sasha is a teenage vampire— well, "teenage" is relative in their world — with an empathy problem. Unlike the rest of her clan, Sasha's fangs don't come out when she's hungry or sensing fear; she needs to feel a personal connection to her prey. And then Sasha meets Paul, an actual teenager convinced he'll never enjoy anything in life. She befriends him, introduces him to her world and its secrets, and he happily volunteers to be her next meal. Which would be great, except for the whole empathy thing.

DIRECTOR
亞希安・路易一塞茲 Ariane LOUIS-SEIZE
PRODUCER
Line SANDER EGEDE
Jeanne-Marie POULAIN
SCREENPLAY
亞希安・路易一塞茲 Ariane LOUIS-SEIZE
Christine DOYON
CINEMATOGRAPHER
Shawn PAVLIN
EDITOR
Stéphane LAFLEUR
MUSIC
Pierre-Philippe CÔTÉ
SOUND
Simon GERVAIS
Marie-Pierre GRENIER
Luc BOUDRIAS
Thierry Bourgault D'AMICO
CAST
Sara MONTPETIT
Félix-Antoine BÉNARD
PRINT SOURCE
好威映象有限公司 Hooray Films, Ltd.

▌ 2023 溫哥華影展觀眾票選獎 Audience Award, Vancouver FF
▌ 2023 多倫多影展 Toronto IFF
▌ 2023 威尼斯影展威尼斯日單元最佳影片 Giornate Degli Autori Award, Venice Days, Venice FF

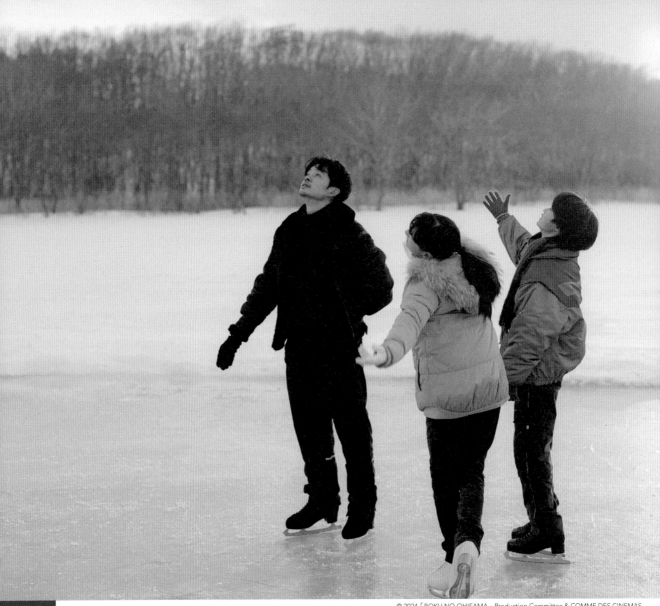

© 2024 「BOKU NO OHISAMA」 Production Committee & COMME DES CINEMAS

奥山大史，1996年生於日本東京，21歲時便以首部劇情長片《與神同行的小孩》一鳴驚人，獲得包括聖賽巴斯提安影展新導演獎等多項影展大獎。2020年參與名導是枝裕和執導的影集《舞伎家的料理人》。《我心裡的太陽》是他的第二部長片。

OKUYAMA Hiroshi is a director, screenwriter, editor, and cinematographer. In 2009, aged only 13, he helmed the music video *Graduationparty!!!!!*, which premiered at the Kyoto International Film Festival. His first feature, *Jesus* (2018), won the New Directors Award at the San Sebastian Film Festival. *My Sunshine* is his second feature film.

06.22 SAT 10:40 信義 HYC 10 ★ | 06.24 MON 16:10 信義 HYC 10 ★ | 06.30 SUN 21:00 信義 HYC 10

我心裡的太陽

My Sunshine

日本 Japan｜2024｜DCP｜Color｜90min

北海道的小鎮裡，木訥斯文的少年怎麼樣也跟不上身邊好動男孩們的一切。直到這個冬天，他在冰上曲棍球隊練習時，深深被優雅的花式滑冰女孩吸引，也迷上這項大家眼中陰柔的運動。場外，擔任教練的退役名將把一切看在眼裡，他不但從頭教起男孩花式滑冰的一切，還安排女孩和少年搭檔練習，準備參加雙人滑冰舞蹈比賽。沒想到一次偶然，讓教練的祕密意外曝光，一切的安排也都被打亂。

由電影旬報影帝池松壯亮主演的療癒小品。曾被譽為天才導演的奧山大史，以低成本的預算完成了第二部劇情長片，他集編、導、攝影、剪輯於一身，以淡雅日式的攝影風格，靈動地捕捉演員們的優雅步伐，打造出雪國版的《舞動人生》。

On a Japanese island, life revolves around the changing seasons. Winter is time for ice hockey at school, but Takuya isn't too thrilled about it. His real interest lies in Sakura, a figure skating rising star from Tokyo, for whom he starts to develop a genuine fascination. Coach and former champion Arakawa spots potential in Takuya, and decides to mentor him to form a duo with Sakura for an upcoming competition. As winter persists, feelings grow, and the two children form a harmonious bond. But even the first snow eventually melts away.

▎2024 雪梨影展 Sydney FF
▎2024 坎城影展 Cannes

DIRECTOR, SCREENPLAY, CINEMATOGRAPHER
奧山大史 OKUYAMA Hiroshi

EDITOR
奧山大史 OKUYAMA Hiroshi
Tina BAZ

PRODUCER
西谷壽一 NISHIGAYA Toshikazu
澤田正道 SAWADA Masa

MUSIC
Humbert Humbert

SOUND
勝亦櫻 KATSUMATA Sakura

CAST
池松壯亮 IKEMATSU Sosuke
越山敬達 KOSHIYAMA Keitatsu
中西希亜良 NAKANISHI Kiara
山田真歩 YAMADA Maho
若葉竜也 WAKABA Ryuya

PRINT SOURCE
Charades

肯哲別克・沙伊卡科夫，導演、編劇及演員，出生於1977年，畢業於哈薩克國立藝術學院，專攻電影和戲劇表演，後曾在哈薩克各電視台擔任記者。首部編導的處女作《Tent》獲2015年亞太電影大獎最佳劇本提名。

Kenzhebek SHAIKAKOV is a film director, screenwriter and actor born in Aktobe, Kazakhstan in 1977. He has also worked as a journalist, editor, and director for Kazakh television. His feature debut, *Tent* (2014), was invited to the Asia Pacific Screen Awards. *Scream* is his second feature.

06.23 SUN 12:30 信義 HYC 10 ★ | 06.25 TUE 11:20 華山 SHC 1 ★ | 06.28 FRI 20:50 華山 SHC 1

吶喊荒村

Scream

哈薩克 Kazakhstan｜2023｜DCP｜Color｜108min

在蘇聯統治時期一座哈薩克小村莊裡，先天畸型的單親爸爸與年幼的兒子相依為命。無腿的男人為兒子悉心熨整著象徵忠誠的領巾，貼心的兒子則掛心著對父親再婚的期待，微小而日常的幸福不過就是這麼簡單。每當軍用直升機的聲響劃破寂靜的上空，孩子們便會高聲歡呼明天又將是停課的大好日子，大人們則是靜默無語，唯有瘋子出沒的嚎叫聲，格外地刺耳淒厲。某天，陌生的紅衣女子來到了男人的村莊，為無瀾的生活增抹了神祕的血色，就像兒子總是流淌不止的鼻血一樣……。

電影揭示了一段哈薩克鮮為人知的歷史與政治悲劇，本片取景之地塞米巴拉金斯克（Semipalatinsk）於 1949 至 1989 年因附近核彈基地近 500 次的試爆，當地居民與環境迄今仍受到輻射的嚴重危害。導演以寫實鏡頭凝視著這一代哈薩克人的渴望與失望，同時也透過魔幻寫實的轉譯手法，溫柔道出人們和土地最深的哀慟。

Mels, who was born without legs, lives in a small rural village with his young son. Although there is a weapons testing site near the village, Mels and the other village residents maintain a peaceful life. At some point, Mels' body and the weapons test— meaning nuclear testing— begin to become intertwined, plunging the village into turmoil.

DIRECTOR, SCREENPLAY
肯哲別克・沙伊卡科
Kenzhebek SHAIKAKOV
PRODUCER
Erbol BORANSHY
CINEMATOGRAPHER
Ekpin ZHENIS
EDITOR
Timur SARILBAYEV
MUSIC
Jaqsibek QALELBEK
SOUND
Elaman AQANBAY
CAST
Orynbek SHAIMAGANBETOV
Arnur AKRAM
Zhandarbek AYUBAI
PRINT SOURCE
M-Build

▌ 2024 法國維蘇亞洲影展國際評審團大獎、奈派克獎、馬克・哈茲獎
　　Grand Jury Award, NETPAC Award, Marc Haaz Award, Vesoul IFF of Asian Cinema
▌ 2023 釜山影展 Busan IFF

瑪瑞亞・裘博，突尼西亞裔美國導演，現居蒙特婁。作品《烽火中的兄弟》入圍奧斯卡最佳實景短片，並於超過150個以上影展放映。首部長片《屋簷下沒有煙硝》入選2024年柏林影展主競賽。

Meryam JOOBEUR's short films *Gods, Weeds and Revolutions* (2012) and *Born in the Maelstrom* (2017) were screened internationally. Her Oscar-nominated short *Brotherhood* (2018) screened at more than 150 festivals and won 75 international prizes. *Who Do I Belong To* is her first feature film.

06.23 SUN 15:30 信義 HYC 10 ★ | 06.25 TUE 13:30 信義 HYC 10 ★ | 06.28 FRI 10:20 信義 HYC 11

屋簷下沒有煙硝

Who Do I Belong To

突尼西亞、法國、加拿大 Tunisia, France, Canada｜2024｜DCP｜Color｜118min

女人與丈夫、三個兒子住在一處近海的小農村。兩個大兒子離家加入 ISIS，徒留心碎的女人、憤怒的丈夫與懵懂的小兒子。灰藍的海對離去的人沉默不語，而女人常常夢見白馬與開滿小黃花的原野，彷若家的樂園還存在。某天，出乎所有人的意料，其中一個兒子突然出現在家門口，身邊卻跟隨一位神祕的藍眼懷孕女子。已然分崩離析的家再現波瀾，未來將何去何從？

導演瑪瑞亞・裘博擴寫她入圍奧斯卡最佳實景短片的作品《烽火中的兄弟》，將故事焦點由兄弟轉為母親，以近似童話的敘事語言、簡潔凝練的鏡頭設計及沉鬱低迴的配樂，訴說一段自我認同的崩解與追尋之旅。大量的特寫鏡頭精準捕捉角色的心理變化，而從短片起參與的素人三兄弟與專業演員搭配相得益彰、畫龍點睛。

Aicha lives in the isolated north of Tunisia with her husband and youngest son. The family lives in anguish after the departure of the eldest sons Mehdi and Amine to the violent embrace of war. When Mehdi unexpectedly returns home with a mysterious pregnant wife, a darkness emerges, threatening to consume the entire village. Aicha is caught between her maternal love and her search for the truth.

DIRECTOR, SCREENPLAY
瑪瑞亞・裘博 Meryam JOOBEUR
PRODUCER
Nadim CHEIKHROUHA
Sarra BEN HASSEN
Annick BLANC
Maria Gracia TURGEON
瑪瑞亞・裘博 Meryam JOOBEUR
CINEMATOGRAPHER
Vincent GONNEVILLE
EDITOR
Maxime MATHIS
瑪瑞亞・裘博 Meryam JOOBEUR
MUSIC
彼得・維內 Peter VENNE
SOUND
Gwennolé LE BORGNE
CAST
Salha NASRAOUI
Mohamed HASSINE GRAYAÂ
Malek MECHERGUI
Adam BESSA
Dea LIANE
Rayen MECHERGUI
Chaker MECHERGUI
PRINT SOURCE
Luxbox

▌2024 香港電影節新秀電影競賽（世界）最佳導演
Best Director, Young Cinema Competition (World), Hong Kong IFF
▌2024 柏林影展 Berlinale

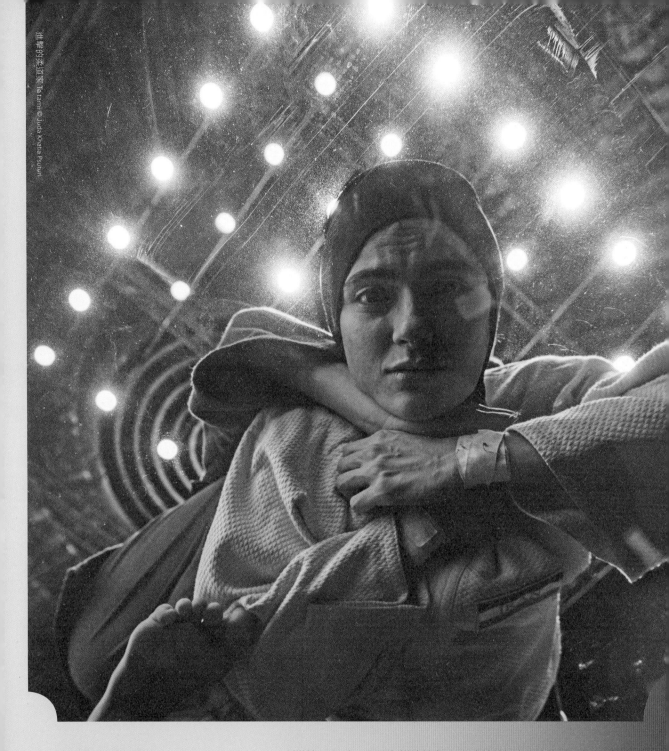

進擊的柔道家 Tatami © Juda Khatia Psuturi

國新競賽：
20年的探索
INTC: 20 YEARS OF
EXPLORATION

創辦於 2005 年，國際新導演競賽 20 年來持續探索影壇的明日之星，搶先引介。包括莎拉‧波莉、塔伊加‧維迪提、那達夫‧拉匹、羅賓‧康皮洛等名導的第一、二部長片，都曾在此呈現。本單元追蹤近年入選影人的最新力作。

Founded in 2005, the International New Talent Competition (INTC) has continuously unearthed the future stars of the film industry over the past 20 years, introducing them to the world ahead of time. The first or second feature films of renowned filmmakers including Sarah Polley, Taika Waititi, Nadav Lapid, and Robin Campillo have all been presented here. This section tracks the latest works of filmmakers selected to the INTC in recent years.

© Toon Aerts

© SofieGeysens

費恩・特羅赫，比利時導演，創作不輟近20年，常探討社區群體對共同創傷經驗的消化。2006年以《意外的兇手》在台北電影節國際新導演競賽獲得評審團特別獎，2016年以《Home》再奪威尼斯影展地平線單元最佳導演。本片為其第五部長片。

Fien TROCH is a Belgian film director and screenwriter. Her debut feature, *Someone Else's Happiness* (2005), was selected to TIFF and San Sebastian, winning several awards; *Kid* (2008) won the Eurimages Award for Most Promising Project at Rotterdam; *Home* (2016) won the Orizzonti Best Director Award at Venice.

魔女荷莉
Holly

比利時、荷蘭、盧森堡、法國 Belgium, The Netherlands, Luxembourg, France｜2023｜DCP｜Color｜104min

少女荷莉一早醒來，因為不祥的預感決定請假，沒想到當天學校就失火了。事後陪伴受難家屬的她，又展現出驚人的撫慰能量，成了鎮上的療癒天使。但這樣的「使命」隨著眾人的需求越來越沉重，家庭並不幸福的荷莉，如何在助人與助己之間，找到不會受傷的平衡？

本片以一個具若有似無超能力的女孩故事，探討療癒與善行的被神聖化、脫離現實，以及更殘酷的：青春女孩的自我價值探索。場景在信仰虔誠的比利時小鎮，社群網絡的壓力叫人窒息。導演透過大量特寫，完美展露初次演戲的女主角如一張無聲白紙的脆弱感，搭配淺景深、夢境一般的

恍惚氣氛，以及模擬高敏者日常壓力的電子環境音，道出世上不只有再多善意都無法抵銷的惡，純粹無私的善行，也不見得存在。

Fifteen-year-old Holly calls her school to say she is staying home for the day. Soon after, a fire breaks out at the school, killing several students. With everyone touched by the tragedy, the community comes together, trying to heal. Anna, a teacher, intrigued by Holly and her strange premonition, invites her to join the volunteering group she runs. Holly's presence seems to bring peace of mind, warmth, and hope to those she encounters. But soon, people begin to seek out Holly and her cathartic energy, demanding more and more from the young girl.

▌2023 芝加哥影展 Chicago IFF
▌2023 釜山影展 Busan IFF
▌2023 威尼斯影展 Venice FF

DIRECTOR, SCREENPLAY
費恩・特羅赫 Fien TROCH
PRODUCER
Antonino LOMBARDO
Elisa HEENE
CINEMATOGRAPHER
Frank VAN DEN EEDEN (SBC NSC)
EDITOR
Nico LEUNEN (ACE)
MUSIC
Johnny JEWEL
SOUND
Tijn HAZEN
CAST
Cathalina GEERAERTS
Felix HEREMANS
Greet VERSTRAETE
Serdi FAKI ALICI
PRINT SOURCE
好威映象有限公司 Hooray Films, Ltd.

06.22 SAT 22:00 信義 HYC 10

INTC: 20 YEARS OF EXPLORATION 79

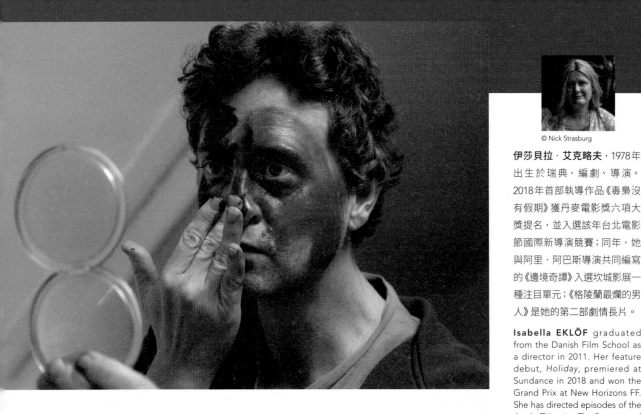

© Nick Strasburg

伊莎貝拉‧艾克略夫，1978年出生於瑞典，編劇、導演。2018年首部執導作品《毒梟沒有假期》獲丹麥電影獎六項大獎提名，並入選該年台北電影節國際新導演競賽；同年，她與阿里‧阿巴斯導演共同編寫的《邊境奇譚》入選坎城影展一種注目單元；《格陵蘭最爛的男人》是她的第二部劇情長片。

Isabella EKLÖF graduated from the Danish Film School as a director in 2011. Her feature debut, *Holiday*, premiered at Sundance in 2018 and won the Grand Prix at New Horizons FF. She has directed episodes of the Apple TV series *The Servant*, and the HBO TV series *Industry*.

格陵蘭最爛的男人

Kalak

亞洲首映 Asian Premiere

丹麥、瑞典、挪威、芬蘭、格陵蘭、荷蘭 Denmark, Sweden, Norway, Finland, Greenland, The Netherlands
2023｜DCP｜Color｜125min

男護士聽著罹病老男人的狡辯，硬是把亂倫性虐待掰成對性的自由體驗，男護士也不是省油的燈，要他乖乖躺下休息，最好是永遠！男護士原任職於丹麥醫院，自願攜家帶眷前往冰天凍地的格陵蘭島服務，他既不是返鄉中年，更無意到偏鄉圓夢，他逃亡的原動力源自濕黏滯悶的午畫，半寐半醒之間的一雙手、一張嘴，還有令人作嘔的自圓其說。

炙手可熱的瑞典導演艾克略夫繼超限制級犯罪劇情片《毒梟沒有假期》後，此次與丹麥知名作家基姆‧萊恩合作改編其自傳性小說，關注經歷性創傷的人們及曾被丹麥殖民的格陵蘭島，在清創過程中的精神掙扎。

A male nurse listens to a sick old man try to justify incestuous sexual abuse as sexual freedom. But the nurse is not easy to deal with either, telling the old man to lie down, preferably forever! The male nurse originally worked for a Danish hospital but voluntarily relocated his family to icy Greenland. He's not a middle-aged man returning home, nor seeking to fulfill dreams in a remote area. The driving force behind his escape comes from the dull, sticky afternoons, the hand over his mouth as he lay half-asleep, and the nauseating self-justifications.

▌2024 伊斯坦堡影展 Istanbul FF
▌2024 哥特堡影展 Göteborg FF
▌2023 聖賽巴斯提安影展評審團特別獎、最佳攝影 Special Prize of the Jury, Best Cinematography, San Sebastian IFF

DIRECTOR
伊莎貝拉‧艾克略夫 Isabella EKLÖF
PRODUCER
Maria Møller KJELDGAARD
SCREENPLAY
伊莎貝拉‧艾克略夫 Isabella EKLÖF
基姆‧萊恩 Kim LEINE
Sissel DALSGAARD THOMSEN
CINEMATOGRAPHER
Nadim CARLSEN
EDITOR
Anna EBORN
伊莎貝拉‧艾克略夫 Isabella EKLÖF
SOUND
Mark GLYNNE
CAST
Emil JOHNSEN
Asta KAMMA AUGUST
Berda LARSEN
Connie KRISTOFFERSEN
Vigga TUKULA
PRINT SOURCE
Totem Films

06.21 FRI 16:20 信義 HYC 10 ｜ 06.23 SUN 21:30 信義 HYC 10 ｜ 06.25 TUE 17:30 華山 SHC 1

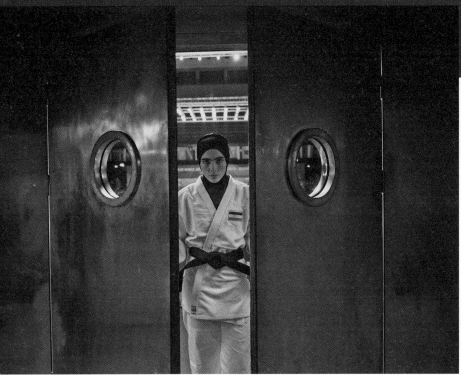
© Juda Khatia Psuturi

© Theo & Juliet　Photo by Kris Dewitte

蓋・那提，導演、編劇。2007
年曾以《雙城戀曲，陌生人》
入選台北電影節國際青年導演
競賽，2019年以《復黑計畫》
獲奧斯卡最佳實境短片獎。

Guy NATTIV is a filmmaker
originally from Israel whose first
American short, *Skin*, won the 2019
Oscar for Best Live Action Short.

查赫拉・阿米爾・易卜拉希米
演員、製片、導演、選角指導。
曾以《聖蛛》獲封坎城影后，並
獲BBC選為最具啟發和影響力
的百位女性之一。

Zar AMIR EBRAHIMI is an Iranian-
French actress, producer, director
and casting director who won Best
Actress at Cannes for *Holy Spider*.

進擊的柔道家
Tatami

喬治亞、美國 Georgia, USA │ 2023 │ B&W │ 103min

苦練多年，柔道選手萊拉終於闖進世界大賽，在嚴師瑪莉雅的指導下一路勢如破竹，冠軍賽近在咫尺。眼看夢想就在眼前，祖國卻派來密電，強硬脅迫萊拉稱病退賽，只因不希望她在決賽與敏感敵國交手。曾面臨相同處境的教練苦口勸說，萊拉卻抵死不從，誓言拚戰到最後。就在此時，針對萊拉摯愛親友的人身恐嚇，開始從她的家鄉越洋傳來⋯⋯。

坎城影后查赫拉・阿米爾・易卜拉希米，在名作《聖蛛》後演而優則導，持續聚焦故鄉伊朗的女權議題，描繪今日仍深受伊斯蘭政教壓抑的女性處境。刺激的競技對抗與驚悚的權勢迫害交織並進，使本片不僅是一部熱血沸騰、張力十足的運動電影，作為史上首部由伊朗裔和以色列裔導演共同執導的劇情長片，本片為自由、夢想、平等與和平鬥士們獻上的崇高致敬更是令人動容。

Iranian female judokas Leila and her coach Maryam travel to the Judo World Championship, intent on bringing home Iran's first gold medal. Midway through the tournament, they receive an ultimatum from the Islamic Republic ordering Leila to fake an injury and lose, or she will be branded a traitor of the state. With her own and her family's freedom at stake, Leila is faced with an impossible choice: comply with the Iranian regime as her coach Maryam implores her to do, or fight on, for the gold.

▎2023 蘇黎世影展 Zurich FF
▎2023 東京影展評審團特別獎、最佳女演員 Special Jury Prize, Best Actress, Tokyo IFF
▎2023 威尼斯影展地平線單元布萊恩獎 Brian Award, Orizzonti, Venice FF

DIRECTOR
蓋・那提 Guy NATTIV
查赫拉・阿米爾・易卜拉希米
Zar AMIR EBRAHIMI
PRODUCER
Adi EZRONI
Mandy Tagger BROCKEY
Jaime Ray NEWMAN
蓋・那提 Guy NATTIV
SCREENPLAY
蓋・那提 Guy NATTIV
Elham ERFANI
CINEMATOGRAPHER
Todd MARTIN
EDITOR
Yuval ORR
MUSIC
Dascha DAUENHAUER
SOUND
Ronen NAGEL
CAST
Arienne MANDI
查赫拉・阿米爾・易卜拉希米
Zar AMIR EBRAHIMI
Jaime Ray NEWMAN
Ash GOLDEH
PRINT SOURCE
WestEnd Films

06.22 SAT 13:00 信義 HYC 11 │ **06.28 FRI 16:40 中山堂 TZH** │ **07.02 TUE 18:00 信義 HYC 11**

魏書鈞，1991 年出生於北京，短片《延邊少年》、劇情片《野馬分鬃》與《永安鎮故事集》陸續獲得各大國際影展肯定，《河邊的錯誤》為其最新代表作，是近年備受矚目的青年導演。

WEI Shujun was born in Beijing and completed a master's degree at the Communication University of China. His film credits include the short film *On the Border* and *Striding into the Wind* (Cannes, 2020).

河邊的錯誤
Only the River Flows

中國 China │ 2023 │ Color │ 102min

九〇年代江東小鎮的河邊死了個老婦。比起瘋子嫌疑犯，追查命案的警長馬哲相信真相不止於此。撿起每一個證物，見過所有的證人，但越是抽絲剝繭，謎底卻越陷越深。警察局長的施壓、家中妻子的問責，在行使正義的路上還能維持理性嗎？「馬哲，又死一人了。」當事實虛實難分、真相真假莫辨，馬哲和瘋子，誰才比較正常？從最接近現實的夢境中醒過來，河邊的雨只能越下越大。

改編自余華同名小說，當年張藝謀買下版權卻不敢駕馭的電影，30 年後由魏書鈞完成了這項高難度計畫。貌似黑色電影風格卻一反標準化類型片的操作，16mm 膠卷拍出的顆粒感在灰暗朦朧中撲朔迷離又幻象叢生。金雞影帝朱一龍和金像影后曾美慧孜連袂出演，道出偏執狂人格的存在偏差，以及荒謬社會的精神病徵。

1990s, Banpo Town, rural China. A woman's body is found by the river. Ma Zhe, Chief of the Criminal Police, heads up the murder investigation that leads to an obvious arrest. His superiors hurry to congratulate him, but several clues push Ma Zhe to delve deeper into the hidden behavior of his fellow citizens.

▌ 2023 平遙電影展藏龍單元最佳影片 Hidden Dragon Best Film, Pingyao IFF
▌ 2023 釜山影展 Busan IFF
▌ 2023 坎城影展 Cannes

DIRECTOR
魏書鈞 WEI Shujun
PRODUCER
黃旭峰 HUANG Xufeng
SCREENPLAY
康春雷 KANG Chunlei
魏書鈞 WEI Shujun
CINEMATOGRAPHER
程馬志遠 CHENGMA Zhiyuan
EDITOR
馬修 Mattieu LACLAU
SOUND
杜則剛 TU Tse-kang
杜篤之 TU Duu-chih
CAST
朱一龍 ZHU Yilong
曾美慧孜 Chloe Maayan
侯天來 HOU Tianlai
佟林楷 TONG Linkai
PRINT SOURCE
杭州當當影業有限公司
Hangzhou Dangdang Film Co., Ltd.

06.23 SUN 18:50 信義 HYC 10 │ 06.29 SAT 11:30 信義 HYC 11 │ 07.02 TUE 12:30 信義 HYC 11

魏書鈞，1991 年出生於北京，
短片《延邊少年》、劇情片《野
馬分鬃》與《永安鎮故事集》陸
續獲得各大國際影展肯定，《河
邊的錯誤》為其最新代表作，
是近年備受矚目的青年導演。

WEI Shujun was born in Beijing
and completed a master's degree
at the Communication University
of China. His film credits include
the short film *On the Border* and
Striding into the Wind.

野馬分鬃
Striding Into the Wind

中國 China｜2020｜DCP｜Color｜129min

憤世嫉俗的學生錄音師，片場經驗混得老道，處
世學分卻落敗延畢。他是學生但太江湖，他在江
湖但太學生。俗世草包的人總能有名有利，反觀
自己有膽有識卻一事無成。快要報廢的吉普車曾
是一匹好馬，載著也快被淘汰的自己，妄想著突
圍無聊兼無能的城市。本該前往內蒙古的公路電
影卻遲遲不能出發，桀驁不馴又無法在大草原上
自由奔騰的野馬，最後終究只能是窠臼中的魯蛇。

六年內四度入選坎城影展，被譽為「怪物級」青
年導演魏書鈞於 2021 年入選台北電影節國際新導
演競賽的作品，進行首映時技驚四座。命題嚴肅
但不失詼諧幽默，小人物的失落命運卻影射了大
社會的世代困局。除了半自傳性回溯導演自身從
事電影的心路歷程，亦一併指向當下青年的生存
現狀；對電影產製提出了舉重若輕的諷刺，也對
電影的激情之夢提出緩步反思。

Kun seems to be messing up pretty much everything:
his senior year at film school, the job on his friend's
graduation film and the relationship with his girlfriend.
But Kun just got his driving license and with it, the
cheapest second-hand car he could find: an old wreck
of a Jeep Cherokee that might turn out to be the key
to his wildest dreams.

▌2020 釜山影展 Busan IFF
▌2020 平遙電影展費穆榮譽獎、最佳男演員 Fei Mu Awards Best Actor, PYIFF
▌2020 坎城影展 Cannes

DIRECTOR
魏書鈞 WEI Shujun
PRODUCER
柳青伶 LIU Qingling
SCREENPLAY
魏書鈞 WEI Shujun
高臨陽 GAO Linyang
CINEMATOGRAPHER
王階宏 WANG Jiehong
EDITOR
孔勁蕾 KONG Jinlei
MUSIC
侯夢婷 HOU Mengting
SOUND
郝剛 HAO Gang
何威 HE Wei
CAST
周遊 ZHOU You
鄭英辰 ZHENG Yingchen
王小木 WANG Xiaomu
佟林楷 TONG Linkai
趙多娜 ZHAO Duona
PRINT SOURCE
前景娛樂有限公司
Flash Forward Entertainment Co., Ltd.

06.24 MON 18:50 信義 HYC 10 ▲｜06.28 FRI 10:40 信義 HYC 10 ▲

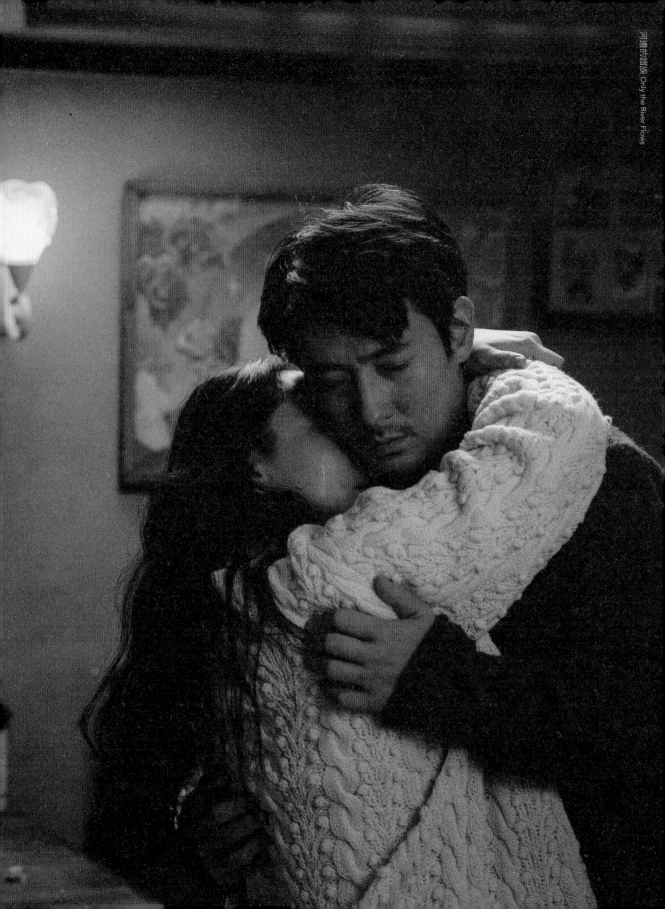

台北電影節
TAIPEI FILM 26th 2024
FESTIVAL 6.21 — 7.6

台北電影節

頒獎典禮

7.6
SAT
19:00-22:00

電視直播	⟶	華視主頻12台
網路直播	⟶	LINE TODAY
YouTube	⟶	台北電影節

OTT平台 中華電視 MOD、Hami Video、四季線上、Gt TV、LiTV、ofiii、Fain TV
海外平台 DishTV、東森美洲台

7.7
SUN
00:30-03:30

電視重播 ⟶ 華視主頻12台

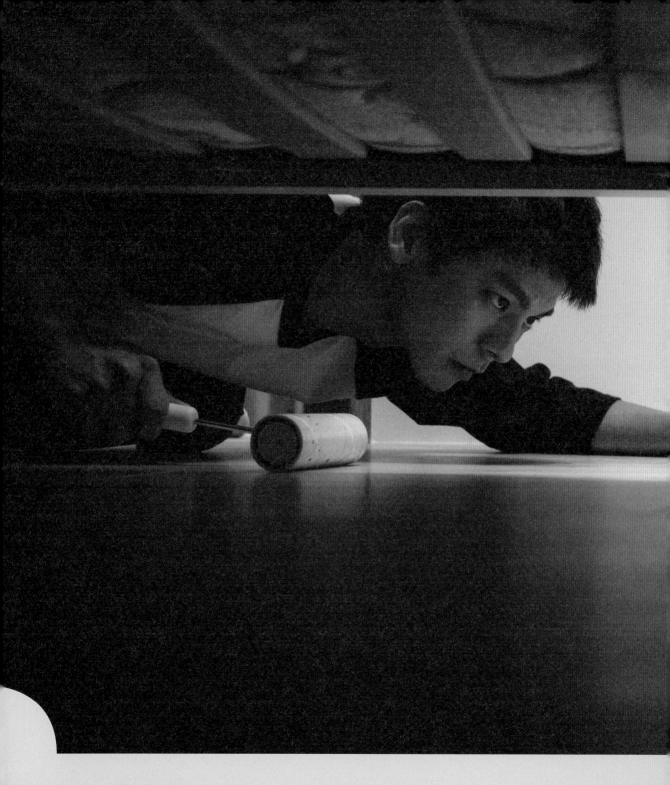

台北電影獎
TAIPEI FILM AWARDS

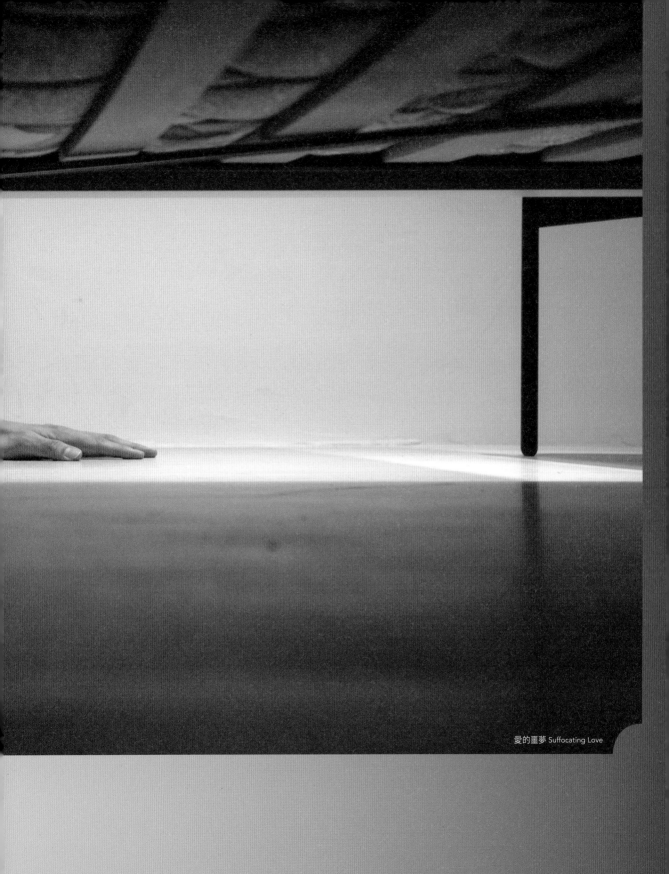

愛的噩夢 Suffocating Love

台北電影獎
TAIPEI FILM AWARDS

台北電影獎源於1988年的「中時晚報電影獎」，並於1994年正式改名為台北電影獎。做為台灣電影競賽主場，每年以國片最高獎金「百萬首獎」為號召，拔擢本土優秀影像創作者、鼓勵不同題材與表現形式，為國片開發各種可能性。

The Taipei Film Awards is the only film competition exclusively aimed at Taiwanese filmmakers. Every year, the NT$1 million Grand Prize for domestic films attracts Taiwan's most outstanding filmmakers and encourages different themes and stylistic expressions, opening up all kinds of possibilities for Taiwanese cinema.

正式競賽項目 Official Awards

最佳劇情長片 Best Feature

最佳紀錄片 Best Documentary

最佳短片 Best Short Film

最佳動畫片 Best Animation

最佳導演 Best Director

最佳編劇 Best Screenplay

最佳男主角 Best Actor

最佳女主角 Best Actress

最佳男配角 Best Supporting Actor

最佳女配角 Best Supporting Actress

最佳新演員 Best New Talent

最佳攝影 Best Cinematography

最佳剪輯 Best Editing

最佳配樂 Best Music

最佳美術設計 Best Art Design

最佳造型設計 Best Makeup & Costume Design

最佳聲音設計 Best Sound Design

最佳視覺效果 Best Visual Effects

傑出技術 Award for Outstanding Artistic Contribution

非正式競賽項目 Non-official Awards

觀眾票選獎 Audience Choice Award

媒體推薦獎 Press Award

入圍獎項

最佳男配角
最佳新演員
最佳造型設計

少男少女
A Boy and A Girl

台灣 Taiwan | 2023 | DCP | Color | 140min

在一個「什麼都沒有」的濱海小鎮裡，百無聊賴的少年遇見了失戀的少女。少年得知了少女過往與足球教練戀愛的祕密，嚮往離開小鎮的他便向少女提議勒索教練，換取足以離開的金錢。這個天真的計畫無法從大人手中拿到分毫。然而離開的念頭一動，就再也無法喊停。傷心的少女向少年提議，讓她用最原始的本能賺錢，而少年負責其他事情。

小鎮的周邊總是不缺寂寞無聊的男性，這「生意」很快就發展起來。隨著時間過去，有錢的生活卻讓「離開」這個目標逐漸變得模糊；與此同時，他們的生意被轄區的警察盯上，反遭控制與勒索。一夕之間，「離開」的目標又清晰了起來。絕望的少年決定鋌而走險，開始販毒，卻不知道這一切的終點，是背叛。

In a declining small town, an idle boy encounters a heartbroken girl. Trying to get away, they come up with a secret plan and set off for a one-way journey.

許立達，臺北藝術大學電影創作學系碩士班導演組畢業。作品涵蓋女性、愛情、家庭、殘酷青春等題材，並持續創作類型片，擅長描述細膩人性情感。電視電影作品《告別》獲得 2017 年金鐘獎迷你劇集類導演、編劇獎。

HSU Li-da's works cover themes that span across women, love, family and cruel adolescence. His television film *The Long Goodbye* won Best Director and Best Writing for a Miniseries or Television Film at the Golden Bell Awards.

▋ 2023 金馬獎 Golden Horse Awards
▋ 2023 釜山影展 Busan IFF

DIRECTOR, SCREENPLAY
許立達 HSU Li-da
EXECUTIVE PRODUCER
唐在揚 David TANG
PRODUCER
王佩嫻 Angelin ONG
李芃君 Daphne LEE
CINEMATOGRAPHER
陳克勤 CHEN Ko-chin
賴菘諺 LAI Sung-yen
衛子揚 WEI Tz-yang
EDITOR
廖慶松 LIAO Ching-sung
許立達 HSU Li-da
MUSIC
盧律銘 LU Luming
SOUND
杜篤之 TU Duu-chih
CAST
李銘忠 Frederick LEE
姚淳耀 YAO Chun-yao
張懷秋 Harry CHANG
管馨 Kris KUAN
胡語恆 Travis HU
尹茜蕾 Kira SKELLY
PRINT SOURCE
嘉揚電影有限公司
RISE PICTURES CO., LTD.

06.26 WED 14:40 華山 SHC 2 ★

Photo by LIU Chen-Hsiang

入圍獎項

最佳男主角
最佳女主角

春行
A Journey in Spring

台灣 Taiwan｜2023｜DCP｜Color｜90min

跛腳男人欽福與妻子相依為命，住在臺北近郊的老房裡。妻子驟然逝世後，欽福隱藏起她已死的事實，繼續看似平靜的生活。然而離家多年的兒子與他的新伴侶突然出現，欽福終究必須面對妻子的死亡。帶著對妻子的思念，他在潮濕的春季，開始一段面對生命遺憾的旅程。

An old man with a limp, Khim-hok, has depended on his wife over the years. They live in an old house on the urban fringe of Taipei. After his wife suddenly passes away, Khim-hok covers it up and goes on living a seemingly peaceful life. But their long-estranged son and his new partner suddenly appear, so Khim-hok has to face his wife's death when the end finally comes.

DIRECTOR
彭紫惠 PENG Tzu-hui
王品文 WANG Ping-wen
PRODUCER
彭紫惠 PENG Tzu-hui
王品文 WANG Ping-wen
SCREENPLAY
余易勳 YU Yi-hsun
CINEMATOGRAPHER
加藤陽介 KATO Yosuke
蘇偉鍵 SOU Wai Kin
EDITOR
彭紫惠 PENG Tzu-hui
MUSIC
彭炫斑 PENG Hsun-ting
SOUND
澎葉生 Yannick DAUBY
CAST
喜翔 KING Jieh-wen
楊貴媚 YANG Kuei-mei
藍葦華 LAN Wei-hua
張書偉 CHANG Shu-wei
陳佳穗 CHEN Chia-sui
PRINT SOURCE
彭紫惠 PENG Tzu-hui
王品文 WANG Ping-wen

Photo by Crystal Pan

彭紫惠，藝術家與電影導演。**王品文**，電影導演。兩人共同執導首部劇情長片《春行》，入圍2023年聖賽巴斯提安影展主競賽，並獲得最佳導演銀貝殼獎。

PENG Tzu-hui is an artist and film director. **WANG Ping-wen** is a film director. Their debut feature film, *A Journey in Spring*, won the Silver Shell for Best Director at the 2023 San Sebastian IFF.

▌2024 香港電影節國際影評人費比西獎、新秀電影（華語）競賽最佳男演員 FIPRESCI Prize, Best Actor, Young Cinema Competition (Chinese Language), Hong Kong IFF
▌2023 新加坡影展銀幕獎最佳表演、劇本 Silver Screen Award for Best Performance, Best Screenplay, Singapore IFF
▌2023 聖賽巴斯提安影展最佳導演銀貝殼獎 Silver Shell for Best Director, San Sebastian IFF

06.23 SUN 19:00 中山堂 TZH ★ ｜ 06.27 THU 13:20 信義 HYC 11 ★

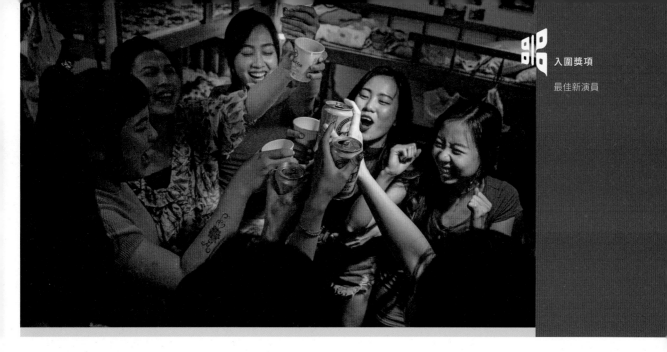

彈味中的嬰孩

All the Innocence and the Bloodshed

台灣 Taiwan｜2023｜DCP｜Color｜81min

透過婚姻買賣嫁到台灣，以改善母國家人生活的越南新住民黎清清，離取得身分證的日子不遠了；她想方設法避免成為丈夫的生孩子工具，又偷在色情養生館工作，渴望早點轉夠錢，以擁有往後人生的自由。苦悶日常中，只有和正值青春期的繼女白家家打鬧和談心時，黎清清才得以喘息一下，也因此仍感到對這個家的責任感。然而一位奇怪的客人總是到養生館找黎清清，打亂了平淡的日常，也讓她認知到，一切不只是取得身分證及賺夠錢那麼簡單。

To improve her family's quality of life back in Vietnam, Lê Thanh Thanh accepted a marriage in Taiwan for money. Soon to receive her ID card, she strives to avoid being relegated to solely being a childbearing tool for her husband. She works at an adult massage center without anyone's knowledge, hoping to expeditiously accumulate the necessary financial resources to gain future independence.

劉純佑，出生、成長於新竹的客家人。近年作品呈現出不同社會處境下的女性，並聚焦於異鄉人及孩童，也努力去描繪出她們對眼前現實感到迷失的心理狀態。曾以《紅色》入圍金穗獎，以《透明的孩子》入圍高雄電影節。

LIU Chun-yu is an ethnic Hakka born and raised in Hsinchu. His recent works depict women in various social contexts, with particular emphasis on the lives of foreigners and children. His film *Red* was selected for the Golden Harvest Awards, while *Invisible Children* was chosen by the Kaohsiung FF.

DIRECTOR, SCREENPLAY
劉純佑 LIU Chun-yu
EXECUTIVE PRODUCER
於蓓華 YU Pei-hua
李淑屏 LEE Shu-ping
PRODUCER
傅崑閔 Kumi FU
江烽榮 CHIANG Feng-jung
CINEMATOGRAPHER
簡強 CHIEN Chiang
EDITOR
林伶 Dumao LIN
MUSIC
王宗揚 WANG Tsung-yang
SOUND
吳侑庭 WU Yo-ting
CAST
高英軒 KAO Ying-hsuan
楊富江 Dương Phú Giang
劉馥緣 Sean LIU
何潔柔 HO Chieh-jou
PRINT SOURCE
財團法人公共電視文化事業基金會
Public Television Service Foundation

06.25 TUE 12:10 華山 SHC 2 ★

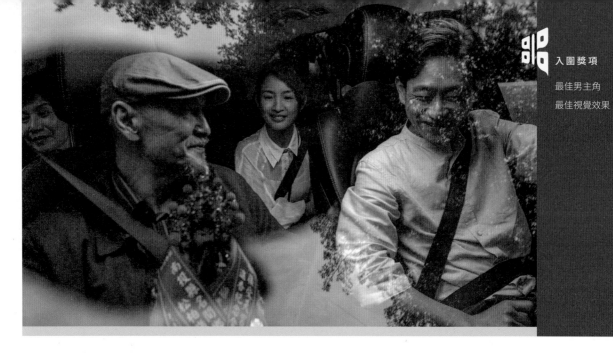

入圍獎項

最佳男主角
最佳視覺效果

車頂上的玄天上帝

Be With Me

台灣 Taiwan｜2023｜DCP｜Color｜130min

芙月是一個電影美術指導，為了返家照顧病重的父親，不得不中途離開電影劇組，放下正在改建的台北古宅，陪著家人回到家鄉嘉義。情愫曖昧的建築師與積極追求的富商聿先生先後闖入她的生活，電影劇組因為資金斷裂岌岌可危，病重的父親不願繼續住院⋯⋯。遭到家庭、事業、愛情三面夾攻的芙月，該如何找到心之所向？

Art director Faye has to leave amid a film shoot to care for her ailing father. With her father's condition worsening, Faye leaves her unfinished old house in Taipei behind and returns to her hometown of Chiayi with her family. Back in her hometown, memories of her long-departed grandfather resurface, along with his enduring faith and beliefs passed down through generations. Ultimately, Faye's life is reaffirmed through this journey.

黃文英，曾七度入圍金馬獎，以《海上花》、《刺客聶隱娘》分別榮獲最佳美術設計與造型設計，與亞洲電影大獎最佳美術設計。並受邀於馬丁・史柯西斯執導的史詩鉅作《沉默》擔任美術指導。2018年獲選為美國影藝學院會員。

HWARNG Wern-ying is a seven-time Golden Horse Award nominee, winning for Best Art Direction for *Flowers of Shanghai* and Best Makeup & Costume Design for *The Assassin*. She brought Taiwan's film aesthetic to the world stage as the supervising art director on Martin Scorsese's *Silence*.

▊ 2024 越南胡志明市影展 HIFF
▊ 2023 金馬影展 Taipei Golden Horse FF
▊ 2023 夏威夷國際影展 Hawaii IFF

DIRECTOR
黃文英 HWARNG Wern-ying
EXECUTIVE PRODUCER
侯孝賢 HOU Hsiao-hsien
PRODUCER
Charles E. MCCARRY
饒紫娟 Jennifer JAO
SCREENPLAY
楊貽茜 YANG Yi-chien
黃文英 HWARNG Wern-ying
陳曉雯 CHEN Hsiao-wen
CINEMATOGRAPHER
余靜萍 YU Jing-pin
EDITOR
廖慶松 LIAO Ching-song
陳曉東 CHEN Hsiao-dong
MUSIC
林強 LIM Giong
雷光夏 Summer LEI
楊琬茜 YANG Wan-chien
SOUND
杜篤之 TU Duu-chih
吳書瑤 WU Shu-yao
CAST
周渝民 Vic CHOU
林依晨 Ariel LIN
阮經天 Ethan JUAN
PRINT SOURCE
香港商甲上娛樂有限公司台灣分公司
Applause Entertainment Limited
Taiwan Branch (H.K.)

06.25 TUE 14:40 華山 SHC 2 ★

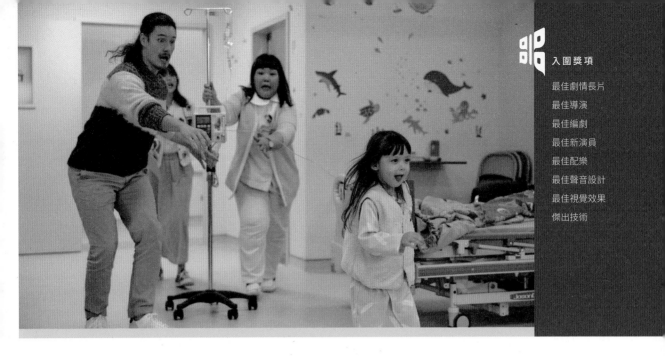

入圍獎項

最佳劇情長片

最佳導演

最佳編劇

最佳新演員

最佳配樂

最佳聲音設計

最佳視覺效果

傑出技術

BIG
BIG

台灣 Taiwan｜2023｜DCP｜Color｜159min

816病房的小孩身上都劃上了勇士的印記，這是跟病魔纏鬥的徽章。整日鬧哄哄的病房裡有在動物園長大的源源、老躲在自製機器人裡的是延、騎著車在醫院走廊冒險的羅恆、屁股長了球球只能穿裙子的努拉、厭世音樂少女珈農、情竇初開的中二少男大杉，以及老是吵架鬥嘴，到了緊要關頭卻又互相扶持的家長們。

這裡有耶穌vs地藏王、有輪椅尬車大會，有小孩說要喇舌一起睡？苦樂共享的816病房，把握每個當下，珍惜好好說再見的機會。到底是誰把門上的816塗改成BIG？BIG代表什麼？全員又是為了什麼祕密任務而逃離醫院呢？行動暗號「耶穌誕生」，是聖誕，是新生，更是重生。

Welcome to Ward 816, a place filled with incredible children. Each carries a badge symbolizing their strength in fighting various diseases. In this bustling ward, you'll meet: Yuan, who grew up in a zoo; Shi-yan, the clever inventor who hides inside a self-made robot; Luo Heng, the adventurous biker exploring the hospital hallways; Nuala, who wears skirts due to a lump on her bottom; Jia-nong, the music-loving melancholic girl; and Da-shan, experiencing the magic of first love. Despite their parents' occasional arguments, they always come together to support one another when it matters most.

魏德聖，1969年生，導演。2008年執導長片《海角七號》在台灣創下台灣影史票房第一名紀錄；2011年完成《賽德克‧巴萊》入圍威尼斯影展主競賽，亦獲得金馬獎最佳影片。其他電影包括監製作品《餘生－賽德克‧巴萊》以及《KANO》。

WEI Te-sheng's works include the highest-grossing domestic film in Taiwanese film history, *Cape No. 7*, and *Warriors of the Rainbow: Seediq Bale*, which competed at Venice FF and won Best Feature Film at the 48th Golden Horse Awards.

▌ 2024 北京電影節 Beijing IFF
▌ 2024 大阪亞洲電影節 Osaka Asian FF

DIRECTOR, SCREENPLAY
魏德聖 WEI Te-sheng
EXECUTIVE PRODUCER
徐國倫 HSU Kuo-lun
PRODUCER
劉旻泓 LIU Min-hung
CINEMATOGRAPHER
葉少青 YIP Siu-ching
EDITOR
蘇珮儀 Milk SU
MUSIC
何國杰 Ricky HO
SOUND
杜篤之 TU Duu-chih
吳書瑤 WU Shu-yao
CAST
馬志翔 Umin Boya
曾沛慈 Pets TSENG
曾珮瑜 Peggy TSENG
黃采儀 HUANG Tsai-yi
黃鐙輝 Brando HUANG
王夢麟 WANG Mon-lin
范逸臣 Van FAN
周厚安 Andrew CHAU
田中千繪 TANAKA Chie
鄭又菲 Fei-fei CHENG
PRINT SOURCE
米倉影業股份有限公司
Storyage Pictures Co., Ltd.

06.26 WED 11:00 華山 SHC 2 ★

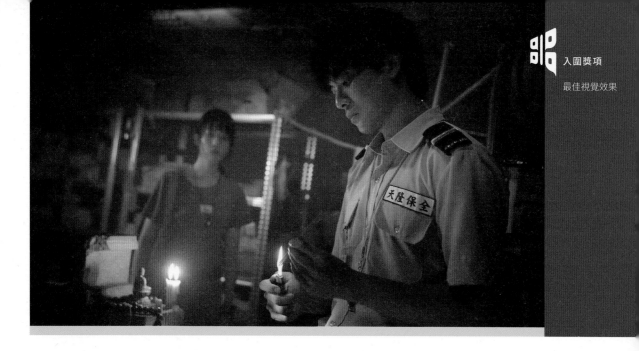

入圍獎項

最佳視覺效果

女鬼橋2：怨鬼樓
The Bridge Curse: Ritual

台灣 Taiwan｜2023｜DCP｜Color｜101min

傳說中，文華大學位於陰陽交界之地，當年設計師將建築物設計成鎮煞用的「逆八卦」陣形，命名為「大忍館」，希望能用此鎮煞陣形來困住孤魂野鬼以免傷人，沒想到大忍館因此陸續傳出眾多校園怪談：不只有人搭電梯卻誤闖陰間，還有人撞見在教室跳舞的女鬼，更有許多學生在晚上聽到幽幽的歌聲……。

就讀文華大學的連裕婷（王渝萱 飾），自從三年前哥哥（施柏宇 飾）在校內發生意外後，便昏迷不醒至今，裕婷一直想完成哥哥用畢生心血設計的AR遊戲。然而當她與同學們在進入最後實測階段時，眾人卻開始發生離奇詭譎的靈異事件，而裕婷也在無意間發現哥哥昏迷不醒的原因……。

Based on an urban legend of the most haunted university in Taiwan. Rumor has it that during construction of a school building, the architect disrupted the university's harmonizing feng shui and turned it into a beacon for supernatural entities. Years later, in an attempt to test their AR game on dark rituals that summon the dead, students unknowingly unleash evil spirits into the world.

奚岳隆，廣告導演出身，作品橫跨電視、電影。2020年首部執導電影《女鬼橋》創下票房佳績，秀出驚悚視覺饗宴，同時為當年度Netflix台灣電影點閱率冠軍；《女鬼橋2：怨鬼樓》將再次帶領觀眾體驗陰森恐怖的校園靈異傳說。

Lester HSI is a multifaceted creative force, traversing the realms of film, television drama, and advertising with finesse. *The Bridge Curse* marked his debut in the feature film landscape. In *The Bridge Curse: Ritual*, he once again beckons audiences into a realm of uncanny terror.

▌2023 西班牙錫切斯影展 Sitges Film Festival
▌2023 金馬獎 Golden Horse Awards

DIRECTOR
奚岳隆 Lester HSI
EXECUTIVE PRODUCER
郝柏翔 Alain HAO
莊啟祥 Shawn CHUANG
徐沛語 Amy HSU
李嘉元 LI Chia-yuan
張耿銘 Ken CHANG
瞿友寧 Arthur CHU
PRODUCER
葉紹威 Jeff YEH
SCREENPLAY
呂蒔媛 LU Shih-yuan
黃彥樵 HUANG Yen-chiao
郝柏翔 Alain HAO
CINEMATOGRAPHER
仉春霖 CHANG Chun-lin
EDITOR
蕭秉亞 HSIAO Ping-ya
MUSIC
王建威 WONG Kin Wai
SOUND
何湘鈴 HO Hsiang-ling
廖厚閔 LIAO Hou-min
CAST
林哲熹 JC LIN
王渝萱 WANG Yu-xuan
施柏宇 Patrick SHIH
胡釋安 Shawn HU
王品澔 Boris WANG
詹子萱 CHAN Tzu-hsuan
席惟倫 Riko XI
PRINT SOURCE
樂到家國際娛樂股份有限公司
LOTS HOME ENTERTAINMENT CO., LTD.

07.01 MON 12:30 華山 SHC 2 ★

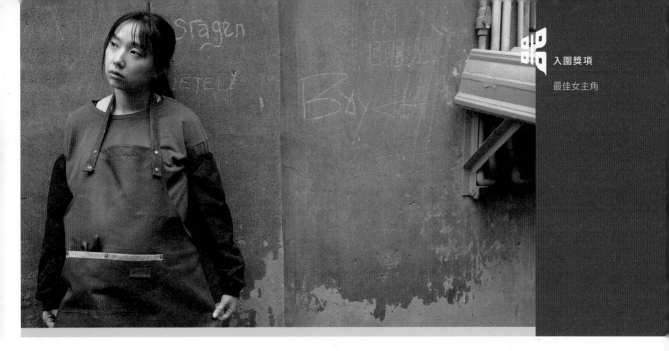

明日之子
Child of Tomorrow

台灣 Taiwan │ 2023 │ DCP │ Color │ 82min

阿菲，一位年輕的工廠作業員，未婚懷孕已經40週。老闆威脅若生完小孩無法立刻回來上班，就要她自動辭職。原本以為請人照顧小孩，阿菲就可以保住工作，偏偏那位無照保母收了錢卻不見蹤影，使阿菲懷疑遇到了詐騙。為了拿回錢，她只能拜託最恨的前男友、同時也是小孩的爸爸幫忙。萬萬沒想到，單純的找人，卻意外牽扯出一起虐童事件……。

Afie, a young factory worker, is unmarried and 40 weeks pregnant. Her boss says she must resign if she cannot return to work immediately after giving birth. Initially, Afie thought hiring someone to take care of the child would allow her to keep her job, but unfortunately, the unlicensed babysitter she hired disappeared after taking her money, leading Afie to suspect fraud. To recover her money, she has no choice but to reluctantly ask her ex-boyfriend, who is also the father of the child, for help. But she never expected this simple search would uncover a case of child abuse...

DIRECTOR, SCREENPLAY
蔡俊彬 TSAI Chun-pin
EXECUTIVE PRODUCER
於蓓華 YU Pei-hua
PRODUCER
林瓊芬 LIN Chiung-fen
李淑屏 LEE Shu-ping
CINEMATOGRAPHER
潘建明 PAN Chien-ming
EDITOR
楊仕丞 YANG Shih-chen
MUSIC
尊室安 TON That An
SOUND
余政憲 YU Chen-hsien
CAST
劉宸筆（五木）FiveWood
李雪 Angel LEE
王自強 WANG Zhi-chiang
楊小黎 YANG Shao-li
PRINT SOURCE
財團法人公共電視文化事業基金會
Public Television Service Foundation

蔡俊彬，臺灣藝術大學電影碩士，現職為導演、編劇。短片《運轉法則》榮獲西寧FIRST青年電影展最佳短片，並兩度入選金雞海峽兩岸暨港澳青年短片季。作品展現獨特的影像美學，富含神祕主義特質，擅長刻劃人物內涵與核心衝突。

TSAI Chun-pin, a director and screenwriter, is well-known for the short film *A Monk and His Mother*, which won Best Short Film at the FIRST IFF. His films embody mystic qualities and exhibit a distinctive visual aesthetic.

06.27 THU 15:50 華山 SHC 2 ▲ ★

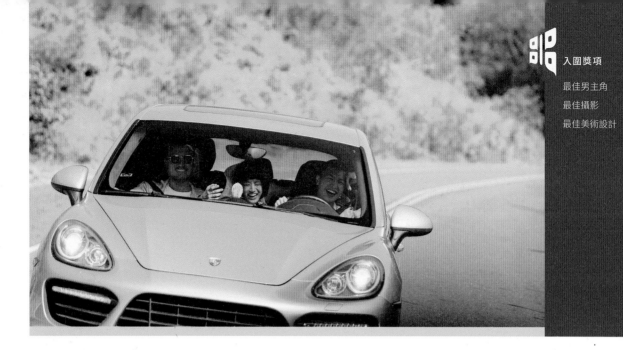

入圍獎項

最佳男主角
最佳攝影
最佳美術設計

（真）新的一天
Fish Memories

台灣 Taiwan｜2023｜DCP｜Color｜117min

一件幽靈包裹，串起老闆趙子傑和少年尚、少女真真彼此滲透的奇妙生活。富裕但貧瘠，貧窮但豐盈，這是半百人與青春仔的博弈遊戲。三人行的日子荒誕瘋狂，他愛她愛他，直到那聲槍響，關係變調，謎局揭曉。導演陳宏一再出奇作，打散章節仿擬金魚記憶，漫走黃暖與冷藍時空。李銘忠聯手新世代演員王碩瀚、虹茜一同撒野，怪誕乖張，追問失去之傷，還有愛與自由。

Two men from different generations with a 30-year age difference might be father and son, brothers, friends, lovers or enemies. They meet in parallel universes and get involved in each other's lives... Such absurd and debauched days change completely after a gunshot. The battle between the past and future might inevitably happen. Anything that can go wrong will go wrong.

陳宏一，臺灣大學哲學系畢業，廣告、MV、電影導演。首部劇情長片《花吃了那女孩》獲2008年金馬獎最佳造型設計，《消失打看》獲2011年台北電影獎最佳導演等四項大獎，並以《自畫像》、《揭大歡喜》先後入圍鹿特丹影展大銀幕競賽。

CHEN Hung-i's *Honey Pupu* won Best Director at the Taipei Film Awards 2011. His films *As We Like It* and *The Last Painting* competed in the Big Screen Competition at IFF Rotterdam.

▌2023 金馬獎最佳攝影 Best Cinematography, Golden Horse Awards

DIRECTOR
陳宏一 CHEN Hung-i
EXECUTIVE PRODUCER
陳宏一 CHEN Hung-i
姚經玉 Gene YAO
劉大武 Tawu LIU
黃共義 Joey HUANG
PRODUCER
姚聖洋 Albert YAO
陳宏一 CHEN Hung-i
王毓薇 WANG Yu-wei
SCREENPLAY
陳宏一 CHEN Hung-i
游善鈞 YOU Shann-jiun
陳育律 Hank CHEN Yu-lu
CINEMATOGRAPHER
余靜萍 YU Jing-pin
EDITOR
李明文 Maurice LI
陳宏一 CHEN Hung-i
MUSIC
魏賽門 Simon WHITEFIELD
SOUND
鍾彙成 CHUNG Hui-cheng
CAST
李銘忠 Frederick LEE
虹茜 Lavinia
王碩瀚 Hank WANG
邱志宇 Oscar CHIU
PRINT SOURCE
紅色製作有限公司 Red Society Films

06.24 MON 15:20 華山 SHC 2 ★

入圍獎項

最佳導演
最佳剪輯

愛是一把槍
Love Is a Gun

台灣、香港 Taiwan, Hong Kong｜2023｜DCP｜Color｜81min

小鎮青年蕃薯剛出獄，只想自力更生、安份踏實過日子，卻頭頭碰著黑，一邊在海灘做些不賺錢的工作，一邊聯絡舊同學或朋友，企圖為自己找份工作。不想走回頭路，但過去的人事物卻總如幽魂般纏繞著他：一直潛水的黑幫老大、負債累累的老媽，以及專門製造麻煩的老友等。人生像煙花，是燦爛耀眼抑或稍縱即逝？但無論如何機會都只得一次。

Ex-convict Sweet Potato has been desperately trying to go straight. However, his criminal past always finds its way to catch up to him — his old gang boss, whom he has never met, his mother, who thrusts all her debts upon him, and his buddy, who makes nothing but trouble. One after the other, they regain control over his present life, leaving him no hope for a new future.

DIRECTOR
李鴻其 LEE Hong-chi
EXECUTIVE PRODUCER
單佐龍 SHAN Zuolong
廖哲毅 LIAO Che-i
PRODUCER
齊艾 QI Ai
李瀟遠 LI Xiaoyuan
安鍵豪 Andy AN
SCREENPLAY
李鴻其 LEE Hong-chi
林政勳 LIN Cheng-hsu
CINEMATOGRAPHER
朱映蓉 ZHU Ying-rong
EDITOR
秦亞楠 QIN Yanan
MUSIC
蘇柏瑋 Bruce SU
SOUND
杜篤之 TU Duu-chih
CAST
李鴻其 LEE Hong-chi
林映唯 LIN Ying-wei
鄭青羽 CHENG Ching-yu
林可人 LIN Ke-ren
李宇曜 LEE Yu-yao
宋柏緯 Edison SONG
PRINT SOURCE
好威映象有限公司 Hooray Films, Ltd.

李鴻其，導演、演員。畢業於中國文化大學中國戲劇學系。2015年以《醉‧生夢死》獲金馬獎最佳新演員及台北電影獎最佳男主角。《愛是一把槍》為其自編自導自演之首部長片作品，獲威尼斯影展未來之獅獎。

A renowned actor, **LEE Hong-chi** directed his debut feature *Love Is a Gun* and won the prestigious Lion of the Future award at Venice FF.

▋ 2024 耶路撒冷影展 Jerusalem FF
▋ 2023 金馬獎 Golden Horse Awards
▋ 2023 威尼斯影展未來之獅獎 Lion of the Future, Venice FF

06.26 WED 18:10 華山 SHC 2 ★

入圍獎項

最佳導演
最佳編劇
最佳男配角
最佳新演員
最佳剪輯
最佳造型設計
最佳聲音設計

請問，還有哪裡需要加強
Miss Shampoo

台灣 Taiwan｜2023｜DCP｜Color｜120min

泰哥（春風 飾）在一次黑道火拼中身受重傷，躲進洗頭妹阿芬（宋芸樺 飾）的理髮廳，在阿芬的掩護下躲過一劫。為了報答阿芬，大難不死的泰哥交代所有幫派小弟獻出熱騰騰的腦袋，讓阿芬練習剪！剪！剪！

不打不相識，阿芬的心逐漸被魯小小的泰哥撬開，但火拼事件的幕後黑手卻也讓泰哥腹背受敵，他要如何在求愛與復仇間，展現男子漢的浪漫與尊嚴？

In a fierce gang battle, Tai gets seriously injured and seeks refuge in Fen's hair salon. With Fen's protection, Tai narrowly escapes danger. To show his gratitude, Tai orders all his gang members to offer their hair for Fen to practice cutting! Fen's heart gradually opens up to the persistent Tai. However, the mastermind behind the gang battle leaves Tai surrounded by enemies. How will he navigate between seeking love and revenge, while still maintaining the romanticism and dignity of a true man?

九把刀，本名柯景騰，1978年生。2000年起開始在網路上發表創作小說，內容題材多元，作品廣受年輕人喜愛而成為暢銷小說家，目前著有82本書。曾有數部小說作品被改編拍攝成電影，包括《那些年，我們一起追的女孩》及《月老》等。

Giddens KO was born in 1978. Since 2000, he has been publishing online novels with a variety of themes, making him popular among younger generations and establishing him as a best-seller author. He has made several film adaptations of his own novels, including *You Are the Apple of My Eye* and *Till We Meet Again*.

▌ 2023 金馬獎 Golden Horse Awards
▌ 2023 台北電影節 Taipei FF

DIRECTOR, SCREENPLAY
九把刀（柯景騰）Giddens KO
EXECUTIVE PRODUCER
盧維君 LU Wei-chun
九把刀（柯景騰）Giddens KO
PRODUCER
方曉茹 Molly FANG
CINEMATOGRAPHER
周宜賢 CHOU Yi-hsien
EDITOR
蘇珮儀 Milk SU
MUSIC
侯志堅 Chris HOU
SOUND
高偉晏 R.T KAO
鄭元凱 Kenny CHENG
CAST
洪瑜鴻（春風）Daniel HONG
宋芸樺 Vivian SUNG
柯震東 Kai KO
蔡昌憲 Emerson TSAI
應朗丰 YING Lang-feng
胡智強 HU Jhih-ciang
百白 Bai Bai
鍾欣凌 CHUNG Hsin-ling
PRINT SOURCE
麻吉砥加電影有限公司
MACHI XCELSIOR STUDIOS

06.24 MON 12:10 華山 SHC 2 ★

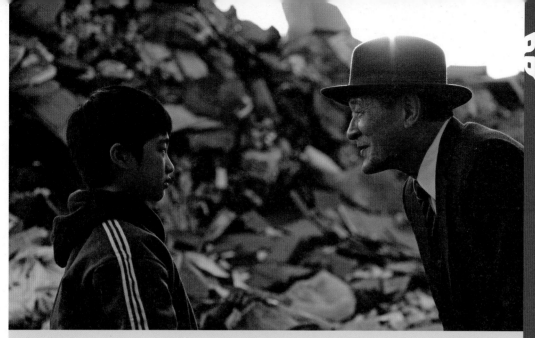

老狐狸
OLD FOX

台灣 Taiwan | 2023 | DCP | Color | 112min

1989年，11歲廖界與父親廖泰來慢慢存錢，以為再三年就可以買房子，但他們沒有注意到世界正在改變。房價漲了，一瞬間他們的錢變得不夠，挫敗的廖界體會到貧窮的現實。相對於父親，人稱老狐狸的房東是勝利組，似乎更能給他人生的指引。老狐狸教廖界許多社會法則，那些都是父親沒教他的。廖界在老狐狸身上學的，反過來讓他傷害了老狐狸。但另一面，他又如同自己的父親，有同理別人的特質，這個特質，使他終究沒有成為另一個老狐狸。

1989. Eleven-year-old Liao Jie and his father have been saving money, hoping to buy a home of their own in three years. However, they fail to notice that the world is rapidly changing. Property prices sky-rocket, and in the blink of an eye, their savings are not enough. Liao Jie comes to realize the harsh reality of being poor. In contrast to his father, their landlord "Old Fox" emerges as a seemingly better mentor to Liao Jie. Old Fox teaches Liao Jie how to survive in society, and that is something his father has never taught him.

蕭雅全，1967年出生，台灣中生代電影導演、編劇。擅長捕捉細膩情感，作品具有濃厚的文學性。

HSIAO Ya-chuan was born in Taipei in 1967. As a Taiwanese middle-generation director and screenwriter, he is an expert at portraying characters' subtle emotions, and his works often have a literary feel to them.

▌ 2023 金馬獎最佳導演、男配角、造型設計、原創電影音樂 Best Director, Best Supporting Actor, Best Makeup & Costume Design, Best Original Film Score, Golden Horse Awards
▌ 2023 東京影展 Tokyo IFF

DIRECTOR
蕭雅全 HSIAO Ya-chuan
EXECUTIVE PRODUCER
侯孝賢 HOU Hsiao-hsien
小坂史子 OSAKA Fumiko
林逸心 Elisa Y.H. LIN
PRODUCER
王雲明 Michael WANG
黃詩珊 Susan HUANG
SCREENPLAY
蕭雅全 HSIAO Ya-chuan
詹毅文 CHAN I-wen
CINEMATOGRAPHER
林哲強 LIN Tse-chung
EDITOR
陶竺君 TAO Chu-chun
MUSIC
侯志堅 Chris HOU
SOUND
杜篤之 TU Duu-chih
江宜真 CHIANG Yi-chen
CAST
白潤音 BAI Run-yin
劉冠廷 LIU Kuan-ting
陳慕義 Akio CHEN
劉奕兒 Eugenie LIU
游珈瑄 YU Chia-hsuan
PRINT SOURCE
合影視有限合夥
Tomorrow Together Capital

06.29 SAT 16:10 華山 SHC 2 ★

入圍獎項

最佳劇情長片
最佳導演
最佳編劇
最佳男主角
最佳男配角
最佳女配角
最佳攝影
最佳配樂
最佳美術設計
最佳造型設計
最佳聲音設計
最佳視覺效果
傑出技術

周處除三害
The Pig, The Snake and The Pigeon

台灣 Taiwan｜2023｜DCP｜Color｜134min

通緝犯陳桂林在角頭大哥告別式上公然尋仇，在眾目睽睽之中完成了轟動全台的華麗演出後，卻從此消聲匿跡。四年後，陳桂林被黑道地下醫師張貴卿告知已肺癌末期，頂多只剩半年性命，陳桂林徹夜無眠，決定去自首，不料卻在警察局的通緝公告上發現他只不過是全台灣排行第三的通緝犯。他心想橫豎只有半年命，消滅這兩個大賊也算為世界做好事，為自己積陰德。他要成為全台灣第一通緝犯，要全世界的人都知道他叫陳桂林！在一一去除兩位他視為眼中釘的頭號勁敵後，陳桂林以為自己已成為當代的周處除三害，得意地享受眾人敬畏的目光，卻沒想到永遠參不透的貪嗔癡，才是人生終要面對的罪與罰。

When fugitive Chen Kui-lin discovers that he has only six months left to live and is only Taiwan's third-most-wanted criminal, he decides to track down the top two criminals and eliminate them both so that his name will forever live in infamy.

黃精甫，香港導演。2004年作品《江湖》奪得香港金像獎最佳新晉導演；2010年編導作品《復仇者之死》獲莫斯科影展競賽單元最佳導演獎，為該獎項首位華人得獎者。

WONG Ching Po is a Hong Kong filmmaker. His first commercial film, *Jiang Hu* (2004), won Best New Director at the Hong Kong Film Awards; *Revenge: A Love Story* (2010) won Best Director at the Moscow IFF.

▌2024 香港電影金像獎最佳亞洲華語電影 Best Asian Chinese Language Film, Hong Kong Film Awards
▌2023 金馬獎最佳動作設計 Best Action Choreography, Golden Horse Awards

DIRECTOR, SCREENPLAY, EDITOR
黃精甫 WONG Ching Po
EXECUTIVE PRODUCER
李烈 LEE Lieh
黃江豐 Roger HUANG
PRODUCER
呂彥萩 LU Yen-chiu
CINEMATOGRAPHER
王金城 Jimmy WONG
MUSIC
盧律銘 LU Luming
林孝親 LIN Hsiao-chin
林思妤 LIN Szu-yu
保卜・巴督路 Baobu Badulu
SOUND
簡豐書 Book CHIEN
陳家俐 CHEN Jia-li
楊家慎 YANG Jia-shen
湯湘竹 TANG Hsiang-chu
CAST
阮經天 Ethan JUAN
陳以文 CHEN Yi-wen
袁富華 Ben YUEN
李李仁 LEE Lee-zen
王淨 Gingle WANG
謝瓊煖 XIE Qiong-xuan
PRINT SOURCE
一種態度電影股份有限公司
An Attitude Production Co., Ltd.

06.28 FRI 17:50 華山 SHC 2 ▲ ★

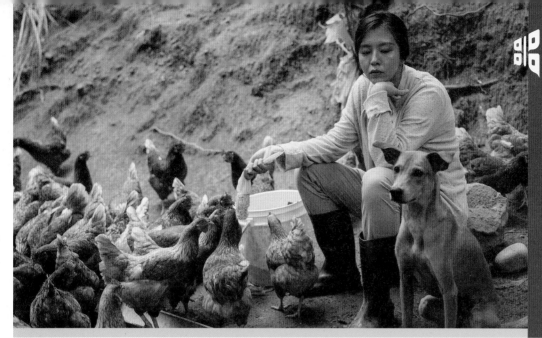

莎莉
Salli

台灣 Taiwan｜2023｜DCP｜Color｜105min

超過適婚年齡的女主角林惠君在台中山裡養雞、種玉米，過著簡單愜意的日子，身邊有總擔心自己嫁不出去的姑姑、從上海回來且正值叛逆期的姪女林心茹，還有整天和未婚妻你濃我濃的弟弟林偉宏，看著兩人的甜膩模樣，也讓她心生想談戀愛的念頭。內心渴望愛情卻又怯於表達的她，只能透過交友軟體化名「莎莉」與法國男子馬丁談情說愛，此舉一出不僅弟弟唱酸，全村的人還都說她被騙了，她決定義無反顧飛到巴黎，展開一場屬於自己的追愛之旅！

An online romance with a foreigner takes a lonely middle-aged chicken farmer to an unknown land. Despite everyone saying it is a romance scam, she wants to prove that her love indeed exists.

DIRECTOR, EDITOR
練建宏 LIEN Chien-hung
EXECUTIVE PRODUCER
曾曼盈 Amanda Manyin REINERT
王威人 Uilin ONG
PRODUCER
林香伶 LIN Shiang-ling
SCREENPLAY
練建宏 LIEN Chien-hung
劉梓潔 Essay LIU
CINEMATOGRAPHER
廖敬堯 LIAO Ching-yao
MUSIC
李英宏 LEE Ying-hung
SOUND
杜則剛 TU Tse-kang
杜篤之 TU Duu-chih
CAST
劉品言 Esther LIU
林柏宏 Austin LIN
李英宏 LEE Ying-hung
楊麗音 YANG Li-yin
湯詠絮 TANG Yung-hsu
PRINT SOURCE
前景娛樂有限公司
Flash Forward Entertainment Co., Ltd.

練建宏，編劇與導演。曾入選柏林影展新銳營。《莎莉》是其首部電影劇情長片。

LIEN Chien-hung is a filmmaker and screenwriter based in Taipei. He took part in Berlinale Talents in 2019. *Salli* is his debut feature film.

▌ 2024 哥德堡影展 Göteborg FF
▌ 2023 金馬影展 Taipei Golden Horse FF
▌ 2023 釜山影展 Busan IFF

07.02 TUE 12:20 華山 SHC 2 ★

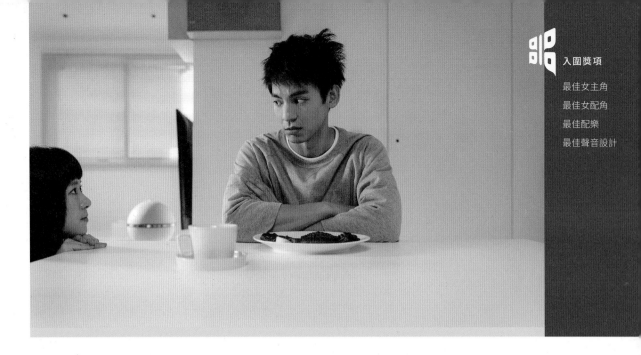

入圍獎項

最佳女主角
最佳女配角
最佳配樂
最佳聲音設計

愛的噩夢
Suffocating Love

台灣 Taiwan │ 2024 │ DCP │ Color │ 102min

男子愛上了一個控制狂，熱戀期他都甘心付出，直到另一個女生出現，他才知道原來愛情可以這麼自由。男子在夢中許了一個「換女朋友」的願望，而願望居然成真了！這是幸福的開始？還是恐怖的到來？

A man falls in love with a control freak. He is willing to obey and give what he can during the infatuation phase, until another girl appears and he realizes that love can be so fickle. In a dream, he wishes to "change his girlfriend," and the wish comes true in real life! Is this the beginning of happiness? Or the arrival of terror?

DIRECTOR, SCREENPLAY, CINEMATOGRAPHER, EDITOR
廖明毅 LIAO Ming-yi
EXECUTIVE PRODUCER
丁長鈺 Olive TING
林秉聿 Benjamin LIN
PRODUCER
閻俊瑋 YEN Chun-wei
MUSIC
許家維 HSU Chia-wei
SOUND
劉小草 Agnes LIU
曾雅寧 Ning TSENG
CAST
林柏宏 Austin LIN
謝欣穎 Nikki HSIEH
項婕如 Chloe XIANG
吳志慶 McFly WU
黃宣 HUANG Hsuan
林艾璇 Josie LIN
PRINT SOURCE
良人行影業有限公司
Third Man Entertainment Co., Ltd.

廖明毅，曾參與製作《六弄咖啡館》、《阿嬤的夢中情人》、《那些年，我們一起追的女孩》等片。2019 年以 iPhone 攝製短片《停車》，榮獲 FiLMiCFest 影展世界首獎；2020 年長片《怪胎》創台灣票房佳績，於世界重要影展獲多項殊榮。

LIAO Ming-yi's 2019 short film *Parking*, shot on an iPhone, won the Grand Prize at FiLMiCFest. His 2020 feature film *I WeirDO* was a box office success in Taiwan and received numerous awards at major international film festivals.

06.26 WED 19:00 中山堂 TZH ★

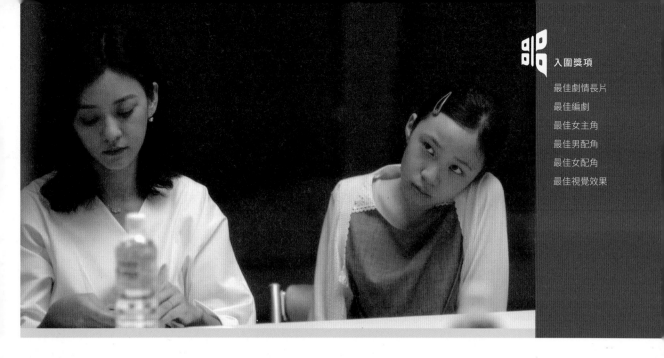

入圍獎項

最佳劇情長片
最佳編劇
最佳女主角
最佳男配角
最佳女配角
最佳視覺效果

小曉
Trouble Girl

台灣 Taiwan ｜ 2023 ｜ DCP ｜ Color ｜ 103min

小曉（林品彤 飾）是一位活在自己世界的女孩，因為一個令人揪心的祕密，她在學校被同學霸凌孤立，媽媽薇芳（陳意涵 飾）也視她為麻煩，在國外長期工作的爸爸更像既熟悉又遙遠的陌生人，唯有班導保羅（劉俊謙 飾）彷彿能理解並舒緩她的情緒。一次颱風天下課，小曉目睹了媽媽與班導的祕密，困惑的她不僅必須強迫自己適應這個複雜的情感關係，也逐漸發現原來她與媽媽都有各自對生活說不出的無奈……。

Xiao Xiao is a girl who lives in her own world. She is isolated and bullied by her classmates at school. Even her own mother sees her as a troublemaker. Her father, who has worked abroad for a long time, is like a familiar yet distant stranger. Only her teacher, Paul, seems to understand her. One day, during a typhoon, Xiao Xiao witnesses a secret between her mother and Paul. Confused, she must force herself to adapt to this complicated emotional relationship, but she also gradually discovers that both she and her mother have unspeakable frustrations towards life.

DIRECTOR, SCREENPLAY
靳家驊 CHIN Chia-hua
EXECUTIVE PRODUCER
葉如芬 YEH Ju-feng
王小茵 Eva WANG
PRODUCER
姜乃云 CHIANG Nai-yun
王雲明 Michael WANG
CINEMATOGRAPHER
陳麒文 CHEN Chi-wen
EDITOR
靳家驊 CHIN Chia-hua
賴秀雄 LAI Hsiu-hsiung
MUSIC
福多瑪 Thomas FOGUENNE
SOUND
胡序嵩 Sidney HU
李俊逸 LI Chun-yi
CAST
林品彤 Audrey LIN
劉俊謙 Terrance LAU Chun Him
陳意涵 CHEN Yi-han
朱語晴 Una CHU
PRINT SOURCE
寓言工作室
GEPPETTO FILM STUDIO

靳家驊，短片《大吉》屢獲金鐘獎、金穗獎、高雄電影節、紐約電視電影獎等肯定，並入圍克萊蒙費宏影展國際競賽。首部長片《小曉》入圍金馬獎七項大獎，並獲最佳女主角。新作《市場裡的女鬼》入選香港亞洲電影投資會，並獲台北市電影委員會大獎。

CHIN Chia-hua's short *Lucky Draw* was selected to Clermont-Ferrand. His first feature film, *Trouble Girl*, earned seven Golden Horse Award nominations, winning for Best Leading Actress. His project *A Ghost in the Market* was selected to HAF IDP and won the Taipei Film Commission Award.

▌ 2024 大阪亞洲電影節 Osaka Asian FF
▌ 2024 亞洲電影大獎 Asian Film Awards
▌ 2023 金馬獎最佳女主角獎 Best Leading Actress, Golden Horse Awards

06.30 SUN 15:20 華山 SHC 2 ★

雪水消融的季節
After the Snowmelt

台灣、日本 Taiwan, Japan ｜ 2024 ｜ DCP ｜ Color ｜ 110min

《雪水消融的季節》講述了年輕人初次面對摯友離世的傷痛經驗。在成年前夕，我的摯友宸君和聖岳去尼泊爾健行，並與我相約在途中會合。但這份約定卻淪為缺憾：他們因大雪而受困在岩洞裡，當聖岳在受困第47天獲救時，宸君已於三天前離世。倖存的聖岳帶回宸君給我的信，並告訴我他們的約定：活下來的人要說出這個故事。我於是拿起相機、跟隨聖岳走入山中，以此面對宸君的遺願。但聖岳逐漸對山難避而不談，促使我獨自來到尼泊爾，履行當初與宸君相約會合的承諾。漸漸地，我的旅程與宸君的旅途重疊在一起，並通往同一個目的地：山難岩洞。

在雪融的季節，有些事物重見天日，有些事物則隨之消逝。當我追索宸君的腳步來到洞口時，等待我的會是什麼？

After the Snowmelt is a coming-of-age tale about profound loss. Filmmaker Yi-shan's best friends in high school, Chun and Yueh, were trapped in a Nepalese cave for 47 days. Chun died three days before Yueh's rescue, leaving behind a last wish: "The survivor must share their story." To honor this wish, Yi-shan takes up the camera, accompanies Yueh to the mountains, and retraces Chun's footsteps. Her journey gradually overlaps with Chun's, blurring the past and present, and finally converges at the same destination. When she reaches the cave, what awaits her there?

DIRECTOR
羅苡珊 LO Yi-shan
PRODUCER
羅苡珊 LO Yi-shan
陳詠雙 CHEN Yung-shuang
卓紫嵐 CHO Tze-lan
CINEMATOGRAPHER
羅苡珊 LO Yi-shan
蔡維隆 TSAI Wei-long
EDITOR
林婉玉 Jessica LIN Wan-yu
MUSIC, SOUND
澎葉生 Yannick DAUBY
PRINT SOURCE
羅苡珊 LO Yi-shan

羅苡珊，臺灣大學歷史學系畢，現為紀錄片與文字工作者，關注性別與身體、自然與社會的交互關係。首部紀錄長片《雪水消融的季節》獲多個國際創投獎項，並入圍2024年瑞士真實影展炫光競賽單元、韓國全州影展國際競賽單元。

LO Yi-shan is a Taiwanese filmmaker whose fascination with human and non-human relationships in subtropical mountains led her to start making films. Her documentary debut, *After the Snowmelt*, will had its world premiere at Visions du Réel's Burning Lights Competition and its Asian premiere at Jeonju IFF.

▌2024 全州影展 Jeonju IFF
▌2024 瑞士真實影展 Visions du Réel

06.22 SAT 18:20 信義 HYC 11 ★

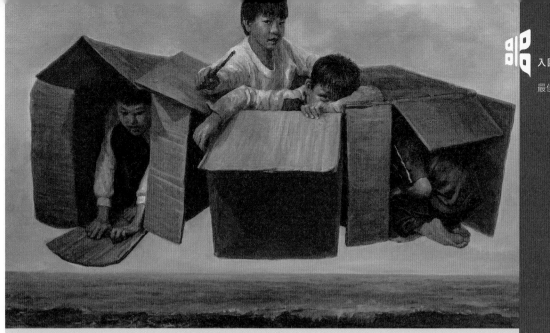

孩子們
Child Portrait

台灣 Taiwan | 2024 | DCP | Color | 61min

《孩子們》的「們」是種多面的鏡子,從多角度的方式進入生命,反映出自我與他者的各種關係,不同情緒之間的課題。繪畫不單是薄薄一層的技法呈現,而是一種深度理解與被接納的藝術。畫作拋出的問題,我帶著攝影機走進畫中的世界,與創作者跨越時空去尋覓答案。

Child Portrait is a mirror that presents life from multiple perspectives, reflecting the various relationships between the self and others, and the issues that come with different emotions. Painting is not simply a thin-layered medium presenting one's skills, but an art of deep understanding and acceptance. The painting throws out questions, and I walk into the world of the painting with my camera to find answers with the painter across time and space.

DIRECTOR
陸孝文 LU Hsiao-wen
EXECUTIVE PRODUCER
李佩禪 Emma LEE
PRINT SOURCE
陸孝文 LU Hsiao-wen

陸孝文,於新竹美學館、影像博物館、紀錄桃園擔任紀錄片製作講師。作品有《甘吱拉》、《農地重金屬樂章》、《澎湖的法國麵包》等。

LU Hsiao-wen is a lecturer in documentary film production at the National Hsinchu Living Arts Center, Image Museum of Hsinchu City, and Action Taoyuan. His publicly screened works include *Gumjlla*, *Farmland Heavy Metal*, and *French Bread in Penghu*.

06.30 SUN 19:00 華山 SHC 1 ▲ ★

診所
The Clinic

台灣 Taiwan｜2023｜DCP｜Color｜86min

一間位於緬甸仰光的診所，往來的都是失眠或有幻聽幻覺的精神病人，還有一些病人需要戒酒。診所的兩位醫生是一對藝術家夫妻，他們不只用藥物讓病人鎮定，他們也用藝術讓病人抒發自己的臆想和瘋狂。這個國家是一間巨大的精神診所，每個人都有著不同程度的心理疾病。男醫生想拍一部反映這個現狀的電影，但遲遲不敢下手；女醫師治療著精神病人的同時，自己也需要被治癒。

這是一部劇情與紀錄交錯的電影。電影中的電影、紀錄中的紀錄。它的戲劇來自於它的真實，而它的真實裡則充滿了戲劇。

In a clinic in Yangon, most of the patients have mental disorders, including insomnia and auditory hallucination. Furthermore, some have drinking problems and must quit alcohol. The two doctors who run the clinic are a couple who are also artists. They not only use medicine to calm their patients down but also teach them painting, allowing the patients to vent their hallucinations and madness through artistic creation.

The Clinic is a mixture of documentary and narrative. There is a film within the film and a documentary within the documentary. The drama stems from reality, and reality is packed with drama.

趙德胤，曾經製作四部紀錄片，包括《挖玉石的人》、《翡翠之城》以及《十四顆蘋果》；第一部在鹿特丹影展，二、三部則在柏林影展世界首映。《翡翠之城》獲金馬獎最佳紀錄提名，並在山形紀錄片影展榮獲特別提及。《診所》為其最新紀錄片。

Midi Z has made four documentaries to date, including *Jade Miners*, *City of Jade*, and *14 Apples*. *City of Jade* was nominated for Best Documentary at the 2016 Golden Horse Awards and won a Special Mention at Yamagata 2017. *The Clinic* was nominated for Best Documentary Feature at the 2023 Golden Horse Awards.

▍2024 台灣國際紀錄片影展再見真實獎首獎 TIDF Visionary Award - Grand Prize, TIDF
▍2023 阿姆斯特丹紀錄片影展 IDFA
▍2023 金馬獎 Golden Horse Awards

DIRECTOR
趙德胤 Midi Z
EXECUTIVE PRODUCER
趙德胤 Midi Z
蕭丁毓 Tim HSIAO
PRODUCER
王興洪 WANG Shin-hong
林聖文 LIN Sheng-wen
翁明 AUNG Min
珊珊烏 San San OO
何美瑜 Isabella HO
蘇啟禎 Tony SU
CINEMATOGRAPHER
潘駿春 Peter PAN
EDITOR
趙德胤 Midi Z
吳可熙 WU Ke-xi
MUSIC
林強 LIM Giong
SOUND
周震 CHOU Cheng
黃在恩 HUANG Tsai-en
林延融 LIN Yan-rong
PRINT SOURCE
岸上影像有限公司
Seashore Image Productions

07.01 MON 17:40 華山 SHC 1 ★

由島至島
From Island to Island

台灣 Taiwan | 2024 | DCP | Color | 290min

台灣在二戰期間是日本帝國的一部分，此片是首次嘗試處理這一主題的紀錄片，努力挖掘和重新整理台灣在二戰期間的隱藏記憶。影片探索在日本帝國內的台灣士兵和醫生的經歷，以及生活在東南亞的海外台灣人。

影片以兒子對父親的提問開場，透過跨世代的記憶對話、家書、日記和家庭成員之間的影片，探討台灣歷史記憶的複雜性及這一時期存在的各種身分。

Taiwan was part of the Japanese Empire during World War II. This documentary, tackling this subject for the first time, endeavors to unearth and reorganize the hidden memories of World War II in Taiwan. It explores the experiences of Taiwanese soldiers and doctors within the Japanese Empire, as well as overseas Taiwanese living in Southeast Asia.

The film begins with a son's question to his father. Through cross-generational memory dialogues, family letters, diaries, and videos among family members, the film addresses the complexities of Taiwan's historical memory and the various identities that existed during this period.

DIRECTOR, EDITOR
廖克發 LAU Kek Huat
PRODUCER
林婉玉 Jessica LIN Wan-yu
CINEMATOGRAPHER
廖克發 LAU Kek Huat
蔡維隆 TSAI Wei-long
MUSIC
澎葉生 Yannick DAUBY
SOUND
黃年永 HUANG Nien-yung
陳奕伶 CHEN Yi-ling
PRINT SOURCE
蜂鳥影像有限公司
Hummingbird Production Co., Ltd.

廖克發，馬來西亞出生的台灣導演。劇情片《菠蘿蜜》入選釜山影展新潮流競賽，並獲金馬獎最佳新導演提名；短片《妮雅的門》獲釜山影展超廣角單元最佳亞洲短片。紀錄片作品包括《不即不離》、《還有一些樹》、《野番茄》等。

LAU Kek Huat is a Malaysian-born filmmaker based in Taiwan. His film *Boluomi* earned him a Golden Horse Awards nomination for Best New Director; *Nia's Door* won Best Short Film at Busan. Documentaries include *Taste of Wild Tomatoes*, *Absent Without Leave*, and *The Tree Remembers*.

▌2024 台灣國際紀錄片影展 TIDF

06.24 MON 14:00 華山 SHC 1 ★

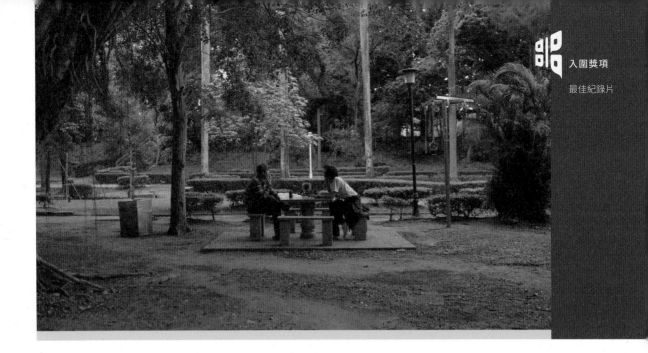

公園
Taman-taman (Park)

台灣 Taiwan｜2024｜DCP｜Color｜101min

兩位印尼詩人相約在夜裡的台南公園，將各自於這座公園的白日，與印尼同胞們的相遇、相處，其所見所聞所感，譜成詩歌，發想成計畫，於夜裡吟唱、想像、行動……。於白日採集，在夜裡釋放，像一則古老的影像寓言，但我們終究見不到他們所說的白日種種，只能任夜裡的話語投射出面貌不一的形象。天光被推遲，漫漫長夜有訴不盡的故事，再不脫身，說故事的人也變成了故事的一部分。

Two Indonesian poets rendezvous in Tainan Park at night, crafting poetry inspired by their daytime experiences with fellow Indonesians. Their verses, a blend of chanting, imagination, and action, create a nocturnal journey reminiscent of an ancient fable. The daylight remains unseen, leaving only diverse images projected through their nighttime words. As daylight fades, the prolonged night becomes a canvas for countless untold stories, with the storytellers merging into the tales they weave.

DIRECTOR, EDITOR
蘇育賢 SO Yo-hen
EXECUTIVE PRODUCER
蕭丁毓 Tim HSIAO
PRODUCER
蘇啟禎 Tony SU
CINEMATOGRAPHER
蘇育賢 SO Yo-hen
田倧源 TIEN Zong-yuan
SOUND
Nigel BROWN
PRINT SOURCE
你哥影視社有限公司
Your Bros. Filmmaking Group CO.

蘇育賢，藝術愛好者，曾就讀臺南藝術大學造形藝術研究所，現為你哥影視社成員。創作無特定媒材，不去想自己在幹嘛。

SO Yo-hen, an art enthusiast, attended the Graduate Institute of Arts at Tainan National University of the Arts and is currently a member of Your Bros. Filmmaking Group CO. His creative work spans various mediums, and he approaches it without preconceived notions about what he's doing.

▌2024 台灣國際紀錄片影展亞洲視野競賽首獎、台灣競賽首獎、再見真實獎評審團特別獎
Grand Prize, Asian Vision Competition, Grand Prize, Taiwan Competition, TIDF Visionary Award - Special Jury Prize, TIDF

06.29 SAT 18:50 華山 SHC 1 ★

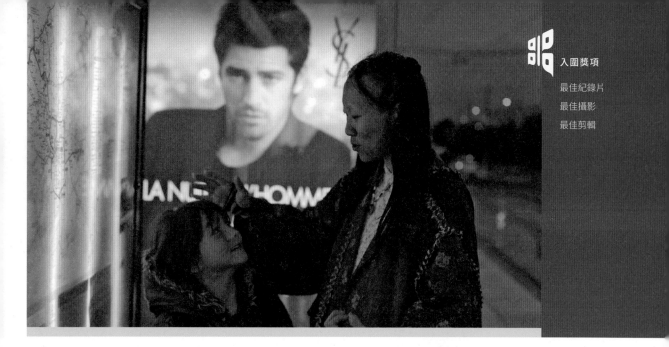

XiXi
XiXi

亞洲首映
Asian Premiere

台灣、南韓、菲律賓 Taiwan, South Korea, Philippines │ 2024 │ DCP │ Color, B&W │ 100min

對自由的渴望，使羞澀溫吞的台灣導演和狂野自在的中國藝術家XiXi在柏林街頭一見如故。透過她們多年的友誼，《XiXi》記錄她們在藝術創作、自我認同、角色身分轉換的過程中，努力找回自由的可能。這是一段跨越世代、超越意識形態的療傷經驗。

A friendship between two women that originated from their search for freedom leads to a transgenerational healing journey of resilience and self-reinvention.

DIRECTOR
吳璠 WU Fan
PRODUCER
吳璠 WU Fan
Venice DE CASTRO ATIENZA
Sona JO
Yoonsoo HER
CINEMATOGRAPHER
XiXi
吳璠 WU Fan
Venice DE CASTRO ATIENZA
EDITOR
Anna Magdalena SILVA SCHLENKER
MUSIC
葛雷琴 Gretchen JUDE
SOUND
高銀河 KO Eun-ha
PRINT SOURCE
宇宙子媒體藝術有限公司
Svemirko Audiovisual Art Productions

吳璠，台灣導演、製片，歐盟DocNomads紀錄片導演碩士。她的製片及導演作品包含《海邊最後的夏天》（2021年柏林影展新世代單元）、《XiXi》（加拿大Hot Docs紀錄片影展）等。曾獲釜山亞洲電影基金（ACF）、日舞紀錄片製作基金等國際補助。

Taiwanese filmmaker **WU Fan** is an alumna of Rotterdam Lab, IDFAcademy, and European MFA program DocNomads. She co-produced *Last Days at Sea* (Berlinale 2021), and directed *XiXi* (Hot Docs 2024). She was awarded the Asian Network of Documentary (AND) Fund and Sundance Institute - Documentary Fund.

▉ 2024 加拿大紀錄片影展最佳國際新銳導演獎 Emerging International Filmmaker Award, Hot Docs

06.25 TUE 18:30 信義 HYC 11 ★ │ 07.01 MON 12:00 華山 SHC 1 ★

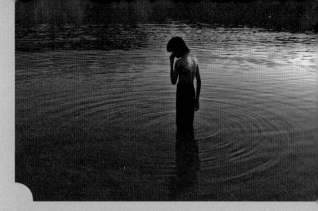

新年舊日
A Year Apart

中國 China｜2023｜DCP｜Color, B&W｜17min

王慧琳習慣每天對著一尊關公像傾訴日常種種，栽培已久的葡萄藤卻因肥施多了日漸枯萎。隨著丈夫逝世後的第一個生日即將到來，生活也正悄悄地發生轉變。

Huilin confides in a Guan Gong statue daily, sharing life's ups and downs. However, over-fertilization leads to the withering of her cherished grapevine. With her husband's recent passing, his approaching birthday, and subtle life changes, she stands at a pivotal moment.

▌ 2023 基輔影展 Molodist Kyiv IFF
▌ 2023 賈家莊短片週最佳影片
　　 Best Film, Jia Village Short Film Week

DIRECTOR, SCREENPLAY, CINEMATOGRAPHER, EDITOR
秦海 Ocean CHIN
PRODUCER
廖勇 LIAO Yong
王天霸 Yasmin WANG
SOUND
孫軼 SUN Yi
CAST
王慧琳 WANG Huilin
PRINT SOURCE
水母人文化傳媒有限公司
ShuiMuRen Media Co., Ltd.

秦海，高雄人。畢業於捷克FAMU，2018年金馬電影學院學員，以攝影師身分參與多部長、短片。《新年舊日》為首部導演作品，榮獲2023年86358賈家莊短片週最佳影片殊榮、基輔影展最佳短片提名。

Ocean CHIN graduated from FAMU in 2018. He was selected for the 10th Golden Horse Film Academy, and has worked as a DP on many feature and short films.

入圍獎項
最佳短片

河童
And I Talk Like A River

中國 China｜2023｜DCP｜Color｜12min

一個青春期男孩心中隱祕的回憶：關於湖邊人人厭棄的怪人、亦真亦幻的河童傳說，好奇、躁動與不安交織繁衍……直至發現每個人心中暗藏的那頭野獸。

A hidden memory in the heart of a teenage boy: a strange, despised person by the lake, the elusive legend of the kappa, curiosity, restlessness, and anxiety intertwined and proliferated... until the wild beast lurking in everyone's heart is found.

▌ 2024 奧柏豪森短片影展 ISFF Oberhausen
▌ 2023 西寧 FIRST 青年電影展 FIRST IFF

DIRECTOR, SCREENPLAY
錢檸 QIAN Ning
EXECUTIVE PRODUCER
高一天 GAO Yitian
PRODUCER
朱文慧 ZHU Wenhui
CINEMATOGRAPHER
李超塵 LI Chaochen
EDITOR
聶光昕 NIE Guangxin
SOUND
劉孟岳 LIU Mengyue
CAST
鄭昊森 ZHENG Haosen
居·丹增尼瑪 DanZeng NiMa
PRINT SOURCE
並馳（上海）影業有限公司
BingChi (Shanghai) Pictures Co., Ltd.

錢檸，曾就讀臺灣藝術大學，2020年金馬電影學院學員。短片《第七天》獲波蘭EnergaCAMERIMAGE影展金蝌蚪獎。試圖在展現背離常識的事物的同時，突出世界的某種真實。

QIAN Ning is an alumnus of the 2020 Golden Horse Film Academy. His short film Creation, Or the Quarantine Hotel won the Golden Tadpole at the EnergaCAMERIMAGE Film Festival.

入圍獎項
最佳短片

06.23 SUN 16:00 信義 HYC 11 ▲ ★ ｜06.26 WED 21:30 信義 HYC 11 ▲ ★

回收場的夏天
Reclaim My Summer

台灣 Taiwan｜2023｜DCP｜Color｜29min

17歲的小萱正值叛逆年紀，卻因家裡經營回收場，只能坐困場內整理資源回收物、照顧小妹。眼看媽媽對拾荒者總是多一分貼心，為何她想打扮、買新東西，卻樣樣不行。心裡的積怨越埋越深，小萱拿著媽媽交派的錢，決定與朋友出去玩，母女間的爭吵一觸即發。

Everyone and everything deserves a second chance. Seventeen-year-old Xuan grew up in a recycling yard. The only opportunity she gets to hang out with her friends is when she goes out collecting recyclables from neighbors...

▌2024 金穗獎最佳劇情片、演員
　Best Narrative Short Film, Best Performer, Golden Harvest Awards
▌2024 香港ifva 獨立短片及影像媒體節亞洲新
　力量組銀獎 Asian New Force Silver Award, ifva
▌2023 金鐘獎戲劇類節目聲音設計獎 Best Sound Design
　for Television Series, Golden Bell Awards

DIRECTOR, SCREENPLAY, EDITOR
陳浩維 CHEN Hao-wei
EXECUTIVE PRODUCER
於蓓華 YU Pei-hua
PRODUCER
葉日祺 YE Ri-qi
陳浩維 CHEN Hao-wei
CINEMATOGRAPHER
張誌騰 CHANG Chih-teng
MUSIC
陳昶豪 CHEN Chang-hao
SOUND
歐千綺 OU Chien-chi
張易婷 Mei CHANG Yi-ting
陳晏如 Sylvia CHEN Yen-ju
張嘉恩 CHEUNG Ka Yan
CAST
林怡婷 LIN Yi-ting
曾皓澤 ZENG Hao-ze
劉淑娟 LIU Shu-juan
PRINT SOURCE
財團法人公共電視文化事業基金會
Public Television Service
Foundation

陳浩維，生於台灣台中，朝陽科技大學畢業。第一部作品《腸躁男孩》獲金穗獎肯定，並入圍台北電影節。經常以青少年對成長環境的價值衝突為主題，透過寫實的刻畫勾起觀眾的共同記憶。

CHEN Hao-wei graduated from Chaoyang University of Technology. His first short film, *Irritable Boy*, was a Golden Harvest Award winner and selected for the 2022 Taipei Film Festival.

入圍獎項
最佳短片
最佳新演員
最佳美術設計

公鹿
The Stag

台灣 Taiwan｜2023｜DCP｜Color｜15min

一年一度的鹿茸採收季到來，工人阿合載著兩個兒子來到鹿場。他安靜地清潔空間、餵養群鹿，孩子則跑跳玩耍，彷彿日常。這日在老闆的指令下，受過傷的阿合將再次上場處理公鹿。當他踏進四方圍欄，與公鹿面對面時，鎮上的男人們與他的兒子們都將圍觀這場對決……。

At a deer farm in Changhua County, a middle-aged man is asked to cut off a stag's antlers in front of his two kids.

▌2024 金穗獎評審團特別獎、最佳攝影、音效
　Special Jury Prize, Best Cinematographer,
　Best Sound Effect, Golden Harvest Awards
▌2024 瑞士真實影展 Visions du Réel
▌2024 日舞影展國際劇情短片單元評審團獎
　Short Film Jury Award: International Fiction, Sundance FF

DIRECTOR, SCREENPLAY
朱建安 An CHU
PRODUCER
王姿元 WANG Tzu-yuan
CINEMATOGRAPHER
廖凱文 LIAO Ching-wen
EDITOR
黃懿齡 HUANG Yi-ling
MUSIC
蔡偉德 Nick TSAI
SOUND
林延融 LIN Yan-rong
何森 HO Sen
CAST
陳勇合 CHEN Yung-he
陳威任 CHEN Wei-en
陳思愷 CHEN Si-kai
PRINT SOURCE
朱建安 An CHU

朱建安，政治大學企業管理學系、紐約哥倫比亞大學電影研究所畢業。作品「鹿場三部曲」入選多項國內外影展，《公鹿》獲得日舞影展國際劇情短片單元評審團獎。

An CHU is a graduate of the MFA Film program at Columbia University. His short film, *The Stag*, won the the Short Film Jury Award: International Fiction at Sundance Film Festival.

入圍獎項
最佳短片

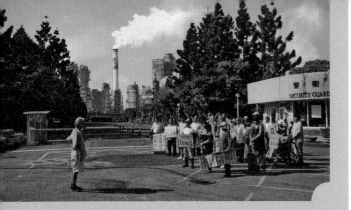

下風處
When the Wind Rises

台灣 Taiwan | 2023 | DCP | Color | 18min

一位年邁的抗爭者在漁村中孤身奮鬥,抵抗油煉廠的擴建。與此同時,其他村民則在眼下的生活保障與永續發展之間猶豫不決。

An aging activist wages a solitary struggle against the expansion of an oil refinery in his tiny fishing village. All the while, the other villagers are infectiously united in their indecisiveness between sustainable change and short-term social security.

▌2024 金穗獎 Golden Harvest Awards
▌2024 香港 ifva 獨立短片及影像媒體節 ifva
▌2024 鹿特丹影展 IFF Rotterdam

DIRECTOR, SCREENPLAY, EDITOR
陳浤 CHEN Hung
EXECUTIVE PRODUCER
何平 HO Ping
PRODUCER
邱鼎豪 CHIU Ting-hao
CINEMATOGRAPHER
潘建明 PAN Chien-ming
SOUND
林晉德 LIN Jin-de
戴以婕 TAI Yi-chieh
CAST
江忠明 CHUNG Ming-chiang
舒偉傑 SHU Wei-chieh
PRINT SOURCE
陳浤 CHEN Hung

陳浤,高雄人,導演、剪輯,臺灣藝術大學電影學系研究所畢業,導演作品《伊卡洛斯》入選2019年台北電影節;《下風處》入圍2024年鹿特丹影展 香港ifva獨立短片及影像媒體節。

CHEN Hung is a Taiwanese director with an MFA in Filmmaking from National Taiwan University of Arts. His latest short film, *When The Wind Rises* (2023), was selected to IFF Rotterdam.

入圍獎項

最佳短片

06.23 SUN 16:00 信義 HYC 11 ▲ ★ | 06.26 WED 21:30 信義 HYC 11 ▲ ★

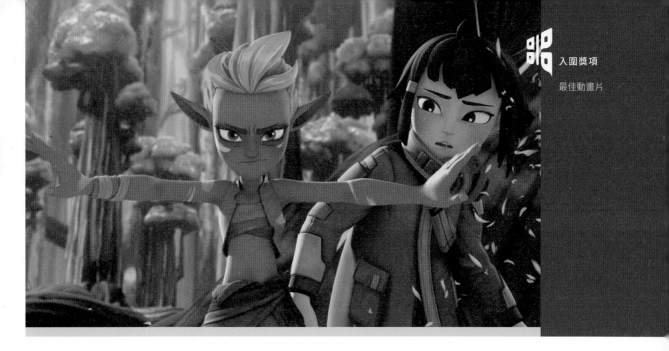

妖怪森林
LUDA

台灣 Taiwan｜2023｜DCP｜Color｜87min

小女孩菈奇闖進森林尋找父母，卻遇到了魔神仔路達。菈奇跟隨著路達進入了森林，展開了一段奇幻的尋親之旅。菈奇和路達在危機四伏的森林中冒險，途中遇到了許多潛藏在森林中的妖怪，在經歷了許多危機之後，成為了互相信任的朋友。但是到了森林的深處，菈奇才發現路達真正的目的卻只是為了把他留在森林中。她該選擇相信朋友？她會如願找到父母嗎？

Laqi enters a forest to find her parents but encounters Luda, a demon spirit. Together, they journey through the forest, encountering various monsters and overcoming dangers to become trusted friends. However, Laqi discovers that Luda's true motive was to capture her, leading her to question her trust.

DIRECTOR
王世偉 Vick WANG Shih-wei
EXECUTIVE PRODUCER
黃俊傑 HUANG Chun-chieh
SCREENPLAY
王世偉 Vick WANG Shih-wei
高逸峯 KAO I-feng
Ben TRANDEM
EDITOR
王世偉 Vick WANG Shih-wei
胡育彰 Rick HU
MUSIC
劉士齊 LIU Shih-chi
SOUND
胡育彰 Rick HU
PRINT SOURCE
原金國際有限公司
ENGINE STUDIOS LLC

王世偉，動畫導演、製作人。監製原創動畫影集《再探飛鼠部落》、《吉娃斯愛科學》皆獲金鐘獎最佳動畫節目。2002年以《雙瞳》，獲金馬獎最佳視覺特效提名。

Vick WANG Shih-wei is an acclaimed animation director and producer. An associate professor of Shih-Chien University, he won a Golden Bell Award as producer of the animated TV series *Go Go Giwas*.

▌2023 台中動畫影展 Taichung IAF

06.27 THU 18:20 華山 SHC 2 ★

八戒
PIGSY

台灣 Taiwan｜2023｜DCP｜Color｜96min

八戒是一個有著街頭智慧，但卻常常把事情搞砸的魯蛇。沒想到這一天，他居然被選進了象徵成功人士的新世界，他終於能讓奶奶為他感到驕傲了；但是高興沒多久，才被告知這一切搞錯了。

Pigsy often messes things up. One day, he is chosen to enter the new world, to become a symbol of success. But it turns out to be a mistake...

邱立偉，臺南藝術大學畢業，擁有北京電影學院博士學位。曾以《窗邊的星星》及《小貓巴克里》獲金馬獎最佳短片與最佳動畫片提名，並以《八戒》獲得2023年金馬獎最佳動畫片。

CHIU Li-wei graduated from Tainan National University of the Arts and holds a PhD from Beijing Film Academy. He has produced and designed many animated films and won numerous awards.

▌ 2023 金馬獎最佳動畫片 Best Animated Feature, Golden Horse Awards
▌ 2023 巴西 AnimaVerso 影展最佳動畫長片、劇本、藝術指導、聲音特效、視覺特效
　Best Animated Feature Film, Best Script, Best Art Direction, Best Sound Effects, Best Visual Effects, AnimaVerso IF

最佳動畫片
最佳美術設計
最佳造型設計
最佳聲音設計

DIRECTOR
邱立偉 CHIU Li-wei
EXECUTIVE PRODUCER
湯昇榮 Phil TANG
Bruno FELIX
PRODUCER
馮偉倫 Allen FENG
林子揚 Denny LIN
林品妤 Sharon LIN
SCREENPLAY
邱立偉 CHIU Li-wei
高橋奈津子 TAKAHASHI Natsuko
蘇洋徵 SU Yang-zheng
王保權 John WANG Pao-chuan
EDITOR
解孟儒 SHIEH Meng-ju
MUSIC
陳建騏 George CHEN
孫令謙 Francis SUN
SOUND
蔡瀚陞 Hanson TSAI
VOICE
劉冠廷 LIU Kuan-ting
許光漢 HSU Kuang-han
庾澄慶 Harlem YU
邵雨薇 SHAO Yu-wei
PRINT SOURCE
兔子創意股份有限公司
STUDIO2 ANIMATION LAB CO., LTD.

07.02 TUE 17:20 華山 SHC 1 ★

眾生相
Anthropocene

台灣 Taiwan｜2023｜DCP｜Color｜11min

這部動畫作品是對人類一句溫柔的提醒：堅實豐美的天地滋養是理所應該的嗎？我們是不是常忽略最基本的問題？近年來世界持續的動盪讓我們痛心，也促使我們反省！人類的集體慾望如巨獸獨立行走，單獨的個人陷入價值混亂而無望。我們內心真正無法失去的東西到底是什麼？我們能夠靜下心來認真地想一回嗎？

This animation gently reminds us to cherish nature's gifts and ponder life's complexities amidst global turmoil. Let's take a moment for serious reflection.

▌2023 台中動畫影展
Taichung IAF

DIRECTOR
黃勻弦 HUANG Yun-sian
劉靜怡 Raito LOW Jing Yi
PRODUCER
吳彥杰 Jet WU
王綺穗 WANG Chi-sui
SCREENPLAY
黃勻弦 HUANG Yun-sian
CINEMATOGRAPHER
劉靜怡 Raito LOW Jing Yi
唐治中 TANG Zhi-zhong
EDITOR
黃勻弦 HUANG Yun-sian
唐治中 TANG Zhi-zhong
MUSIC
黃浩倫 HUANG Hao-lun
黃勻弦 HUANG Yun-sian
石恩明 Emma SHIH
SOUND
黃浩倫 HUANG Hao-lun
三川娛樂有限公司
KAWA Music Co., Ltd.
PRINT SOURCE
旋轉犀牛原創設計工作室
TurnRhino Original Design Studio

黃勻弦，從小在廟口賣捏麵人的停格動畫導演。代表作品有《巴特》、《當一個人》，以及《山川壯麗》。

劉靜怡，馬來西亞停格動畫創作者，以植物創造結合人文與自然的視覺語彙。

HUANG Yun-sian has been an animation director since 2010. She enjoys teamwork with artists and solitary reflection.
Raito LOW Jing Yi is a stop-motion creator from Malaysia whose experimental visuals combine humanity and nature.

入圍獎項
最佳動畫片
傑出技術

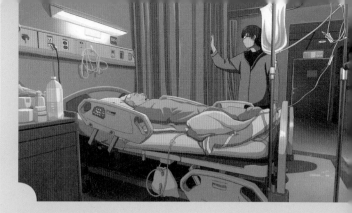

長期照顧
Long Term Care

台灣 Taiwan｜2023｜DCP｜Color｜7min

我把我照顧家人所遇到的困難，生活遇到的情況，還有直面內心的深處做成一部動畫。我的日子很單調無聊，日復一日、年復一年。製作影片的動機是：讓我們一起努力。我也希望生活一帆風順，但有時世事難料。我們的社會正進入老化階段，像我這樣的人還有很多。因為家庭的原因，我擱置了自己的人生夢想。最後如果你也遇到，我希望它會繼續下去，一起加油、一起努力。

After graduating from college, I encountered a life choice between dream and family. Although it only lasted seven minutes, it took me 10 years to walk a journey.

▌2024 金穗獎 Golden Harvest Awards

DIRECTOR, PRODUCER, SCREENPLAY, CINEMATOGRAPHER, EDITOR
謝宗旻 XIE Zong-min
MUSIC
余佳倫 A-len
SOUND
楊子霆 YANG Tzu-ting
PRINT SOURCE
謝宗旻 XIE Zong-min

我叫**謝宗旻**，是一個台灣人，很榮幸我能參加到這比賽，我的興趣是打遊戲、看影片跟畫圖。這是我獨自一人做的影片，我把照顧家人的經驗做成一部動畫，希望大家會喜歡。

My name is **XIE Zong-min** and I am Taiwanese. I am honored to participate in this competition. My hobbies are playing games, watching videos, and drawing. This is a video I made alone.

入圍獎項
最佳動畫片

游墓
The Nomadic Tomb

台灣 Taiwan｜2023｜DCP｜B&W｜4min

在偷偷死掉也不會被發現的夜晚，有座墳墓很久沒人來掃了。
生不帶來，死帶著走，一趟落跑墳墓的公路之旅和游牧人生。

We enter the world from the womb with empty hands, and depart with nothing but our tomb. A runaway tomb on its journey represents a nomadic existence. Life is like a road trip that eventually leads to rebirth for all.

2024 金穗獎評審團特別獎
Special Jury Prize, Golden Harvest Awards
2023 台灣國際女性影展評審團特別獎
Special Jury Prize, Women Make Waves IFF
2023 高雄電影節 Kaohsiung FF

DIRECTOR
游珮怡 YU Pei-yi

SCREENPLAY / PRODUCER
林巧芳 LIN Chiao-fang

EDITING
安居 Utingling

PRINT SOURCE
游珮怡 YU Pei-yi

游珮怡，桃園製造，野台養成，作品常取材自在地文化與個人經驗，相較主流更關注邊緣，擅於賦予泛靈奇想與人文關懷。左手抓離合器，右手拿筆，愛好當代精神分析。

YU Pei-yi's works draw inspiration from Taiwanese local culture and personal experiences. She is passionate about imbuing her art with spiritual and imaginative elements, as well as humanistic concerns.

入圍獎項
最佳動畫片

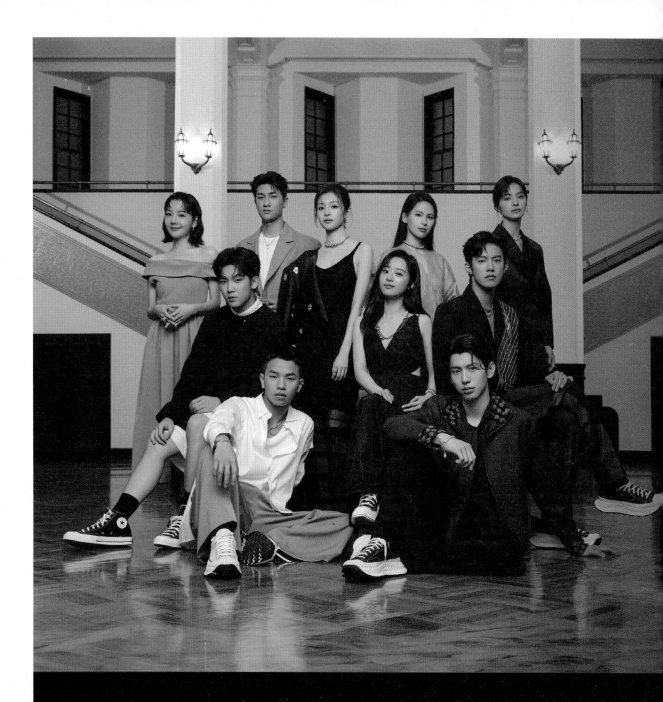

非常新人

林恩廷　林臨家　陳秦河　裴子齊　鞠子尊　蕭莉廷　林亨莉　徐碩廷　余杰恩　蒲庆菲

從產業需求出發
為台灣影視圈挖掘潛力新演員

非常新人，銀幕裡不容忽視的新星，台北
電影節看見了，你也應該看見。
2019年，台北電影節率台灣影展之先，推
出「非常新人」企劃，挖掘並推薦具有潛
質的新演員，獲得業界熱烈迴響。

2024年，台北電影節秉持一樣的精神與業
界的期待，公開招募新演員報名，並邀請
業界專業人士參與評選，從眾多報名者中
選出10位潛力新人。

2024
台北電影節

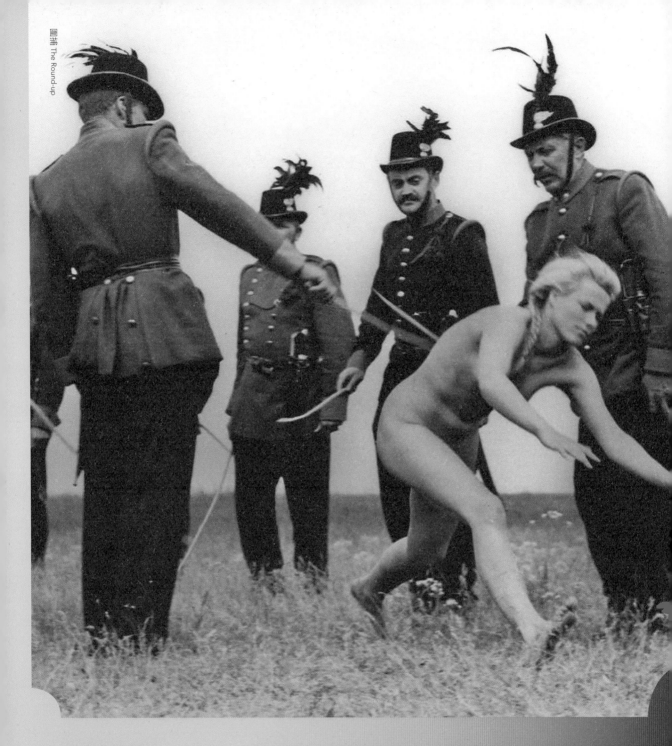

焦點城市：
布達佩斯
CITY IN FOCUS:
BUDAPEST

多瑙河貫穿的布達佩斯素有小巴黎之稱，也曾是中歐的文化藝術重鎮，二戰後蘇聯鐵幕帶來動盪，卻擋不住創作者對迂腐權力的憤怒與對自由的嚮往，1960 年代一波新浪潮百花齊放，直至今日，仍可見到創作者以藝術對抗反動勢力的精神。

With the Danube River flowing through it, Budapest— known as the "Paris of the East" — was once an important cultural and artistic hub in Central Europe. Following World War II, the turmoil brought by the Iron Curtain could not suppress artists' anger towards authoritarian power or their longing for freedom. In the 1960s, a new wave blossomed, and the spirit of filmmakers using art to oppose reactionary forces can still be seen today.

自由的魔力

貝拉巴拉茲製片廠和當代匈牙利電影

文——艾斯特‧法澤卡斯（匈牙利電影中心｜電影資料館修復部門主任）

譯——劉若瑄

▶ 今年台北電影節的「焦點城市：布達佩斯」單元精選了貝拉巴拉茲製片廠（下稱BBS）有史以來最前衛的創作，以及優秀的知性作品。即使在歐洲，BBS也稱得上是出色的實驗影像工作坊，一直持續運作到千禧年左右，可謂匈牙利現代劇情長片的孵化器。

作為東西歐之間獨特的內陸國家，匈牙利自古即為多元社會、文化、政治的大熔爐，亦曾受蒙古、鄂圖曼、哈布斯堡和蘇聯的壓迫，這個1,000萬人口的民族，說著特有的語言，就持續在歐陸中心存在著，並為世界孕育出許多重要的藝術家，例如作曲家貝拉‧巴爾托克（Béla Bartók）、捷爾吉‧李蓋悌（György Ligeti）、彼得‧于特福許（Péter Eötvös）、捷爾吉‧庫爾塔克（György Kurtág）；作家費倫茨‧莫爾納（Ferenc Molnár）、因惹‧卡爾特斯（Imre Kertész）、彼得‧伊斯特海茲（Péter Esterházy）；榮獲坎城終身成就獎的電影導演米克羅斯‧楊秋（Miklós Jancsó）、奧斯卡得主導演伊斯特凡‧沙寶（István Szabó），以及曾獲奧斯卡提名的導演伊爾蒂蔻‧恩伊達（Ildikó Enyedi）。

在1960年代，世界各地以不同的形式表現現代主義，且和新興的視覺方言有所關聯。在中東歐地區，歐洲新浪潮的實驗探索也和關注今昔問題的社會運動息息相關。

1956年匈牙利革命後，人民經歷了數年鎮壓，到了1960年代初期，卡達爾政權[1]的文化政策逐漸成形，其一重點工作即是電影產業的去中心化，以培植自立的新生代影人來抗衡匈牙利經典電影導演佐爾坦‧法布里（Zoltán Fábri）、費利克斯‧馬里亞（Félix Máriássy）、拉斯洛‧拉諾迪（László Ranódy）、佐爾坦‧瓦爾科尼（Zoltán Várkonyi）。實踐目標的方式是於1959年成立嶄新的實驗電影製片廠，專為電影導演畢業生進入職涯鋪路。每年，製片廠都會拿到一筆製作實驗電影的預算，這筆預算足以支應幾部短片的製作，且沒有映演的義務。這項政策的進步在於製片廠成員得以自由選擇創作主題，享有比「官方」核准範圍更大的藝術自由，創作者的大綱僅需經過製片廠管理階層討論，而最終經製片廠董事會允許拍攝的短片，日後在世界各國影展中亦斬獲佳績，然而1960年代末期後，卻開始有短片被當局文化官員禁播。

1960年代，製片廠的主要作品為劇情短片和詩意紀錄短片，不過偶爾也有實驗電影或影像詩在國內外影展放映。製片廠培育的第一代具代表性的導演有：伊斯特凡‧沙寶（István Szabó）、伊斯特凡‧嘉爾（István Gaál）、桑多爾‧薩拉（Sándor Sára）、派爾‧蓋勃（Pál Gábor）、索爾特‧凱

[1] 1956-1988 年間，由匈牙利社會主義工人黨第一書記——亞諾斯‧卡達爾（János Kádár）領導匈牙利人民共和國時期。

茲迪-科瓦奇（Zsolt Kézdi-Kovács）、尤迪特‧艾萊克（Judit Elek）、亞諾斯‧羅薩（János Rózsa）、因惹‧吉尤塞（Imre Gyöngyössy）、佐爾坦‧胡薩里克（Zoltán Huszárik）和亞諾斯‧托許（János Tóth）。此時期最成功的作品有：伊斯特凡‧沙寶《我眼裡的妳》（You，1962）、桑多爾‧薩拉《流浪者藍調》（Gypsies，1962）和佐爾坦‧胡薩里克《良駒輓歌》（Elegy，1965）。

1960年代初期，社會趨向穩定，新一代文學、藝術和音樂人士著重於對照古今，處理歷史、自由和傳統的問題，亦在1950年代社會寫實主義運動興起之際，以回顧1930和1940年代的前衛音樂和視覺藝術，重建匈牙利藝術和歐洲主流藝術的連結。在BBS製作的短片中，藝術家們總是「現身說法」。社會的進步、崎嶇的歷史：納粹大屠殺和拉科希政權[2]總是出現在視覺語言中，常見於地景及街景中，也能見於畫作中熟悉的氛圍，或者在描繪一句詩的系列影像中。短片作品發表後，這批創作者在短短幾年內便成為了當代匈牙利電影中最傑出的劇情長片導演。

1959年，米克羅斯‧楊秋製作了非凡的前衛紀錄片《Immortality》，講述一位在BBS草創時期成為烈士的雕塑家，到了1960年代中期，楊秋儼然成為歐洲現代藝術電影的代表人物。在迄今最具影響力的匈牙利電影《圍捕》（The Round-up，1966）中，楊秋以幾何構圖的「長鏡頭」和加以編排的動作段落，呈現1848年的權力體系如何捉捕法外之徒，此一表達方式讓世界各地的觀眾立刻明白他影射的是1956年匈牙利革命後的一系列鎮壓。

伊斯特凡‧嘉爾和桑多爾‧薩拉在BBS的早期職涯也是著重幾何構圖、前衛社會抒情主義、地景和傳統民俗母題，

例如：《Section Gang》和《流浪者藍調》。他們爾後完成的劇情長片《青春暗流》（Current，1964）、《導演流浪指南》（The Upthrown Stone，1969）成為匈牙利新浪潮的代表作。個人的歷史經驗可以說是這對創作夥伴的職涯起點，亦是兩人的「生命學校」，探索的主題包含：戰爭、拘留、村莊、貧困、羅姆人作為社會邊緣人的命運，以及弱勢族群。兩位導演和佐爾坦‧胡薩里克是中學同學，而胡薩里克又和攝影師亞諾斯‧托許合作拍攝了一系列可謂匈牙利前衛影像詩巔峰之作。《良駒輓歌》和《白色奇想曲》（Capriccio，1969）是關於時間的流逝、自然的毀滅、傳統和價值；胡薩里克亦執導了《Sinbad》，這部的調性近似於有「匈牙利普魯斯特」之稱的久拉‧克呂德（Gyula Krúdy）所打造的懷舊諷刺世界，故事從死亡的當下倒敘，運用一連串的自由聯想，接續述說每位女人的故事。

在伊斯特凡‧沙寶早期的電影作品中，受法國新浪潮影響的痕跡顯而易見，像是類似法蘭索瓦‧楚浮的俏皮風格和輕鬆自由聯想的呈現。沙寶於BBS拍攝的愛情短片《我眼裡的妳》中，以同樣的抒情、親密調性拍攝被愛慕的女孩和被鍾愛的城市，伴隨城市中女孩畫面的是大量的街景；《我的千面老爸》（Father，1966）以優雅的懷舊場景堆砌而成，改編自個人經歷，講述1940和1950年代一位半孤兒男孩的成長故事。歷史創傷——在當時為禁忌主題——一代缺乏父愛之人的模樣，就在孩童的幽默想像、絲絲記憶和真正的歷史異狀中於我們眼前閃現。

三位甫開啟創作生涯的女導演瑪塔‧梅薩洛斯（Márta Mészáros）、尤迪特‧艾萊克（Judit Elek）、莉薇雅‧蓋爾瑪蒂（Lívia Gyarmathy）也在1960年代匈牙利電影革新中扮

[2] 1947-1956年期間，由拉科西‧馬加斯（Rákosi Mátyás）擔任匈牙利人民共和國最高領導人。

演重要角色。尤迪特・艾萊克以在BBS拍攝的抒情紀錄片《How Long Does a Man Live?》（1967）首次於坎城亮相；1969年的《寂寞換換屋》（The Lady from Constantinople）巧妙融合了劇情和紀錄片元素，廣受好評，且此片發表早於布達佩斯學派出現前近十年，影片以抒情調性描繪一名即將搬離公寓的老婦的孤寂，手法夾雜微妙的幽默、荒謬和諷刺元素。艾萊克之後所有的劇情長片皆具有直接電影的敏感度和觀點。

在十年交替之際，新一代影人出現了，也就是久拉・葛茲達（Gyula Gazdag）、捷爾吉・紹米亞什（György Szomjas）、伊斯特萬・達代（István Dárday）和加博・柏迪（Gábor Bódy）成為BBS的主要成員時。爾後，他們開放製片廠讓非電影科班畢業的創作者加入，給予藝術家、作家、作曲家有實現電影點子的機會。朵拉・毛雷爾（Dóra Maurer）、米克洛斯・厄德利（Miklós Erdély）、彼德・多鮑伊（Péter Dobai）、湯瑪斯・斯喬比（Tamás Szentjóby）、蒂博莫・哈賈斯（Tibor Hajas）、佐爾坦・傑涅（Zoltán Jeney）、拉斯洛・維多夫斯基（László Vidovszky）等人的出現，帶來了豐富多樣的跨領域藝術作品。此時，製片廠的功能已經轉變：1970年代以電影語言實驗主義和探索社會問題的紀錄片為特色，各種情境式紀錄片可說是暢所欲言，尤其點出布列茲涅夫主義[3]當道，導致卡達爾主義[4]復興的荒謬，例如：捷爾吉・紹米亞什的《Honeymoons》（1970）和久拉・葛茲達的《長跑英雄》（The Long Distance Runner，1968）。《Decision》（1972）這部優秀的紀錄片是關於以（表面）民主方式請走合作社老闆的事件，由兩位最常被禁的導演久拉・葛茲達和尤迪特・恩貝爾（Judit Ember）執導，這部片於1996年被國際紀錄片協會選為史上百大紀錄片。1975年，伊斯特萬・達代執導

了《英國之旅有沒有》（Holiday in Britain），這部後來被譽為布達佩斯學派的經典之作，以預先設定好的劇情，使用業餘演員在原事件發生的場景拍攝，講述了少年先鋒隊生活的荒謬之處。此時，貝拉・塔爾（Béla Tarr）在BBS的職涯也隨著《家庭公寓》開始了。

加博・柏迪是BBS實驗風潮的領導人物，他視電影為實驗視覺方言的工具。值得注意的是，他的畢業作品是一部長片，而所執導的《American Torso》（1975）於曼海姆影展獲獎，影片貌似有百年歷史的拾得影像紀錄片。

BBS最後一個蔚為風潮的群體是「新感性」、後現代的藝術家，由加博・柏迪的巨作《Narcissus and Psyche》（1980）為濫觴。亞諾斯・桑圖斯（János Xantus）的短片《Diorissimo》（1980）和《她的掌心》（In Woman's Hands，1981）標誌著一種新手法的誕生。這個風潮中最受歡迎的作品《Eskimo Woman Feels Cold》（1983），曾在坎城影展放映，也是桑圖斯的作品。

曾獲奧斯卡提名的世界知名導演伊爾蒂蔻・恩伊達（Ildikó Enyedi）的職涯與 BBS 的實驗、前衛風潮密切相關，她在BBS拍攝了第一部短片《Flirt》（1979）和長片《特務情謎》（Mole，1987），而她的《我的二十世紀》（My 20th Century，1989）由奧列格・揚科夫斯基（Oleg Yankovsky）主演，在國際上成績斐然，並榮獲坎城影展金攝影機獎。

總的來說，貝拉巴拉茲製片廠是一個不斷轉變、活力充沛的文人工作室，由於其特殊地位，總是為匈牙利電影的發展提供想像和機會。◆

[3] 以蘇聯前領袖昂尼德・布里茲涅夫（Leonid Brezhnev）所命名，是在蘇聯及華沙條約成員國內推行的一套對外擴張和對東歐社會主義國家進行思想和政治控制的理論。

[4] 1956 年匈牙利革命後，匈牙利人民共和國於 1962-1989 年期間採取了一系列政策，以改善匈牙利人民生活及改革經濟為目標，而這些改革帶來了幸福感及相對的文化自由，使此時期的匈牙利被譽為最幸福的軍營。

The Magic of Freedom

Béla Balázs Studio and Modern Hungarian Cinema

Written By Eszter FAZEKAS (Head of the restoration department at NFI – Film Archive)

▶ Hungarian films in the classic focus of this year's festival include some of the most progressive works that ever came out of Béla Balázs Studio (BBS), an experimental workshop remarkable even in European terms, as well as the wonderful intellectual emanations of this experimental studio, which proved to be an incubator for full-length modern Hungarian feature films until the moment the studio became unviable and closed at the turn of the millennium.

Hungary, an unique small landlocked country in Europe standing between East and West, is a crucible in which, throughout its history, has been subject to numerous different social, political and cultural influences. Exposed to Mongol, Ottoman, Habsburg and Soviet oppression, this 10-million-strong ethnic group speaking a unique language continues to survive in the heart of Europe, giving the world such major artists as composers Béla Bartók, György Ligeti, Péter Eötvös, György Kurtág, writers Ferenc Molnár, Imre Kertész, Péter Esterházy, and film directors including Miklós Jancsó, who holds a lifetime achievement award from Cannes, Oscar laureate István Szabó, and Ildikó Enyedi, who has been nominated for an Academy Award.

In the 1960s, Modernism, which took on many forms worldwide, was associated with the emergence of a new idiomatic expressive modality of visuality. In Central-Eastern Europe, experimentation in the form of European New Waves was linked with special social progression processing past and present.

In Hungary, the years of suppression of the 1956 Revolution were followed by a gradually consolidating cultural policy of the Kádár regime in the early 1960s. One aim of this was the decentralization of the film industry, which placed emphasis on a new, self-raised generation contrary to classic Hungarian film directors (Zoltán Fábri, Félix Máriássy, László Ranódy, Zoltán Várkonyi). The tool to achieve this was the foundation (1959) of a groundbreaking, experimental workshop designed to prepare graduates fresh from the film directing faculty for future careers.

Each year, the studio received an experimental film budget, out of which several shorts could be made without any obligation for their presentation. The progressive element here was that members of the studio were given a free hand when it came to choosing a topic, and they could enjoy greater artistic freedom than was "officially" permitted. The resulting synopses were then discussed by studio management. Films given the green light by the studio board went on to pick up countless prizes at festivals worldwide. Others, primarily from the late 1960s onwards, were listed as banned by cultural supremos.

During the 1960s, the studio's profile was determined by short feature films and lyrical, short documentaries, although occasionally an experimental film or film poem was also shown at domestic or foreign film festivals. The first generation was represented by István Szabó, István Gaál, Sándor Sára, Pál Gábor, Zsolt Kézdi-Kovács, Judit Elek, János Rózsa, Imre Gyöngyössy, Zoltán Huszárik, and János Tóth. The most successful works from this time were You (Te, István Szabó, 1962), Gypsies (Cigányok, Sándor Sára, 1962) and Elegy (Elégia, Zoltán Huszárik, 1965).

In the fields of literature, fine art and music, the fundamental aspiration of the new generation of the consolidating 1960s was to process the issues of history, freedom and tradition from the situation of the present, the "here and now", and by reaching back to music and visual arts avant-garde of the 1930s and 1940s, reconnect Hungarian art to the European mainstream in the wake of the Socialist Realism movement of the 1950s. Artists of shorts made in BBS in the early 1960s always "spoke in pictures" (Sándor Sára). Social progression, the processing of the past filled with numerous historical twists, the Holocaust and Rákosi regime, always appeared in the language of visuality, frequently in the landscape, one or other passage, recognizable moods evoking paintings, or even in a series of images depicting a particular line of poetry. Following on from their short films, these creators became the most outstanding full-length feature film artists of modern Hungarian cinema in just a few short years.

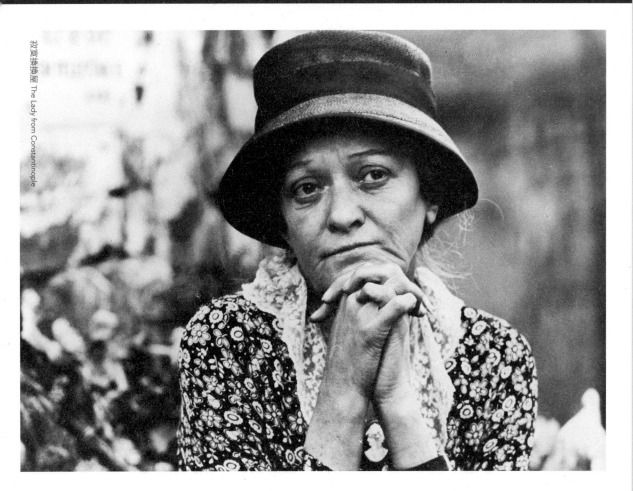

Miklós Jancsó, who made the extraordinary, avant-garde documentary *Immortality* (*Halhatatlanság*, 1959), about a martyr sculptor in the proto-BBS, had become an icon of European modern art film by the mid-1960s. In the most influential Hungarian film to date, *The Round-Up* (*Szegénylegények*, 1966), he constructed the depiction of the rites of power that captured the outlaws of 1848 on abstract, geometric "long cuts" and choreographed movement sequences. Audiences worldwide immediately understood that by using this method, he was speaking about the reprisals that followed the crushing of the 1956 uprising.

The early careers of István Gaál and Sándor Sára at BBS were similarly based on geometric tableaux, avant-garde socio-lyricism, motifs of landscape and traditional folklore (*Section Gang/ Pályamunkások, Gypsies/Cigányok*). Then their first feature films made after these— *Current* (*Sodrásban*, 1964), *The Upthrown Stone* (*Feldobott kő*, 1969) — became symbolic pieces of the Hungarian New Wave. Personally experienced historical material determined the initiation of the creative partners' careers as a "school of life": the war, internments, the village, poverty, the fate of Roma living on the fringes of society, and the vulnerable. They attended the same grammar school as Zoltán Huszárik,

who along with cinematographer János Tóth made the serial, avant-garde pinnacle of Hungarian film poetry. *Elegy* (*Elégia*, 1965) and *Capriccio* (1969) are about the passage of time, the loss of nature, traditions and values. Zoltán Huszárik also directed *Sindbad* (*Szindbád*), which brings to mind the nostalgic-ironic world of Gyula Krúdy, the "Hungarian Proust", by looking back from the moment of death, as a loose string of associations, wandering from one woman to another.

French Nouvelle Vague, primarily the playfulness of François Truffaut, the lightness of associations, is palpable in the early films of István Szabó. In his short love story etude titled *You*, shot in BBS, the adored girl is filmed with the same lyrical intimacy as the adored city, where, accompanying the girl, he describes large French passages. The gracefulness of the French flashback determines István Szabó's film *Father* (*Apa*), based on personal motifs. It is the coming-of-age story of a half-orphaned boy in the 1940s and 1950s. Historical traumas — taboos at the time — of a fatherless generation flash in front of our eyes from behind the humorous blurring of childish imagination, wisps of memory, and true historical anomalies.

Márta Mészáros, Judit Elek and Lívia Gyarmathy, female directors just starting their careers, also played a vital role in the renewal of Hungarian films in the 1960s. Judit Elek debuted at Cannes with her lyrical documentary made at BBS, *How Long Does a Man Live?* (*Meddig él az ember*, 1967). The 1969 screening of *The Lady from Constantinople* (*Sziget a szárazföldön*) in the French city, blending in a remarkable way fictional and documentary elements, was a triumph. Her film predated the Budapest School method by almost a decade. The lyrical depiction of the loneliness of the old woman on the verge of switching apartments is interwoven with delicate humor, absurd and ironic elements. All later feature films of Judit Elek were also made with the sensitivity and perspective of original direct cinema.

A new generation appeared at the turn of the decade; this was when Gyula Gazdag, György Szomjas, István Dárday, and Gábor Bódy became leading members of BBS. They then opened up the workshop to artists who had not graduated from film school, thereby allowing fine artists, writers and composers to realize their cinematic concepts. The appearance of Dóra Maurer, Miklós Erdély, Péter Dobai, Tamás Szentjóby, Tibor Hajas, Zoltán Jeney, László Vidovszky and others resulted in prolific, interdisciplinary works of art. By this time, the studio's function had changed: the 1970s were defined by film idiom experimentalism and documentaries exploring social issues. Diverse, situational documentaries about the absurdity of Kádárism being restored as a consequence of the Brezhnev Doctrine talked about everything. Examples include György Szomjas's *Honeymoons* (*Nászutak*) and Gyula Gazdag's *Long Distance Runner* (*Hosszú futásodra mindig számíthatunk*). *Decision* (*A határozat*, 1972), an unparalleled document about the "democratic" (for appearances' sake) sacking of a cooperative boss, is the joint work of two of the most banned directors, Gyula Gazdag and Judit Ember. In 1996, the film was selected by the International Documentary Association as one of the 100 best documentaries of all time. In 1975, István Dárday made his movie *Holiday in Britain* (*Jutalomutazás*), a classic of the so-called Budapest School; it is a feature film with a pre-determined plot about the perversities of Young Pioneer life, filmed in original locations using amateurs. The career of Béla Tarr within BBS also started at this time (*Family Nest/Családi t zfészek*, 1977).

Gábor Bódy was the leading figure of the experimental trend at BBS. He looked at film as a tool for idiomatic experimentation. Remarkably, his diploma film was a full-length work. *American Torso* (*Amerikai anzix*, 1975), winner of a prize at Mannheim, looks like a 100-year-old, found footage documentary.

The last "trend" group was artists of the "new sensibility", postmodern era, initiated by Gábor Bódy's grand opus *Narcissus and Psyche* (*Psyché*, 1980). János Xantus's shorts *Diorissimo* (1980) and *In Woman's Hands* (*Női kezekben*, 1981) signalled the birth of a new approach. The most popular work of this trend, *Eskimo Woman Feels Cold* (*Eszkimó asszony fázik*, 1983), which was screened at Cannes, is similarly a Xantus film.

The career of Oscar nominee and world-famous film director Ildikó Enyedi is associated with the experimental, avant-garde trend of BBS, where she shot her first short (*Flirt, Hypnosis/Hipnózis*, 1979), and first feature (*Mole/Vakond*, 1987). Her feature film, *My 20th Century* (*Az én XX. századom*) starring Oleg Yankovsky, was an international hit, winning a Golden Camera for best first feature at Cannes.

Thus, to sum up, it is possible to state that Béla Balázs Studio was a constantly transforming, dynamic intellectual workshop which, due to its special status, always provided opportunities for the progressive aspirations of Hungarian cinema. ◆

布達佩斯：
匈牙利新浪潮
BUDAPEST:
THE HUNGARIAN NEW WAVE

1956 年的大革命，在匈牙利共產黨藝術審查被震出的隙縫，透出了自由的曙光，新世代創作者把握機會搭上歐陸新浪潮列車，大膽觸碰當局禁忌，訴說真正屬於人民的故事。

The Hungarian Revolution of 1956 opened a crack in the Hungarian Communist Party's artistic censorship, revealing a glimmer of freedom. A new generation of filmmakers seized the opportunity by boarding the European New Wave train, boldly touching upon political taboos and telling stories that truly belong to the people.

青春暗流
Current

匈牙利 Hungary｜1964｜DCP｜B&W｜86min

夏日炎炎，一群大學生在河畔享受溪水的沁涼，正當眾人沉醉在青春的暢快與甜美時，沒人發現一名同夥不見了！同伴分頭尋人，天色漸暗卻仍不見蹤影。一夥人忐忑不安、焦急萬分，內疚、懊惱、恐懼，這場悲劇性的經歷，徹底改變了這群青年的人生。一則殘酷且無以抹滅的成長記事。

本片標誌著匈牙利新浪潮面向國際影壇的開端，導演伊斯特凡·嘉爾首部劇情長片，即展現其對人性與社會氛圍細膩的刻畫，他與同輩攝影師桑多爾·薩拉合作無間，精準透過影像構圖、黑白攝影的光影對比，陽光、河流、青春的胴體，鄉村廣闊的地景與人物的心境產生巧妙的呼應，義大利名導帕索里尼亦曾頌讚本片「詩意、新穎，令人耳目一新。」

A company of young people spend their summer holidays by the Tisza, absorbed in sun-bathing and swimming. None of them notice that Gabi has drowned in the river. The tragedy forces them to examine themselves, and question their responsibility and how they relate to the world and each other. They grow into adulthood burdened by the tragedy, their relationships transformed. Luja and Zoli are willing to face their conscience; Laci finds consolation in abstract principles, while others try to idealize their role.

伊斯特凡·嘉爾（1933-2007），匈牙利新浪潮代表人物，1933年出生於北部礦業小鎮紹爾戈陶爾揚，五〇年代展開電影創作生涯，直至九〇年代晚期，執導超過20部電影，其中《The Falcons》獲得1970年坎城影展評審團大獎。

István GAÁL (1933-2007) is a founder of Béla Balázs Studio. His first feature film, *Current*, became a symbol of the rebirth of Hungarian cinema. He has held several photo exhibitions in Hungary and abroad, and lectures at the Rome Film Academy and in Pune, India.

DIRECTOR, SCREENPLAY, EDITOR
伊斯特凡·嘉爾 István GAÁL
PRODUCER
Lajos F. KISS
CINEMATOGRAPHER
桑多爾·薩拉 Sándor SÁRA
MUSIC
安德拉斯·索爾洛西 András SZŐLLŐSY
Girolamo FRESCOBALDI
SOUND
Tibor RAJKY
CAST
Andrea DRAHOTA
Marianna MOÓR
Istvánné ZSIPI
András KOZÁK
Tibor ORBÁN
PRINT SOURCE
National Film Institute Hungary

▌ 1965 匈牙利影評人獎最佳導演、攝影 Best Director, Best Cinematographer, Hungarian Film Critics Awards
▌ 1964 卡羅維瓦利影展最佳影片 Best Film, Karlovy Vary IFF

06.23 SUN 19:00 華山 SHC 2｜06.28 FRI 21:10 華山 SHC 2｜06.30 SUN 13:00 華山 SHC 2

我的千面老爸
Father

匈牙利 Hungary｜1966｜DCP｜B&W｜91min

1945年，老羅斯福總統逝世的消息傳遍大街小巷，喪父的男孩編織著英雄父親夢，在男孩記憶中的父親是個解救猶太人脫離納粹毒手的國族英雄，有著各種神祕的身分，受到全國人民的愛戴。直到1956年，成年的男孩參與匈牙利十月革命並戀上一位猶太女孩後，他意識到必須擺脫對父親昔日榮光的想像，才能真正獨當一面。

本片為導演伊斯特凡·沙寶第二部長片，奠定他成為匈牙利電影代表導演之一。電影巧妙地透過男孩的成長故事，折射大時代的變化，從個人的私密經驗，連結亂世中人民對偉人形象的渴求。由匈牙利新浪潮重要攝影師桑多爾·薩拉掌鏡，影像同時帶有義大利新寫實主義與法國新浪潮的神采，細細鋪陳男孩的生活與心境變化，以幽默的筆觸勾勒現實的同時，亦對歷史提出反思，反映出後革命的青年世代缺乏當代典範的焦慮。

Budapest, the darkest years of the Stalinist era. A young boy weaves a series of fantasies around his father, who died in the war. This traumatic period of dictatorship is evoked through the boy's emotions and experiences: Auschwitz, the 1956 Hungarian Revolution, and the contradictions of existing socialism. It is the story of the insecurity of a fatherless generation.

伊斯特凡·沙寶，為國際上知名的匈牙利導演之一。作品《千面惡魔》為匈牙利贏得首部奧斯卡最佳外語片，1985年《雷德爾上校》則獲得坎城影展評審團大獎。同為貝拉巴拉茲製片廠創始成員之一。

István SZABÓ is the most internationally acclaimed Hungarian filmmaker since the 1960s. A founding member of Béla Balázs Studio, he is an important director of the Hungarian New Wave. His films have won almost 40 awards worldwide, with *Mephisto* (1981) winning the Oscar for Best Foreign Language Film.

DIRECTOR, SCREENPLAY
伊斯特凡·沙寶 István SZABÓ
PRODUCER
Tibor HRANITZKY
CINEMATOGRAPHER
桑多爾·薩拉 Sándor SÁRA
EDITOR
亞諾斯·羅薩 János RÓZSA
MUSIC
János GONDA
SOUND
György PINTÉR
CAST
Miklós GÁBOR
Klári TOLNAY
Dániel ERDÉLY
PRINT SOURCE
National Film Institute Hungary

▮ 1967 盧卡諾影展評審團特別獎 Special Jury Prize, Locarno FF
▮ 1967 莫斯科影展金獎 Grand Prix, Moscow IFF

06.22 SAT 18:40 華山 SHC 2 ｜ 06.25 TUE 18:00 華山 SHC 2 ｜ 07.02 TUE 11:40 華山 SHC 1

圍捕
The Round-up

匈牙利 Hungary｜1966｜DCP｜B&W｜81min

故事從 1848 年人民起義，反抗哈斯堡王朝的失敗革命談起。統治者抓捕革命分子，並將支持者集中關押入戰俘營。20 年後，叛軍頭子和他的游擊隊據說是革命的最後一股力量，獄卒不惜動用私刑以獲取有關游擊隊成員的消息，以斷絕任何對政權的威脅。這是一部關於權力模樣的電影，導演楊秋細膩呈現掌權者和革命分子之間不間斷的角力，以及人民面對獨裁政權時的堅強意志力，從未真正現身的游擊隊首領宛若神話人物般，象徵著人民反抗的精神。

本片為楊秋揚名國際之作，入選坎城影展主競賽，亦被選為匈牙利奧斯卡最佳外語片代表。影片勾勒的雖為歷史事件，但也被當年的觀眾解讀為對

1956 年匈牙利十月革命運動，推翻蘇聯統治失敗後被鎮壓的隱喻。當年在國內上映時票房反應熱烈。匈牙利名導貝拉·塔爾更視本片為其十大片單之一。

In 1869, count Ráday Gedeon is appointed to be a government commissioner. His task is to ensure general security of property and to capture outlaws following the 1848-49 War of Independence. Ráday does not prove to be fastidious and gentle about the tools he uses. The outlaws are taken to a castle prison called "The Trench" in Nagyalföld (Great Plain), and with cruel psychological methods, they are forced to betray their fellows. The former soldiers of Kossuth, leader of the Hungarian freedom fight, are trapped because of their pride and dignity.

米克羅斯·楊秋（1921-2014），匈牙利國寶級導演，畢業於布達佩斯戲劇與電影學院導演系，五〇年代後期開始拍攝劇情電影。代表作包含《紅與白》、《靜默與呼喊》、《紅聖歌》等，常以象徵形式描繪歷史。曾獲坎城影展最佳導演、威尼斯影展終身成就金獅獎。

Miklós JANCSÓ (1921-2014) was a Hungarian filmmaker and screenwriter. In 1965, *The Round-Up* made him internationally famous as an innovator of film style. He won numerous international awards, including Best Director at Cannes in 1972, as well as lifetime achievement awards at Cannes (1979), Venice (1990), and Budapest (1994).

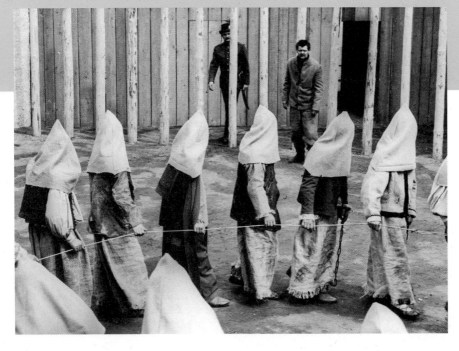

▌ 1966 盧卡諾影展 Locarno FF
▌ 1966 坎城影展 Cannes

DIRECTOR
米克羅斯·楊秋 Miklós JANCSÓ
PRODUCER
István DAUBNER
SCREENPLAY
Gyula HERNÁDI
CINEMATOGRAPHER
Tamás SOMLÓ
EDITOR
Zoltán FARKAS
SOUND
Zoltán TOLDY
CAST
János GÖRBE
Zoltán LATINOVITS
András KOZÁK
Tibor MOLNÁR
PRINT SOURCE
National Film Institue Hungary

06.22 SAT 13:40 華山 SHC 1｜06.24 MON 20:50 華山 SHC 2｜06.30 SUN 18:20 華山 SHC 2

寂寞換換屋
The Lady from Constantinople

匈牙利 Hungary ｜ 1969 ｜ B&W ｜ 77min

亞洲首映
Asian Premiere

數位修復
Restored

一位孤獨的年長婦人住在布達佩斯的一間大公寓裡，因故被迫離開目前的居所，搬到一間較小的公寓生活。搬遷，令老婦的獨居生活產生巨大的改變。各種記憶湧現，她重新適應新的環境，與各類性格迥異的鄰居相遇。

本片是匈牙利直接電影先鋒尤迪特·艾萊克執導的首部劇情長片，她延續其擅長的紀錄片拍攝手法，帶入超現實主義的怪誕幽默；攝影師埃萊梅爾·拉加里運用輕便、可自由移動的手持攝影機深入拍攝人們的日常生活場景。電影細膩地描繪1960年代的城市氛圍、布達佩斯高昂的居住現實，以及奠基於此而生的人際互動。

尤迪特·艾萊克：「我開始閱讀這些租屋廣告，漸漸地，我對這裡的氛圍、這些人和他們遭遇的問題產生了興趣。我意識到他們不僅在尋找居住的地方，而且在尋找朋友。這個故事的想法就這樣誕生了。」

An elderly lady decides she wants to exchange her two-room flat for something smaller. The storm of people interested rattles her solitary life with short-lived acquaintances, connecting her with strangers for just a brief moment. Judit Elek's first feature film is a sensitive portrait of loneliness and human relations painted through unusual everyday scenes and delicately grotesque humor. Several scenes in the film were shot in documentary style with random people walking down the street.

尤迪特·艾萊克，匈牙利新浪潮中少數的女性導演。1937年出生於布達佩斯，畢業於布達佩斯戲劇與電影學院導演系，於Mafilm製片廠展開創作生涯，為匈牙利直接電影的代表人物之一，創作包含紀錄片、劇情片與實驗電影，是貝拉巴拉茲製片廠的創始成員之一。

Judit ELEK is a Hungarian director and screenwriter born in 1937. A founding member of Béla Balázs Studio, she is one of the most significant figures in Hungarian film history. She has appeared at Cannes on four occasions and is the holder of many European and international festival prizes.

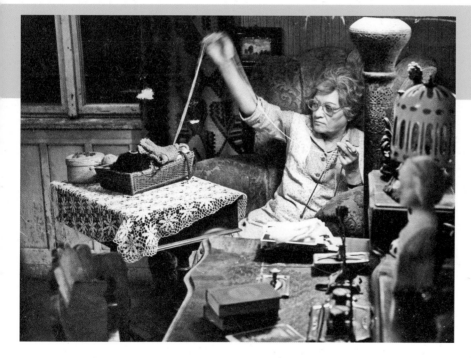

1969 紐約影展 New York FF

DIRECTOR
尤迪特·艾萊克 Judit ELEK
PRODUCER
Lajos KISS
András NÉMETH
SCREENPLAY
尤迪特·艾萊克 Judit ELEK
Iván MÁNDY
CINEMATOGRAPHER
埃萊梅爾·拉加里 Elemér RAGÁLYI
EDITOR
Sándor BORONKAY
MUSIC
Vilmos KÖRMENDI
SOUND
Károly PELLER
CAST
Manyi KISS
István DÉGI
Ági MARGITAI
PRINT SOURCE
National Film Institute Hungary

06.22 SAT 14:50 華山 SHC 2 ｜ 06.28 FRI 15:50 華山 SHC 2 ｜ 06.30 SUN 11:10 華山 SHC 2

導演流浪指南
The Upthrown Stone

匈牙利 Hungary｜1969｜DCP｜B&W｜89min

數位修復
Restored

鐵路工人之子夢想著就讀電影學院成為導演，但因父親的政治背景含冤入獄，使兒子的人生留下污點，無法進入國立大學。他好不容易找到一份土地測量員的工作，在蘇聯共產黨推動農業集體化的時期，隨隊走訪不同的村落，過程中，他見識到形形色色的廣大工農民，並親眼目睹當局對羅姆人的粗暴待遇。勞動者一張張布滿風霜的臉龐，他們是人民歷史的見證者；而攝影技術，則為時代寫下註腳。

本片為匈牙利新浪潮導演、攝影師桑多爾·薩拉執導的首部長片，具有強烈的現代主義風格，帶有濃厚的自傳性色彩，被認為是他最重要的作品之一。在著名作曲家索爾洛西的樂音烘托下，

攝影鏡頭細細地凝視人們的臉龐，跨越族裔、職業、城鄉，呈現匈牙利在共產黨統治時期的基層人民群像。本片於1968年入選坎城影展，但因五月學運影展停辦，而未能放映。

Director and cinematographer Sándor Sára's first feature film is an extraordinary modernist production and autobiographical work from the Hungarian New Wave. Balázs Pásztor's father is innocently imprisoned in the 50s, while Balázs is rejected by the University of Film when he applies to study directing. Working as a land surveyor during the communist collectivisation, he attempts to organize a farm base with a Greek partisan couple, who are eventually killed by farm workers. Sára works with long, geometrical stills to portray suffering and the absurdity of the age.

桑多爾·薩拉（1933-2019），匈牙利導演、攝影師，拍攝紀錄片入行，也參與劇情電影。與新浪潮導演包含伊斯特凡·加爾·費倫茨·科薩、伊斯特凡·沙寶等人合作過。影像風格豐富，擅長以長鏡頭詩意地呈現自然地景。

Sándor SÁRA (1933-2019) was a Hungarian director and cinematographer. He began his career making documentaries and also participated in narrative films, collaborating with many filmmakers from the Hungarian New Wave. He was known for his rich visual style and poetic long shots of natural landscapes.

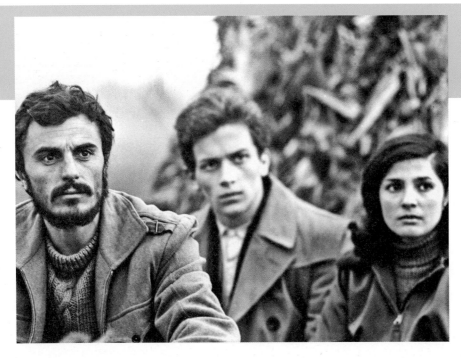

▌1968 坎城影展 Cannes

DIRECTOR, CINEMATOGRAPHER
桑多爾·薩拉 Sándor SÁRA
PRODUCER
Lajos GULYÁS
SCREENPLAY
桑多爾·薩拉 Sándor SÁRA
Sándor CSOÓRI
Ferenc KÓSA
EDITOR
Mihály MORELL
MUSIC
安德拉斯·索爾洛西 András SZŐLLŐSY
SOUND
György PINTÉR
CAST
Lajos BALÁZSOVITS
Todor TODOROV
Nagyezsda KAZASZJAN
Kati BEREK
János PÁSZTOR
József BIHARI
László BÁNHIDI
Tibor MOLNÁR
PRINT SOURCE
National Film Institute Hungary

06.23 SUN 21:10 華山 SHC 2 ｜ 06.25 TUE 20:20 華山 SHC 2 ｜ 06.28 FRI 16:00 華山 SHC 1

英國之旅有沒有
Holiday in Britain

匈牙利 Hungary | 1975 | DCP | Color | 84min

少年先鋒隊的幹部被黨指派要找一位會演奏樂器、工人階級出身、學業出色的青年入隊，在一所名不見經傳的鄉間學校裡，年輕的吉他手被黨看上，成為前往英國一個月巡演的不二人選。過程中發生各種的大小插曲，展現一般農民家庭和青年組織面對眼前黨指派任務的不同處境與態度，具體而微地展現政客的老練、人民的真誠。

電影依據一位鄉村青年的故事為雛形創作，為他量身打造這齣帶有詼諧、逗趣調性的幽默喜劇，片中角色由素人擔綱，多以即興演出、紀錄片般的紀實手法拍攝，看似信手捻來的環節，卻處處可見細心安排的喜劇細節。本片是以拍攝具社會意義之紀錄片聞名的「布達佩斯學派」的開山之作，以寫實的諷刺與幽默，呈現逐漸浮現的社會主義危機。

The head of the administrative district receives good news: one lucky pioneer has the chance to go to Britain on holiday for 30 days. The office machinery immediately starts up and the choice falls on eighth grader Tibi Balogh. A diligent student, he can play the guitar and his parents are working class, perfectly in line with bureaucratic expectations. The party comrades rush down to the village to impart the joyous news. István Dárday and Györgyi Szalai reveal the slow decay behind the calm surface of socialism by focusing on everyday moments, tentative glimpses and gestures.

伊斯特萬・達代，1940年出生於布達佩斯，畢業於布達佩斯戲劇與電影學院。七〇年代參與貝拉巴拉茲製片廠紀錄片製作，為「布達佩斯學派」的核心人物，長期與吉爾吉・薩萊合作，兩人曾獲得布達佩斯紀錄片影展終身成就獎肯定。

István DÁRDAY made his first documentary feature, *Holiday in Britain*, in 1974 at Béla Balázs Studio. In the 1970s and 1980s, he became a central figure of the Budapest School, an internationally recognized documentary style. He is a long-time collaborator of screenwriter Györgyi Szalai.

1975 曼海姆影展首獎 Grand Prize, IFF Mannheim-Heidelberg

DIRECTOR
伊斯特萬・達代 István DÁRDAY
PRODUCER
János BÓDIS
SCREENPLAY
伊斯特萬・達代 István DÁRDAY
吉爾吉・薩萊 Györgyi SZALAI
CINEMATOGRAPHER
路易斯・寇坦 Lajos KOLTAI
EDITOR
Andrásné KÁRMÉNTŐ
MUSIC
Antal SOLYMOS
Imre PAPP
Gábor PRESSER
László TOLCSVAY
SOUND
György KOVÁCS
CAST
Kálmán TAMÁS
Kálmánné TAMÁS
József BORSI
Mária SIMAI
István MÁRTON
PRINT SOURCE
National Film Institute Hungary

06.21 FRI 20:20 華山 SHC 2 | 06.27 THU 21:00 華山 SHC 2 | 07.02 TUE 15:10 華山 SHC 2

布達佩斯：浪潮最前線——
BBS貝拉巴拉茲製片廠
BUDAPEST: RIDING ON THE
CREST—BÉLA BALÁZS STUDIO

貝拉巴拉茲製片廠是匈牙利新浪潮的創新發電機，敞開雙手擁抱不同背景的創作者，帶來全新視野，讓影像美學在此混種、變形，以全新方式詮釋真實，實驗視覺語言。

Béla Balázs Studio was an innovative powerhouse of the Hungarian New Wave that openly embraced filmmakers from diverse backgrounds. It ushered in a fresh perspective, providing a place where visual aesthetics could be intermingled and transformed, paving the way for new ways to interpret reality and the experimentation of visual language.

再見同學會
Instructive Story

匈牙利 Hungary｜1976｜DCP｜B&W｜143min

一場時隔八年的同學聚會暗潮洶湧，昔日情人聚首，眼神游離追憶你儂我儂，還有當年那起始料未及的墜樓事件，在每個人心頭留下難以抹平的傷口。15、16歲荳蔻年華，小團體曾經為何凝聚，最終又為何分離？當年自傷的女孩現身說法，連女孩母親也親臨現場。嫉妒、罪咎、困惑、絕望……記憶在口述重構中扭曲，真相在控訴與辯護中飄移，直到最後，看見最赤裸又脆弱的人性。

流動的運鏡徘徊於人物間，採擷多方視角，時而沉靜旁觀，時而探入特寫，影片以獨具一格的紀實手法，錄下一群年輕生命的青春追憶。重見老友、言詞交鋒、復訪現場，在高密度的

自清與詰問中戲劇高潮迭起，模糊日常與展演的分際。直到片中人也不知不覺走入故事，成為重建的一環，在表象的真實之外，展露出豐富且深刻的紀錄層次。

It is rare for the subjects of teen coming of age, personal fulfillment and emotional crises to come into the focus of documentary filmmakers so crisply, clearly, and yet with such nuance. The exceptional sensitivity of Judit Ember is manifested in the way that, as an artist, she takes a step back, allowing the characters to reveal themselves and discuss — from the perspective of seven years — the fateful period they once lived together. Facing up to the past and recognizing personal responsibility for others is never easy, but the film clearly shows why we have a desperate need for this.

尤迪特・恩貝爾（1935-2007），生於匈牙利，以紀錄片《The Resolution》在國際影壇聞名。喜好處理被大眾媒體忽視的題材，創作多部挑戰社會禁忌的禁播紀錄片，致力於探索真實事件背後的歷史脈絡，讓沉寂多時的人物在片中發聲。

Judit EMBER (1935-2007) is a Hungarian filmmaker who began as a contractor for TV Híradó (News) in the early 1960s before joining Popular Science Studio in 1968 and Mafilm in 1970. She was also an active member of Béla Balázs Studio, where she made primarily sociographical documentaries and documentary features.

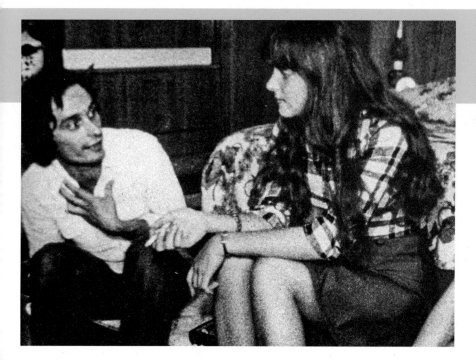

DIRECTOR
尤迪特・恩貝爾 Judit EMBER
PRODUCER
貝拉巴拉茲製片廠 Béla Balázs Studio
CINEMATOGRAPHER
János ILLÉS
EDITOR
Zsuzsa KONDOR
SOUND
István SIPOS
CAST
István ALMÁSI
Gizella WAISZ
Sándor HERPAI
PRINT SOURCE
National Film Institute Hungary

06.23 SUN 14:00 華山 SHC 2 ｜ 06.26 WED 20:30 華山 SHC 2 ｜ 06.28 FRI 11:00 華山 SHC 2

特務情謎
Mole

匈牙利 Hungary｜1987｜DCP｜B&W｜74min

一名來歷不明的天外飛「諜」，跳傘降落到某座靜謐林野中。他行事謹慎、刻意匿蹤，嘗試無痕融入當地環境，冷靜觀察風土民情。然而，從遇見一名慵懶自在的絕世美女開始，本應保持距離、隱身潛伏的他，逐漸迷失於悠然循環的時間、如詩如畫的生活，以及悸動難平的情感之間……。

大師級名導伊爾蒂蔻‧恩伊達初出茅廬時，曾於匈牙利影像藝術重鎮——貝拉巴拉茲製片廠進行創作。與貝拉‧塔爾等巨匠分庭並進，恩伊達以極具實驗精神的電影語言，細膩譜寫奇詭神祕，卻又浪漫滿懷的人間日記，奠定了穿透現實與夢魘的獨到風格。相較於一鳴驚人的《我的二十世紀》和成熟完滿的《夢鹿情謎》，本片架構出宛若柏拉圖洞穴寓言般的全景幻境故事，兼具哲學深度與自然詩意，令人得見恩伊達作品粗礪大膽的另類面貌。

A mysterious secret agent arrives on planet Earth. According to his information, this area should have no trace of life, but to his astonishment he detects the presence of humans. He closely observes them from his hiding place, but after a time, a meeting is unavoidable. However, it suddenly hits him that they don't even sense his presence...

伊爾蒂蔻‧恩伊達，1955年生於布達佩斯，匈牙利著名導演、編劇。1989年曾以《我的二十世紀》於坎城影展獲金攝影機獎；1994年再以《魔幻獵人》提名威尼斯影展金獅獎；2017年更以代表作《夢鹿情謎》獲柏林影展金熊獎殊榮及奧斯卡最佳外語片提名。

Ildikó ENYEDI made her first short at Béla Balázs Studio as a third-year university student. Her feature film, *My 20th Century*, won a Golden Camera at Cannes. *On Body and Soul* won a Berlinale Golden Bear and was nominated for Best Foreign Language Film at the Oscars.

DIRECTOR
伊爾蒂蔻‧恩伊達 Ildikó ENYEDI
PRODUCER
Mónika RÓTA
SCREENPLAY
László RÉVÉSZ
伊爾蒂蔻‧恩伊達 Ildikó ENYEDI
CINEMATOGRAPHER
Tibor KLÖPFLER
EDITOR
Mariann DÓZSA
SOUND
Ottó OLÁH
CAST
Andor LUKÁTS
Rozi BÉKÉS
Tamás ERÖS
János SUGÁR
PRINT SOURCE
National Film Institute Hungary

06.22 SAT 20:50 華山 SHC 2 ｜ 06.28 FRI 14:00 華山 SHC 2 ｜ 07.02 TUE 19:20 華山 SHC 2

布達佩斯：BBS 短片選
BUDAPEST: BBS SHORT
FILMS COLLECTION

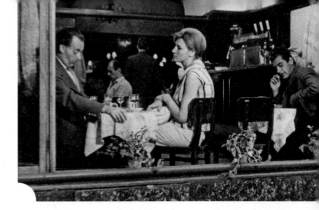

流浪者藍調
Gypsies

亞洲首映 Asian Premiere　數位修復 Restored

匈牙利 Hungary ｜ 1962 ｜ DCP ｜ Color ｜ 18min

電影開宗明義地揭示匈牙利境內羅姆人的處境。他們被視為次等公民，以各種理由被迫遷離生活的環境，缺乏足夠的教育與醫療資源，死亡、病痛如影隨形。導演以一張張關於羅姆人的靜態攝影，和貼近生活的紀實影像，呈現羅姆人的生活百態，在傳唱的歌謠與誦唱祝禱聲中，孩子們述說著他對社會現實的關注與人道關懷。

A lyrical yet passionate "situation report" on the living conditions of Hungarian Gypsies. With this, his first significant work, Sándor Sára, who went on to become one of the most influential figures in Hungarian cinema as both cinematographer and director, aimed not only to document but also to take a standpoint on this critical topic. The exposition of the film determines the context: newspaper articles and socio-photos reporting on the plight of the Roma, listing numbers and statistics, and in the follow-on, Sára depicts the problem through motion pictures.

DIRECTOR, SCREENPLAY
桑多爾・薩拉 Sándor SÁRA
PRODUCER
András NÉMETH
CINEMATOGRAPHER, EDITOR
伊斯特凡・嘉爾 István GAÁL
SOUND
Gyula NOVÁK
PRINT SOURCE
National Film Institute Hungary

桑多爾・薩拉（1933-2019），匈牙利導演、攝影師，拍攝紀錄片入行，也參與劇情電影。與新浪潮導演包含伊斯特凡・嘉爾、費倫茨・科薩、伊斯特凡・沙寶等人合作過。影像風格豐富，擅長以詩意長鏡頭呈現自然地景。

Sándor SÁRA (1933-2019) was a Hungarian director and cinematographer. He began his career making documentaries and also participated in narrative films, collaborating with many filmmakers from the Hungarian New Wave. He was known for his rich visual style and poetic long shots of natural landscapes.

愛在下午邂逅時
Encounter

亞洲首映 Asian Premiere　數位修復 Restored

匈牙利 Hungary ｜ 1963 ｜ DCP ｜ Color ｜ 22min

護士巡視病房展開一日的工作。日復一日，她往返於醫院與自家、工作與生活之間，平凡而規律。某天，她鼓起勇氣約了徵友啟事的對象見面，兩人約在陽光明媚的公園，一邊散步一邊聊天，聊興趣、過去、未來規劃、工作的意義。電影以護士的一天，呈現時代女性的樣貌，自信且獨立。

The first Hungarian cinéma direct film is the story of a classified ad. A nurse and a bachelor meet with the intention of going to the cinema but they cannot get tickets. Instead, they sit down in a cafeteria and talk. All dialogue between the nurse and the creative colleague of Judit Elek, the writer Iván Mándy, is improvised.

▍2023 鹿特丹影展 IFF Rotterdam

DIRECTOR, SCREENPLAY
尤迪特・艾萊克 Judit ELEK
PRODUCER
István DAUBNER
CINEMATOGRAPHER
István ZÖLDI
EDITOR
米克羅斯・楊秋 Miklós JANCSÓ
MUSIC, SOUND
安德拉斯・索爾洛西 András SZÖLLÖSY
CAST
Iván MÁNDY
PRINT SOURCE
National Film Institute Hungary

尤迪特・艾萊克，匈牙利新浪潮中少數的女性導演。1937年出生於布達佩斯，畢業於布達佩斯戲劇與電影學院導演系，於 Mafilm 製片廠展開創作生涯，為匈牙利直接電影的代表人物之一，創作形式多元，是貝拉巴拉茲製片廠的創始成員之一。

Judit ELEK is a Hungarian director and screenwriter born in 1937. A founding member of Béla Balázs Studio, she is one of the most significant figures in Hungarian film history. She has appeared at Cannes on four occasions and is the holder of many European and international festival prizes.

布達佩斯：BBS 短片選 I

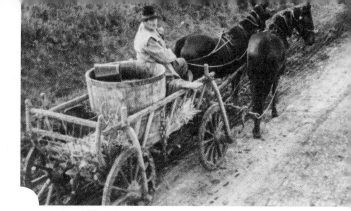

我眼裡的妳
You

匈牙利 Hungary ｜ 1963 ｜ DCP ｜ Color ｜ 11min

影片以一個小小的請求開始。女孩要眼前的男子為她作畫，男子回應自己不是畫家。繪畫無法捕捉人物的動作，而動作，對他來說才能呈現一個人的精神內涵。攝影機追隨女孩碎步輕巧地行走在熱鬧街上，舉手投足之間散發著青春活力；她一路觀察周邊的人事物，不時端詳自己的各種倒影。這是一則輕快的都市物語，也是創作者對電影藝術的浪漫告白。

The young and radiant Cecília Esztergályos stars in this short film evoking the French New Wave style. Every detail in this etude of fragmented structure bears significance. The evanescence of any given minute is important, the impressions that moments stacked one on top of another leave in the viewer.

良駒輓歌
Elegy

匈牙利 Hungary ｜ 1965 ｜ DCP ｜ Color ｜ 21min

原野上奔馳的駿馬，飛揚的馬鬃充滿光澤，馴馬的老牧民以溫和的眼神，靜靜地凝視著眼前的一切，靜與動，攝影機一一捕捉，那如油畫般的影像質地，散發出萬物的靈魂內裡。枯樹、飛鳥、馬匹，照顧馬的人與靠馬賺錢的人，那些即將凋零、步入遲暮的職業人們與躺在血泊中的生靈，在歷史檔案影像的蒙太奇交織下，一曲從田園牧歌揭開序幕的馬之輓歌緩緩演出時代的悲哀。

Elegy is a unique motion picture experiment that created a new way of seeing things. The film was made at Béla Balázs Studio, which that was always supportive of uncompromising experimentation. The concept was originally inspired by the 1963 poem Búcsúzik a lovacska (The Little Horse Says Goodbye) by Nagy László. Director Zoltán Huszárik produced numerous sketches prior to filming and the remarkable imagery of the work was worked out in collaboration with cinematographer János Tóth.

■ 1963 坎城影展短片特別提及
Special Mention, Short Film, Cannes

■ 1966 奧柏豪森短片影展最佳短片
Best Short Film, ISFF Oberhausen

DIRECTOR, PRODUCER, SCREENPLAY
伊斯特凡·沙寶 István SZABÓ
CINEMATOGRAPHER
Thomas VÁMOS
EDITOR
亞諾斯·羅薩 János RÓZSA
SOUND
Nándor SÁDRI
CAST
Cecília ESZTERGÁLYOS
PRINT SOURCE
National Film Institute Hungary

伊斯特凡·沙寶，為國際上知名的匈牙利導演之一。作品《千面惡魔》為匈牙利贏得首部奧斯卡最佳外語片，1985 年《雷德爾上校》則獲得坎城影展評審團大獎，同為貝拉巴拉茲製片廠創始成員之一。

István SZABÓ is the most internationally acclaimed Hungarian filmmaker since the 1960s. A founding member of Béla Balázs Studió, he is an important director of the Hungarian New Wave. His films have won almost 40 awards worldwide, with *Mephisto* (1981) winning the Oscar for Best Foreign Language Film.

DIRECTOR, SCREENPLAY
佐爾坦·胡薩里克
Zoltán HUSZÁRIK
PRODUCER
Jenő GÖTZ
CINEMATOGRAPHER
亞諾斯·托許 János TÓTH
EDITOR
Mihály MORELL
MUSIC
Zsolt DURKÓ
SOUND
Ferenc CSONKA
PRINT SOURCE
National Film Institute Hungary

佐爾坦·胡薩里克（1931-1981），1931 年出生於匈牙利，1950 年代於布達佩斯學習拍電影，拍攝有多部實驗短片與兩部長片，本片為其首部短片作品。六〇年代自電影學院畢業後，跨域嘗試各種工作，包括導演、平面設計師、書籍插畫家和電影製片。

Zoltán HUSZÁRIK (1931-1981) was born in Hungary and studied filmmaking in Budapest in the 1950s. He directed several experimental short films and two feature films. His career spanned various fields including directing, graphic design, book illustration, and film production.

06.22 SAT 16:50 華山 SHC 2 ｜ 06.29 SAT 19:10 華山 SHC 2

布達佩斯：BBS 短片選 II

長跑英雄
The Long Distance Runner

匈牙利 Hungary | 1968 | B&W | 14min

本片是導演久拉·葛茲達的首部紀錄片。運動員展開艱鉅的長跑任務，下定決心挑戰從布達佩斯起跑一路向東，跑到匈牙利東邊的小鎮肯代賴什，連跑128公里。攝影機與世人的目光如影隨形，一路拍攝報導，人人都對這場意志力的大考驗感到好奇。本片利用雙重角度呈現後座力強大的諷刺，一面記錄一個運動員以行動為自己的國家爭取更大的榮耀，一面呈現當局官員的自大與迂腐。

Taxi driver and marathon runner György Schirilla covers the distance from Budapest to Kenderes in order to inaugurate a bistro in the village in his honor. Director Gyula Gazdag does nothing more than record events, while petty socialism, dilettantism, and the need for attention do the rest.

DIRECTOR, SCREENPLAY, EDITOR
久拉·葛茲達
Gyula GAZDAG
PRODUCER
Lajos GULYÁS
CINEMATOGRAPHER
Péter JANKURA
SOUND
Ernő WECHTER
CAST
György SCHIRILLA
PRINT SOURCE
National Film Institute Hungary

久拉·葛茲達，創作橫跨影視與劇場，拍攝紀錄片也創作劇情電影。多數作品在匈牙利共產主義時代被禁演，代表作包含獲得盧卡諾影展評審團特別獎、入選坎城影展導演雙週的《A Hungarian Fairy Tale》，九〇年代後於加州大學洛杉磯分校任教，並活躍於國際影壇。

Gyula GAZDAG was born in Budapest in 1947. He is best known for his satirical documentaries made at Béla Balázs Stúdió, becoming one of the most banned filmmakers in Hungary between the early 1970s and mid-1980s. His works mostly revealed the ludicrous absurdity of the communist system.

白色奇想曲
Capriccio

匈牙利 Hungary | 1969 | DCP | Color | 18min

隆冬雪地裡，萬物俱寂，孩子們打著雪仗的歡笑聲劃破孤絕。林裡的禽鳥，成群結隊地穿梭在高冷的枝頭，各種造型的雪人為色調單一的凜冬增添色彩。風中飄搖的火光，蠟燭在高溫的推進下消融，寒冷的冬日也是。林中迴盪著交響樂曲，雪人們列隊，似是為即將離去的冰封悼念，迎來下一個生命的起頭。

Birds, trees, clouds, the changing seasons — and snowmen. Images of birth, mortality and rebirth are intertwined in this agelessly wise short.

DIRECTOR, SCREENPLAY
佐爾坦·胡薩里克
Zoltán HUSZÁRIK
PRODUCER
Jenő GÖTZ
Péter MAGYAR
CINEMATOGRAPHER, EDITOR
亞諾斯·托許 János TÓTH
MUSIC
佐頓·傑涅 Zoltán JENEY
PRINT SOURCE
National Film Institute Hungary

佐爾坦·胡薩里克（1931-1981），1931年出生於匈牙利，1950年代於布達佩斯學習拍電影，拍攝有多部實驗短片與兩部長片，本片為其首部短片作品。六〇年代自電影學院畢業後，跨域嘗試各種工作，包括導演、平面設計師、書籍插畫家和電影製片。

Zoltán HUSZÁRIK (1931-1981) was born in Hungary and studied filmmaking in Budapest in the 1950s. He directed several experimental short films and two feature films. His career spanned various fields including directing, graphic design, book illustration, and film production.

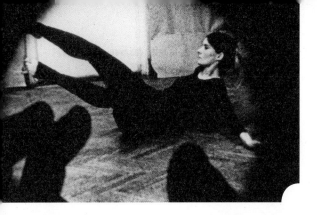

前衛四品
Four Bagatelles

匈牙利 Hungary｜1975｜DCP｜B&W｜28min

本片為貝拉巴拉茲製片廠製作之《Film Idiom》系列之一，集結四段影像：人們跳舞的畫面、英國攝影師邁布里奇的攝影運動理論，以及癮君子討論著酒醉與清醒的文化意義，以此提出分析電影的語言結構，並以影像實驗實踐電影藝術。場景轉換在田園風光與現代風格的工作室，在看似無關的圖像間，產生迴聲與變奏的張力，於影格的縫隙間創造意義。

The title refers to short and inventive musical pieces, bagatelles, and miniature slices of reality which can take on different interpretations when filmed and transformed on the animation table. It comprises four short finger exercises made within the framework of the Film Idiom series in Béla Balázs Studio.

DIRECTOR
加博・柏迪 Gábor BÓDY
PRODUCER
貝拉巴拉茲製片廠
Béla Balázs Studio
CINEMATOGRAPHER
György MARTIN
Zsolt HARASZTI
加博・柏迪 Gábor BÓDY
PRINT SOURCE
National Film Institute
Hungary

加博・柏迪（1946-1985），1946年出生於布達佩斯，為匈牙利電影新浪潮貝拉巴拉茲製片廠重要成員之一，以實驗性的電影語言著稱。1973年他在製片廠旗下創辦實驗電影團體K3，重塑了戰後匈牙利前衛電影的發展道路。1985年，以39歲的年紀英年早逝，至今死因成謎。

Gábor BÓDY (1946-1985) became influential during his time at Béla Balázs Studio. His debut film, *American Torso*, showcased his experimental style. Despite completing his final film, *Dog's Night Song*, in 1985, his death under mysterious circumstances, amidst allegations of collaboration with the Hungarian Secret Police, remains unresolved.

她的掌心
In Woman's Hands

匈牙利 Hungary｜1981｜DCP｜Color｜24min

飛馳的列車上，身穿紅色毛衣的男子穿過一節節車廂，一名白衣女子手持相機尾隨在後，轉瞬之間，他以迅雷不及掩耳的動作將女子迷昏後離去。包廂裡，一位神祕的女子與他大聊掌紋手經，一桌牌卡勾起男子久未觸及的過去。畫面上不斷閃現的SEX字樣，跳動的火紅，種種視覺符碼預示著男子內心所慾望的未來。

A train rattles through the night, a young man flees down narrow corridors ahead of an elegant blonde. Later, he finds himself sitting in the coupé of a strange fortune teller who tells him she sees an impending train crash in his life...

1981 奧柏豪森短片影展 ISFF Oberhausen

DIRECTOR
亞諾斯・桑圖斯 János XANTUS
PRODUCER
Gyuláné GROSZ
SCREENPLAY
György KOZMA
亞諾斯・桑圖斯 János XANTUS
CINEMATOGRAPHER
András MATKÓCSIK
EDITOR
Marianna MIKLÓS
MUSIC
István MATÚZ
SOUND
Béla PROHÁSZKA
CAST
亞諾斯・桑圖斯 János XANTUS
Marietta MÉHES
Andor LUKÁTS
PRINT SOURCE
National Film Institute
Hungary

亞諾斯・桑圖斯（1953-2012），1953年出生於布達佩斯，1979年畢業於表演藝術學院，主修電影導演。創作初期在貝拉巴拉茲製片廠拍攝短片，1983年完成首長片《Eskimo Woman Feels Cold》。九〇年代，他開始在表演藝術學院授課，並擔任舞台劇導演。

János XANTUS (1953-2012) was born in Budapest in 1953. After directing short feature films with Béla Balázs Studio, he made his first feature film, *Eskimo Woman Feels Cold*, in 1983. Has began lecturing at the Academy of Performing Arts in 1992 and has also directed for the stage.

06.23 SUN 17:00 華山 SHC 2 ｜ 06.29 SAT 21:00 華山 SHC 2

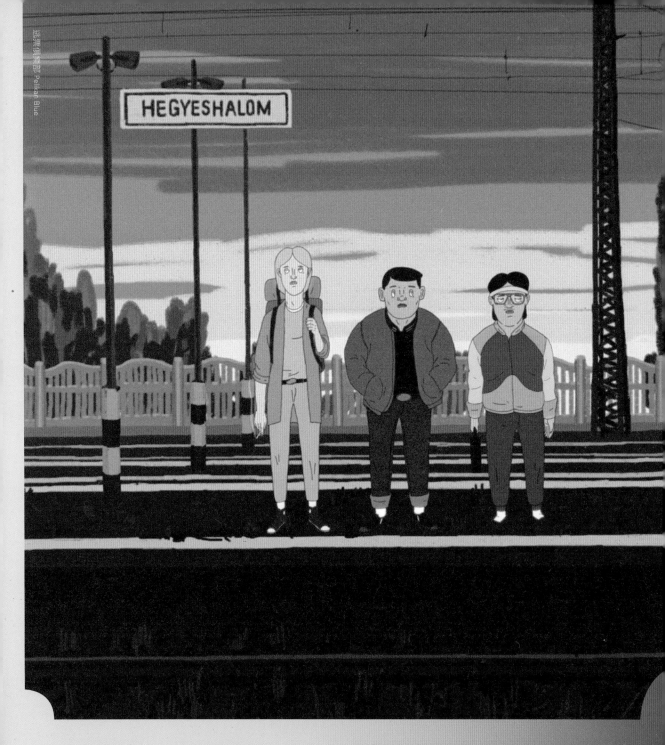

迷票俱樂部 Pelikan Blue

布達佩斯：當代精選
BUDAPEST: CONTEMPORARY PANORAMA

集結匈牙利名家與新銳最新作品，《海上鋼琴師》攝影師執導演筒拍出年度匈牙利國片票房冠軍，還有威尼斯影展獲獎新銳之作，以當代視角回顧歷史，也觀照當下社會脈動。

A collection of the latest works from renowned Hungarian filmmakers and emerging talents, including the top-grossing Hungarian film of the year directed by the cinematographer of *The Legend of 1900*, as well as the Venice FF award-winning work of an emerging director, offering a modern perspective on history while also reflecting on the pulse of contemporary society.

解釋的總和
Explanation for Everything

匈牙利、斯洛伐克 Hungary, Slovakia｜2023｜DCP｜Color｜152min

畢業口試前夕，少年墜入愛河，被死黨女同學深深吸引，未料她卻單相思似地喜歡著歷史老師；好巧不巧，歷史老師曾與少年的保守派父親有過衝突。荒謬的四角關係，從學生時期懵懂純愛，爬升至大人世界互不相讓。壓力環繞追撞，一場失敗的畢業考試，一段臨時起心動念的謊話，戳刺國族符號的敏感神經，最後演變成社會輿論關注的政治事件，少年的青春心思，究竟又該何處安放？

匈牙利新銳導演細察社會現象，以觀點兩極對立、民眾停止溝通的政治環境出發。手持鏡頭攝影，風格受羅馬尼亞新浪潮的自然主義啟發，輔以作者對於立場不同、各派觀點的深度同理心，電影結構更為別出心裁，以不同角色觀點穿梭於相同時間，反覆堆疊，最終以青少年的慘綠憂愁為引，呈現對匈牙利政治現實之層層感知。

It's summer in Budapest, and high school student Abel is struggling to focus on his final exams while coming to the realization that he is hopelessly in love with his best friend, Janka. The studious Janka has her own unrequited love with married history teacher Jakab, who had a previous confrontation with Abel's conservative father. The tensions of a polarized society come unexpectedly to the surface when Abel's history graduation exam turns into a national scandal.

嘉博·雷茲，1980年生，匈牙利電影導演，於羅蘭大學主修電影史及理論，並在布達佩斯戲劇與電影學院攻讀電影創作。首部劇情長片《魯蛇又怎樣》與《爛情詩》接連獲得國際影展與票房肯定，是匈牙利電影界重要新銳之一。

Gábor REISZ is a Hungarian filmmaker. His debut feature, *For Some Inexplicable Reason* (2014), premiered at Karlovy Vary IFF. He developed his second feature, *Bad Poems* (2018), during Cannes' Residence program. The film went on to win 16 awards, including the Grand Prize of Hungarian Film Week in 2019.

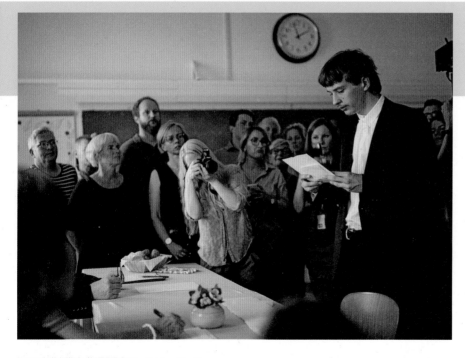

■ 2024 紐約新導演／新電影影展 New Directors / New Films
■ 2023 芝加哥影展金雨果獎最佳劇情長片、銀雨果獎最佳編劇 Gold Hugo for Best Feature, Silver Hugo for Best Screenplay, Chicago IFF
■ 2023 威尼斯影展地平線單元最佳影片 Best Film, Orizzonti, Venice FF

DIRECTOR
嘉博·雷茲 Gábor REISZ
PRODUCER
Júlia BERKES
SCREENPLAY
嘉博·雷茲 Gábor REISZ
Éva SCHULZE
CINEMATOGRAPHER
Kristóf BECSEY
EDITOR
Vanda GORÁCZ
嘉博·雷茲 Gábor REISZ
MUSIC
András KÁLMÁN
嘉博·雷茲 Gábor REISZ
SOUND
Richard FŰLEK
Péter BALOGH
CAST
Gáspár ADONYI-WALSH
István ZNAMENÁK
András RUSZNÁK
Rebeka HATHÁZI
Eliza SODRÓ
Lilla KIZLINGER
Krisztina URBANOVITS
PRINT SOURCE
Films Boutique

06.25 TUE 14:20 華山 SHC 1 ｜ 06.28 FRI 13:00 信義 HYC 11 ｜ 07.01 MON 20:20 華山 SHC 1

逃票俱樂部
Pelikan Blue

匈牙利 Hungary｜2023｜DCP｜Color｜79min

© Palos Gyorgy

1989年10月，鐵幕解除，匈牙利邊界開放，「自由民主」的新鮮空氣湧入，社會風氣驟變。年輕人們無一不想出發壯遊，奈何理想美好，通往大千世界的火車票卻貴到讓人無法負擔。三個年輕朋友突發奇想，著手利用家用工具偽造車票，細心研究、大膽動手，成功瞞天過海。三個人的冒險，很快變成整群年輕人的共同希望，自由的另一端，有什麼樣的命運在等著他們呢？

體裁短小精悍，由大量訪談錄音轉換為動畫形式，結合戲劇重現片段，成就一部讓觀者身歷其境的動畫紀錄片。返回九〇年代東歐，在世界秩序易位的歷史時刻，感受彼時匈牙利青年的樂觀活力，並一睹這座「低成本」犯罪王國，如何成為一整個世代的回憶縮影。

With the fall of the Iron Curtain in the 1990s, travel in Hungary was finally possible but unaffordable.

Ákos, Petya and Laci discover a simple method of using household detergents to dissolve Pelikan's Blue carbon ink, allowing them to forge train tickets to any destination and providing the opportunity for a whole generation to experience the outside world. Over time, they become professional and infamous forgery artists. For a long time, everything goes along smoothly, but when the police start an investigation, the friends discover that freedom comes at a price.

拉斯洛·札基，1977年生於匈牙利，動畫導演、視覺藝術家。以紀錄片、動畫等創作活躍於國際影展，2010年以短片《Tincity》獲得匈牙利電影週最佳紀錄片。現於布達佩斯城市大學動畫系任教。《逃票俱樂部》是他的首部長片。

László CSÁKI is an independent visual artist, animator and animation film director known for his unique chalkboard-drawing style. Several of his animated, documentary and short films have won multiple awards around the world. He has vast experience as an animation tutor at Budapest Metropolitan University (METU), Animation Department.

DIRECTOR, SCREENPLAY
拉斯洛·札基 László CSÁKI
PRODUCER
Miklós KÁZMÉR
Ádám FELSZEGHY
Réka TEMPLE
CINEMATOGRAPHER
Árpád HORVÁTH
EDITOR
Dánel SZABÓ
MUSIC
Ambrus TÖVISHÁZI
Miklós PREISZNER
SOUND
Tamás ZÁNYI
CAST
Norman LÉVAI
Olivér BÖRCSÖK
Ágoston KENÉZ
Kornél TEGYI
Vivien RUJDER
PRINT SOURCE
National Film Institute Hungary

▋ 2024 安錫動畫影展 Annecy IAFF
▋ 2023 塔林黑夜影展 Tallinn Black Nights FF
▋ 2023 都靈影展 Torino FF

06.25 TUE 21:40 信義 HYC 10 ｜ 06.28 FRI 13:30 信義 HYC 10 ｜ 06.30 SUN 19:00 信義 HYC 10

白袍先知：塞麥爾維斯

Semmelweis

匈牙利 Hungary｜2023｜DCP｜Color｜127min

一名年輕的婦產科醫生，為了找出產後高燒的原因，不惜槓上整個醫學界！塞麥爾維斯是個前途無量的醫生，接生過無數新生兒，但同時也無奈送走許多因感染而發燒致死的產婦。他著急地想找出幕後元兇，但萬萬沒想到兇手不只一人。他要如何揭發真相，揪出這群多年來潛伏在城市裡，每間醫院中都有的「看不見」的敵人。

奧斯卡提名的名攝影師路易斯・寇坦於2005年首執導筒，以逃出納粹集中營的傳記名片《非關命運》獲柏林影展金熊獎，一舉成名，相隔18年後，再次挑戰改編被譽為「母親的救世主」的匈牙利傳奇醫生——塞麥爾維斯傳記，寶刀未老，打破匈牙利五年戲院票房紀錄。

Today, Ignaz Semmelweis is remembered as a legend: brave and relentless, a man of both knowledge and hunger for justice. He is known as the savior of mothers for a reason. But in his own time, he was seen in a very different way. The other Hungarian doctors he worked with in the obstetrics clinic in Vienna thought he was mad. The Austrian doctors thought him unbearably violent. He had only one goal in mind, the health of the mothers in his care; and for the sake of this sacred cause, he crossed every barrier and broke every rule.

路易斯・寇坦，1946年出生於布達佩斯，導演、攝影師。以其掌鏡作品《千面惡魔》、《海上鋼琴師》、《陽光情人》、《真愛伴我行》等片聞名國際。2005年以首部執導長片《非關命運》入選柏林影展主競賽。現任教於布達佩斯戲劇與電影學院。

Lajos KOLTAI is an Oscar-nominated cinematographer and director who has worked on both documentary and aestheticist films. He was an Associate Professor at the Department of Moving Image Culture at Eszterházy Károly Catholic University and is currently head of the MA in Film Directing at SZFE.

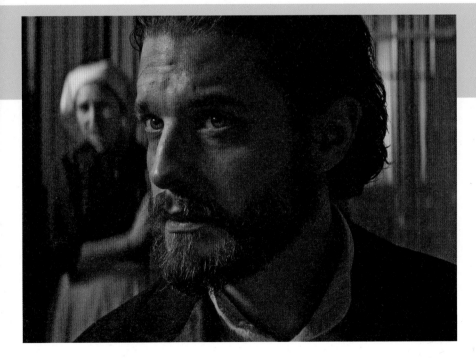

▌2023 洛杉磯匈牙利影展 MOZAIK 獎 MOZAIK Bridging The Borders Award, Hungarian FF Los Angeles

DIRECTOR
路易斯・寇坦 Lajos KOLTAI

PRODUCER
Tamás LAJOS
Joe VIDA

SCREENPLAY
Balázs MARUSZKI

CINEMATOGRAPHER
András NAGY (H.S.C.)

EDITOR
Zoltán KOVÁCS (H.S.E)

MUSIC
Attila PACSAY

SOUND
Rudolf VÁRHEGYI

CAST
Miklós H. VECSEI
Katica NAGY
László GÁLFFI
Tamás KOVÁCS

PRINT SOURCE
National Film Institute Hungary

06.21 FRI 16:00 信義 HYC 11｜06.30 SUN 11:20 中山堂 TZH｜07.02 TUE 15:10 信義 HYC 11

師控正義
Without Air

匈牙利、羅馬尼亞 Hungary, Romania｜2023｜DCP｜Color｜104min

一個空穴來風的家長指控，莫名打在這所匈牙利百年高中的文學老師頭上。她原是學校裡最受學生歡迎，且校長委以重任的明星教師，因為一名男轉學生的到來，讓她從天堂墜落到地獄。她的教師資格受到質疑，校內調查閃電進行，校方立場從支持到底變成曖昧不明，同事為自保而選邊站，學生接連被訊問，一切的一切只因為課堂上一個無心的電影推薦，這堂課在短短幾天內全面失控，她該如何為自己辯護？

導演摩爾多瓦在報紙上發現這起真實的荒謬事件：一次投訴足以摧毀敬業的教師，反思現今匈牙利禁止學校教授LGBT+內容的法案。本片攝影巧妙利用場景空間的畫作與顏色，隱喻現實中

令人窒息的氛圍，使得描繪法律訴訟的場景更加肅穆。女主角微妙詮釋束手無策的憤怒，及吸引人的聲音表現，更完美演繹角色的掙扎。

Ana, a literature teacher, is being accused of misconduct for suggesting Agnieszka Holland's movie— Total Eclipse — to her 17-year-old students. The movie contains homosexuality, which the parents object to. The scandal that follows has unforeseeable consequences upon her life, and the life of her student, Victor, whose father makes the complaint.

As the case ends up in different court investigations, post-socialist fixations come to the surface, and the air around Ana and Viktor slowly disappears. The film explores questions of acceptance, being a teacher, and the nature of power and oppression.

卡塔琳·摩爾多瓦，1982年出生於羅馬尼亞，畢業於布達佩斯城市大學電視電影創作研究所。曾以短片《As Up to Now》入選2019年坎城影展電影基石單元；首部劇情長片《師控正義》於多倫多影展世界首映。

Katalin MOLDOVAI was born in Romania in 1982 and earned her MA in Television and Film Directing at Budapest Metropolitan University. Her latest short, *As Up to Now* (2019), was nominated for the Cinéfondation Award at Cannes. *Without Air* is her first feature film.

DIRECTOR
卡塔琳·摩爾多瓦 Katalin MOLDOVAI
PRODUCER
Béla Attila KOVÁCS
András MUHI
卡塔琳·摩爾多瓦 Katalin MOLDOVAI
SCREENPLAY
Zita PALÓCZI
卡塔琳·摩爾多瓦 Katalin MOLDOVAI
CINEMATOGRAPHER
András TÁBOROSI
EDITOR
Orsolya SOLTÉSZ
MUSIC
Tibor CÁRI
SOUND
Gábor KEREKES
CAST
Ágnes KRASZNAHORKAI
Áron DIMÉNYI
Soma SÁNDOR
Zsolt BÖLÖNYI
Ágnes LRINCZ
PRINT SOURCE
National Film Institute Hungary

▌2023 鐵撒隆尼卡影展 Thessaloniki IFF
▌2023 華沙影展國際影評人費比西獎最佳影片、青年費比西審團獎最佳首部東歐電影
FIPRESCI Prize for Best Film, Young FIPRESCI Jury Award for Best Eastern European Debut Film, Warsaw IFF
▌2023 多倫多影展 Toronto IFF

06.21 FRI 21:00 華山 SHC 1 ｜ 06.27 THU 15:20 華山 SHC 1 ｜ 06.29 SAT 11:40 華山 SHC 2

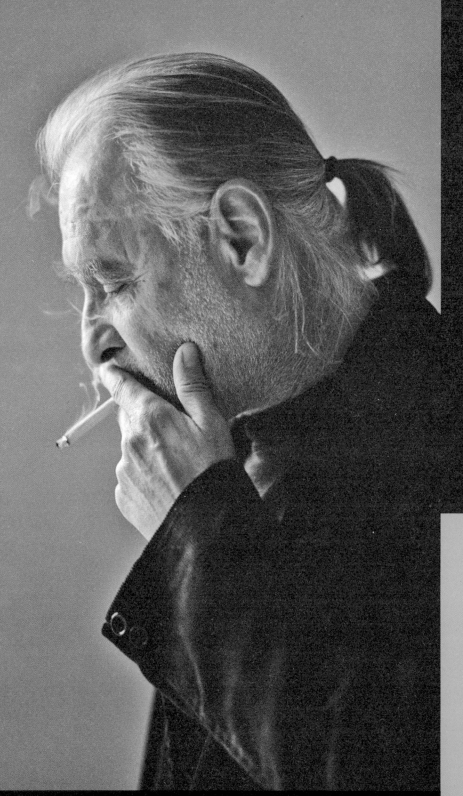

焦點影人：貝拉・塔爾
FILMMAKER IN FOCUS: BÉLA TARR

貝拉·塔爾，1955年生於匈牙利。早期曾演出電視電影，16歲起開始拍攝紀錄短片，內容關注匈牙利貧窮問題與底層工人階級，這些作品引起貝拉巴拉茲製片廠對其關注，並於1977年資助他拍攝首部長片《家庭公寓》，他以低成本、非職業演員之團隊完成作品。爾後就讀布達佩斯戲劇與電影學院，早期作品如《局外人》、《積木生活》延續首部作品對社會現狀的觀察，並融合紀錄片拍攝手法，為忠於寫實主義的「社會電影」（Social Cinema）。

《五個人的幽閉恐懼症》為貝拉·塔爾電影創作風格之分野，他的影像從寫實主義、紀實攝影，轉而關注更形而上、存在主義的哲學思辨，並發展出標誌性的長鏡頭。1988年與小說家拉斯洛·卡勒斯納霍凱合作編劇《媽的毀滅吧》，爾後許多作品亦奠基於文學之上。同樣改編拉斯洛小說之《撒旦的探戈》、《鯨魚馬戲團》，與《媽的毀滅吧》被視為貝拉·塔爾的「文學三部曲」，他亦自此獲國際關注。除以黑白攝影與長鏡頭樹立風格，作品亦具特殊時間、空間感，其敘事常發生在限縮、孤立、荒蕪的空間中，其中人物絕望地走向命定悲劇。

《都靈之馬》上映時貝拉·塔爾稱其為自己最後一部作品。2013年於塞拉耶佛創辦電影學校，他稱之為「電影工廠」（Film Factory）。2017年為荷蘭EYE電影博物館策展，除將過去影像以錄像形式展出，亦使用拍攝到的影像、劇場道具創作，也為此再重拾攝影機，拍攝關於難民的錄像片段。其創作形式與內容均深刻影響匈牙利當代電影。

Béla TARR began his career at 16 as an amateur filmmaker before working at Béla Balázs Studio, where he made his feature debut. He is the president of the Hungarian Filmmakers' Association, a member of the Széchenyi Academy of Letters and Arts, and has been given the most prestigious Hungarian prize for artists, the Kossuth Prize, and the Hungarian prize for filmmakers, the Béla Balázs Prize. He was named a Chevalier dans l'Ordre des Arts et Lettres and was honored with several remarkable national, international awards, honorary doctorates, and life achievement awards.

作品年表 Filmography

1978	瑪格尼錫旅店 Hotel Magnezit	Doc Short	D, W
1979	Cinemarxisme	Short	D
1979	家庭公寓 Family Nest	Feature	D, W
1982	局外人 The Outsider	Feature	D, W
1982	馬克白 Macbeth	TV Movie	D, W
1982	積木生活 The Prefab People	Feature	D, W
1984	五個人的幽閉恐懼症 Autumn Almanac	Feature	D, W
1988	媽的毀滅吧 Damnation	Feature	D, CW
1990	City Life (segment "The Last Boat")	Doc	CD, CW
1994	撒旦的探戈 Sátántangó	Feature	D, CW
1995	Journey on the Plain	Short	D, CW
1998	Passion	Feature	CW
2000	鯨魚馬戲團 Werckmeister Harmonies	Feature	D, CW
2004	歐洲圖像 Visions of Europe (segment "Prologue")	Feature	CD, CW
2007	來自倫敦的男人 The Man from London	Feature	D, CW
2011	都靈之馬 The Turin Horse	Feature	D, CW
2017	Muhamed	Doc Short	D, W
2019	Missing People	Doc	D

導演 Director (D)　編劇 Writer (W)　共同導演 Co-Director (CD)　共同編劇 Co-writer (CW)

局外人 The Outsider

始終與痛苦靈魂同在

淺談貝拉・塔爾

文──洪健倫（台北電影節 選片人）

▶對於聚焦匈牙利布達佩斯的「焦點城市」單元而言，貝拉・塔爾有著承先啟後的意義。善以長鏡頭犀利剖析人生的他，創作始於「貝拉巴拉茲製片廠」（下稱BBS）的「布達佩斯學派」精神，爾後才發展其獨樹一幟且超脫世外的電影美學。適逢其首兩部長片《家庭公寓》與《局外人》先後完成數位修復，它們不但呼應今年「焦點城市」的方向，更是2004年金馬影展首次在台放映這兩部作品的20年後，重返大師創作起點的難得機會。此外，我們也選映他2011年的最後一部長片《都靈之馬》，對照貝拉・塔爾在創作起點與終點的變與不變。

成長於布達佩斯，立志成為哲學家的貝拉・塔爾，因16歲時父親送他一台8mm攝影機，意外開啟了電影之路。起初，他以業餘身分拍攝左派紀錄短片為工人階級發聲，獲得彼時擁抱非電影專業背景創作者的BBS關注。當時年僅22歲、未受專業訓練的貝拉・塔爾在BBS支持下，僅以約一萬美元預算，花了六天便完成《家庭公寓》的拍攝。其後他進入布達佩斯戲劇與電影學院就讀，並延續此一接近真實電影的寫實手法，陸續完成《局外人》與《積木生活》等兩部長片。

為小人物發聲的左派憤青

站在貝拉‧塔爾創作終點回望，很難想像這位極簡形式主義大師在創作初期竟是以手持貼近人物的攝影、大量對話與快步調的剪輯，用入世的角度描繪升斗小民的掙扎。年輕的貝拉‧塔爾，似乎對於世間的良善仍保有一絲想望與同情，同時憤怒地揭露這世界與人性醜陋的一面如何碾壓僅存的理想。

在《家庭公寓》中，貝拉‧塔爾把觀眾放進一個三代、七口之家蝸居的小公寓，近距離目睹所有日常口角如何壓垮青年世代，尤其是片中的年輕妻子。在這如英國「廚房水槽電影」般的作品裡，令人印象深刻的不是關於柴米油鹽的牢騷口角，而是在這些日常衝突間，貝拉‧塔爾屢次冷不防地呈現人性險惡一面的手法。例如離家許久的丈夫才剛與妻子團聚不久，酒酣耳熱之際竟轉身就與友人在樓下強暴了妻子邀來作客的年輕羅姆女子；或是公公嚴厲質疑媳婦的忠貞後，鏡頭一轉，他竟在酒吧裡死纏爛打地向情婦調情。這些鏡頭彷彿透露彼時才20歲出頭的貝拉‧塔爾，對於揭露社會與人性陰暗面的犀利與執著。

第二部長片《局外人》是貝拉‧塔爾從影生涯唯二的彩色電影，片中年輕男子對於人生有著浪漫的期待，他嚮往成為無拘無束的音樂家，也期待擁有美好家庭，但出身坎坷的他沒有資源實踐天賦，面對骨感的現實壓力，他一面寄情酒精，一面仍企圖實現波西米亞式的藝術家生活，卻讓他的夢想與人生因而分崩離析。除了描繪現代都市的物質生活如何無情碾壓邊緣人的理想，幾個角色人前人後的轉變，也再次展示了貝拉‧塔爾對於人性現實面的失望。

凝視生存本質的哲思先知

結束早期社會現實路線後，貝拉‧塔爾的電影逐漸離開都市，走進泥濘不堪的鄉村；遠離現實，走進時空莫辨的寓言。身為說書人的他，也從一個帶著憤慨積極走動的觀察家，成為絕望而抽離的全然旁觀者。他的電影越來越極簡，在他的創作終點，長鏡頭下對角色生命狀態的全然客觀凝視，取代了劇情的起伏。《都靈之馬》裡30多個長鏡頭呈現的，是老馬與年邁父女在暴風鄰近的困頓農場上六天的生活，在這六天中，我們看到的是他們在嚴苛環境下日復一日的掙扎，沒有救贖，也沒有終點。

「這是一個真實的故事。它沒有在電影中的角色身上發生，但它有可能會發生。」貝拉‧塔爾在《家庭公寓》的開場字卡上如此寫道。我們可以說，貝拉‧塔爾從創作的初始，便企圖從現實提煉普世寓言，最終，寓言則取代了現實。而在創作的旅程上，他對描繪人性、環境的殘酷本質的著迷，最終淹沒了他電影裡殘存的理想。從一個左派憤青到電影大師，貝拉‧塔爾始終與世上受苦靈魂同在，只是他最終參透的是，他們的生命本質僅是一場沒有止境的背水一戰。

承先啟後的行動者

儘管理想在貝拉‧塔爾的作品中蕩然無存，但在現實世界中，他仍積極為未來的影壇種下希望，貝拉‧塔爾自創作晚期到近年在歐、亞各地持續提攜年輕後進，許多新銳導演都深受其影響，例如，曾以《索爾之子》奪下奧斯卡最佳外語片的的匈牙利導演拉斯洛‧納米斯。

不論創作或是身為電影人，貝拉‧塔爾都扮演著承先啟後的角色。他的作品從新浪潮的「布達佩斯學派」出發，開展出截然不同的面貌，成為當代匈牙利電影的代名詞。曾經獲得BBS資源的他，不斷在世界各地開枝散葉。作為同樣關注新銳的台北電影節，希望貝拉‧塔爾的創作精神，以及他對於新進創作者的提攜，都能為這個影展及它的觀眾帶來更多啟發。◆

Always Be with the Suffering Souls

On Béla Tarr

家庭公寓 Family Nest

▶ Integral to Taipei Film Festival's "City in Focus: Budapest" section is Béla Tarr, a filmmaker who inherited traditions and inspires future generations. An expert in analyzing life with long takes, Tarr began his career with the support from the Béla Balázs Studio (BBS); he inherited the spirit of the Budapest School before developing his unique, distant, and unworldly film aesthetics. As Tarr's first two features, *Family Nest* and *The Outsider*, have been digitally restored, they not only echo this year's "City in Focus" but offer us a rare opportunity to revisit the master's early works 20 years after they were screened at the Taipei Golden Horse Film Festival for the first time in Taiwan in 2004. Furthermore, Taipei Film Festival showcases his last feature made in 2011, *The Turin Horse*, to reflect the changed and the unchanged throughout Tarr's career as a filmmaker.

Béla Tarr grew up in Budapest and intended to become a philosopher. However, when he was 16, his father gave him a Super 8mm camera and that unexpectedly led him to filmmaking. As an amateur, Tarr made some leftwing documentary shorts to speak up for the working class and attracted attention from BBS, which supported filmmakers without professional backgrounds. At the age of 22, Tarr, who had no formal training, received a small budget of around 10,000 US dollars from BBS to make *Family Nest*, which took him just six days to shoot. Subsequently, Tarr went to the Academy of Drama and Film in Budapest and continued with a realistic approach similar to cinema verité as he completed two features, *The Outsider* and *The Prefab People*.

Written by HUNG Jian-luen (Taipei Film Festival Programmer) Translated by Isabella HO

A Leftist Angry Young Man Speaking Up for the Common People

When we look back at Tarr's filmmaking career from where it ended, it is hard to imagine that a minimalist master like him began with a hand-held camera shooting his protagonists at close range; with a large amount of dialogue and at a fast pace, Tarr compassionately portrayed how common people struggled in their lives. The young Béla Tarr seemed to have kept some hopes of human kindness and sympathy while angrily revealing how the world and the ugliness of human nature stamped out the remaining ideals.

In *Family Nest*, Tarr squeezes the audience into the tiny apartment that houses seven family members of three generations; up close, the audience witness how the daily bickering in the family drags down the younger generations, especially the young wife in the film. In this work that resembles the British "kitchen sink drama," what leaves the deepest impression on viewers are not the squabbles over trivial matters but the unexpected revelations Tarr made about the ugliness of human nature amid the daily conflicts. For instance, the husband, who just gets reunited with his wife after a long time away from home, rapes the young Romani woman, a guest invited by his wife, with his friend downstairs when he gets drunk. Another example is that after the father-in-law unsparingly questions his daughter-in-law's faithfulness to his son, we see him pestering and flirting with his mistress in a bar. These shots seem to demonstrate how sharply and insistently Tarr disclosed the dark side of society and human nature even though he was only in his early 20s.

Tarr's second feature, *The Outsider*, is one of the only two films he shot in color. In the film, the young hero is a romantic, who hopes to become a carefree musician and build a happy family of his own. Nevertheless, his poor background cannot provide him with the resources to realize his dreams; when facing the harsh reality, he seeks comfort in drinking while striving to live like a bohemian artist, but in the end, his dreams and life crumble into dust. In addition to the portrayal of how the material life in a modern city shatters the dreams of those who live on the margins of society, the hypocrisy and mendacity seen in several characters once again show Tarr's disappointment in human nature.

A Philosopher and Prophet Who Gazes at the Essence of Existence

Once Tarr ended his social realistic approach seen in his early works, his films slowly moved away from the city and walked into the muddy countryside; moreover, they were detached from reality and turned into fables in an unidentifiable time and space. As a narrator, Tarr transformed himself from an active angry observer into a desperate onlooker totally detached from the surroundings. His films became more and more minimalistic; by the end of his career as a filmmaker, the absolutely objective gaze at the characters' lives in the long takes replaced the dramas in the plot. In *The Turin Horse*, what is revealed in the over 30 long takes are the lives of an old horse, an elderly father, and his daughter on a desolate farm for six days when a storm is approaching. In these six days, we see their continuous struggle in such a harsh environment day in, day out, and there is neither redemption nor an end.

"This is a true story, it didn't happen to the people in the film, but it could have," wrote Tarr in the opening intertitles in *Family Nest*. We can say that right at the beginning of Tarr's career, he had tried to extract the universal fables from reality and in the end, the fables had replaced reality. On his journey as a filmmaker, Tarr's obsession with portraying the cruel nature of human beings and the environment eventually drowned out his last remaining ideals of film. From a left-wing angry young man to a great film director, Béla Tarr has always stayed with the suffering souls in the world; it is just that he has come to realize that the essence of life is a never-ending war people keep fighting until their last breath.

A Man of Action Who Inherited Traditions and Inspires Future Generations

Although Tarr lost all his ideals in his films, he actively sows seeds of hope for future filmmakers in real life. From the final stage of his filmmaking career until now, Tarr has been nurturing new talents in Europe and Asia. He has had a profound influence on many emerging filmmakers, including Hungarian director László Nemes, who won the Oscar for Best Foreign Language Film for *Son of Saul*.

Whether as a creator or a filmmaker, Tarr inherited traditions and inspires future generations. Starting from the Budapest School, his films have evolved into a completely different aesthetic and become synonymous with contemporary Hungarian cinema. Tarr received the support of Béla Balázs Studio at an early stage in his career and since then, he has been nurturing new talents all over the world. Like Tarr, Taipei Film Festival has always been supportive of rising filmmakers, and therefore, we hope that Tarr's creative spirit and support for new talents will inspire Taipei Film Festival as well as the audience. ◆

家庭公寓
Family Nest

匈牙利 Hungary｜1979｜DCP｜B&W｜105min

布達佩斯一間狹小的房子裡，住著三代同堂的工人家庭。限縮的空間放大了所有可能的衝突與爭執。男人的父親挑撥他們的夫妻關係，女人想帶著女兒搬出去，她們需要一間自己的房間。無奈共產政府遲遲拖延著他們的房屋申請，這個巢居將演變成什麼樣子？被大環境擠壓著的人又該何去何從？

貝拉·塔爾首部長片，晃蕩的長鏡頭在深焦閉鎖空間裡凝視一個又一個面容，叨叨絮絮的對話將環境賦予角色的逼仄感表露無遺。《家庭公寓》以寫實風格呈現家庭日常，甚至讓角色如紀錄片受訪之姿獨白自敘心情；其從敘事乃至影像上建構的「巢居」空間，在在指向當代匈牙利社會環境。「這是一個真實的故事。它沒有在電影中的角色身上發生，但它有可能會發生。」塔爾以這些超出景框的特寫面容，堆疊映照出社會集體經驗。

Irén lives with her daughter in a small apartment of her in-laws, in the center of Budapest. Her husband Laci just came back from his national service and his relationship with Irén is deteriorating. Soon, the young woman wants to leave the family, but her rehousing request gets stuck into the communist administration.

DIRECTOR, SCREENPLAY
貝拉·塔爾 Béla TARR
PRODUCER
貝拉巴拉茲製片廠 Béla Balázs Studio
János BÓDIS
CINEMATOGRAPHER
Ferenc PAP
EDITOR
Anna KORNIS
MUSIC
János BRÓDY
SOUND
András VÁMOSI
CAST
László HORVÁTH
Gábor KUN
Lászlóné HORVÁTH
Adrienne KÁDÁR
Irén RÁCZ
PRINT SOURCE
Luxbox

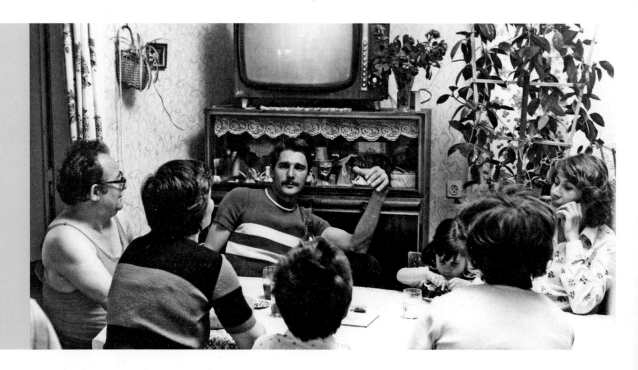

▌ 1980 鹿特丹影展 IFF Rotterdam
▌ 1979 曼海姆影展首獎 Grand Prize, Mannheim-Heidelberg IFF

06.22 SAT 15:40 華山 SHC 1 ｜ 07.01 MON 17:30 華山 SHC 2

局外人
The Outsider

匈牙利 Hungary | 1982 | DCP | Color | 128min

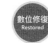

青年小提琴家流浪著,工作一個換過一個。他穿梭酒吧,聲色犬馬,載歌載舞麻痺自己,藉以逃離現實。某天他遇見一個女人結了婚,然而漂泊並未終止,婚姻與家庭也沒為他帶來安定,生活的答案究竟在何方?

貝拉・塔爾唯一一部彩色電影,延續前作《家庭公寓》對社會現狀的觀察,以受布達佩斯學派影響的紀實風格,拍出個體在環境中的飄蕩無定。手持鏡頭跟隨主角音樂家在街頭流浪,記錄下他與不同人的對話。不時穿插音樂表演橋段,樂音於敘事內外,都成為人遁入理想、逃離現實的媒介。大量人臉特寫鏡頭既引導觀眾同感角色心理,又將他們與環境切割。樂聲響起,主角沉浸地閉上雙眼拉琴,鏡頭環視周遭的精神病院,病人們空洞的目光落在他身上。光影流轉,恍惚之間,「局外人」如何在現實與理想幻境中自處?

In an industrial town in Hungary, András, a music-loving young nurse, is fired for alcoholism. It's another failure in his life. As he wanders through the city, András drifts through his relationships, both social and romantic.

DIRECTOR, SCREENPLAY
貝拉・塔爾 Béla TARR
PRODUCER
János BÓDIS
Gyuláné GROSZ
CINEMATOGRAPHER
Barna MIHÓK
Ferenc PAP
EDITOR
Ágnes HRANITZKY
MUSIC
András SZABÓ
SOUND
Béla PROHÁSZKA
CAST
András SZABÓ
Jolan FODOR
Imre DONKÓ
István BALLA
Ferenc JÁNOSSY
Imre VASS
PRINT SOURCE
Luxbox

1982 鹿特丹影展 IFF Rotterdam

06.23 SUN 18:40 華山 SHC 1 | 07.01 MON 19:50 華山 SHC 2

都靈之馬
The Turin Horse

匈牙利 Hungary｜2011｜DCP｜B&W｜155min

數位修復 Restored

1889年哲學家尼采於都靈街頭看見一匹不願前行，而被馬夫狠狠鞭打的老馬，他嚎叫阻止馬夫，精神狀態自此後陷入瘋狂。畫外音以說書人之姿道出尼采瘋癲謎團，電影敘事則從此展開。第一天，馬夫與女兒起床、更衣、吃飯、提水、工作；第二天，起床、更衣、煮飯、工作……第三天、第四天，日復一日，父女的生活皆然。老馬拒絕飲食，井水乾涸見底，疾風暴雨襲來，他們的生活是否將有所改變？

敘事與配樂的輪迴和重複性，以及貝拉・塔爾標誌性的長鏡頭彷彿凝鍊了時空，荒原小屋裡的父女生活樣態形成寓言，而景框中人物的命運也被預言。當人活著的勞動性被影像時間標誌，死亡的絕望感同時蔓延，人存在的意義為何？塔爾最後一部作品，自此他不再拍攝，其早期對社會的批判，和後期哲學思辨於焉融合。

In Turin on 3rd January, 1889, Friedrich Nietzsche steps out and sees the driver of a hansom cab having trouble with a stubborn horse. Despite his urging, the horse refuses to move, and the driver takes his whip to it. Nietzsche comes up and puts an end to the brutal scene, throwing his arms around the horse's neck, sobbing.

His landlord takes him home; he lies motionless and silent for two days until he mutters his last words, and lives for another 10 years, silent and demented, cared for by his mother and sisters.

DIRECTOR
貝拉・塔爾 Béla TARR
Ágnes HRANITZKY
PRODUCER
Gábor TÉNI
Marie Pierre MACIA
Juliette LEPOUTRE
Ruth WALDBURGER
Martin HAGEMANN
SCREENPLAY
拉斯洛・卡勒斯納霍凱
László KRASZNAHORKAI
貝拉・塔爾 Béla TARR
CINEMATOGRAPHER
Fred KELEMEN
EDITOR
Ágnes HRANITZKY
MUSIC
Mihály VÍG
SOUND
Gábor ERDÉLYI
CAST
Erika BÓK
János DERZSI
Mihály KORMOS
PRINT SOURCE
Luxbox

▍ 2012 棕櫚泉影展國際影評人費比西獎最佳外語片 Best Foreign Language Film, FIPRESCI Prize, Palm Springs IFF
▍ 2011 多倫多影展 Toronto IFF
▍ 2011 柏林影展評審團大獎、國際影評人費比西獎 Grand Jury Prize, FIPRESCI Prize, Berlinale

06.21 FRI 18:50 信義 HYC 11 ｜ 06.30 SUN 15:50 華山 SHC 1

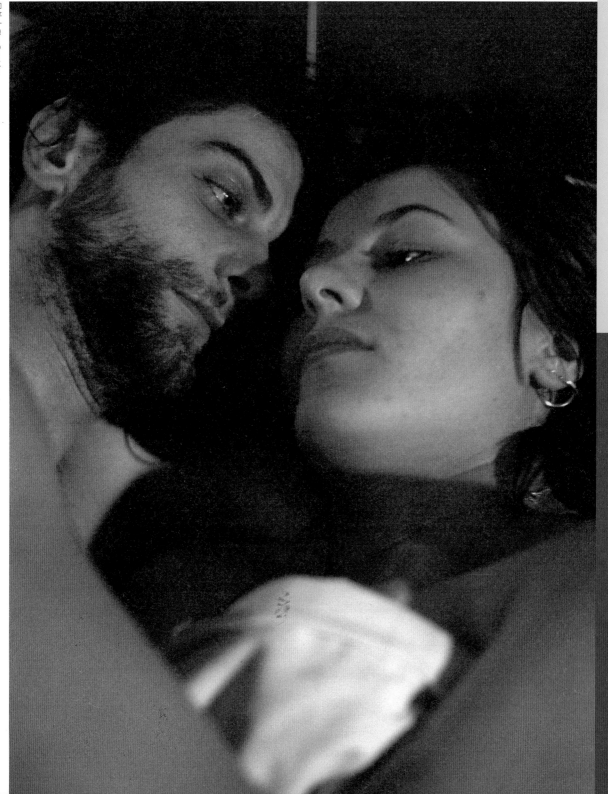

焦點影人：許秦豪

FILMMAKER IN FOCUS: HUR JIN-HO

許泰豪，1963年出生於韓國全羅北道全州市，畢業於延世大學哲學系，後於韓國電影藝術學院修讀電影製作，是該學院首批畢業生之一。1990年代初入電影圈，受韓國名導朴光洙引導啟發，從片場做起。

1998年他以首部劇情長片《八月照相館》初試啼聲，即一舉拿下大鐘獎最佳新導演，奠下作者風格，該片也被視作啟蒙韓影新浪潮的文藝先鋒之作，票房口碑雙豐收。2001年，他再以浪漫愛情片《春逝》角逐鹿特丹影展，同時榮獲東京影展藝術貢獻特別獎，在國際影壇嶄露頭角。2005年，他續以集結兩位韓影巨星裴勇浚、孫藝珍的《外出》深掘愛情命題，締造海外佳績。

早期的許泰豪以拍攝愛情電影見長，有「情感大師」之稱，善於以細膩筆觸刻繪男女情愛，也在作品中透見人生無常與時光流逝，有著獨具一格的內斂浪漫。而後，他也曾嘗試拍攝多部中韓合製作品，包括《好雨時節》、《危險關係》等。近年來，他則將類型觸角伸向史詩、時代、傳記等題材，從《末代公主》到《天文：問天》，皆展現其調度大格局敘事的蓬勃野心，但同時，也再度發揮其處理角色情感的深厚內蘊。

許泰豪在類型上持續耕耘不輟，於去年再推出雜糅家庭與犯罪的新作《非普通家族》，改編自荷蘭作家的暢銷小說，在多倫多影展驚艷亮相。

Born in 1963 in Jeonju, South Korea, **HUR Jin-ho** graduated from the Korean Academy of Film Arts. His first steps as a film director did not go unnoticed as his first short, *For Go-chul*, was selected for the Vancouver IFF. He later co-wrote the script of *A Single Spark* and *Kilimanjaro*. All his feature films, *Christmas in August* (1998), *One Fine Spring Day* (2001), *April Snow* (2005), *Happiness* (2007) and *A Good Rain Knows* (2009) are variations on his favorite theme: love.

作品年表 Filmography				
1992	For Go-chul		Short	D, W
1995	美麗青年全泰壹 A Single Spark		Feature	CW
1998	八月照相館 Christmas in August		Feature	D, CW
2000	Kilimanjaro		Feature	W
2001	春逝 One Fine Spring Day		Feature	D, W
2003	Alone Together		Short	D
2004	My New Boyfriend		Short	D, W
2005	外出 April Snow		Feature	D, CW
2007	尋找幸福的日子 Happiness		Feature	D, CW
2009	情慾五感圖 Five Senses of Eros (segment "I'm Here")		Feature	CD, CW
2009	好雨時節 A Good Rain Knows		Feature	D, CW
2012	危險關係 Dangerous Liaisons		Feature	D
2016	末代公主 The Last Princess		Feature	D, CW
2017	兩道光 Two Lights: Relumino		Short	D
2019	The Present		Short	D
2019	天文：問天 Forbidden Dream		Feature	D
2021	人間失格 Lost		TV Series	CD
2023	非普通家族 A Normal Family		Feature	D

導演 Director (D)　編劇 Writer (W)　共同導演 Co-Director (CD)　共同編劇 Co-writer (CW)

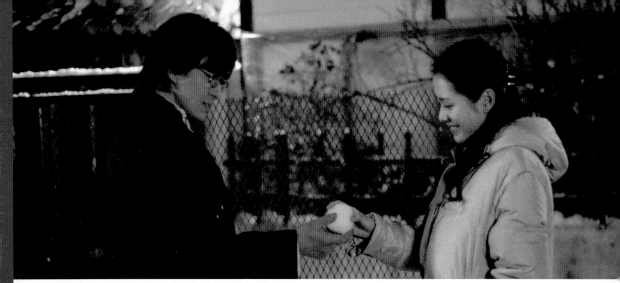

許秦豪的電影之路

文——張婉兒（影評人、編劇）

▶ 1998 年以長片首作《八月照相館》初試啼聲的導演許秦豪，是當代韓國重要的導演之一。因早年執導了多部經典愛情片，素有「情感大師」之稱。許秦豪初在影壇嶄露頭角的九〇年代，正是韓國電影的世代交替期，在電影審查制度被裁定違憲、題材與類型走向多樣化的同時，也湧現眾多新人導演。與許秦豪同期亮相的，尚有在前一年剛完成電影首作《青魚》的導演李滄東，以及在同年度交出第二部長片《江原道之力》的洪常秀、第三部長片《雛妓》的金基德等，皆是台灣影迷相當熟悉的面孔。

許秦豪甫出道即包攬韓國青龍獎、大鐘獎最佳新導演的頭銜，並以其恬靜克制的電影風格與獨具一格的浪漫腔調，躋身作者導演之列。本年度台北電影節特別選映他早期的三部愛情文藝片，與最新推出的兩部不同類型的作品，恰能令影迷一窺其創作軌跡，也正好投映出不同時空背景下的韓國電影樣貌。

有別於現今普遍認知的強烈戲劇性、重視情節的韓影印象，事實上許秦豪的早年作品瀰漫著相當清澈的生活感，如同《八月照相館》中主角來回折返於相館、家屋與街路，也似 2001 年的《春逝》中主角幾度造訪極富味道的地方車站。

在這些作品中，場與場之間不存在絕對必然的因果關聯，因而我們會在《春逝》的河邊看見一群莫名正在演奏樂器的學生，也會在《八月照相館》裡看見主角朋友教導一班練跆拳道的孩子。這些過於細瑣、甚至難以被言明的枝節旁襯，於許秦豪，都是豐滿生活的一部分。

在創作初期，許秦豪常喜歡以一連串觀察式的定鏡，安靜地記敘人物流動，在平淡日常中，看見小人物的情思翻湧。他不僅擅長調度無聲的情感，更能以充滿細節的鏡頭堆排，帶出意蘊悠長的氣味。比如在《春逝》中的那場「告別戲」，先是看見老者換上華衣，撐傘出門，緩緩回眸，再是主角坐在喪車上，最後接上數張老相片的蒙太奇，一組立基現實又超於現實的含蓄表達，便道盡了一切。

許秦豪的作品無疑非常注重感官，以及人與自然的關係，因而它們不僅「好看」，往往也相當「好聽」。悠揚抒情的配樂，鋪襯出一股慢慢漾開的時光感，一如我們能在《八月照相館》的日常中，讀見一種雋永的格調，伴隨著曠達的主角走向生命終章。

在《春逝》中，因男主角是錄音師的職業身分，感官感受更被放大到極致。不論是男女主角初見時的竹林風聲，又或是屋簷下的雪聲、溪畔的水聲、愛人的吟唱聲，還是故事最末的草叢沙沙聲，皆對應著主角幽微

的心境起伏。雪景在許秦豪的前兩部片中皆不曾缺席，到了 2005 年的《外出》，前後呼應的春日降雪，更直接被昇華成「知音難覓，緣分難尋」的意象與暗示。

許秦豪顯然很知道如何揮灑浪漫筆觸，但最可貴的，其實是他鏡頭下的那些人物，往往都帶著一種青澀的笨拙。那般乾淨的純真，才是最難以被複製與臨摹的。就像《八月照相館》中主角的憨癡，在於他心知自己已時日無多，不願意耽誤對方，只敢默默守望，最後又在感念戀人給予的愛情懷想中，無悔離去；而《春逝》中的兩位主角，也會因在廣播中聽見自己的主持聲感到羞赧，不好意思地戴上墨鏡，更會在被對方撞見自己喜形於色時，嘟嚷著丟臉至極；《外出》雖然處理的是熟齡已婚男女的出牆之戀，但兩個在寒夜街上相伴散步的人，也會因為覺得太冷，忽然跑起步來。他們是這樣「青春」的靈魂。這是屬於許秦豪的浪漫。

只是，許秦豪雖被奉為愛情電影巨擘，但嚴格說來，他最早期的幾部愛情片卻又不完全關乎「愛情如何發生」，而往往是關於「愛情如何離開」。如《八月照相館》中註定無法結果的戀曲，被獨自留下的年輕女警不解故人為何突然音訊全無；也如《春逝》中情竇初開的錄音師，在痴纏推拉之中，困惑著愛情怎麼會走得如此匆忙；更似《外出》裡，因一場車禍才得知各自伴侶出軌的一雙男女，糾結著自己到底做錯了什麼？這是屬於許秦豪電影的魔力——在他的作品裡，浪漫與悵然總是如影隨形。

在以數部愛情文藝片奠下風格基底之後，許秦豪又經歷了多部中韓合製電影的商業嘗試，隨後，他將創作觸角從愛情片伸向了史詩題材。他在 2016 年推出改編自韓國作家同名小說的傳記片《末代公主》，廣獲好評。而 2019 年取材自史實的歷史古裝片《天文：問天》，同樣是許秦豪的一次野心嘗試，恢弘的大製作調度在片中俯拾即是，他也明顯改變了早期偏好定鏡的運鏡模式，以更為靈活的鏡頭輾轉於人物之間，捕獲朝堂之上的暗流湧動，更不時將鏡頭拉近，探入人物。

然而，在類型上更為圓滑精準的打磨，仍無礙於許秦豪為觀眾編織他最擅長的細膩情感戲。《天文：問天》看似放眼家國大義，卻也實實在地說了一段世宗大王與科學家蔣英實之間的「愛情故事」。片中，那場蔣英實為世宗在窗門上畫滿星空的戲，即彷如許秦豪多年來匠心陶煉的集大成。當光影暗下，窗紙上洩出撲閃著的燭光星斗，照映在世宗臉上，正是蔣英實為他親手築成的星光。一屏一息，皆滿溢著浪漫柔情，堪比美國電影《美麗境界》中手繪星空的名場面。

與此同時，轉換不同片型跑道的許秦豪，也依然延續著他對空間的極度敏感。如同《八月照相館》中主角隔著相館窗戶的張望，以及《春逝》裡主角在錄音室內外的相視，到了《天文：問天》，同樣少不了幾名階下囚透著屋頂的碎瓦片縫隙，望向星空的浪漫景框。

2023 年，許秦豪再交出新作《非普通家族》，強烈的類型語言、家庭通俗劇式的情節織構，以及驚人的最後一擊，堪稱他溫潤風格下難得一見的冷冽轉身，與此同時，彷彿也揭示了他與當今韓影風格的真正合流。值得一提的是，該片的主演薛景求和張東健，也皆是九〇年代崛起的明星演員，與許秦豪初入影壇的年代相仿。如今不再專事愛情片型的許秦豪，會如何以一部融合家庭與犯罪元素、後座力驚人的類型片與他的早年作品對話？或許廣大影迷可以在片中細細檢視這位作者導演的視角。

不論是早年對人物純真臉孔的內斂捕捉，又或是歷經歲月淬鍊與產業浮沉之後，在新作中對挑戰角色極限，探索人性深淵與人物雙面性的濃厚執迷，皆展現出許秦豪於大銀幕之上以人為本的創作哲學。曾經，「當愛情離開以後」是他對情感關係與人生無常最親密、又最不耽溺的觀察取徑，那麼，當離開了愛情片以後，許秦豪的創作之路又會如何繼續無限拓深？依然令人翹首期待著。◆

After Love Has Departed

Hur Jin-ho's Filmmaking Journey

▶ Hur Jin-ho, who made his debut feature, *Christmas in August*, in 1998, is one of the most important contemporary Korean directors. Since Hur made several classic romance movies in the early years of his career, he is hailed as the "master of emotions." In the 1990s when Hur began to make his name, Korean cinema was undergoing a generational change. While censorship was ruled unconstitutional and subject matters and genres diversified, many new directors emerged. The directors, who launched their careers around the same time as Hur, included Lee Chang-dong, who made his debut, *Green Fish*, in 1997, Hong Sang-soo, who made his second feature, *The Power of Kangwon Province*, in 1998, and Kim Ki-duk, who made his third feature, *Birdcage Inn*, in 1998. All these directors are well-known to Taiwanese audiences.

八月照相館 Christmas in August

Soon after Hur began his career, he won Best New Director at the Blue Dragon and the Grand Bell Awards; his serene and restrained style as well as the unique romantic tone in his films made him an auteur. This year, Taipei Film Festival selects three of his early romance films and two latest works of different genres. This selection not only allows fans to see Hur's career trajectory but also the different looks of Korean cinema reflected in different times and places.

Contrary to most people's impression nowadays that Korean cinema is known for its high drama and well-crafted plots, a clear sense of everyday life permeates Hur's early works. Like in *Christmas in August*, the hero walks back and forth between the photography studio, home, and streets. Also, in *One Fine Spring Day* made in 2011, the male protagonist visits the quaint local station several times.

In these films, what happens in a scene is not necessarily related to what happens in the next. Therefore, we see a group of students playing musical instruments by the river for no reason in *One Fine Spring Day* or the protagonist's friend teaching taekwondo to a class of children in *Christmas in August*. For Hur, these excessively detailed or even incomprehensible subplots are what enrich our lives.

In the early stage of his career, Hur liked to use a series of static observational shots to quietly record the characters going about their business; in their undramatic daily lives, we see how these ordinary people's emotions are stirred up. Hur not only excels in maneuvering silent feelings but often conveys meaningful sentiments through a series of shots packed with details. For instance, in the "farewell" in *One Fine Spring Day*, the elderly woman changes into lavish clothes and goes out, holding an umbrella; then slowly, she turns back to look before we see the male lead sitting in the

funeral car, followed by a montage of several old photos. It is a sequence composed of realistic and yet surreal shots that implicitly expresses everything.

Without a doubt, Hur's works put much emphasis on the senses and the relationship between man and nature; as a result, his films not only "look good" but also "sound nice." The soft melodious music complements a sense of time that gradually unfolds; like in the daily lives portrayed in *Christmas in August*, we hear an eternal tone that accompanies the protagonist as he calmly walks towards the end of his life.

In *One Fine Spring Day*, since the hero is a recording engineer, sounds are magnified to the limit. Whether it is the sound of the wind in the bamboo forest, where the hero and the heroine first meet, the sound of snow under the eaves, the sound of water flowing in the river, the lovers' chanting or the rustling in the bushes in the end of the story, all these sounds echo with the subtle changes in the protagonists' emotions. Snow is never absent in Hur's first two films and in *April Snow* made in 2005, the snowing in spring in the beginning and the end of the film is often interpreted as an image and an implication that it is hard to find a soulmate and it is also hard to keep the relationship.

Obviously, Hur knows very well how to create romantic scenes, but what is most precious is that through his lenses, all his characters are a bit green and clumsy. The pure innocence in his works is the most difficult thing to copy or imitate. Like in *Christmas in August*, the protagonist is loving and yet timid because he knows he is dying and he does not want to waste the girl's time; therefore, he can only silently love and protect her, and in the end, he feels grateful for the love his lover gave him as he leaves the world without regrets. In *One Fine Spring Day*, the heroine feels so shy when she hears herself hosting the radio program that she hides herself behind sunglasses; moreover, when the hero realizes that the heroine accidently

Written by Cari CHANG (Film critic, scriptwriter) Translated by Isabella HO

catches sight of him skipping over-exuberantly, he cannot stop mumbling about how embarrassed he feels. Although the lovers in *April Snow* are two mature people married to their own spouses, when they are strolling in the street on a wintery night, they feel so cold that they suddenly break into a run. They have such youthful souls, and this is a romantic scene that bears Hur's signature.

However, although Hur is hailed as the master of romance movies, strictly speaking, his early works are not all about "how love happens" but "how love departs." For example, in *Christmas in August*, which tells of a doomed romance, the young policewoman, who is left behind, never knows why her lover suddenly vanishes into thin air. In *One Fine Spring Day*, the recording engineer, who just had his first taste of love, feels confused about how quickly love can disappear amid the tug of war between lovers. In *April Snow*, when the protagonists find out that their spouses are having an affair after a traffic accident, they cannot stop asking themselves what they have done wrong. This is the magic power of Hur's films – in his works, romance is always accompanied by a sense of disappointment and sorrow.

Having established his style with several romance movies, Hur made many commercial Korean-Chinese co-productions and later ventured into epic films. In 2016, he directed *The Last Princess*, a screen adaptation of a Korean novel, earning widespread acclaim. In 2019, Hur made the historical drama *Forbidden Dream*; another ambitious attempt notable for the mise-en-scène on a grand scale. Hur obviously ditched the static shots he favored in his early works and moved the camera more freely between the characters to capture the undercurrents in the court of King Sejong; from time to time, he zoomed in to explore the characters and the events further.

Nevertheless, despite Hur's more precise and polished approach to the genre, it does not stop him showing his forte – conveying the characters' feelings to the audience. Seemingly, *Forbidden Dream* focuses on state affairs and history, but it also tells the "romance" between King Sejong and the scientist Jang Yeong-sil. The scene in which Jang Yeong-sil paints the starry sky on the window for King Sejong seems to be the culmination of all the skills Hur has developed over the years. In the candlelight and shadow, the stars twinkling on the paper screen and reflecting on King Sejong's face emit the starlight that Jang Yeong-sil has created for the King. With romantic love and tenderness permeating the air, this is a scene that could compete against the famous star drawing scene in the American film *A Beautiful Mind*.

Meanwhile, Hur, who has been working in different genres, maintains his acute sensitivity to space. Like the protagonists looking around through the window in the photography studio in *Christmas in August* and the hero and heroine looking at each other in and out of the recording studio in *One Fine Spring Day*, in *Forbidden Dream*, there is a romantic shot of several prisoners looking up to the starry sky through the gaps in the terracotta tiles on the roof.

In 2023, Hur made *A Normal Family*, his latest work. The strong genre film language, the conventional plot and structure of a family drama, and the shocking twist in the end, can be seen as a rare and abrupt change from Hur's usually warm and tender style. At the same time, it seems to reveal that Hur has blended himself with current mainstream Korean cinema. It is worth mentioning that the lead actors of *A Normal Family*, Sol Kyung-gu and Jang Dong-gun, are stars who rose to fame in the 1990s, a period that coincided with the time Hur launched his filmmaking career. How does Hur, who no longer confines himself to romance films, respond to his early works with a powerful genre movie that combines family drama with crime? Maybe it is what allows the audience to carefully examine this auteur's viewpoints in his films.

In Hur's early works, he discreetly captured the characters' innocent faces. Having matured and experienced the ups and downs of the film industry, in his latest production, Hur challenges the characters' limits, conveying the depth of human nature and his obsession with the characters' duplicity. All these demonstrate Hur's philosophy of filmmaking, which always focuses on people. Once, "the departure of love" provided Hur with the closest and yet the least self-indulgent way of observing people's emotions and the unpredictability of life. Now, as he himself has departed from romance movies, how will Hur keep expanding and deepening his works in the future? This is something that is eagerly anticipated. ◆

八月照相館
Christmas in August

南韓 South Korea｜1998｜DCP｜Color｜97min

DIRECTOR
許秦豪 HUR Jin-ho
PRODUCER
CHA Seoung-jae
SCREENPLAY
許秦豪 HUR Jin-ho
OH Seung-uk
SHIN Dong-hwan
CINEMATOGRAPHER
YOU Yong-kil
EDITOR
HAHM Sung-won
MUSIC
CHO Sung-woo
SOUND
KIM Bum-soo
CAST
韓石圭 HAN Seok-kyu
沈銀河 SHIM Eun-ha
PRINT SOURCE
Sidus

相館青年的人生即將倒數，但他臉上的笑容不曾消失。他單純的生活總是兜轉於相館與家，思念著已經離世的母親，關心著嫁為人婦的青梅竹馬，和家人一起啃著西瓜，日復一日，幫客人沖洗、照相，直到某日，那個俏麗可愛的交警女孩闖入他的世界，也成了他生活的另一盞光。他們吃冰、玩鬧，又或靜靜坐著不說話，但無以擁有的幸福，卻讓他不得不做出殘酷的抉擇。

韓國情感大師許秦豪安靜細膩的長片首作，展現節制自然的作者風格，甫推出即驚艷影壇。以恬靜安穩的定鏡，搭襯情思飽滿的配樂，捕捉靜靜流淌的生活質感，更見證情愫萌芽，蔓延至相館窗裡窗外，深情訴說關於「在愛情中離去」的極致浪漫。《青魚》影帝韓石圭搭檔有「韓國林青霞」之稱的傳奇女星沈銀河，演繹至真至純的浪漫戀曲。

Tucked away in a corner of Seoul, a 30-something photographer runs a small studio, quietly optimistic about his life. One day, a young parking officer enters his studio and the unlikely couple embark on the makings of a romance. The relationship between Jung-won and Dar-im is tested when Jung-won is struck down by an unnamed illness early in the romance. Forced to come to terms with his impending death, Jung-won tries to protect Dar-im by keeping his suffering a secret.

▌ 1998 溫哥華影展龍虎獎特別提及 Dragons and Tigers Award - Special Mention, Vancouver IFF
▌ 1998 釜山影展國際影評人費比西獎特別提及 FIPRESCI Prize - Special Mention, Pusan IFF
▌ 1998 坎城影展 Cannes

06.26 WED 22:20 信義 HYC 10 ▲ ｜ 06.29 SAT 18:20 信義 HYC 10 ▲★

春逝
One Fine Spring Day

南韓 South Korea｜2001｜DCP｜Color｜115min

那天，奶奶依然未能在車站等到已離世的爺爺，但年輕的男錄音師等來了那個謎一樣的電台主持人。一男一女初次搭檔，在竹林裡一起聽沙沙的風聲。一個年輕熱烈，一個曾離試探後，走過結冰的川流，看著雪落下的庭院，兩人在推拉試探後，墜入愛河。同居生活雖平淡，卻藏著驚喜，直到情意逐漸消磨，往日的傷痕又築起無可翻越的心牆。當萌芽於冬日的心動音符，在夏日戛然而止，那個天長地久的盟誓還有復甦的可能嗎？

許泰豪在國際影展廣獲好評的第二部長片，延續前作的內斂基調，藉著自然聲響與悅耳配樂，將人物情思放大，為觀眾帶來細緻豐盈的感官盛宴。

本片巧妙並置祖孫二人的難捨情緣，帶出對「愛情何以來去匆匆」的深沉叩問。當《原罪犯》劉智泰戀上《大長今》李英愛，是那年冬天最忘不了的愛。

Sang-woo, a boy who tries to record rare and endangered sounds from nature, walks through the bamboo forest on a winter's day to record the wind. There he meets EungSu, a radio DJ who is recording sounds for her radio programme. Together, they record the sound of the temple bell. At night, when soft warm snowflakes fall, their love blossoms. Seasons later, they are on the beach to record the sound of the surf. SangWoo and EungSu now have different views about love and start to grow apart. You can record a sound hanging in the air, but can you capture love forever?

DIRECTOR
許泰豪 HUR Jin-ho
PRODUCER
TCHA Sung-jai
SCREENPLAY
SHIN Joon-ho
CINEMATOGRAPHER
KIM Hyeong-gu
EDITOR
KIM Hyeon
MUSIC
CHO Sung-woo
SOUND
GOTOU Nobuchika
CAST
劉智泰 YOO Ji-tae
李英愛 LEE Young-ae
PRINT SOURCE
Sidus

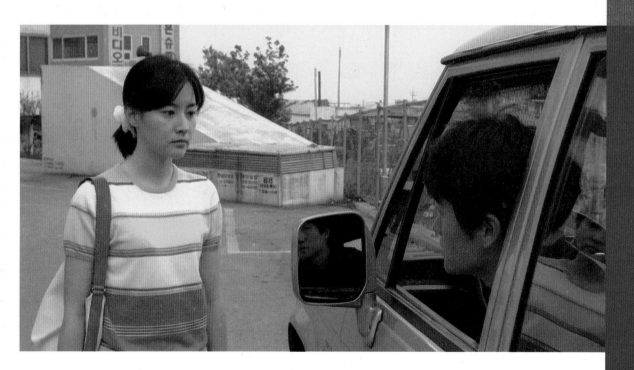

2002 鹿特丹影展 IFF Rotterdam
2001 東京影展最佳藝術貢獻獎 Best Artistic Contribution Award, Tokyo IFF
2001 釜山影展國際影評人費比西獎 FIPRESCI Prize, Pusan IFF

06.25 TUE 21:20 信義 HYC 11 ▲｜06.27 THU 21:00 信義 HYC 10 ▲

外出
April Snow

南韓 South Korea｜2005｜DCP｜Color｜106min

男人和女人在醫院相遇，躺在病榻上的車禍肇事者，卻是他的妻子和她的丈夫。遺落的相機影格，暴露了不為人知的偷歡情事。懷著震驚與不解，他和她輾轉於同間旅館、同所醫院，甚至不得不出入同場葬禮。兩人從一開始的形單影隻、忌憚疏離，到逐漸敞開心扉、投向彼此，既是報復心作祟，也是情潮暗湧。然而妻子卻在這時清醒，擊碎一切幻夢。當春日降下白雪，究竟是注定不可能的緣分，還是他和她的情牽到白頭？

許泰豪以高張力的起點作頭，踩在道德禁忌邊緣，呈現熟男熟女的糾葛愛戀，彷如韓版《花樣年華》。本片延續導演一貫細膩內斂的抒情基調，將複雜情感化於不言，同時又融入大膽纏綿的情慾書寫。《冬季戀歌》裴勇浚搭檔《緣起不滅》孫藝珍，「師奶殺手」與「國民初戀」的亮眼組合，風靡亞洲。

A traffic accident kills a young man and plunges the two occupants of the car into a deep coma. The husband and wife of the couple that were injured in the accident, who were lovers, meet at the hospital and join forces to face up to a difficult future. A beautiful love story that shies away from all the clichés of melodrama to focus on the intimate drama of its characters with extraordinary sensitivity and delicacy.

DIRECTOR
許泰豪 HUR Jin-ho
PRODUCER
KANG Bong-rae
SCREENPLAY
許泰豪 HUR Jin-ho
SHIN Joon-ho
LEE Won-sik
SEO You-min
LEE Il
CINEMATOGRAPHER
LEE Mo-gae
EDITOR
LEE Eun-soo
MUSIC
CHO Sung-woo
SOUND
LEE Byung-ha
CAST
裴勇浚 BAE Yong-jun
孫藝珍 SON Ye-jin
PRINT SOURCE
采昌國際多媒體股份有限公司
Cai Chang International, Inc.

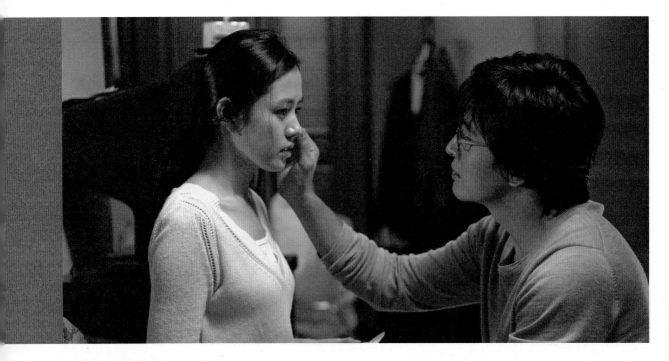

▌ 2006 亞太影展最佳女演員 Best Actress, Asian-Pacific FF
▌ 2005 芝加哥影展 Chicago IFF
▌ 2005 聖賽巴斯提安影展 San Sebastian IFF

06.22 SAT 21:10 華山 SHC 1 ▲ ｜ 06.28 FRI 15:30 信義 HYC 10 ▲ ｜ 07.02 TUE 10:10 信義 HYC 10 ▲

天文：問天
Forbidden Dream

南韓 South Korea｜2019｜DCP｜Color｜133min

十五世紀，朝鮮世宗一心想掙脫大明王朝的統御，編寫本國曆法，為民謀利，改革自強。出身低賤的官奴蔣英實因一雙巧手獲世宗賞識，得以大展天文長才。他設計報時裝置，發明觀星儀器，使命必達。一個是才華洋溢的大發明家，一個是心懷百姓的君王，兩人心意相通，一見如故。夜觀星象，共築夢想，相知相扶廿載，然而浪漫理想，終不敵保守派暗渡陳倉。詭譎多變的內憂外患，令兩人身陷生死大關。

許秦豪以史實為本，挑戰格局宏大的歷史古裝，描繪朝鮮王朝史上最重要的君王，將故事舞台搬至世宗發明訓民正音前夕，勾勒一段銘心刻骨、曖昧禁忌的君臣情誼。這是許秦豪繼《八月照相館》後與韓石圭二度合作，也是韓石圭與《原罪犯》影帝崔岷植睽違20年再度攜手，共織窗門繪星、斷袖分桃的大叔之愛。

King Sejong the Great of Joseon wants to enhance the nation's riches and military power through the study of astronomy, and his loyal subject and scientist, Jang Yeong-sil, creates the instruments he imagines into reality.

Threatened by Joseon's ever-evolving astronomical technology, the Ming Empire orders Joseon to cease the studies and for Jang Yeong-sil to be dispatched. Afraid of Ming, Joseon's court subjects insist Jang must be sent at once, but King Sejong, who thinks dearly of Jang, is deeply troubled by the dilemma.

DIRECTOR
許秦豪 HUR Jin-ho
PRODUCER
KIM Chul-yong
KIM Won-kuk
SCREENPLAY
鄭凡植 JUNG Bum-shik
LEE Ji-min
CINEMATOGRAPHER
LEE Mo-gae
EDITOR
KIM Hyeong-ju
MUSIC
CHO Sung-woo
CAST
崔岷植 CHOI Min-sik
韓石圭 HAN Seok-kyu
PRINT SOURCE
Lotte Entertainment

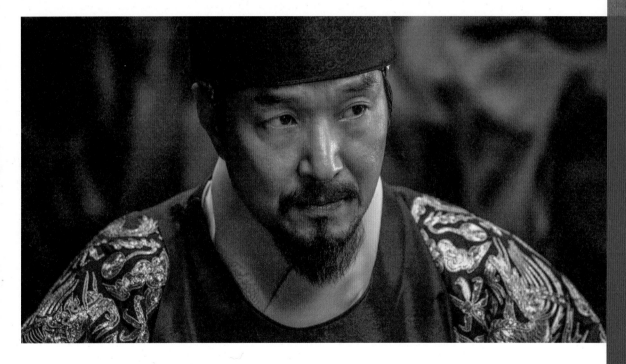

▌2020 紐約亞洲影展 New York Asian FF

06.26 WED 15:20 信義 HYC 11｜06.29 SAT 15:10 信義 HYC 10

非普通家族
A Normal Family

南韓 South Korea｜2023｜DCP｜Color｜116min

一個是為錢辯護的王牌律師，一個是為信念救人的正直醫生，因為擺脫不了兄弟的血緣羈絆，不得不以定期的奢華晚餐，維持貌似和平的兩家情誼。直到一個漫長的夜，他們正值青春期的兒女犯下了無可彌補的過錯，作為家長的他們也瞬間變成被謊言牽著走的小丑。到底要埋葬，還是自首？當晚餐話題逐漸失控，站在天平兩端的他們，掀起了激烈交鋒，殊不知一不小心，便放出了心底的野獸。

改編自荷蘭作家荷曼‧柯赫的暢銷小說，許泰豪一反溫煦風格的冰寒新作，以有條不紊的類型敘事，揭露韓國階級社會中的教育扭曲，深挖親情牽扯下

的角色雙面與道德底線。出乎意料的終極翻轉，引人直擊深不見底的人性深淵。全片陣容堅實，集結薛景求、張東健、金喜愛等人狂飆演技，在體面的杯盤之下，上演暗潮洶湧的交鋒戲碼。

Jae-wan is a materialistic criminal defense lawyer who has no problem defending murderers. His younger brother is Jae-gyu, a morally adept and warm pediatrician. They meet once a month with their wives for dinner.

One day, security camera footage of a teenage boy and a girl beating a homeless man to death goes viral. The police begin their investigation, but since the perpetrators' faces weren't shown, the case goes nowhere. But having seen the footage, Jae-gyu's wife Yeon-kyung and Jae-wan's wife Ji-su uncover a shocking secret.

DIRECTOR
許泰豪 HUR Jin-ho
PRODUCER
KIM Won-kuk
SCREENPLAY
PARK Eun-kyo
PARK Joon-seok
CINEMATOGRAPHER
GO Rak-sun
EDITOR
KIM Hyung-joo
MUSIC
CHO Sung-woo
SOUND
CHO Min-ho
PARK Yong-ki
CAST
薛景求 SUL Kyung-gu
張東健 JANG Dong-gun
金喜愛 KIM Hee-ae
秀賢 Claudia KIM
PRINT SOURCE
網銀國際影視股份有限公司
Wanin International Visual Enterprise, Ltd.

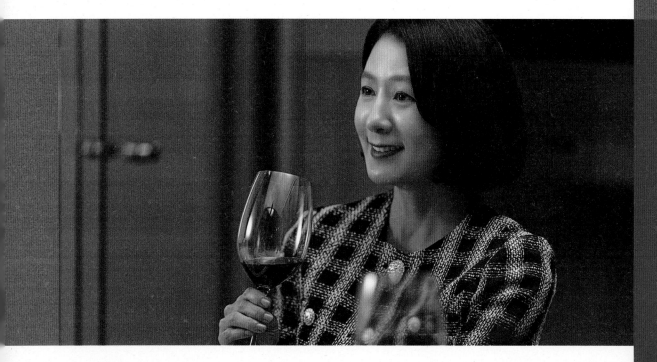

▊ 2024 棕櫚泉影展 Palm Springs IFF
▊ 2023 新加坡影展 Singapore IFF
▊ 2023 多倫多影展 Toronto IFF

06.30 SUN 19:00 中山堂 TZH ★

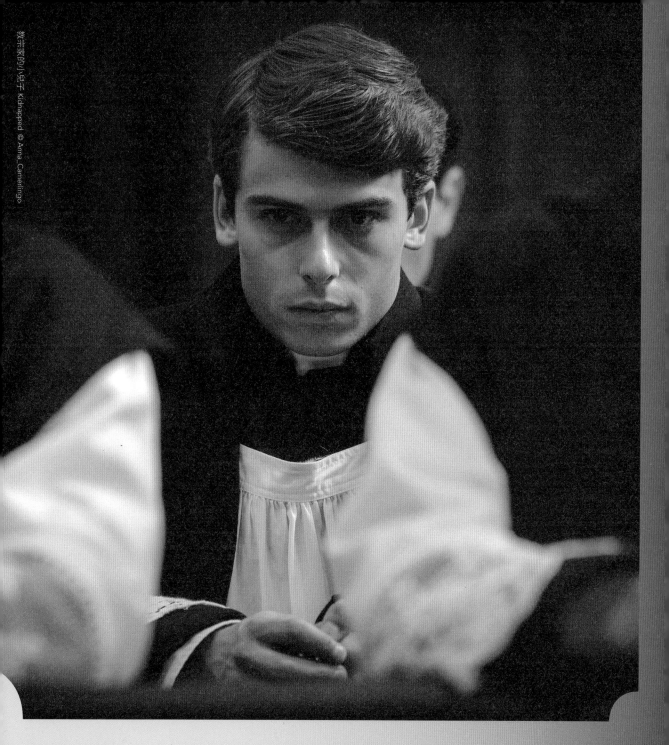

名家大賞
MASTERS

蒐羅過去一年坎城、威尼斯、柏林等大影展，以及奧斯卡名導最新力作，且看一段真假莫辨的母女故事重演如何打進奧斯卡最佳紀錄長片；還有走在情愛鋼索上的女性故事、跨越兩個世代的雙城物語，和一趟揭開美洲大陸神祕面紗的魔幻旅程，皆在此一一上演。

A collection of the past year's highlights from major film festivals such as Cannes, Venice, and Berlinale, as well as the latest work of an Oscar-nominated director. Witness how the reenactment of a story about a mother and her daughters that blends truth and fiction managed to earn an Oscar nomination for Best Documentary Feature; also explore a female story about love on the edge, experience a tale of two cities that spans two generations, and embark on a magical journey that lifts the mysterious veil of the American continent.

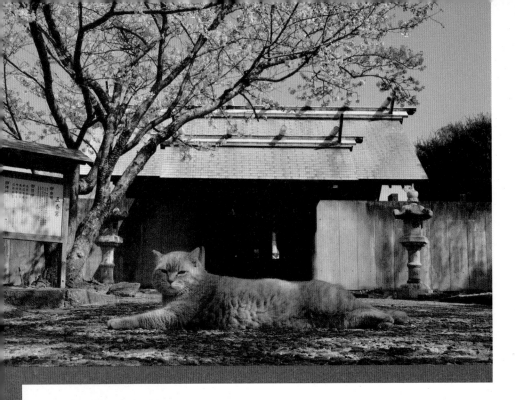

想田和弘，1970年生於日本栃木縣，畢業於東京大學與紐約視覺藝術學院。以實踐獨到的「觀察電影」方法論著稱，深信觀察與傾聽的力量。2007年首部作品《完全選舉手冊》即受邀柏林影展並獲得眾多大獎，迄今已拍攝共十部觀察電影，皆深入社會各類議題，如《完全精神手冊》、《完全和平手冊》、《夢幻球場》等。

SODA Kazuhiro is a Peabody Award-winning filmmaker. He's also a recipient of the Marek Nowicki lifetime achievement prize awarded by the Helsinki Foundation for Human Rights. He practices an observational method of documentary filmmaking based on his own "Ten Commandments", which prohibits him from pre-shoot research or writing a synopsis before filming.

五香宮的貓
The Cats of Gokogu Shrine

日本、美國 Japan, USA｜2024｜DCP｜Color｜119min

以「觀察電影的十誡」創作出多部重要紀錄片的導演想田和弘，與製片人妻子柏木規與子，毅然離開長年旅居的紐約，回到瀨戶內海的故鄉——牛窗重新定錨生活，也開啟這個純樸小鎮同居共感的日子。拍攝當地並非第一回，繼2015年《牡蠣工廠》、2018年《港町》之後，本次鏡頭則轉向五香宮神社的浪貓，同時也凝視著這個臨港小鎮的居民和遊客，溫柔地記錄下牠們與他們的共生日常。

長達一年的拍攝，街貓的群像既馴化也具野性，人們的集散既相親也互斥，在這個嚴重高齡、產業沒落的傳統村落裡，貓的生存是一種環境的包袱，卻也帶來了社區再生的希望。日復一日，皆是生物與人物交纏不清的相愛相殺，直至死生，又周而復始。如同觀景窗裡四季更迭的百花與雪花、晴陽與暴雨，不只是直視凋亡，更是再次復甦的力量。

Gokogu is a small, ancient Shinto shrine in Ushimado, Japan, on the Seto Inland Sea. Home to dozens of street cats, it is also known as "Cat Shrine." Many people visit the shrine for various reasons — worship gods, gardening, or to play after school. Others visit Gokogu to see and feed the freely roaming stray cats or to take pictures of them. It is a haven for cat lovers, but some residents complain about the waste the cats leave around the neighborhood. Gokogu looks peaceful on the surface, but it is also the epicenter of a sensitive issue that divides the local community.

▌ 2024 全州影展 Jeonju IFF
▌ 2024 香港電影節 Hong Kong IFF
▌ 2024 柏林影展 Berlinale

DIRECTOR, CINEMATOGRAPHER, EDITOR
想田和弘 SODA Kazuhiro
PRODUCER
想田和弘 SODA Kazuhiro
柏木規與子 KASHIWAGI Kiyoko
PRINT SOURCE
Asian Shadows

06.23 SUN 11:00 華山 SHC 1 ｜ 06.27 THU 20:40 華山 SHC 1

Photo by Cris Lyra

Photo by Theo Lavagnoli

胡莉安娜‧羅哈思，1981年生於巴西。長年與影人馬可‧杜特拉合作，以編導雙人組聞名影壇。首部劇情長片《Hard Labor》即入選2011年坎城影展一種注目單元，2017年更以長片《血色搖籃曲》獲頒盧卡諾影展評審團特別獎。

Juliana ROJAS is a writer and director born in Campinas, Brazil. Her solo works include the award-winning short films *O Duplo* (Special Mention, Cannes Critics' Week) and *The Passage of The Comet* (Rotterdam), and the feature film *Necropolis Symphony* (FIPRESCI Prize, Mar Del Plata).

我城；她鄉
Cidade; Campo

巴西、德國、法國 Brazil, Germany, France｜2024｜DCP｜Color｜121min

一場毀滅性的洪災，迫使老婦人離開被泥沙埋沒的家傳農場，搬到大城市投靠姊姊與甥孫。她穿行於城市各處，從事到府清潔，與新的世界逐漸有了情感連結，往日家園的幻影卻屢次浮現夢境，入侵她懸而未定的現實。相似的遷徙，不同的方向，青年女同志帶著伴侶返回故土，住進先父遺留在荒野中的屋舍。一張老相片揭露她可能的身世，而死藤水引發的恐慌，更令她懷疑，有不可見的力量籠罩著這片土地。

本片勇奪2024年柏林影展邂逅單元最佳導演。兩位女性，兩種空間再現，兩段關於遷徙與記憶的故事。當代巴西電影的代表人物胡莉安娜‧羅哈思，以平行對照的兩段式敘事，結合其熟稔的恐怖片及音樂劇元素，糅合現實、夢境及幻覺，並從女性觀點及身體經驗出發，探討氣候變遷下的迫遷農工困境，以及當代原住民族文化議題。

Two tales of migration between city and countryside. In the first part, after a tailings dam disaster floods her hometown, rural worker Joana moves to São Paulo to find her sister Tania, who lives with her grandson Jaime. Joana struggles to thrive in the "working city". In the second part, after the death of her estranged father, Flavia moves to his farm with her wife Mara. Nature forces the two women to face frustrations and cope with old memories and ghosts.

■ 2024 哥倫比亞卡塔赫納影展 Cartagena FF
■ 2024 柏林影展邂逅單元最佳導演 Best Director, Encounters, Berlinale

DIRECTOR, SCREENPLAY
胡莉安娜‧羅哈思 Juliana ROJAS
PRODUCER
Sara SILVEIRA
Maria IONESCU
CINEMATOGRAPHER
Cris LYRA
Alice Andrade DRUMMOND
EDITOR
Cristina AMARAL
MUSIC
Rita ZART
SOUND
Tiago BELLO
CAST
Fernanda VIANNA
Mirella FAÇANHA
Bruna LINZMEYER
Andrea MARQUEE
Preta FERREIRA
Marcos DE ANDRADE
Nilcéia VINCENTE
Kalleb OLIVEIRA
PRINT SOURCE
The Open Reel

06.23 SUN 11:20 華山 SHC 2 ｜ 06.27 THU 13:10 華山 SHC 2 ｜ 06.30 SUN 20:50 華山 SHC 2

李桑德羅・阿隆索，1975年生於布宜諾斯艾利斯。以助導與聲音設計身分工作至2000年。作品風格融合紀錄與劇情，內容常關注孤獨的個體。首部長片《自由無上限》入選坎城影展一種注目單元後，其後長片均於坎城影展首映。

Lisandro ALONSO was born in 1975 in Buenos Aires. His first feature, *La Libertad*, premiered at Cannes' Un Certain Regard. After creating his own production company, 4L, he returned to Cannes in 2004 with *Los Muertos*, which premiered at Directors' Fortnight. In 2014, *Jauja* won the FIPRESCI Prize at Cannes' Un Certain Regard.

魔幻尤里卡

Eureka

法國、阿根廷、德國、葡萄牙、墨西哥 France, Argentina, Germany, Portugal, Mexico
2023｜DCP｜B&W、Color｜147min

黑白西部片裡，牛仔來到城鎮，穿過印第安妓女與酒鬼，欲尋找失散的女兒；原住民保留區的雪夜裡，女警獨自處理數起道路案件後，決定不再回應對講機訊息；女籃教練毅然決然放棄俗世，在祖父與祖靈的幫助下，展開一趟跨時空、身軀的魔幻旅程。鳥兒振翅、降落，靜靜看著叢林裡的原始部落生活樣態，生命的靈光降在何處？誰又找到了真正的自己？

擅長拍攝西部片，並刻劃男性氣概的李桑德羅・阿隆索，這回轉而關注女性角色，以及美洲原住民居處現代西方文明的困頓。本片以模糊的時空背景，雜糅出不同年代對西部邊疆的認知與想像。原文片名「Eureka」為希臘語中「發現、找到」之意，分段敘事一層層揭示不同女性角色處境與選擇，引領著觀眾隨著她們尋找自己的身分。

Tired of being a police officer in the Pine Ridge Reservation, Alaina decides to stop answering her radio. After waiting all night, her niece Sadie decides to begin her journey with the help of her grandfather: she will fly through time and space to South America, and everything will feel different when she hears the dreams of other people, those who live in the forest. But there will be no definitive conclusions... Birds don't talk to humans, yet if only we could understand them, they would surely have a few truths to tell us.

▌2023 紐約影展 New York FF
▌2023 釜山影展 Busan IFF
▌2023 坎城影展 Cannes

DIRECTOR
李桑德羅・阿隆索 Lisandro ALONSO
PRODUCER
Marianne SLOT
Carine LEBLANC
SCREENPLAY
李桑德羅・阿隆索 Lisandro ALONSO
Fabian CASAS
Martin CAMAÑO
CINEMATOGRAPHER
Timo SALMINEN
Mauro HERCE MIRA
EDITOR
Gonzalo DEL VAL
MUSIC
Domingo CURA
SOUND
Catriel VILDOSOLA
Santiago FUMAGALLI
Vincent COSSON
CAST
維果・莫天森 Viggo MORTENSEN
Chiara MASTROIANNI
Alaina CLIFFORD
Sadie LAPOINTE
Villbjørk MALLING
Adanilo
PRINT SOURCE
Le Pacte

06.23 SUN 13:30 華山 SHC 1 ｜ 07.02 TUE 20:00 華山 SHC 1

© Laurent Koffel

卡勞瑟爾·賓·漢耶，1977年生於突尼西亞，於突尼西亞和巴黎學電影。作品類型橫跨劇情與紀錄片，深刻省思穆斯林社會對於身分、性，以及宗教的看法。2017年《女孩站起來》入選坎城影展一種注目單元；2021年以《販膚走卒》獲奧斯卡最佳國際影片提名。

Kaouther BEN HANIA is an award-winning director who studied filmmaking in Tunis and Paris (La Fémis and the Sorbonne). Her films have screened at Cannes, Locarno, and Venice, with *The Man Who Sold His Skin* earning a nomination for Best International Feature Film at the 2021 Academy Awards.

出走的女兒
Four Daughters

法國、突尼西亞、德國、沙烏地阿拉伯 France, Tunisia, Germany, Saudi Arabia
2023｜DCP｜Color｜108min

「這部片將講述關於歐法女兒們的故事，她的兩個大女兒被狼吃掉了……」以歐法兩名女兒們失蹤案為底，導演選角了三名演員飾演消失的女兒們及歐法，他們同歐法本人及兩個小女兒以口述回憶及重演的方式，從母女的雙視角，道出此破碎家庭的故事。拼湊著記憶，籠罩她們的父權陰霾顯現，阿拉伯文化地區女性的「頭巾權」也再次被討論。吞噬了兩個女孩的狼，究竟為何？

《出走的女兒》融合了紀實與劇情，反身地揭露本片從選角、服裝化妝、訪談，到演繹故事的過程。影像上大量運用鏡子元素，探問著這些女性的身分，以及她們代與代、平輩之間的複製或平行關係。本片不只揭開突尼西亞父權社會加諸於女性的陳年傷疤，對被攝者來說，更是一次情感淨化，讓本片入圍奧斯卡最佳紀錄片。

The life of Olfa, a Tunisian woman and mother of four daughters, oscillates between light and shadow. One day, her two eldest daughters disappear. To fill their absence, director Kaouther Ben Hania calls upon professional actors and sets up an extraordinary film mechanism to unveil the story of Olfa and her daughters.

This is an intimate journey full of hope, rebellion, violence, intergenerational transmission and sisterhood, which will question the very foundation of our societies.

▋ 2024 凱薩電影獎最佳紀錄片 Best Documentary Film, César Awards
▋ 2023 多倫多影展 Toronto IFF
▋ 2023 坎城影展紀錄片金眼睛獎 The Golden Eye, Cannes

DIRECTOR, SCREENPLAY
卡勞瑟爾·賓·漢耶
Kaouther BEN HANIA
PRODUCER
Nadim CHEIKHROUHA
Habib ATTIA
Thanassis KARATHANOS
Martin HAMPEL
CINEMATOGRAPHER
Farouk LAÂRIDH
EDITOR
讓-克里斯托夫·海姆
Jean-Christophe HYM
Qutaiba BARHAMJI
卡勞瑟爾·賓·漢耶
Kaouther BEN HANIA
MUSIC
Amine BOUHAFA
SOUND
Amal ATTIA
Manuel LAVAL
Henry UHI
Maxim ROMASEVICH
CAST
Hend SABRI
Olfa HAMROUNI
Eya CHIKHAOUI
Tayssir CHIKHAOUI
PRINT SOURCE
The Party Film Sales

06.21 FRI 18:40 華山 SHC 1 ｜ **06.24 MON 20:00 華山 SHC 1** ｜ **06.28 FRI 13:20 華山 SHC 1**

馬可·貝洛奇歐，1939年出生，當代著名義大利導演。作品深入義大利社會肌理，1965年首部長片《口袋裡的拳頭》被公認為影史經典。曾於1991年以《The Conviction》獲得柏林影展評審團大獎，並先後獲得威尼斯影展終身成就金獅獎及坎城影展榮譽金棕櫚獎。

Marco BELLOCCHIO is a renowned Italian filmmaker. His debut feature, *Fists in the Pockets*, is widely regarded as a classic. His 1991 film *The Conviction* won the Silver Bear Special Jury Prize at Berlinale. He received the Golden Lion for Lifetime Achievement at Venice IFF in 2011.

教宗家的小兒子

Kidnapped

義大利 Italy｜2023｜DCP｜Color｜135min

19世紀中葉，義大利波隆那受到教廷統治，出身於猶太教家庭的男孩在年幼時被信奉天主教的女僕祕密受洗，成為教會名冊上的信徒，按規定不得由猶太教徒撫養。男孩被士兵連夜帶走、離鄉背井，在教皇的掌握下學習天主教教義；家人心急如焚展開行動，誓言討回兒子。兩方勢力碰撞下，男孩心靈孤立無援，壟罩其上的不僅是信仰的分歧，也是塵俗人世的權柄爭奪。

改編自撼動義大利歷史的真實事件，當代義大利電影大師馬可·貝洛奇歐再以歷史與宗教背景交織創作，以19世紀浪漫主義繪畫做為視覺參照，描繪服飾、色彩與光影氛圍。貝洛奇歐展現高超技法，將人物情感掙扎與心智狀態的高度關注鎔鑄於情節，並映照義大利統一的關鍵時代背景，由個人故事出發，打磨出張力高漲的史詩戲劇，讓此片再次入選坎城影展主競賽。

In 1858, in the Jewish quarter of Bologna, the Pope's soldiers burst into the Mortara family's home. By order of the cardinal, they have come to take Edgardo, their seven-year-old son. The child was secretly baptized as a baby and papal law is unquestionable: he must receive a Catholic education. Edgardo's parents will do anything to get their son back. Supported by public opinion and the international Jewish community, the Mortaras' struggle quickly takes a political dimension. But the Church and the Pope will not agree to return the child, to consolidate an increasingly wavering power.

▌2023 義大利銀緞帶獎最佳影片、導演、劇本、女主角、男配角、剪輯、吉列爾莫·畢拉吉獎
Best Film, Best Director, Best Screenplay, Best Actress, Best Supporting Actor, Best Editing, Guglielmo Biraghi Award, Nastro d'Argento

▌2023 紐約影展 New York FF

▌2023 坎城影展 Cannes

DIRECTOR
馬可·貝洛奇歐 Marco BELLOCCHIO
PRODUCER
Beppe CASCHETTO
Paolo DEL BROCCO
Simone GATTONI
SCREENPLAY
馬可·貝洛奇歐 Marco BELLOCCHIO
Susanna NICCHIARELLI
CINEMATOGRAPHER
Francesco DI GIACOMO
EDITOR
Francesca CALVELLI
Stefano MARIOTTI
MUSIC
Fabio Massimo CAPOGROSSO
SOUND
Adriano DI LORENZO
CAST
Paolo PIEROBON
Fausto Russo ALESI
Barbara RONCHI
PRINT SOURCE
光年映畫 Light Year Images Co., Ltd.

06.25 TUE 18:50 信義 HYC 10 ▲

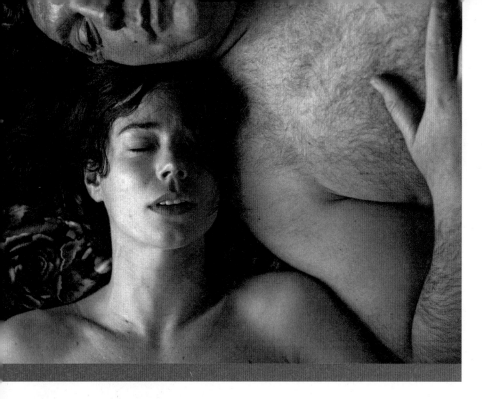

伊莎貝拉·庫謝，1960年生於西班牙，導演、編劇、譯者、作家。巴塞隆納大學歷史系畢業後投入廣告業，於2000年創立製作公司「Miss Wasabi Films」。曾以《無我新生活》、《艾莉莎與瑪榭拉》入選柏林影展主競賽，亦曾以《東京聲音地圖》入選坎城影展主競賽。

Isabel COIXET is a Spanish film director, scriptwriter, translator and writer. In 1989, she debuted as a film script writer and director with the drama *Demasiado viejo para morir joven*, which earned a nomination for Best New Director at the Goyas. She won the National Cinematography Prize in 2020.

愛的一種練習
Un Amor

西班牙 Spain｜2023｜DCP｜Color｜127min

年輕女子逃離城市來到西班牙偏遠鄉村，租下一間破舊的小閣樓，養了隻野狗，開始耕種，她想要在此重建新生活。直到一日，天花板開始鏽蝕滲水，求助房東無門，屋漏偏逢連夜雨，她不得已只好以身體交換鄰居男子提出的天花板修繕服務。不料，這個短暫、帶有微妙權力關係，柔和又同時暴力的交歡，竟釋放了她體內被壓抑的激情。

改編自同名小說，《愛的一種練習》以悠緩的鏡頭跟著女主角進入陌生鄉野，沉靜的遠景透著大自然的神祕力量，對比她工作時筆電中播放著的人臉大特寫，張弛有度地反映出她想逃離的人情與世俗。本片以疏離卻又赤裸暴力的鏡頭呈現性愛，有時具臨場感，有時如藝術靜照，迫使觀眾跟著主人翁思考自己身體在特定環境、空間中的存在位置。

Escaping her overwhelming life in the city, 30-year-old Natalia finds refuge in the small village of La Escapa, deep in the Spanish countryside. In a rustic derelict house, flanked by a wild and clumsy dog, the young woman aims to rebuild anew. When confronted with the hostility of her landlord and the distrust of the local villagers, Nat finds herself giving in to an unsettling sexual proposal from her neighbor Andreas. From this strange and conflicting encounter sparks a devouring and obsessive passion that will consume Nat fully, forcing her to reconsider the woman she thought she was.

▍2023 雨舞影展 Raindance FF
▍2023 東京影展 Tokyo IFF
▍2023 聖賽巴斯提安影展 Feroz Zinemaldia 獎 Feroz Zinemaldia Award, San Sebastian IFF

DIRECTOR
伊莎貝拉·庫謝 Isabel COIXET
PRODUCER
Marisa Fernández ARMENTEROS
Sandra HERMIDA
SCREENPLAY
伊莎貝拉·庫謝 Isabel COIXET
Laura FERRERO
CINEMATOGRAPHER
Bet ROURICH
EDITOR
Jordi AZATEGUI
MUSIC
Jan Willem DE WITH
SOUND
Albert GAY
CAST
蕾雅·柯絲塔 Laia COSTA
霍威克·庫奇萊恩 Hovik KEUCHKERIAN
Luis BERMEJO
Hugo SILVA
PRINT SOURCE
Film Constellation

06.22 SAT 21:20 信義 HYC 11 ｜ 06.28 FRI 16:10 信義 HYC 11 ｜ 07.01 MON 13:50 信義 HYC 10

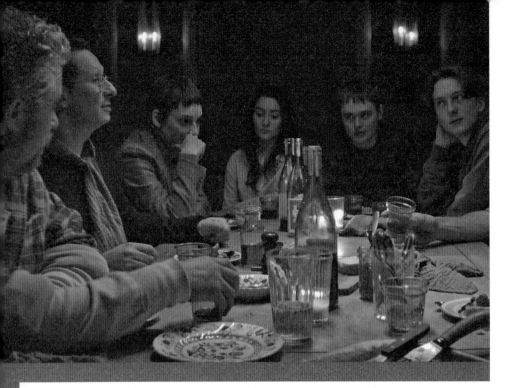

© Nicolas Cannicconi

菲利浦·勒薩吉，於加拿大魁北克省出生及成長。大學時期攻讀文學，畢業後前往歐洲電影學院就讀。起初為紀錄片導演，2010年開始拍攝劇情長片。曾以《惡魔》、《少年初長成》入選國際知名影展主競賽，作品皆善於描寫青春人物的成長狀態。新作《夏焰晚風》於柏林影展首映。

Philippe LESAGE started out with such noted documentaries as *The Heart That Beats*, winner of the 2012 Jutra Award for Best Documentary Feature. He transitioned to fiction with *The Demons*, which won numerous prizes after premiering at San Sebastian. *Genesis* premiered at Locarno and has been invited to over 70 festivals.

夏焰晚風
Who by Fire

亞洲首映
Asian Premiere

加拿大、法國 Canada, France │ 2024 │ DCP │ Color │ 161min

對藝術充滿憧憬的少年，受邀與好友前往知名導演的森林小屋，與他的一群好友共度假期，準備享受理想與愛情。他們年少輕狂，慾望蠢蠢欲動，無意間刺中導演心中被現實捶打後的傷疤。遺世獨立的小屋、狂歡飲酒的深夜、美麗無情的大自然，召喚出不同生命階段的課題。漫長的假期好似永遠不會結束，所謂的成長難道只是一場「幽閉煩躁症」？

導演菲利浦·勒薩吉以空間氛圍映襯角色的內心世界和情感變化，細膩講述一個男性成長故事。小屋安全溫暖，令人窒息；大自然空曠自由，帶著不祥的危險氣息。場場精采交鋒的對話，彰顯人物的內心衝突，角色的掙扎看似個人，卻相互呼應。被時間推著走的每一個人，沒有人能毫髮無傷地離開。

Jeff is invited by his friend Max to travel deep in the woods and stay at the isolated estate of acclaimed director Blake Cadieux. He has high expectations for the trip: Cadieux is an artist he greatly admires, plus Aliocha, Max's older sister, with whom he is secretly in love, is also coming. The untouched and hostile forest and the director's huge cabin become the territory where the youthful search for ideals and freedom confronts the wounded egos of the adults.

DIRECTOR, SCREENPLAY
菲利浦·勒薩吉 Philippe LESAGE
PRODUCER
Galilé MARION-GAUVIN
CINEMATOGRAPHER
Balthazar LAB
EDITOR
Mathieu BOUCHARD-MALO
MUSIC
Cédric DIND-LAVOIE
SOUND
Frédéric CLOUTIER
CAST
Arieh WORTHALTER
Noah PARKER
Aurélia ARANDI-LONGPRÉ
Paul AHMARANI
PRINT SOURCE
Be For Films

▌2024 柏林影展新世代單元青少年評審團首獎 Grand Prix of the International Jury, Generation 14plus, Berlinale

06.22 SAT 18:00 華山 SHC 1 │ 06.25 TUE 20:10 華山 SHC 1 │ 07.02 TUE 13:50 華山 SHC 1

影迷新樂園
WONDERLAND

令人回味再三的精彩故事、大開眼界的創作手法，集結而成一場影像的嘉年華盛會。法式莊園的曖昧綺戀、跨越20年的愛情絮語、超展開的奇幻動畫史詩。這裡是影展新朋友的第一站，也是影癡挖寶的驚奇樂園。

Captivating stories that leave a lasting impression and eye-opening creative techniques converge in this carnival of imagery. Ambiguous romantic entanglements in a French manor, love whispers spanning 20 years, and an animated fantasy epic— this is the first stop for new friends of the festival, and a thrilling wonderland for film fanatics to unearth new gems.

人海同遊
Borrowed Time

中國 China｜2023｜DCP｜Color｜95min

颱風臨近，颺起深埋心底的潮濕記憶。婚禮前夕，與母親居住在廣州的年輕女子前往香港，尋找20年未見的父親。破殼荔枝，打口唱片，渡輪越過海洋，走進水果市場，世界真是小，小得真奇妙，時間在每個人心中留下印記，而真相並不總是溫柔。重逢的夜，冒險漫遊恍若彼時映照，傷痛在午夜夢迴襲來，終將在夢醒時分離開。

拍攝紀錄片起家，導演蔡杰籌備多年劇情長片首作，將地域和時代寄寓於一趟尋親之旅，以內斂敘事舒展生命潛藏的陣痛與謎團。此片由關錦鵬監製、雷光夏作曲，新銳導演黃樹立掌鏡廣州部分，極度敏感的光影調度以景寄情，共譜親密又疏離的異鄉人視角。寫實遁入幻夢，歷經宿命般的相聚、離散與重逢，才知你我有緣並行，不過一段人海同遊。

Ting is on the brink of marriage, but still wounded by her father's departure 20 years earlier. Setting out in search of him and for a sense of resolution, she travels from Guangzhou to Hong Kong, moving through late-night fruit markets and piers soaked in blue light, as an impending summer typhoon grows near. Meeting a childhood friend and reconnecting over a bootleg CD, Ting delves into her family's secrets and the emotional turmoil still sharply rooted in her life.

▌2024 香港電影節 Hong Kong IFF
▌2024 鹿特丹影展 IFF Rotterdam
▌2023 釜山影展 Busan IFF

蔡杰，1988年生於廣東潮州，現於中央戲劇學院電影電視系攻讀博士，並於廣州大學廣播電視藝術系任教。導演作品包括紀錄短片《雲上佛童》、《有生之年》與劇情短片《歸省》，曾入選多項國際影展。《人海同遊》為其首部劇情長片。

CHOY Ji was born in 1988 in Guangdong, China. His short films include *Nature's Kids* (2012), *Recalling* (2013), and *A Piece of Time* (2014), which were introduced at the Busan International Short Film Festival and the Tampere Film Festival. *Borrowed Time* is his first feature film.

DIRECTOR
蔡杰 CHOY Ji
PRODUCER
莫津津 MO Jinjin
SCREENPLAY
王寅 WANG Yin
CINEMATOGRAPHER
黃樹立 HUANG Shuli
EDITOR
秦亞楠 QIN Yanan
MUSIC
雷光夏 Summer LEI
SOUND
劉琪 LAU Bobo
CAST
林冬萍 LIN Dongping
孫陽 Sunny SUN
歐陽駿 Eddy AU-YEUNG
潘結 PAN Jie
太保 Tai-Bo
PRINT SOURCE
視幻文化 Parallax Films

06.29 SAT 13:20 華山 SHC 1 ★｜06.30 SUN 21:00 華山 SHC 1 ★

小懶猴不哭
Cu Li Never Cries

越南、新加坡、法國、菲律賓、挪威 Vietnam, Singapore, France, Philippines, Norway
2024｜DCP｜B&W｜92min

女人帶著丈夫的骨灰，從德國返回越南與姪女相依為命。終日陪伴女人的，是失睦的丈夫生前留下的小懶猴；正值青春年華的姪女，殷殷期盼早日披上嫁紗，與男友步入婚姻。同一個屋簷下，兩個女人像是沒有交集的平行線。女人被過往記憶圍困，舞廳成為她重溫青春的慰藉；為愛昏頭的姪女，連當保母都全力以赴，像是生養子女做練習。而小懶猴淚眼汪汪，被迫離開棲息地被圈養，但小懶猴不哭，眼淚是珍珠。

越南導演范玉麟以犀利卻溫柔的視角，在小人物的生命歷程裡，悠緩尋覓國族歷史的傷痕，並透過黑白影像折射塵封般的回憶質地，在以物擬物、如幻似真的敘事裡，撿拾越南人民個體與集體的記憶碎片，拼湊著滿溢懷舊、無奈，似又懷抱希望的現世光景。越南國民女星阮明珠四度與導演合作，這次她以節制內斂的表演，完美詮釋劇中女人沉鬱卻渴望愛情的心緒。

A woman tries to cling onto dimming links to her past after inheriting a pygmy slow loris from her long-estranged husband. Meanwhile, her niece prepares for marriage as the young couple ponders their uncertain future together. The present and the complex echoes of Vietnamese history intertwine with a contemplative and poetic perspective.

▌ 2024 全州影展 Jeonju IFF
▌ 2024 紐約新導演／新電影影展 New Directors/New Films
▌ 2024 柏林影展最佳首部電影 GWFF Best First Feature Award, Berlinale

范玉麟，1986年生於越南，大學主修都市規劃，27歲開始自學電影，曾以劇情短片《越南迷情》及《庇蔭之地》入選柏林影展短片競賽。2024年其首部劇情長片《小懶猴不哭》再次入選柏林影展，並獲最佳首部電影。

PHẠM Ngọc Lân is a Vietnamese director with a background in urban planning and architecture. His debut short, *The Story of Ones* (2011), has screened at numerous film festivals and art museums. His newest short, *The Unseen River*, had its world premiere in the Pardi di Domani section of Locarno FF.

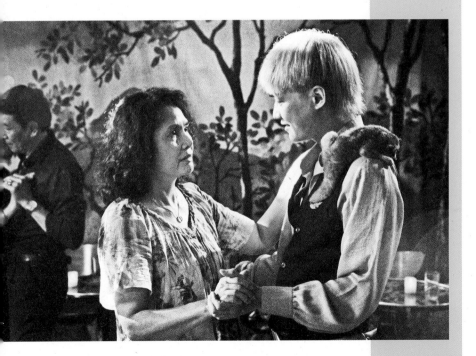

DIRECTOR
范玉麟 PHẠM Ngọc Lân
PRODUCER
NGHIÊM Quỳnh Trang
TRẦN Thị Bích Ngọc
SCREENPLAY
范玉麟 PHẠM Ngọc Lân
NGHIÊM Quỳnh Trang
CINEMATOGRAPHER
VŨ Hoàng Triều
NGUYỄN Vinh Phúc
NGUYỄN Phan Linh Đan
EDITOR
Julie BÉZIAU
MUSIC
TRẦN Kim Ngọc
SOUND
Bruno EHLINGER
Arnaud SOULIER
HOÀNG Thu Thủy
CAST
阮明珠 Minh Châu
HA Phương
XUÂN An
HOÀNG Hà
PRINT SOURCE
Square Eyes

06.23 SUN 16:30 華山 SHC 1 ｜ 06.26 WED 13:00 華山 SHC 1 ｜ 07.02 TUE 17:10 華山 SHC 2

莊園夢中人
The Dreamer

法國 France｜2023｜DCP｜Color｜95min

僻遠的法國鄉村中，年近六旬的拉斐爾負責看守一座豪華老宅，與年邁的母親過著簡樸的生活。身材粗獷、其貌不揚的他，閒來無事就捉捉地鼠、練習風笛，偶爾和郵差老婦調情，日子平凡無奇卻也自得其樂。直到某個暴雨之夜，老宅的繼承人突然歸來。這位風姿綽約的女藝術家，一舉一動都攪動著拉斐爾心底的一池春水，原本單純的主僕關係，更隨著兩人的相處而萌生質變……。

法國導演為外表獸性、內心溫柔的男主角量身打造劇本，看似改編鄉村版《鐘樓怪人》，實則更是現代版《包法利夫人》。隱隱諷刺當代藝術之餘，男女主角間神祕難解的曖昧情愫，與藝術家和模特兒間看與被看的權力流動巧妙互通，不到最後難以對這段奇情輕下定論。

「我感興趣的不是問題的答案，而是其中迸發的情感。」──導演安娜伊・泰倫

Raphaël, an one-eyed man, is the caretaker of a mansion where no one lives anymore. Soon to turn 60, he lives with his mother in a small house located at the entrance to the grounds of the stately manor. Between mole hunting, bagpipe practice and the occasional ride in the postwoman's Kangoo van, the days resemble one another. But one stormy night, Garance, the estate's heiress, comes back to the family's abode, and nothing will ever be the same again.

▋ 2024 哥特堡影展 Göteborg FF
▋ 2023 釜山影展 Flash Forward觀眾獎 Flash Forward Audience Award, Busan IFF
▋ 2023 威尼斯影展 Venice FF

安娜伊・泰倫，曾為舞者與演員，參與多部電影、電視和舞台演出。2016年起投身導演，執導短片代表作包括曾入選克萊蒙費宏短片影展法國國競賽單元的《Le mal bleu》等；2023年首部長片《莊園夢中人》於威尼斯及釜山影展皆廣獲好評。

Anaïs TELLENNE is a writer and director who started her career as an actress. Her short films include *June 19*, *Le mal bleu* and *Modern Jazz*. She fleshed out the screenplay for her first feature, *The Dreamer*, at the Le Groupe Ouest in-residence writers' workshop.

DIRECTOR, SCREENPLAY
安娜伊・泰倫 Anaïs TELLENNE
PRODUCER
Diane JASSEM
Céline CHAPDANIEL
CINEMATOGRAPHER
Pierre W. MAZOYER
EDITOR
Héloïse PELLOQUET
MUSIC
Amaury CHABAUTY
SOUND
Rémi CHANAUD
CAST
Raphaël THIÉRY
Emmanuelle DEVOS
Mireille PITOT
Marie-Christine ORRY
PRINT SOURCE
Be For Films

06.21 FRI 22:00 信義 HYC 11 ｜ 06.25 TUE 16:40 信義 HYC 10 ｜ 06.30 SUN 16:30 信義 HYC 11

人類之巔3
The Human Surge 3

阿根廷、葡萄牙、巴西、荷蘭、台灣、香港、斯里蘭卡、秘魯 Argentina, Portugal, Brazil, The Netherlands, Taiwan, Hong Kong, Sri Lanka, Peru｜2023｜DCP｜Color｜121min

晦暗的天光下，鬼魅般的攝影鏡頭尾隨片中人物在荒原、村鎮、雨林間遊蕩，多語言的對話交錯，揭示了人們日常生活的瑣事、對現實的恐懼和慾望，同時也反映出生存在全球化時代支離破碎卻又相互聯繫的存在。地貌不停歇地變化，異域般的時空，似有股神祕的驅力引領這夥人朝著山巔走去，在未來等待著的，將會是何等風景？

鬼才導演愛爾華多‧威廉斯延續著前作《人類之巔》再次遊走於現實與超現實之境，展開一場大膽的影音實驗之旅。他以配備八個鏡頭的360度全景攝影機拍攝，前往台灣、斯里蘭卡、秘魯等地取景，以不遵循常規的攝影機運動，呈現在自然萬物與人類感性之間那難以言語表述的流動性。觀眾透過威廉斯的眼，穿越語言藩籬、影像邏輯的邊界，像是真正重新看到了世界，展開一場超凡脫俗、別開生面的視聽饗宴。

Different groups of friends wander a rainy, windy, and dark world. They spend time together, trying to get away from their depressing jobs, meandering constantly towards the mystery of new possibilities.

▌ 2023 紐約影展 New York FF
▌ 2023 聖賽巴斯提安影展 Zabaltegi-Tabakalera 獎 Zabaltegi-Tabakalera Prize, San Sebastian IFF
▌ 2023 盧卡諾影展 Locarno FF

愛爾華多‧威廉斯，1987年出生於布宜諾斯艾利斯，自阿根廷電影學院畢業後，前往法國國立當代藝術工作室，師從葡萄牙導演米格爾‧戈麥斯，擅長以實驗性的影像語言、非線性的敘事結構，挑戰觀眾對影像和情感表述的思考。首部長片《人類之巔》即獲得2016年盧卡諾Filmmakers of the Present金豹獎肯定。

Eduardo WILLIAMS is a filmmaker and artist whose works explore a fluid mode of observation, looking for shared relations and spontaneous adventures within physical and virtual networks. His first feature, *The Human Surge*, won the Pardo d'oro at Filmmakers of the Present at the 69th Locarno Film Festival.

DIRECTOR, SCREENPLAY, EDITOR
愛爾華多‧威廉斯 Eduardo WILLIAMS
PRODUCER
Jerónimo QUEVEDO
張筑悌 CHANG Chu-ti
陳俊佑 CHEN Chun-yu
CINEMATOGRAPHER
Victoria PEREDA
VR Supervisor (Taiwan)
高憲郎 Kurt KAO
MUSIC
Tiago BELLO
SOUND
Paulo LIMA
吳宥賢 WU Yu-hsien
蕭子堯 Chris SHIAO
CAST
Meera NADARASA, Sharika NAVAMANI
Livia SILVANO, Abel NAVARRO
楊政陵 Ri Ri YANG
陳委詳 CHEN Wei-siang
許博凱 HSU Bo-kai, 李玄宗 Levi
吳柏穎 WU Bo-ying, 陳敬翰 Han CHEN
楊欣儀 YANG Hsin-yi
黃小真 HUANG Xiao-zhen
PRINT SOURCE
飛望影像 Volos Films

06.27 THU 17:40 華山 SHC 1 ★ ｜ 06.29 SAT 15:50 華山 SHC 1 ★

催眠
The Hypnosis

瑞典、挪威、法國 Sweden, Norway, France｜2023｜DCP｜Color｜98min

內向的女孩找上擅長催眠療法的心理師，明明是菸癮戒斷療程卻像打開了潘朵拉的盒子，蓄勢待發的她與創業夥伴兼男友，兩人帶著極具市場榮景的最新女性健康管理APP，參加夢寐以求的天使創投工作營。對比搭檔只有演講比賽程度的求生技能，潘朵拉女孩卻能將當年初經來潮的創業初心，唱作俱佳地直搗聽眾心裡。然而女孩超展開的各種尷尬脫序行為，越發像是卡到陰，在創投大會的上場前夕，男孩眼見一手好牌就要被打爛，乾脆一不做二不休力挽狂局！

從雙人演示套招的排練，到集體演示真實的人性，導演在首部處女長作中，不落俗套地將各條諷刺現實的引線埋入場景和對白之中，當你聽見從銀幕裡外的哼然訕笑，其實同時也直視著這場荒誕怪異的社會文明、嘴炮銷售的商業濡沫，或許還有似曾相識的自己。

This incisive, quick-witted, and cringe-inducing satire opens with André and Vera on the cusp of a business breakthrough. Invited to pitch their app concept at an international workshop for young entrepreneurs, the Swedish duo begins to feverishly prepare. Then, days before the event, Vera books a session with a hypnotherapist in hopes that it will help her quit smoking. Now, she's suddenly cigarette-free and has a new outlook on life— one that is completely free of social inhibitions. As their big moment approaches, André begins to worry.

▍ 2024 伊斯坦堡影展 Istanbul FF
▍ 2023 羅馬影展最佳男演員獎 Best Actor Award, Rome FF
▍ 2023 卡羅維瓦利影展國際影評人費比西獎、歐洲電影標籤獎、最佳男演員獎
FIPRESCI Prize, European Cinema Label Award, Best Actor, Karlovy Vary IFF

恩斯特‧德吉爾，生於1989年，曾於瑞典以寫作聞名的民眾高等學校 Biskops Arnö 學習劇本創作，2018年畢業於挪威電影學院主修導演。其執導的畢業短片《The Culture》獲頒全球數座獎項，同時亦入圍挪威國家電影獎。本片為導演蟄伏五年後終於初試啼聲、自編自導的首部長片。

Ernst DE GEER is a Swedish director. His graduation film, *The Culture*, won several prizes around the world and was nominated for the Norwegian National Film Award, Amanda. His feature film debut, *The Hypnosis*, was one of the films competing in the Nordic Competition during the 2024 Göteborg Film Festival.

DIRECTOR
恩斯特‧德吉爾 Ernst DE GEER
PRODUCER
Mimmi SPÅNG
SCREENPLAY
恩斯特‧德吉爾 Ernst DE GEER
Mads STEGGER
CINEMATOGRAPHER
Jonathan BJERSTEDT
EDITOR
Robert KRANTZ
MUSIC
Peder KJELLSBY
SOUND
Håkon LAMMETUN
Matias FRØYSTAD
Anna NILSSON
CAST
Asta Kamma AUGUST
Herbert NORDRUM
Andrea EDWARDS
PRINT SOURCE
好威映象有限公司 Hooray Films, Ltd.

© Jonathan_Bjerstedt

06.27 THU 18:40 信義 HYC 10

愛比死更難

Ivo

德國 Germany｜2024｜DCP｜Color｜104min

一位從事居家安寧照護的能幹護理師、一個一心向死的倔強病人、一個掙扎於病妻與情人之間的矛盾丈夫，剪不斷理還亂的關係在三人之間上演，逐漸逾越醫倫與道德底線。本能赤裸的親密關係背後，是對告別最深切的恐懼。最終誰要為這段關係劃下休止符？迷惘、笑淚、苦痛，最盡職的護理師，也要面對生死交關的十字路口。

德國導演伊娃·托比許以紀實色彩濃厚的破碎影像，追索一位平凡護理師的照護日常，她以車為家，日日流轉於形形色色的家庭間，一面堅毅承接著病者的喜怒哀樂，一面也釋放著自己的愛慾渴求。寫實取材鋪就本片的扎實底蘊，即使是刻劃性愛場面也毫不避諱、大膽直擊。以一段危險平衡的三角關係，拂見死亡陰影下的深沉之愛。

Ivo works as a palliative home-care nurse. Every day, she visits families, couples and single people. They all have different ways of dealing with the time that remains. One of her patients, Solveigh, has become a close friend. Ivo has also formed a relationship with Solveigh's husband, Franz. Day after day, the two work together to care for Solveigh. And they sleep with each other. Solveigh's strength is diminishing and she soon has to rely on support for the simplest tasks. She wants the final decision to be her own: she wants Ivo to help her die.

▊ 2024 香港電影節新秀電影競賽（世界）最佳女演員
Best Actress, Young Cinema Competition, Hong Kong IFF

▊ 2024 柏林影展 Berlinale

伊娃·托比許，1983年生於德國柏林，曾就讀於慕尼黑電視與電影大學、紐約大學Tisch藝術學院、倫敦電影學院。她的首部劇情長片《All Is Well》獲2018年盧卡諾影展最佳首部長片，在各國影展廣獲讚譽，《愛比死更難》是她的第二部長片作品。

Eva TROBISCH was born in Berlin in 1983. She studied film dramaturgy at NYU's Tisch School of the Arts and screenwriting at London Film School. Her debut feature, *All Is Well*, won Best First Feature at Locarno, the Woman in Motion Award at Cannes, and the German Film Critics' Award.

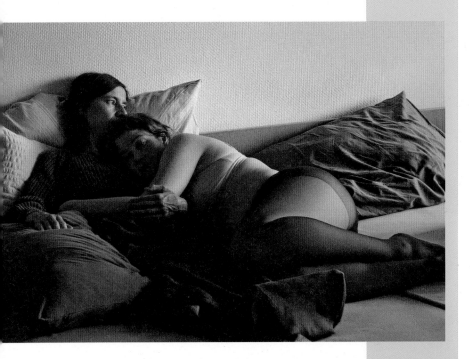

DIRECTOR, SCREENPLAY
伊娃·托比許 Eva TROBISCH
PRODUCER
Lucas SCHMIDT
Wolfgang CIMERA
Lasse SCHARPEN
CINEMATOGRAPHER
Adrian CAMPEAN
EDITOR
Laura LAUZEMIS
MUSIC
Martin HOSSBACH
SOUND
Andreas HILDEBRANDT
CAST
Minna WÜNDRICH
Pia HIERZEGGER
Lukas TURTUR
Lilli LACHER
PRINT SOURCE
Loco Films

06.22 SAT 12:30 華山 SHC 2｜06.24 MON 18:30 華山 SHC 2｜06.27 THU 14:00 信義 HYC 10

我談的那場戀愛
Love Lies

香港 Hong Kong｜2024｜DCP｜Color｜114min

中年喪夫的婦產科名醫余笑琴，冷靜自負的性情卻激不起漣漪；失業青年李偉祖，人生迷惘女友失聯，連電話費都繳不出，意外成為網戀詐騙新手，交友軟體假分身，牽起兩人現實與虛擬的人生。網路交友，戀愛詐騙，投入真情，才能獲得真心。假作真時真亦假，看透現實浪漫到底，不過就是談了一場戀愛而已。

香港新銳導演何妙祺首部劇情長片，將網戀詐騙社會事件化為笑中帶淚的浪漫喜劇。透過詐騙方和受害者的兩方視角交錯，反思愛情真諦，也巧妙反轉立場。香港影后吳君如精湛演繹熟女的遺憾與勇氣，人氣新星張天賦在騙局中挖掘男人真情，演技層次分明，加上鄧麗欣、陳輝虹、張錦程一票演技派助陣，一場跨越真實與虛擬、年齡與身分的不尋常戀愛，就此展開。

Widowed for years, reclusive obstetrician Yu meets Joe, who is disguised as a middle-aged French petroleum engineer on a dating app. When her virtual romance is revealed to be an online scam, Yu insists that she is in love despite being swindled out of a huge sum of money.

▌2024 北京電影節 Beijing IFF
▌2024 香港電影節觀眾票選獎 Audience Choice Award, Hong Kong IFF

何妙祺，香港導演、編劇。大學時至電影公司兼職，後與知名編劇陳慶嘉合作，參與《人間喜劇》、《美人魚》等電影編劇工作。《我談的那場戀愛》為其首部劇情長片，獲選為2020年香港首部劇情電影計劃。

HO Miu Ki started working as a screenwriter in 2008 and has written screenplays for films such as *La Comédie humaine* (2010) and *The Mermaid* (2016), for which she was nominated for Best Screenplay at the Hong Kong Film Awards. *Love Lies* (2024) is her feature directorial debut.

DIRECTOR
何妙祺 HO Miu Ki
PRODUCER
陳慶嘉 CHAN Hing Kai
秦小珍 Janet CHUN
SCREENPLAY
何妙祺 HO Miu Ki
陳慶嘉 CHAN Hing Kai
CINEMATOGRAPHER
譚運佳 TAM Wai Kai
EDITOR
杜杜 To To
MUSIC
戴偉 Day TAI
SOUND
楊智超 Chill YANG
陳曆衡 Roden CHAN
CAST
吳君如 Sandra NG
張天賦 CHEUNG Tin Fu
陳輝虹 CHAN Fai Hung
鄧麗欣 Stephy TANG
PRINT SOURCE
天下一電影發行有限公司
One Cool Pictures Limited

06.28 FRI 21:00 信義 HYC 10 ★｜06.29 SAT 12:20 信義 HYC 10 ★

微望
Mimang

南韓 South Korea｜2023｜DCP｜Color｜92min

一位男子正趕路赴約，在途中與久未碰面的女子巧遇。男子陪著方向感極差的女子走了一段路，兩人有一搭沒一搭的聊著城市及彼此，破碎的對話充滿微妙的氣氛。世事似乎只是一再重複，已有各自生活的兩人，偶然重逢又悄然遠離。巧遇之後的幾年，再次於共同朋友的葬禮上相見，物是人非，已不再懷疑事物的無情轉變。三段對話，三個人生片刻，這些相遇拼湊出時間的神祕，曾經無法理解的事物、無法遺忘的事物，以及遍尋不著的事物，已然過去，卻成為了現在。

《微望》由韓國新銳導演金太陽備受好評的短片《Snail》發展而來。長達四年的拍攝時間，透過首爾的地景和人物角色外貌的變化，見證時光推移；又以大量的對話，重複出現的話題，呈現出「不變」的概念。本片猶如一首輕巧的詩作，談論變幻無常的世事，卻又總是似曾相識的矛盾主題。

The word "mimang" holds multiple meanings in Korean. One, being unable to make sense from ignorance. Two, being unable to forget what one wants to forget. And three, searching far and wide. In Kim Tae-yang's Seoul-based feature debut, the camera observes in three parts the changes in time, space, and characters that align with the above-mentioned definitions. Shot in Seoul over the course of four years, the film vividly captures changes to the characters and the city — specifically the historical area of Jongno — during a couple's strolls up and down (memory) lanes.

▋ 2024 烏迪內遠東影展白桑樹首部長片獎 White Mulberry Award for a First Feature Film, Udine Far East FF
▋ 2023 東京 FILMeX 影展學生評審團獎 Student Jury Prize, TOKYO FILMeX
▋ 2023 多倫多影展奈派克獎榮譽提及 Honorable Mention, NETPAC Award, Toronto IFF

金太陽，韓國導演、編劇，出生於釜山，於首爾建國大學學習電影。曾以短片《Snail》獲2020年釜山短片影展評審團特別提及。《微望》是其首部劇情長片。

KIM Tae-yang was born in Busan, South Korea, and studied film at Konkuk University. He has directed the short films *Actors* (2015), *Snail* (2020), and *The Handover* (2021). *Mimang* is his feature debut.

DIRECTOR, SCREENPLAY
金太陽 KIM Tae-yang
PRODUCER
NOH Ha-jeong
SON Young-hak
CINEMATOGRAPHER
KIM Jin-hyeong
EDITOR
LEE Ho-seung
MUSIC
KIM Tae-san
SOUND
KIM Ju-hyeon
KIM Jun-yong
YANG Hye-jin
CAST
LEE Myung-ha
HA Seong-guk
PARK Bong-jun
BAEK Seung-jin
JUNG Su-ji
PRINT SOURCE
Finecut

06.24 MON 21:10 信義 HYC 11 ｜ 06.28 FRI 22:20 信義 HYC 11 ｜ 07.01 MON 16:40 信義 HYC 10

角落小日子
Oasis of Now

馬來西亞、新加坡、法國 Malaysia, Singapore, France｜2023｜DCP｜Color｜90min

在吉隆坡，綠意包覆的集合住宅四周，女子總是觀望、躲避，或悄悄走在他人身後，進入無數家屋，做起打掃清潔等家務工作。她與人說著不同語言，卻不是誰的家人或鄉親。不具合法身分的她，也無法成為養育女兒的母親。惟有公寓的樓梯間，是母女暫時的容身之地，以共通的母語、擲石子遊戲微弱相繫。然而面對受驅逐威脅的邊緣處境，仍使她和出養的女兒漸行漸遠。

馬來西亞新銳導演謝志芯首部編導長片，以豐富多層的畫外音，與聚焦細微動作的構框形式，刻劃出縈繞於廊道之間幽微的母女情感。極簡的敘事，不僅大幅抹去關係線索，更呈現出非法移民和出養子女，在多語、多族群社會中的隱身和混淆姿態，以凸顯傳統家庭框架的侷限。

In an old apartment complex in Kuala Lumpur, we see lives in unseen corners. The stairwell of a near-abandoned floor of this apartment is one of these corners, where a woman and her daughter take refuge for their secret meetings. They meet at the top of this stairwell, play games and attempt to interact in this stolen time and place they share. Later, they'll have to return separately to their own homes in the same apartment complex. But nothing is quite what it seems.

▌ 2024 柏林影展 Berlinale
▌ 2023 印尼日惹奈派克亞洲影展銀哈努曼獎 Silver Hanoman Award, Jogja-NETPAC Asian FF
▌ 2023 釜山影展 Busan IFF

謝志芯，1983年出生於馬來西亞，曾為亞洲電影大獎學院、西寧FIRST青年電影展訓練營學員。2018年以短片《追風公寓》獲釜山短片影展評審團獎。首部劇情長片企畫案《角落小日子》獲2020年東京新銳獎及東南亞劇本工作坊（SEAFIC）大獎。

CHIA Chee Sum is a Malaysian filmmaker, an alumnus of the Asian Film Academy (Busan), FIRST Training Camp (Xining), and recipient of Talents Tokyo 2020 Award. His short film *High Way* (2018) won the Jury Prize at Busan IFF. He is a co-founder of the Commonist, a film and animation production company.

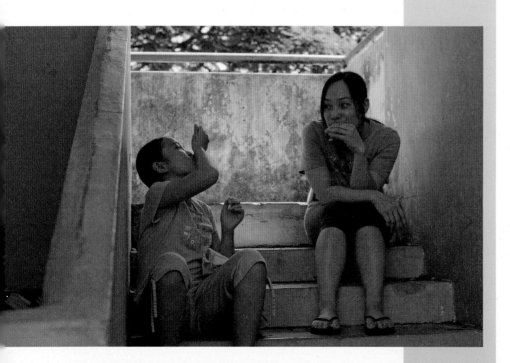

DIRECTOR, SCREENPLAY
謝志芯 CHIA Chee Sum
PRODUCER
李穎文 LEE Yve Vonn
Fran BORGIA
Xavier ROCHER
謝志芯 CHIA Chee Sum
CINEMATOGRAPHER
Jimmy GIMFERRER
EDITOR
Chloe YAP Mun Ee
謝志芯 CHIA Chee Sum
MUSIC
張偉勇 TEO Wei Yong
SOUND
黃楚原 NG Chor Guan
CAST
TA Thi Diu
姚羽 Aster YEOW Ee
Abdul Manaf Bin REJAB
PRINT SOURCE
Diversion

06.23 SUN 21:20 華山 SHC 1　｜　06.26 WED 15:10 華山 SHC 1　｜　06.29 SAT 21:30 華山 SHC 1

時髦女子
Rosalie

法國、比利時 France, Belgium｜2023｜DCP｜Color｜115min

亞洲首映
Asian
Premiere

1870年代的法國，一位名為羅莎莉的女子，外表漂亮端莊，卻藏著不可告人的天大祕密……。她從出生起，全身即長滿毛髮，臉上也會長出男人般的鬍子，她只能將自己隱蔽在衣裳之下。直到新婚，終於藏不住關於她身體的祕密。面對丈夫的抗拒、村民們的異樣眼光，羅莎莉勇敢以真實的自我，驕傲地蓄鬍登場，拒絕向世俗單一的審美眼光低頭！

本片改編自法國「德萊特夫人」之真人真事，將曾經撼動並永遠改變審美觀的傳奇故事搬上大銀幕。導演史黛芬妮·迪·朱斯托繼首部長片《狂舞摯愛》後再次入選坎城影展；本片更因故事特殊題材同時提名角逐酷兒金棕櫚獎。

In 1870s France, Rosalie is a young woman unlike any other: she was born with a face and body covered in hair. She is a genuine bearded lady, but she doesn't want to become a common freakshow. She's concealed her peculiarity all her life to stay safe, shaving to fit in, until Abel, an indebted bar owner unaware of her secret, marries her for her dowry. Rosalie's only wish is to be truly seen as the woman she is despite a difference she no longer wishes to hide. But will Abel be able to love her once he finds out the truth?

▌2023 斯德哥爾摩影展 Stockholm FF
▌2023 聖賽巴斯提安影展 San Sebastian IFF
▌2023 坎城影展 Cannes

史黛芬妮·迪·朱斯托，畢業於法國國立高等裝飾藝術學院與巴黎培寧根高等圖像學校，善於拍攝時裝精品廣告。首部長片《狂舞摯愛》即入選坎城一種注目單元，獲得高度矚目，新作《時髦女子》亦再次於坎城影展首映。

Stéphanie DI GIUSTO graduated from ENSAD and ENSCI–Les Ateliers in France and excels in shooting fashion and luxury brand advertisements. Her debut feature, *The Dancer*, was selected for Cannes' Un Certain Regard section. Her new film, *Rosalie*, also premiered at Cannes.

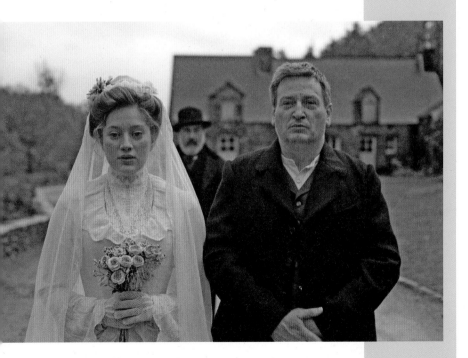

DIRECTOR
史黛芬妮·迪·朱斯托
Stéphanie DI GIUSTO
PRODUCER
Alain ATTAL
SCREENPLAY
史黛芬妮·迪·朱斯托
Stéphanie DI GIUSTO
Sandrine LE COUSTUMER
CINEMATOGRAPHER
Christos VOUDOURIS
EDITOR
Nassim GORDJI-TEHRANI
SOUND
Pierre MERTENS
CAST
Nadia TERESZKIEWICZ
Benoît MAGIMEL
Benjamin BIOLAY
Guillaume GOUIX
PRINT SOURCE
海鵬影業有限公司
Swallow Wings Films Co., Ltd.

06.29 SAT 21:40 信義 HYC 10

大腳怪怪的
Sasquatch Sunset

美國 USA｜2024｜DCP｜Color｜88min

大腳怪一家四口生活在深山叢林裡，逐星月而居、以蟲草為食，所有行為皆受慾望本能驅動、喜怒哀樂皆無需遮掩，雖偶有無常意外，但大致自由自在。然而，他們賴以維生的大自然正在緩慢產生變化，面對人類勢力範圍的步步侵逼，他們的存續將陷入前所未有的艱困處境。

繼《久美子的奇異旅程》後，澤爾納兄弟檔延續自己十多年前的短片《Sasquatch Birth Journal 2》，再拓幻想邊界，架構充滿奇想卻又殘酷寫實的大腳野人生命故事。全片於北加州原始森林裡實景拍攝，以宛若生態紀錄片的形式，透過人類學般的視野，帶領觀眾全心投入大腳野人看似粗獷、實則幽微的情感世界。《社群網戰》演技派男星傑西・艾森柏格飾演靈性大腳怪，全副野人妝容，毫無人話對白，全憑雙眼及肢體展現令人動容的精湛演技。

A family of four nomadic sasquatches lives in the deep mountain forest, dwelling under the stars and moon, dining on herbs and insects. Their actions are driven solely by instinctual desires, with no need to conceal their emotions. Though occasional unpredictable events occur, they generally live freely. However, the natural environment they rely on is slowly changing, encroached by human interference. Their survival will soon face unprecedented challenges.

▌ 2024 西南偏南影展 SXSW
▌ 2024 柏林影展 Berlinale
▌ 2024 日舞影展 Sundance FF

大衛・澤爾納、奈森・澤爾納，美國身兼導演、編劇、演員的全才兄弟檔，分別生於1974和1975年。2012年作品《Kid-Thing》入選柏林影展，2014年再以代表作《久美子的奇異旅程》入選柏林，並獲多個國際影展青睞。2018年西部片作品《Damsel》更闖入主競賽。

Brothers **David ZELLNER** and **Nathan ZELLNER** are American directors, screenwriters, and actors. Their film *Kid-Thing* premiered in the 2012 Forum at Berlinale. *Kumiko, the Treasure Hunter* also screened in the Berlinale Forum in 2014 and was nominated for two Independent Spirit Awards. *Western Damsel* premiered in Competition at Berlinale in 2018.

DIRECTOR
大衛・澤爾納 David ZELLNER
奈森・澤爾納 Nathan ZELLNER
PRODUCER
Tyler CAMPELLONE
傑西・艾森柏格 Jesse EISENBERG
David HARRARI
Lars KNUDSEN
George RUSH
SCREENPLAY
大衛・澤爾納 David ZELLNER
CINEMATOGRAPHER
Michael GIOULAKIS (A.S.C)
EDITOR
大衛・澤爾納 David ZELLNER
奈森・澤爾納 Nathan ZELLNER
Daniel TARR
MUSIC
章魚計畫 The Octopus Project
SOUND
Jack SOBO
CAST
芮莉・克亞芙 Riley KEOUGH
傑西・艾森柏格 Jesse EISENBERG
Christophe ZAJAC-DENEK
奈森・澤爾納 Nathan ZELLNER
PRINT SOURCE
Protagonist Pictures

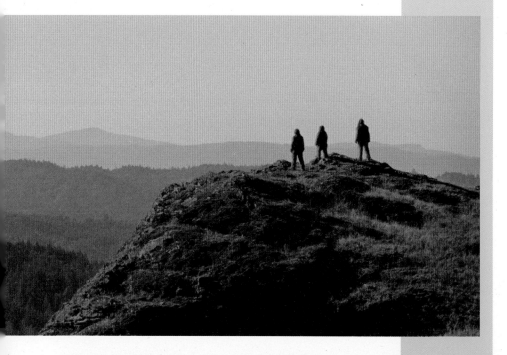

06.21 FRI 19:00 信義 HYC 10 ｜ 06.24 MON 16:50 中山堂 TZH ｜ 07.01 MON 21:40 信義 HYC 10

袋頭亂世：謊言烏托邦

Schirkoa: In Lies We Trust

亞洲首映
Asian Premiere

印度、法國、德國 India, France, Germany｜2024｜DCP｜Color｜103min

在未知時空的某個烏托邦裡，為了消弭差異，每個公民的頭上都必須罩著紙袋，並標註專屬的編號，有人終其一生連自己的臉也未曾見過。公務員197A一向奉公守法，甚至有機會能當選市政委員，卻開始懷疑自己是否生活在一個巨大的謊言之中。某夜，意圖輕生的他來到大廈頂樓，竟遇見一名未戴頭套的女子。在她的引導下，197A平凡的日子就此天翻地覆……。

印度裔新銳導演改編其獲獎無數的反烏托邦短片，從喬治‧歐威爾巨著《1984》出發，引領觀眾進入左派右派分庭抗禮 卻各自走向極端的當代世界。本片使用先進遊戲視覺引擎結合2D／3D技術，完整呈現奇幻異托邦法外之徒的黑色電影氛圍。兼具華麗視覺效果與尖銳批判視野的優質製作，更令國際名導拉夫‧狄亞茲、加斯帕‧諾埃皆受邀獻聲配音。

In a sophisticated near perfect society named "Schirkoa", citizens live with paper bags on heads to dissolve differences. Tensions rise when the whispers of a mythical land without the bags start to float and a fresh council member sparks an accidental revolution...

▌2024 哥特堡影展 Göteborg FF
▌2024 鹿特丹影展奈派克獎 NETPAC Award, IFF Rotterdam

伊尚‧舒克拉，2008年自新加坡3dsense媒體學院畢業後，便投入影視產業從事動畫工作。2016年返回印度完成首部短片《袋頭亂世》，獲獎無數並打開國際知名度，乘勝追擊發展成長片《袋頭亂世：謊言烏托邦》。2023年受Disney+邀請，執導影集《星際大戰：視界》之單集〈The Bandits of Golak〉。

Ishan SHUKLA began his career as a CG artist in Singapore before returning to India, where he made the first Indian animated short to be long listed for the Oscars. He is the director of *The Bandits of Golak*, one of the nine short stories from *Star Wars: Visions Volume 2*.

DIRECTOR, SCREENPLAY, CINEMATOGRAPHER, EDITOR
伊尚‧舒克拉 Ishan SHUKLA
PRODUCER
TRAN Bich Quân
伊尚‧舒克拉 Ishan SHUKLA
MUSIC
Sneha KHANWALKAR
SOUND
Nicolas TITEUX
CAST
Golshiften FARAHANI
Asia ARGENTO
SoKo
King Khan
拉夫‧狄亞茲 Lav DIAZ
加斯帕‧諾埃 Gaspar NOÉ
PRINT SOURCE
TRAN Bich Quân

06.23 SUN 21:20 信義 HYC 11 ｜ 06.25 TUE 16:10 信義 HYC 11 ｜ 06.30 SUN 18:50 信義 HYC 11

夜宵噤時
Small Hours of the Night

亞洲首映
Asian Premiere

新加坡 Singapore │ 2024 │ DCP │ B&W │ 103min

六〇年代末新加坡的一個雨夜，女子被男子徹夜拷問。來自未來的幽靈借軀還魂，娓娓道出一宗離奇的審判事件。時間一分一秒流逝，記憶和身分、私密與公共的界限趨漸模糊。在忽明忽暗的光影和急緩莫測的雨聲中，夾敘夾議的一句句證詞，虛實參半的一個個故事，被供出的究竟是個人的心理寫照還是集體的精神狀態？

繼《新加坡2066》、《星魔》後，導演許瑞峰以隱晦的卡夫卡式敘事與高對比黑白的極簡主義影像，遙指1983年的一起爭議性判決：一名左翼地下組織官員因持槍罪被判處絞刑，其涉及共產思想的墓碑銘文被政府認定為顛覆國家，致使負責後事的胞兄亦被定罪。導演糅合多重歷史人物身分和司法文獻的真實證詞，在時間錯亂與極度不安的室內劇氛圍中，潛入新加坡政治與歷史創傷、探勘司法系統的暗面，並對鐵腕政策下，新加坡當局對異議分子的壓迫提出了批判。

Singapore, late 1960s. The newly independent country is still grappling with its identity. In a dark room, a woman is trapped, being interrogated by a man. Through the course of one long night, identities and time start to blur. Ghosts from the future haunt their conversation, telling of a bizarre tombstone trial that speaks to the state's nascent political and legal landscape.

▌ 2024 美國紐約現代藝術館紀錄片雙週影展 MoMA's Doc Fortnight
▌ 2024 鹿特丹影展 IFF Rotterdam

許瑞峰，1986年生於新加坡，電影導演、電影工作者。畢業於美國加州藝術學院電影系，新加坡獨立製作公司「13 Little Pictures」創辦人之一。作品曾入選柏林、鹿特丹、馬賽、都靈、山形、釜山、紐約林肯中心等多個國際影展。

Daniel HUI is one of the founding members of 13 Little Pictures, a critically acclaimed independent film collective in Singapore. He wrote and directed *Snakeskin*, winner of the Special Jury Award at Torino in 2014, and *Demons*, winner of the Kim Jiseok Award at Busan in 2018.

DIRECTOR, SCREENPLAY
許瑞峰 Daniel HUI
PRODUCER
陳美添 TAN Bee Thiam
CINEMATOGRAPHER
雷遠彬 LOOI Wan Ping
EDITOR
Podsavee KONGKAEW
MUSIC
Cheryl ONG
SOUND
Akritchalerm KALAYANAMITR
CAST
Irfan KASBAN
楊彥絢 Vicki YANG Yanxuan
PRINT SOURCE
INDOX

06.21 FRI 16:00 華山 SHC 2 │ 06.28 FRI 18:10 華山 SHC 1 ★ │ 06.30 SUN 13:20 華山 SHC 1 ★

金髮毒藥
Stella. A Life.

德國 Germany｜2023｜DCP｜Color｜121min

1940年8月，柏林。金髮碧眼的猶太爵士女伶史黛拉年華正勝，生活只不過是唱唱歌、跳跳舞，再談場戀愛。然而戰爭悄悄逼近，暴力與歧視如影隨形，彷若鬼魅糾纏人心。隨著德國納粹對於猶太人的種族清洗手段越加激進，她與父母四處躲藏，卻還是落入蓋世太保手中。為求保全自己與父母的性命，她選擇轉為納粹工作⋯⋯。惡的蔓延，是不是這殘酷世界下的唯一生存方式？

導演奇利安‧烈德豪夫延續有力的社會關懷及細膩的人性刻畫，將目光轉向德國歷史的黑暗篇章。在巨大的惡之下，道德與生存要如何抉擇，又是否有對錯之分？簡潔的剪輯節奏、細緻的美術與場景設計，忠實呈現時代洪流下的人性掙扎。柏林影后寶拉‧貝爾舉手投足散發魅力，演活史黛拉從單純女孩轉變為「金髮毒藥」的心路歷程，錯綜複雜的情感變化、集受害者與加害者於一身的幽微心理，皆令人印象深刻。

Stella. A Life. tells the story of a young woman who dreams of a glittering career as a swing singer on Broadway and yearns for happiness and recognition. But Stella is Jewish and lives in Nazi-run Berlin. After she is forced to go into hiding, she joins a group of forgers to ensure her own survival and that of her parents. When she is arrested by the Gestapo, her life changes from being one of a victim to one of a persecutor.

▌2024 全州影展 Jeonju IFF
▌2024 德國電影獎 German Film Awards
▌2024 哥特堡影展 Göteborg FF

奇利安‧烈德豪夫，德國導演、編劇。作品橫跨電視劇與電影，主要關注社會議題，擅長以敏銳的觀察力切入問題點，並細膩呈現角色的心理變化。長片《原諒的勇氣》曾獲德國電影獎提名。

Kilian RIEDHOF is one of Germany's most successful directors and script writers. He gained international acclaim in 2011 with *Homevideo*, garnering multiple award wins. He also earned success with his feature debut, *Back on Track*, as well as the TV movie *Der Fall Barschel* and BAFTA-nominated series *Gladbeck*.

DIRECTOR
奇利安‧烈德豪夫 Kilian RIEDHOF
PRODUCER
Michael LEHMANN
Katrin GOETTER
Ira WYSOCKI
SCREENPLAY
Marc BLÖBAUM
Jan BRAREN
奇利安‧烈德豪夫 Kilian RIEDHOF
CINEMATOGRAPHER
Benedict NEUENFELS
EDITOR
Andrea MERTENS
MUSIC
Peter HINDERTHÜR
SOUND
Frank HEIDBRINK
CAST
寶拉‧貝爾 Paula BEER
傑尼斯‧紐沃納 Jannis NIEWÖHNER
卡嘉‧瑞曼 Katja RIEMANN
盧卡斯‧米可 Lukas MIKO
PRINT SOURCE
鴻聯國際開發股份有限公司
Eagle International Communication
Co., Ltd.

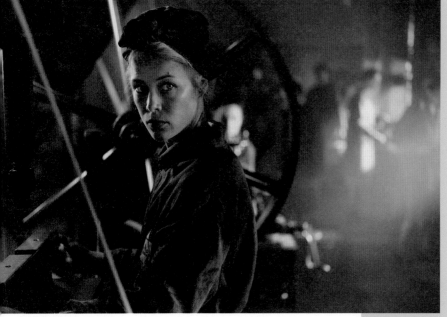

© Christian Schulz

06.27 THU 21:50 信義 HYC 11 ▲

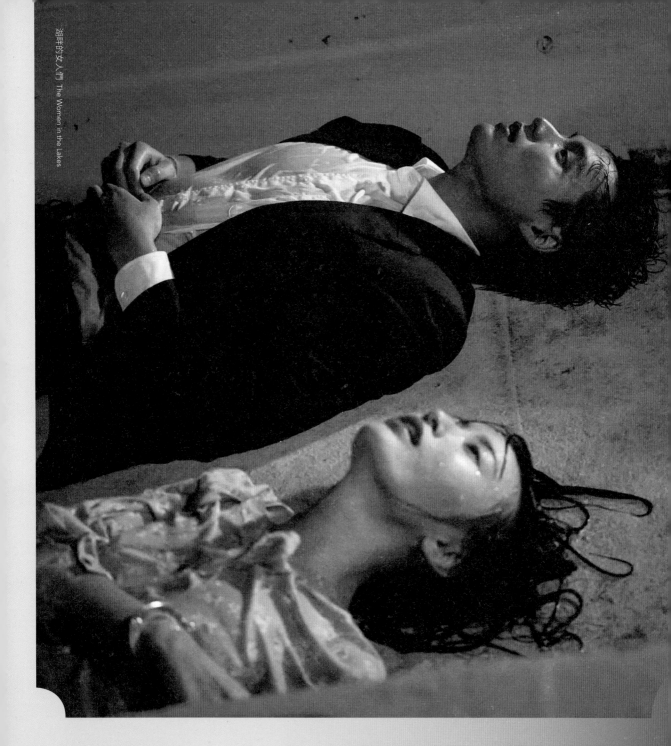

映画新勢力
NIPPON CINEMA NOW

過去一年的日本電影如夏日花火般精采，令人目不暇給，台北電影節特別規劃本單元，集結石原聰美、新垣結衣的精彩演出，改編當代文學與人氣漫畫的話題之作，還有清新小品，讓觀眾一飽眼福。

Japanese films of the past year have been as spectacular as summer fireworks, dazzling and mesmerizing. Taipei Film Festival has specially curated this section to bring together brilliant performances by ISHIHARA Satomi and ARAGAKI Yui, adaptations of contemporary literature and popular manga, as well as a meditative drama, offering audiences a feast for the eyes.

山下敦弘，1976年生，迄今執導逾20部長片，代表作包括《琳達！琳達！》、《苦役列車》、《愛情，突如其來》、《快一秒的他》等，並多次入選知名國際影展。與久野遥子聯手執導的最新動畫作品《Ghost Cat Anzu》入選2024年坎城影展導演雙週單元。

YAMASHITA Nobuhiro is a Japanese director. His first feature, *Hazy Life*, competed for the Tiger Award at Rotterdam in 2000. Since then, he has made several features, including *Linda Linda Linda* (2005) and *Hard-Core* (2018).

自白
Confession

日本 Japan｜2024｜DCP｜Color｜76min

大雪紛飛的山徑寸步難行，兩名大學登山社認識多年的死黨，意外在山裡迷了路，其中一名男子更負傷倒地、動彈不得。瀕死的他出於懺悔，向同行友人坦白了一件驚天祕密，正打算就此長眠，沒想到不遠處有一棟無人的山林小屋，兩人因此獲救。然而，意外倖存的男子在屋內的行徑越發詭譎，友人的猜疑心也隨之膨脹，雙方矛盾越演越烈，氣氛劍拔弩張。當不堪的過往逐一揭開，白雪最終會掩埋罪愆，抑或是再次被鮮血染紅？

改編同名漫畫作品，山下敦弘一改過往清新荒誕風格，挑戰心理驚悚與懸疑動作題材，集結日韓實力派演員生田斗真、梁益準同台飆戲，人氣女星奈緒更特別出演。過去的三角關係盤根錯節，由愛生恨的悲劇點燃兩名男人心中的愧疚與不堪，一場怵目驚心的屋內對峙，於焉展開。

Keisuke Asai and Ryu Ji-yong were members of the same university mountain climbing club. Sixteen years after their graduation, they decide to go mountain climbing to commemorate the death of fellow club member Sayuri Nishida, who died 16 years ago in a mountain climbing accident. During Keisuke and Ji-yong's climb, they encounter a blizzard and get lost in the extreme weather. Ji-yong gets injured and becomes certain that he will die. Keisuke tells Ji-yong to not give up, but Ji-yong suddenly makes a shocking confession.

DIRECTOR
山下敦弘 YAMASHITA Nobuhiro
PRODUCER
佐治幸宏 SAJI Yukihiro
山邊博文 YAMABE Hirofumi
SCREENPLAY
幸修司 YUKI Shuji
高田亮 TAKADA Ryo
CINEMATOGRAPHER
木村信也 KIMURA Shinya
EDITOR
今井大介 IMAI Daisuke
MUSIC
宅見將典 TAKUMI Masa
SOUND
淺梨奈緒子 ASARI Naoko
CAST
生田斗真 IKUTA Toma
梁益準 YANG Ik-joon
奈緒 Nao
PRINT SOURCE
台北双喜電影發行股份有限公司
A Really Happy Film (Taipei) Co., Ltd.

06.30 SUN 17:00 信義 HYC 10

杉田協士，1977 年生於東京，
電影導演及小說家。畢業於立
教大學，曾擔任青山真治、熊
切和嘉及黑澤清等名導之副
導。2011 年首部長片《A Song I
Remember》即登上東京影展，
2017 年作品《Listen to Light》及
2021 年作品《他方的短歌》亦
廣獲國際好評。

SUGITA Kyoshi was born in Tokyo
in 1977. His debut feature, *A
Song I Remember* (2011), screened
at the Tokyo International Film
Festival, as did his second feature,
Listen to Light (2017). His third
feature, *Haruhara-san's Recorder*
(2021), screened at FID Marseille,
San Sebastian, New York, Busan,
among others, winning several
awards.

彼方之聲
Following the Sound

日本、法國 Japan, France｜2023｜DCP｜Color｜83min

帶著一卷錄著淙淙水聲的卡帶，謎樣女子在日常
生活之外，開啟了尋覓聲音來源的支線任務。電
車、課堂、影廳、書店與茶室，周而復始的行程
之間，她邂逅一名嘗試幫助她的獨行中年女子，
路上相逢略顯疏離的父女，以及形形色色的路人
與同學，相伴踏上或長或短的旅程。掩藏著心底
失落的祕密，她在人生河畔漫步終日，追尋的究
竟是方向、解答，亦或是歸屬？

繼前作《他方的短歌》後，杉田協士再度與《偶然
與想像》攝影師飯岡幸子合作，以宛若日本短歌
的節奏，在大量的留白長鏡與自然聲景間，平實
卻深刻地譜寫小城輕熟女的心靈札記。導演內斂

描繪女性肖像與人際關係，靜謐而深邃的風格令
人聯想侯孝賢的日語名作《珈琲時光》，細膩堆砌
的情感張力格外令人驚豔。

Haru, a bookstore clerk, talks to Yukiko pretending to
ask for directions. Haru has detected deep sorrow on
Yukiko's face. Meanwhile, Haru has been spending
days following Tsuyoshi discretely and checking his
expressions. When Haru lost her mother as a junior
high school student, she met and talked separately
to Yukiko and Tsuyoshi by chance. The action was
brought by the remorse that Haru couldn't help her
mother while knowing her sadness. Haru has since
continued to watch Yukiko and Tsuyoshi now and then
as she confronts her grief and feelings towards her
mother.

DIRECTOR, SCREENPLAY
杉田協士 SUGITA Kyoshi
PRODUCER
川村岬 KAWAMURA Misaki
CINEMATOGRAPHER
飯岡幸子 IIOKA Yukiko
EDITOR
大川景子 OKAWA Keiko
MUSIC
Skank
SOUND
黃永昌 HWANG Young Chang
CAST
小川杏 OGAWA An
中村優子 NAKAMURA Yuko
真島秀和 MASHIMA Hidekazu
PRINT SOURCE
Nekojarashi

▌2023 東京影展 Tokyo IFF
▌2023 釜山影展 Busan IFF
▌2023 威尼斯影展威尼斯日單元 Venice Days, Venice FF

06.21 FRI 18:20 華山 SHC 2 ｜ 06.26 WED 17:20 華山 SHC 1 ★ ｜ 06.27 THU 13:00 華山 SHC 1 ★

吉田惠輔，1975年出生於日本，畢業於東京視覺藝術學校，曾任名導塚本晉也的燈光師。2006年以首作《Raw Summer》於夕張奇幻影展獲獎，2021年再推出《拳力出擊》、《空白》，並以《空白》獲電影旬報獎日本電影年度十大佳片，《我的女兒不見了》是其最新作品。

YOSHIDA Keisuke is a Japanese filmmaker born in 1975. His independent film *Raw Summer* (2006) won the Grand Prix in the Fantastic Off-Theater Competition section of the Yubari International Fantastic Film Festival. His 2021 film *Intolerance* won four awards at the 43rd Yokohama Film Festival, including Best Picture and Best Director.

我的女兒不見了

Missing

日本 Japan｜2024｜DCP｜Color｜119min

距女兒消失已過三個月，一名年輕母親依然在街上分發傳單，不放過任何一絲可能的線索。她在女兒失蹤當天去看偶像演唱會，被惡意輿論貼上「失格母親」的標籤。沉靜的丈夫、古怪的弟弟、趨利的記者，當生活不再存在浮木，她只能任悲痛將自己侵蝕。人與人的痛苦真的是相通的嗎？時間不曾給她解答，直到再見一縷陽光。

日本編導吉田惠輔擅長在作品中刻劃女性，此次再將視角望向一名悲傷母親，懷著最大的覺悟寫就生平最需要喘息的作品。在描繪沉痛現實、挖掘深層人心的同時，亦不乏對角色的溫柔關照，讓人想起韓國名導李滄東的《密陽》。日本女星石

原聰美初為人母，演繹敏感脆弱又堅毅要強的母親，說服力十足，貢獻生涯最心碎演出。片中多場層次飽滿、痛徹心扉的哭戲，既殘酷又真實。

A devastating story of a six-year-old girl who goes missing while her mother is attending the concert of her favorite idol. Faced with relentless media, overflowing criticisms on social media, and a crumbling relationship with her husband, the mother begins a downward spiral amidst the turbulent wave of information society.

▌2024 烏迪內遠東影展 Udine Far East FF

DIRECTOR
吉田惠輔 YOSHIDA Keisuke
PRODUCER
大瀧亮 OTAKI Ryo
長井龍 NAGAI Ryo
古賀奏一郎 KOGA Soichiro
SCREENPLAY
增子紗織 MASUKO Saori
CINEMATOGRAPHER
志田貴之 SHIDA Takayuki
EDITOR
下田佑 SHIMODA Yu
MUSIC
世武裕子 SEBU Hiroko
SOUND
松浦大樹 MATSUURA Hiroki
CAST
中村倫也 NAKAMURA Tomoya
石原聰美 ISHIHARA Satomi
青木崇高 AOKI Munetaka
細川岳 HOSOKAWA Gaku
PRINT SOURCE
WOWOW Inc.

06.21 FRI 13:20 信義 HYC 11 ｜ 06.26 WED 18:20 信義 HYC 11 ★ ｜ 06.27 THU 16:00 信義 HYC 11 ★

大森立嗣，1970年生於東京，2005年推出長片首作《鍇之夜》，2013年以《再見溪谷》奪得藍絲帶電影獎最佳導演。代表作包括《真幌站前多田便利屋》、《瀨戶與內海》、《日日是好日》、《母子情劫》等片。

OMORI Tatsushi is a producer and film and stage actor who began making 8mm films at university. His film *A Crowd of Three* received the Best New Director Award from the Directors Guild of Japan in 2010 and was screened in the Forum section of Berlinale.

湖畔的女人們
The Women in the Lakes

日本 Japan｜2024｜DCP｜Color｜141min

一家位於琵琶湖畔的護理之家，驚傳百歲老翁離奇命案。負責調查的俊秀刑警和難脫嫌疑的冷豔照護人員，在審訊期間暗通款曲，私下沉迷於激情禁忌遊戲。他卸下正義化身發號施令，她拋棄天使形象悉聽遵便。肉體的交涉越發淫猥，褪去羞恥的狂想日漸膨脹。隨著案情陷入膠著，墮入黑暗深淵的男女，與此案相關人的傷痛記憶，跨越時空激起漣漪，悄悄從深邃的湖中浮現。波光如鏡，天地絕美無邊，人性之惡卻也俯拾即是。

繼《再見溪谷》後，導演大森立嗣再次改編重量級作家吉田修一同名原著小說，透過社會寫實題材打造「最惡之罪」，綺麗合奏詭譎事件和幽微人心。日本國民男友福士蒼汰與人氣女優松本真理香赤裸主演，祭出生涯最大尺度演出。性格影帝淺野忠信精湛詮釋創傷刑警，深刻動人。

A 100-year-old resident of a Lake Biwa nursing home dies mysteriously. Did a respirator keeping him alive suddenly malfunction, or was he murdered? A young detective on the case meets a female caregiver. The investigation runs into a dead end, but the two fall into a passionate but forbidden relationship. Terrifying memories emerge from the vast, deep lake to ensnare the detectives on the case, the caregivers, and a reporter trying to uncover a hidden past.

DIRECTOR, SCREENPLAY
大森立嗣 OMORI Tatsushi
PRODUCER
吉村知己 YOSHIMURA Tomomi
和田大輔 WADA Daisuke
CINEMATOGRAPHER
辻智彥 TSUJI Tomohiko
EDITOR
早野亮 HAYANO Ryô
MUSIC
世武裕子 SEBU Hiroko
SOUND
吉田憲義 YOSHIDA Noriyoshi
CAST
福士蒼汰 FUKUSHI Sota
松本真理香 MATSUMOTO Marika
淺野忠信 ASANO Tadanobu
福地桃子 FUKUCHI Momoko
財前直見 ZAIZEN Naomi
三田佳子 MITA Yoshiko
PRINT SOURCE
采昌國際多媒體股份有限公司
Cai Chang International, Inc.

06.23 SUN 13:00 信義 HYC 11 ▲

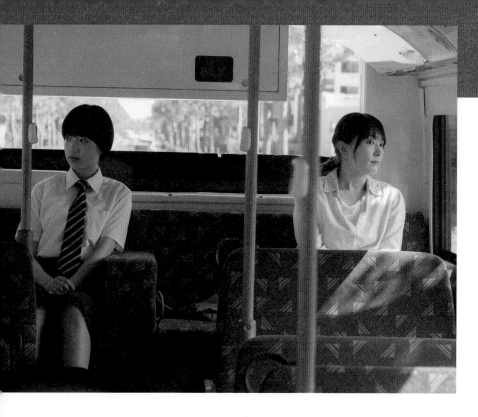

瀨田夏樹，1979年生於大阪，作品多為文學或漫畫改編。代表作包括《說謊的男孩與壞掉的女孩》、《公園小情歌》、《透視畫男孩，與全景畫女孩》等片。

SETA Natsuki's debut feature film, *A Liar and a Broken Girl*, was released in 2011 and screened at international film festivals around the world. Since then, she has directed the films *Parks* (2017), *Georama Boy, Panorama Girl* (2020) and *Homestay* (2022), among others.

異國日記
Worlds Apart

日本 Japan｜2024｜DCP｜Color｜139min

青春正要綻放，父母卻意外雙亡，荳蔻少女猝然陷入無邊無際的黑暗之中。喪禮上，親戚們視遺孤為燙手山芋，然而打從心底厭惡少女母親的阿姨，卻臨時起意「收編」她。一個是35歲社恐小說家，一個是15歲呆萌高校女孩，兩人同住一個屋簷下，新生活尚待磨合，過往傷痕已然蠢蠢欲動。個性迥異的兩人，如何在離群索居與探索未來的合奏中，哼出幸福旋律？而她們的希望與回憶，將一筆一畫銘刻在嶄新的日記裡。

本片改編自山下知子的同名漫畫作品，日本國民女神新垣結衣與亮眼新星早瀨憩連袂主演，搭配透明系人氣女星夏帆、演技派花美男瀨戶康史，以及小宮山莉渚、伊禮姬奈等清新女星，透過酸酸甜甜的女性情誼、舉重若輕的敘事步調，細膩編織一首溫潤人心的療癒之歌。

Thirty-five-year-old novelist Makio Kôdai and her 15-year-old niece Asa live together under one roof. Makio took Asa in on a sudden impulse after Asa's parents passed away. The next day, Makio returns to her senses and remembers that she does not do well in the company of others. So begins their daily life, as Makio attempts to acclimate to a roommate, while Asa attempts to get used to an adult who never acts like one.

DIRECTOR, SCREENPLAY, EDITOR
瀨田夏樹 SETA Natsuki
PRODUCER
西谷壽一 NISHIGAYA Toshikazu
西宮由貴 NISHIMIYA Yuki
CINEMATOGRAPHER
四宮秀俊 SHINOMIYA Hidetoshi
MUSIC
Toaka
SOUND
高田伸也 TAKATA Shinya
CAST
新垣結衣 ARAGAKI Yui
早瀨憩 HAYASE Ikoi
夏帆 Kaho
小宮山莉渚 KOMIYAMA Rina
染谷將太 SOMETANI Shota
瀨戶康史 SETO Koji
PRINT SOURCE
天馬行空數位有限公司
Sky Digi Entertainment Co., Ltd.

06.22 SAT 15:20 信義 HYC 11 ▲

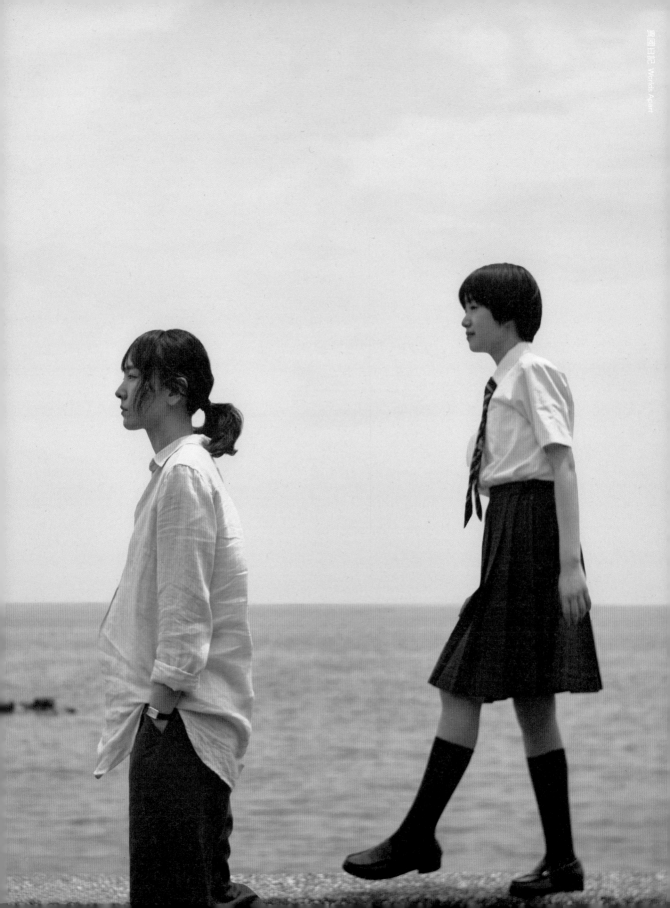

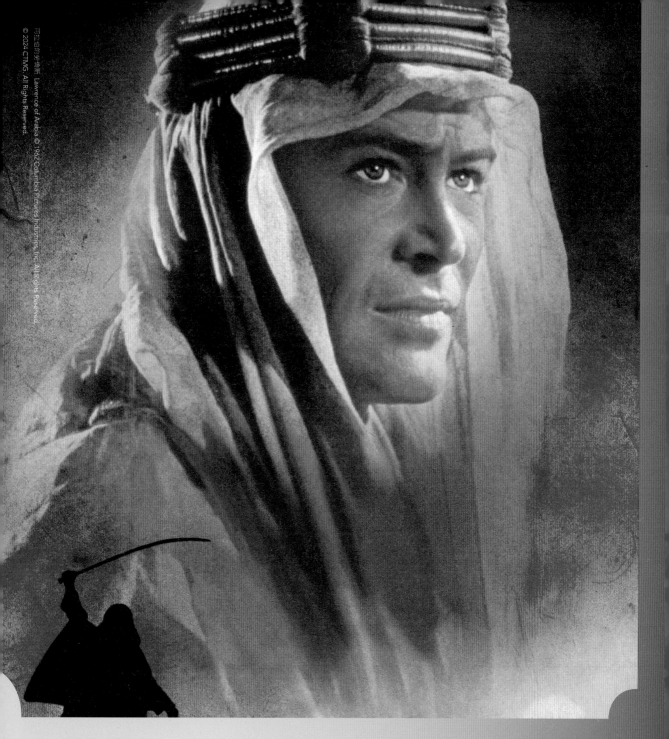

經典再出發：
哥倫比亞百年光華
CLASSICS REVISITED:
COLUMBIA 100

節目協力 Supported by

100 YEARS
COLUMBIA PICTURES
a Sony Company

緊扣時代的脈動

走過一世紀的哥倫比亞

文——洪健倫（台北電影節選片人）

▶1924年，哥倫比亞影業正式成立，在草創初期致力以商業喜劇與續集電影開拓市場，他們和《一夜風流》導演法蘭克‧卡普拉的長期合作，不但打造多部成功的商業佳作，也捧紅如詹姆斯‧史都華、隆納德‧考門等影壇巨星，也為哥倫比亞奠定了事業基礎。

進入1950年代，好萊塢的創作趨勢轉向更複雜的題材，與氣勢恢宏的大格局史詩。哥倫比亞也搭上潮流，積極和佛烈‧辛尼曼、大衛‧連、伊力‧卡山等名導合作，在奧斯卡頻頻嶄獲佳績，諸如1954年的《岸上風雲》、1962年的《阿拉伯的勞倫斯》等，在影史上都是劃時代的代表作。

經過此段輝煌後，哥倫比亞在影視環境快速變化下經歷一波經營考驗，但自六〇年代末到八〇年代仍不斷拓展作品光譜，反映彼時美國社會變化。他們參與製作與發行的作品中，可見如美國新浪潮代表作《逍遙騎士》（1969）、史蒂芬‧史匹柏的科幻經典《第三類接觸》（1977），還有1979年《克拉瑪對克拉瑪》這樣反映美國社會兩性觀點轉變的感人之作。

自九〇年代以降，哥倫比亞在專注投入商業電影的同時也持續和當代名導合作，推出包括馬汀‧史柯西斯《純真年代》（1993）、李安《臥虎藏龍》（2000）、與昆汀‧塔倫提諾的《決殺令》（2012）等。同時，他們的「007」與「蜘蛛人」等系列大片，至今仍是觀眾每一年最期待的作品。

走過一個世紀的哥倫比亞，不斷緊扣著好萊塢與美國社會的脈動。除了持續帶給不同世代觀眾最具娛樂性的視聽饗宴，它的輝煌歷史也為我們留下珍貴銀幕瑰寶。適逢哥倫比亞影業成立一百周年，本屆「經典再出發：哥倫比亞百年光華」單元特別從其二十世紀不同時期，精選四部榮獲奧斯卡最佳影片的重量級作品，回顧這個百年影業對影史的重要貢獻。◆

一夜風流 It Happened One Night ⓒ 1934 Columbia Pictures Industries, Inc. All Rights Reserved.
ⓒ 2024 CTMG. All Rights Reserved.

Keeping Pace with the Times

A Hundred Years of Columbia Pictures

Written by HUNG Jian-luen (Taipei Film Festival Programmer)

Translated by Howard SHIH

▶Columbia Pictures was officially established in 1924, and initially focused on expanding its market with commercial comedies and sequels. Then, through a long-term collaboration with *It Happened One Night* director Frank Capra, Columbia went on to produce many successful box office hits that launched the careers of film stars such as James Stewart and Ronald Colman, laying a solid foundation for the studio.

Entering the 1950s, Hollywood shifted towards more complex themes and grand-scale epics. Columbia followed suit by actively collaborating with renowned directors such as Fred Zinneman, David Lean, and Elia Kazan, achieving regular success at the Oscars. Films such as *On the Waterfront* (1954) and *Lawrence of Arabia* (1962) are all widely regarded as epoch-defining classics.

岸上風雲 On the Waterfront © 1954 Columbia Pictures Industries, Inc. All Rights Reserved. © 2024 CTMG. All Rights Reserved.

Following this glorious era, Columbia experienced a wave of business challenges amidst rapid changes in the film industry. However, from the late 1960s to 1980s, the studio continued to expand its spectrum of works, reflecting the social changes taking place in America at the time. Films produced and distributed included the iconic work of the American New Wave, *Easy Rider* (1969), Steven Spielberg's sci-fi classic *Close Encounters of the Third Kind* (1977), and *Kramer vs. Kramer* (1979), the poignant drama that reflected on the changing gender perspectives in American society.

Since the 1990s, Columbia has focused on commercial films while also collaborating with prominent contemporary filmmakers, releasing works including Martin Scorsese's *The Age of Innocence* (1993), Ang Lee's *Crouching Tiger, Hidden Dragon* (2000), and Quentin Tarantino's *Django Unchained* (2012). Meanwhile, new entries in the studio's blockbuster franchises such as *007* and *Spider-Man* continue to be among the most anticipated releases for audiences each year.

For the past century, Columbia Pictures has kept abreast of the pulse of both Hollywood and American society. Besides continually providing the most entertaining audiovisual feasts to audiences across multiple generations, its illustrious history has also left us with many precious cinematic treasures. In celebration of Columbia's 100th anniversary, "Classics Revisited - Columbia 100" presents a special selection of four Best Picture Oscar winners from different periods of the 20th century, serving as a retrospective of the important contributions of this century-old film studio to the history of cinema. ◆

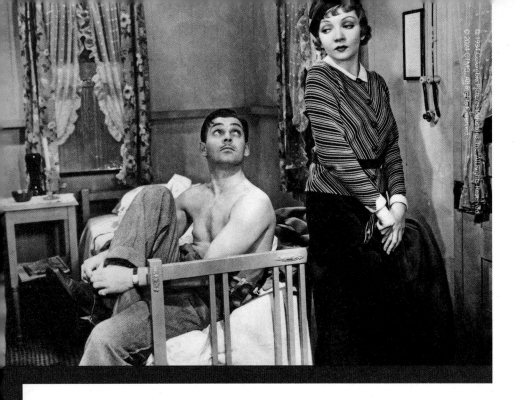

法蘭克・卡普拉（1897-1991），義大利裔美國知名導演。曾以《一夜風流》、《富貴浮雲》、《浮生若夢》三度獲得奧斯卡最佳導演獎，其著名的作品還包括美國人每年耶誕節必看的節慶電影《風雲人物》等。

Frank CAPRA (1897-1991) started his career as a comedy writer before turning to directing during the silent era. He won three Oscars for Best Director (1934, 1936, 1938) and another for Best Documentary for *Prelude to War* (1943), though his crowning achievement remains *It's a Wonderful Life*.

一夜風流
It Happened One Night

美國 USA｜1934｜DCP｜B&W｜105min

奧斯卡金像獎史上第一部同時拿下最佳影片、導演、改編劇本、男主角、女主角五獎，擁有「大滿貫」輝煌紀錄的經典作品，更是影史上公認描寫兩性由敵對邁向和解相戀，被稱為「神經／冤家喜劇」類型的開山鼻祖之作。法蘭克・卡普拉不僅深諳此道，也被視為最能用電影創造美國夢激勵人心的導演之一。

故事講述克勞黛・考爾白飾演的富家千金因父親不同意她的戀情而離家出走，卻陰錯陽差碰上克拉克・蓋博飾演的失業記者，他意外得知富老爸登廣告到處找女兒，決定一路貼身跟蹤搶獨家新聞，沒想到兩人不打不相識，竟漸漸愛上彼此。對白字字珠璣，邊鬥嘴邊愛上對方的浪漫情節，現在已成好萊塢每季都有的標準喜劇片種之一，幾乎所有拍此類型的人，都會以本片做為必修教材。

Spoiled Ellie Andrews escapes from her millionaire father, who wants to stop her from marrying a worthless playboy. En route to New York, Ellie gets involved with an out-of-work newsman, Peter Warne. When their bus breaks down, the bickering couple set off on a madcap hitchhiking expedition. Peter hopes to parlay the inside story of their misadventures into a job. But complications fly when the runaway heiress and brash reporter fall in love.

▌ 1935 奧斯卡最佳影片、導演、改編劇本、男主角、女主角 Best Picture, Best Director, Best Writing, Adaptation, Best Actor in a Leading Role, Best Actress in a Leading Role, Academy Awards
▌ 1934 威尼斯影展 Venice FF
▌ 1934 美國國家影評人協會最佳影片、十大電影 Best Film, Best Top Ten films, National Board of Review, USA

DIRECTOR
法蘭克・卡普拉 Frank CAPRA
PRODUCER
法蘭克・卡普拉 Frank CAPRA
Harry COHN
SCREENPLAY
Robert RISKIN
CINEMATOGRAPHER
Joseph WALKER
EDITOR
Gene HAVLICK
MUSIC
Howard JACKSON
Louis SILVERS
SOUND
Edward BERNDS
CAST
克拉克・蓋博 Clark GABLE
克勞黛・考爾白 Claudette COLBERT
PRINT SOURCE
美商索尼影業台灣分公司
Sony Pictures Releasing Taiwan Corporation

06.24 MON 22:00 信義 HYC 10｜06.27 THU 16:40 中山堂 TZH｜06.29 SAT 10:00 信義 HYC 10

伊力‧卡山 (1909-2003)，出生於土耳其的希臘裔美國著名導演，在戲劇與電影界皆有成就。曾以《君子協定》與《岸上風雲》兩度獲奧斯卡最佳導演獎，其他重要作品包括《慾望街車》、《天倫夢覺》等片。

Elia KAZAN (1909-2003) was a driving force in American theater and a highly-regarded filmmaker. He won three Academy Awards for directing classics like *On the Waterfront* (1954) and *A Streetcar Named Desire* (1951), and won an equal number of Tony Awards for directing such Broadway landmarks as *Death of a Salesman*.

岸上風雲
On the Waterfront

美國 USA｜1954｜DCP｜B&W｜108min

這部五〇年代的電影，放到現在來看，讓人熱血沸騰的程度絲毫未減！面對惡勢力，究竟該委曲求全還是勇敢對抗？馬龍‧白蘭度飾演在碼頭討生活的工人，面對一心尋求正義的愛人、不得不向惡徒低頭的親哥哥，最終他會如何在兩難中掙扎求生？

名導伊力‧卡山成功反映當時碼頭工會的腐敗，與黑道相互力角的社會現實，並貫注濃厚起伏的戲劇魅力。電影大受歡迎，一口氣入圍12項奧斯卡，並榮獲最佳影片、導演、男主角、女配角等八項大獎；除了白蘭度的方法演技，伊娃‧瑪麗‧仙萬綠叢中一點紅的感情戲、三位正反派男配角同時入圍的驚人紀錄，都是列名影史的重要看點。還有由今年奧斯卡入圍片《大師風華：真愛樂章》所刻劃的傳奇作曲家——李奧納德‧伯恩斯坦所譜寫的氣勢磅礴配樂，同樣不可錯過。

Ex-fighter Terry Malloy could have been a contender but now toils for boss Johnny Friendly on the gang-ridden waterfront. Terry is guilt-stricken, however, when he lures a rebellious worker to his death. But it takes the love of Edie Doyle, the dead man's sister, to show Terry how low he has fallen. When his crooked brother Charley the Gent is brutally murdered for refusing to kill him, Terry battles to crush Friendly's underworld empire.

DIRECTOR
伊力‧卡山 Elia KAZAN
PRODUCER
Sam SPIEGEL
SCREENPLAY
Budd SCHULBERG
CINEMATOGRAPHER
Boris KAUFMAN
EDITOR
Gene MILFORD
MUSIC
李奧納德‧伯恩斯坦
Leonard BERNSTEIN
SOUND
James SHIELDS
CAST
馬龍‧白蘭度 Marlon BRANDO
卡爾‧馬登 Karl MALDEN
李‧科布 Lee J. COBB
洛‧史泰格 Rod STEIGER
帕特‧亨寧 Pat HENNING
伊娃‧瑪麗‧仙 Eva MARIE SAINT
PRINT SOURCE
美商索尼影業台灣分公司
Sony Pictures Releasing
Taiwan Corporation

▌1955奧斯卡最佳影片、導演、劇本、男主角、女配角、黑白攝影、剪輯、黑白美術設計
Best Picture, Best Director, Best Actor in a Leading Role, Best Actress in a Supporting Role, Best Writing, Story and Screenplay, Best Cinematography, Black-and-White, Best Editing, Best Art Direction-Set Decoration, Black-and-White, Academy Awards

06.23 SUN 10:40 信義 HYC 11｜06.26 WED 16:30 中山堂 TZH｜07.01 MON 15:40 信義 HYC 11

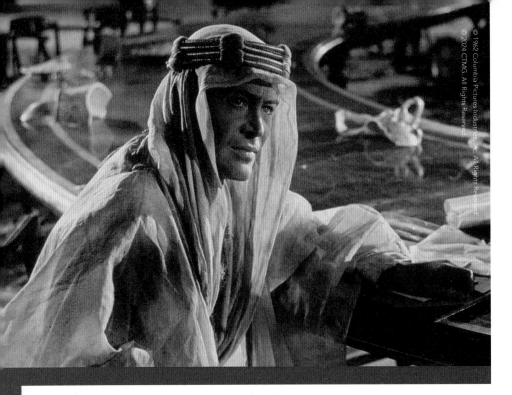

大衛・連（1908-1991），1908年生於英國倫敦，被認為是影史上最偉大的電影導演之一，作品以氣勢磅礴的史詩規模著稱。重要代表作包括《相見恨晚》、《桂河大橋》、《齊瓦哥醫生》等，並曾兩度獲得奧斯卡最佳導演獎。

David LEAN (1908-1991) received his start as an editor and went on to direct adaptations of Charles Dickens' *Great Expectations* (1946) and *Oliver Twist* (1948). He then directed *The Bridge Over the River Kwai* (1957), *Lawrence of Arabia* (1962), and *Doctor Zhivago* (1965), cementing his reputation as one of the greatest directors of all time.

阿拉伯的勞倫斯
Lawrence of Arabia

英國 UK｜1962｜DCP｜Color｜227min

這是一部必須透過大銀幕體會的經典之作，光看開場接近四分鐘的黑幕序曲，以及上下兩部的「中場休息」字卡，就是當代不會再有的觀影經驗。改編自英國軍官勞倫斯的真實故事，特立獨行的他，天生充滿領袖特質，用智慧獲得阿拉伯眾部落的信任，在一戰中團結起來逆襲土耳其，寫下歷史。在那個還沒有電腦特效的年代裡，大衛・連在沙漠實景中拍出當今都令人嘆為觀止、美不勝收的史詩場面；更重要的是，本片凸顯了戰爭的本質是醜陋人性。

莫瑞斯・賈爾的音樂、佛瑞迪・楊的攝影，都成了膾炙人口的影史記憶。彼得・奧圖以出眾氣質與湛藍雙眸，成功詮釋勞倫斯的複雜內在；奧瑪・雪瑞夫與安東尼・昆也貢獻了影帝級的演技。本片在當年一口氣入圍十項奧斯卡，並奪下七座大獎。

David Lean's splendid biography of the enigmatic T. E. Lawrence paints a complex portrait of the desert-loving Englishman who united Arab tribes in a battle against the Ottoman Turks during World War I.

▍ 1963 奧斯卡最佳影片、導演、彩色攝影、彩色美術設計、音效、剪輯、配樂
▍ Best Picture, Best Director, Best Cinematography, Color, Best Art Direction-Set Decoration, Color, Best Sound, Best Film Editing, Best Music Score – Substantially Original, Academy Awards

DIRECTOR
大衛・連 David LEAN
PRODUCER
Sam SPIEGEL
SCREENPLAY
Robert BOLT
Michael WILSON
CINEMATOGRAPHER
佛瑞迪・楊 Freddie A. YOUNG
EDITOR
Anne V. COATES
MUSIC
莫瑞斯・賈爾 Maurice JARRE
SOUND
Winston RYDER
CAST
彼得・奧圖 Peter O'TOOLE
奧瑪・雪瑞夫 Omar SHARIF
安東尼・昆 Anthony QUINN
亞歷・堅尼斯 Alec GUINNESS
傑克・霍金斯 Jack HAWKINS
荷西・費勒 José FERRER
安東尼・奎爾 Anthony QUAYLE
克勞德・雷恩斯 Claude RAINS
亞瑟・甘迺迪 Arthur KENNEDY
PRINT SOURCE
美商索尼影業台灣分公司
Sony Pictures Releasing
Taiwan Corporation

06.25 TUE 18:00 中山堂 TZH｜06.30 SUN 14:10 中山堂 TZH

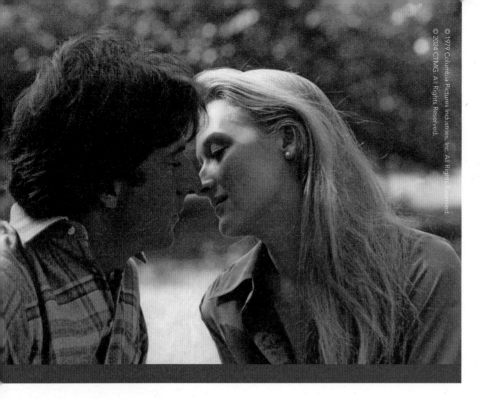

勞勃・班頓，1932年出生於美國德州，編劇、導演，曾五度入圍奧斯卡，1980年憑《克拉瑪對克拉瑪》獲奧斯卡最佳導演、改編劇本獎，1985年以《心田深處》再獲原著劇本獎。其他重要作品還有《大智若愚》、《人性污點》等。

Writer-director **Robert BENTON** began his career in the literary world, working in various editorial capacities and penning several books. Along with David Newman, he scored a huge success and garnered an Oscar nomination for Best Story and Screenplay with their first effort, *Bonnie and Clyde* (1967).

克拉瑪對克拉瑪
Kramer vs. Kramer

美國 USA｜1979｜DCP｜Color｜105min

可說是1979年版的《婚姻故事》。達斯汀・霍夫曼飾演忙於事業的上班族丈夫，梅莉・史翠普則是決心逃離痛苦婚姻、拋夫棄子的狠心妻子。當她一去不回之後，留下丈夫獨自負擔教養兒子的任務，父子兩人都得重新適應殘酷的單親生活；孰知妻子又回頭力爭撫養權，讓一家三口又陷入新的矛盾。

當時好萊塢很流行該路線的家庭通俗劇，簡單、煽情又能引發觀眾共鳴。本片足以名列影史上最經典的離婚故事之一，靠著輕巧卻深刻的情節對白，以及動人的演技加持，反映出當時的兩性議題。除了對簿公堂的掙扎與兩難，電影最討喜的就是達斯汀・霍夫曼與天才童星賈斯汀・亨利讓人又哭又笑的父子親情戲。片中四位主要演員皆入圍奧斯卡，最終霍夫曼與史翠普雙雙獲得殊榮。

Young husband and father Ted Kramer loves his family — and his job, which is where he spends most of his time. When he returns home late one evening from work, his wife Joanna confronts him and then leaves him, forcing Ted to become the sole caregiver to their six-year-old son. Now, Ted must learn to be a father while balancing the demands of his high-pressure career. But just as Ted adapts to his new role and begins to feel like a fulfilled parent, Joanna returns. And now she wants her son back.

DIRECTOR, SCREENPLAY
勞勃・班頓 Robert BENTON
PRODUCER
Richard FISCHOFF
Stanley R. JAFFE
CINEMATOGRAPHER
Néstor ALMENDROS
EDITOR
Gerald B. GREENBERG
MUSIC
Erma E. LEVIN
SOUND
Stan BOCHNER
Jack JACOBSEN
CAST
達斯汀・霍夫曼 Dustin HOFFMAN
梅莉・史翠普 Meryl STREEP
珍・亞歷山大 Jane ALEXANDER
賈斯汀・亨利 Justin HENRY
PRINT SOURCE
美商索尼影業台灣分公司
Sony Pictures Releasing
Taiwan Corporation

▌1980 奧斯卡最佳影片、導演、改編劇本、男主角、女配角
Best Picture, Best Director, Best Writing Screenplay Based on Material from Another Medium,
Best Actor in a Leading Role, Best Actress in a Supporting Role, Academy Awards

06.21 FRI 21:00 信義 HYC 10 ｜ 06.27 THU 16:20 信義 HYC 10 ｜ 06.29 SAT 13:30 中山堂 TZH

NOBODY SEES THE WORLD LIKE WE DO

CONVERSE

La Rive Gauche de la Seine
左岸咖啡館®

台灣杯測冠軍咖啡師 最新力作

甜檸咖啡

新品上市

捕捉巴黎的酸甜檸光

我在左岸咖啡館

左岸咖啡館®
La Rive Gauche de la Seine

甜檸咖啡

Lemon Coffee

 7-ELEVEN® 限定販售

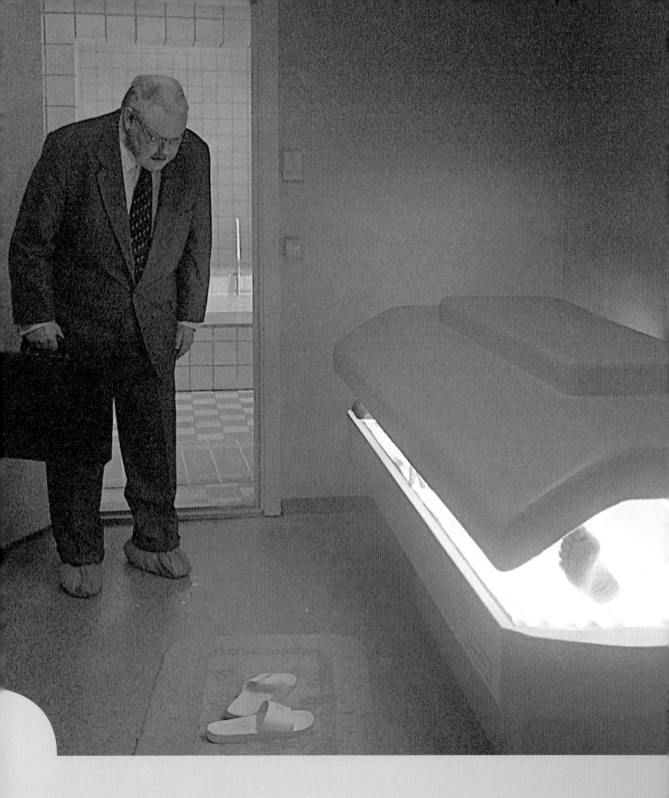

電影正發生：攝影

IN PROGRESS: CINEMATOGRAPHY

電影以光織影，虛實無垠，攝影賦予文字生命，為光影注入靈魂，每一個捕捉畫面的瞬間，便是影像誕生的起點。今年「電影正發生」將潛伏於機器後方的人物搬上舞台，以多種角度介紹「攝影指導」此一角色。

延續以往，影片放映與座談將從四位獨具風格的攝影創作者眼中，發現觀看影像的新方式。同時，受影迷歡迎的創作現場，將拋開傳統攝影流程，兩天時間交由導演與攝影指導相互碰撞，展現創作過程中的攝影策略與有機性。靜態展則提供另一途徑，直面攝影指導過往作品的思考歷程與工作方式。最後由論壇為此次的展覽作結，透過各類型攝影創作者的分享，為此命題拋出想法，開啟大眾的想像。

Cinema weaves light and shadow, blurring the boundaries between illusion and reality. Cinematography breathes life into words, infusing soul into light and shadow. Every moment captured on screen marks the beginning of cinematic creation. This year, "In Progress" brings the figure hidden behind the camera into the spotlight to explore the role of the "cinematographer" from various different angles.

Continuing the tradition of previous editions, the screenings and talks will seek to discover new ways of viewing images through the eyes of four cinematographers, each with their own unique style. Meanwhile, the On-Site depart from traditional cinematographic conventions, allowing directors and cinematographers to collide and showcase their cinematography strategies and the organic nature of the creative process. The static exhibition offers another avenue, delving into the thought processes and methods behind the cinematographers' past works. Finally, this section concludes with talks that will invite different types of cinematographers to share their insights and ideas, opening up everyone's imaginations.

創作現場 ON-SITE

創作現場試圖回溯電影創作源頭，打造開放式實驗場域，聚焦創作過程，呈現其中的細節與取徑，探問影像語言的產生。本次以攝影為題，邀請第56屆金馬獎最佳攝影得主陳克勤與導演錢翔攜手創作，為期兩日的現場激盪，深入剖析攝影的美學思考歷程，揭示文字轉換為影像的魔幻過程。從光影營造、鏡頭選擇到空間的布局，我們將探索攝影的建立和策略的鋪排，展現出創作的有機可能性。

與此同時，同一場域將展出四位攝影指導過往掌鏡作品的工作資料，希望透過各具特色的工作方式之展示，脈絡化呈現他們的思考歷程，在看似毫無斧鑿痕跡的鏡頭之中，窺探攝影指導背後的思緒萬千。展覽內容將包含劇本筆記、勘景照片、場景圖等，試圖解碼攝影指導的多重面貌。

"On-Site" aims to take us back to the origins of filmmaking by constructing an open experimental field that focuses on the creative process, presenting its details and approaches, and exploring the creation of visual language. Centered around cinematography, this year's event invites Chen Ko-chin, winner of Best Cinematography at the 56th Golden Horse Awards, and director Chienn Hsiang for two days of intense collaboration that will delve deep into the aesthetic thinking of cinematography, revealing the magical process of transforming words into images. From the creation of light and shadow, shot selection, to spatial arrangement, we will explore how cinematography is set up and how strategies are implemented, showcasing the organic possibilities of filmmaking.

At the same time, the venue will exhibit the past works of four cinematographers. Our aim is to present their thought processes in a contextualized manner through the demonstration of their unique methods, and in their seemingly unmanipulated frames, take a peek into the myriad thoughts behind a cinematographer's work. The exhibition will also include script notes, location scouting photos, and scene diagrams, attempting to decode the multiple facets of cinematography.

地點 Location |

臺北市中山堂 2F光復廳
Guangfu Auditorium, Taipei Zhongshan Hall 2F

開放時間 Opening Times |

06.28 FRI 14:00-17:00、18:00-21:00
06.29 SAT 14:00-17:00、18:00-21:00

創作團隊
ARTISTS

陳克勤
CHEN Ko-chin

錢翔
CHIENN Hsiang

攝影指導。攝影生涯從紀錄片開始,透過拍攝紀錄片培養觀察及感受情感的能力,同時也接觸廣告、MV,經由不同類型的工作內容培養多重面向思考,並將經驗融入在劇情片的拍攝中。曾以短片《殯財》獲2014年金穗獎一般組攝影獎;並於2017年以電影《分貝人生》提名金馬獎最佳攝影,獲上海電影節亞洲新人獎最佳攝影;2019年以電影《狂徒》擒下金馬獎最佳攝影。2022年掌鏡作品《咒》再次提名金馬獎與台北電影獎最佳攝影;更以影集《告別》、《天橋上的魔術師》、《模仿犯》三度獲金鐘獎攝影獎肯定。

CHEN Ko-chin is a cinematographer. He began his career in documentary films and later honed his skills on commercials and music videos. For the 2017 film *Shuttle Life*, he won Asian New Talent - Best Cinematographer at the Shanghai International Film Festival and Best Cinematography at the Chinese Young Generation Film Forum Awards, and was also nominated for Best Cinematography at the Golden Horse Awards. He later earned two more Golden Horse Award nominations for Best Cinematography, for *The Scoundrels* in 2019 and *Incantation* in 2022. He served as the cinematographer on the drama series *The Long Goodbye*, *The Magician on the Skywalk*, and *Copycat Killer*, all of which won Golden Bell Awards for Best Cinematography.

資深電影攝影、導演。從事影像工作20餘年,作品風格以寫實為基調,擅長描繪角色狀態,細緻捕捉其神情與靈魂。2010年跨界擔任電視電影《歸·途》導演,入圍台北電影獎最佳劇情長片。2014年身兼首部電影長片《迴光奏鳴曲》之編導及攝影,獲台北電影獎最佳劇情長片,並入選盧卡諾、釜山及倫敦等影展。2021年再以自行掌鏡的編導作品《修行》入選釜山影展,並獲金馬獎最佳女主角、最佳改編劇本提名肯定。

CHIENN Hsiang is a seasoned cinematographer and director who has worked in film for over two decades. Known for his realistic style, he specializes in depicting the states of characters and capturing their essence and spirit. In 2010, he directed the TV film *Ranger*, which was nominated for Best Narrative Feature at the Taipei Film Awards. He was the writer, director, and cinematographer of his 2014 debut feature, *Exit*, which won Best Narrative Feature at the Taipei Film Awards and was selected to many international film festivals, including Locarno, London, and Busan. He was again the writer, director, and cinematographer of his 2021 film, *Increasing Echo*, which was selected to Busan and earned Golden Horse Award nominations for Best Leading Actress and Best Adapted Screenplay.

本次邀請六位攝影指導，將以兩場論壇開啟攝影對話。試圖打破大眾對攝影常規與器材使用的固有印象，探問在有限資源下，電影攝影的挑戰與選擇。同時，也透過匯聚業內豐富經驗，挖掘該產業的創作軌跡，並描繪台灣電影攝影的發展面貌。

This year, we invite six cinematographers to initiate a dialogue on cinematography through two separate talks. We aim to break through fixed impressions regarding cinematographic conventions and equipment use, exploring the challenges and choices in film cinematography given limited resources. At the same time, by bringing together a wealth of industry experience, we seek to unearth the creative trajectories of this field and present the development of cinematography in Taiwan.

主持人 Moderator | 林孝謙 Gavin LIN（導演 Director）

地點 Location |
臺北市中山堂 2F 光復廳
Guangfu Auditorium, Taipei Zhongshan Hall 2F

打開攝影的一百種方式
Unlocking a Hundred Approaches to Cinematography

當劇本文字飛揚，情節層層交織，攝影師在有限資源內，如何提煉其精髓、剖析結構、編排故事，另闢蹊徑玩出新意？攝影不僅是技術的堆砌，更是美學、情感和敘事的安排，此次試圖從不同類型的電影攝影切入，以獨特視角挑戰傳統框架，探索每幀畫面中風格化的實驗靈魂。

As the words of the screenplay soar and the plot weaves layer upon layer, how can cinematographers utilize limited resources to refine the film's essence, dissect its structure, arrange its narrative, and carve new paths to innovative ideas? Cinematography is not merely about accumulating techniques; it's also about arranging aesthetics, emotions, and narratives. This time, we attempt to delve into the various types of film cinematography, challenging traditional frameworks from unique perspectives and exploring the spirit of stylized experimentation in each frame.

攝影夢的背後
Behind the Cinematography Dream

觀眾目光停留的每顆鏡頭，皆是攝影師嘔心瀝血的創作。他們形塑空間與時間，說服觀眾眼前的畫面即為真實。當焦點從景框內的篇幅，轉為景框後方的凝視，觀眾將一窺資深攝影指導的專業養成，以及在攝影生涯中，他們如何精準把控每顆鏡頭，將文字轉化為引人入勝的影像語言，在畫面中表現其獨特的美學概念。

Each shot that captures the audience's gaze is a result of the cinematographer's painstaking effort and dedication. They shape space and time, convincing viewers that the image before their eyes is reality. We shift the focus from what is inside the frame to the gaze behind it, giving audiences a glimpse into the professional development of seasoned cinematographers, as well as how they meticulously set up each shot throughout their cinematographic careers to transform words into captivating visual language and showcase their unique aesthetics within the frame.

與談人 Speakers

朱映蓉
ZHU Ying-rong

攝影指導 Cinematographer

沈可尚
SHEN Ko-shang

導演、攝影指導 Director, Cinematographer

廖明毅
LIAO Ming-yi

導演、攝影指導 Director, Cinematographer

與談人 Speakers

包軒鳴
Jake POLLOCK

攝影指導 Cinematographer

余靜萍
YU Jing-pin

攝影指導 Cinematographer

關本良
KWAN Pun-leung

攝影指導 Cinematographer

大丈夫
Husbands

美國 USA｜1970｜DCP｜Color｜142min

宛如七〇年代寫實殘酷版《醉後大丈夫》，卡薩維蒂自編自導自演，將兩位演員好友帶入情境之中，既像虛構又混有真實。三名已婚人夫參加英年早逝好友喪禮，在悲憤又無處發洩的情緒下，他們決定豁出去瘋狂一次，毫無計劃地度過一個充滿菸、酒、女人、自由和各種垃圾話，而且「偽單身」的荒誕假期。過程中一段段看似無意義的對白、爭執與意外，其實盡顯這群長不大幼稚男人的中年危機與人生難關。

此片被喻為卡薩維蒂早期奠定風格的代表作，大量的特寫、手持攝影與跟拍，彷彿更精準捕捉那些難以言詮的內在與焦躁狀態，充滿即興風格又不失濃烈電影感。由攝影指導包軒鳴推薦，稱其為卡薩維蒂較少見，但最值得在大銀幕上觀賞的作品之一。

Three middle-aged friends, Harry, Archie and Gus, embark on a nihilistic voyage after the sudden death of an old friend. It's a journey that makes them question the very fabric and worth of their suburban lives.

Husbands is considered by many to be John Cassavetes' directorial masterpiece, the point at which his filmmaking orthodoxy and innate desire for psychological dissection became one.

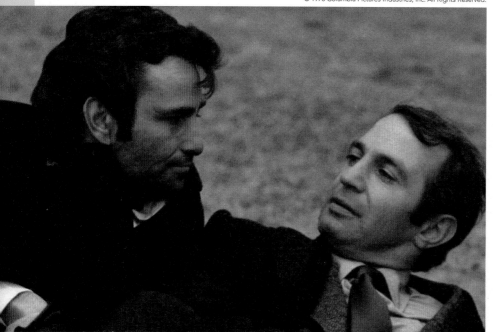

DIRECTOR, SCREENPLAY, EDITOR 約翰·卡薩維蒂 John CASSAVETES **PRODUCER** Al RUBAN **CINEMATOGRAPHER** Victor J. KEMPER **MUSIC** Jack ACKERMAN, Ray BROWN, Stanley WILSON **SOUND** Barry COPLAND, Dennis MAITLAND **CAST** 彼得·福克 Peter FALK, 本·加薩拉 Ben GAZZARA, 約翰·卡薩維蒂 John CASSAVETES **PRINT SOURCE** Park Circus

- 1989 鹿特丹影展 IFF Rotterdam
- 1989 舊金山影展 San Francisco IFF

06.28 FRI 19:00 信義 HYC 11 ★｜07.02 TUE 12:10 信義 HYC 11

▶ 推薦人 Guest Curator

包軒鳴，美籍電影攝影師。曾以《武俠》獲香港電影金像獎及亞洲電影大獎最佳攝影，並以《疫起》、《風中有朵雨做的雲》、《七月與安生》、《女朋友。男朋友》等片多次入圍國內外重要獎項。最新掌鏡作品有陳可辛導演的《醬園弄》和《獨自上場》。

Jake POLLOCK is an American cinematographer based in Taiwan. He won Best Cinematography at the Hong Kong Film Awards and Asian Film Awards for *Dragon (Wuxia)*, and has been nominated for numerous domestic and international awards, including for *Eye of the Storm*, *The Shadow Play*, *Soul Mate*, and *Gf*Bf*.

▶ 推薦理由 Guide

約翰·卡薩維蒂的攝影耐心觀察角色所創造的同理之心，於我而言是首要且深具啟發的。他的作品不太戲劇化，但擁有少數電影能達到的坦誠。本片是第一部我看過彷彿打開一扇通往真實生活之窗的電影，飽含情緒、錯誤及流露真實的片刻。嘗試模擬他作品的參與感和對角色細膩的觀察，是我在追求攝影專業上的動力，即使在我虛構的類型電影中也是。

The willingness of John Cassavetes' camera to patiently observe his characters creates an empathy that was a first for me and is deeply inspiring. Rarely dramatic in the traditional sense but always honest in a way that few movies had been for me. *Husbands* was the first film I saw that felt like a window into real life with all its emotions and mistakes and moments of truth. Trying to emulate John Cassavetes' sense of participation and observation with the characters has always been a driving force in my cinematography, even in my genre films that have little to do with real life. *Husbands* is one of Cassavettes' rarer films, but I think it is one of his best films to see on the big screen.

二樓傳來的歌聲
Songs from the Second Floor

瑞典 Sweden｜2000｜DCP｜Color｜99min

本片為大師級導演洛伊・安德森當年在睽違影壇25年後重新回歸，從此奠定個人獨特風格的重要代表作，也是後來被稱為他「人生三部曲」的第一部。經濟蕭條的城市裡，交通動彈不得，一個個面目蒼白的小人物，在平凡生活中展現出各種難以言喻的無奈與悲涼，看似冷酷無解，卻又滲透出苦中作樂般的迷人幽默，刻意鬆散的情節結構，細火慢熬出警世寓言的滋味。

洛伊・安德森展現當今世上難得一見的獨特美學，時常運用固定鏡位、長時間鏡頭，呼應他精雕細琢的場面調度。深究其創作方法，所有看似寫實的室內外戲，竟全都在自家攝影棚內搭景完成，毋需特效，以視覺上的「透視」概念，塑造超現實的影像手法，花費漫長時間製作，風格獨樹一幟的創作者。

One evening, a series of strange events with no apparent logic take their course. A clerk is made redundant; an immigrant is violently attacked; a magician makes a disastrous mess of his routine. One person stands out in this collection of characters — it's Karl and his face is covered in ash. He has just put a match to his furniture store in order to cash in on the insurance. No one gets a wink of sleep that night.

▶ 推薦人 Guest Curator

余靜萍，台灣攝影師，擅長用鏡頭捕捉人物情緒。曾擔任《九降風》、《花吃了那女孩》、《消失打看》、《七月與安生》、《少年的你》、《揭大歡喜》、《燃冬》、《(真)新的一天》等多部電影之攝影指導。2023年以《(真)新的一天》獲金馬獎最佳攝影，成為金馬獎史上首位獲獎的女性攝影師。

YU Jing-pin is a Taiwanese cinematographer whose works include *Winds of September, Candy Rain, Honey Pupu, Soul Mate, Better Days, As We Like It,* and *The Breaking Ice.* In 2023, she became the first female cinematographer to win the Golden Horse Award for Best Cinematography for *Fish Memories.*

▶ 推薦理由 Guide

歲月靜好是片刻，一地雞毛是日常。

In life, tranquility is but a fleeting moment, while trivialities are commonplace.

DIRECTOR, SCREENPLAY, EDITOR 洛伊・安德森 Roy ANDERSSON **PRODUCER** Lisa ALWERT **CINEMATOGRAPHER** István BORBÁS, Jesper KLEVENÅS **MUSIC** Benny ANDERSSON **SOUND** Jan ALVERMARK (FSFL) **CAST** Lars NORDH, Stefan LARSSON, Torbjörn FAHLSTRÖM, Sten ANDERSSON **PRINT SOURCE** Coproduction Office

▍ 2001 瑞典金甲蟲獎最佳影片、導演、劇本、攝影、成就
Best Film, Best Direction, Best Screenplay, Best Cinematography, Best Achivement, Gulbagge Awards

▍ 2000 挪威影展影評人獎 Norwagian Film Critics Award, Norway IFF

▍ 2000 坎城影展評審團獎 Jury Prize, Cannes

06.21 FRI 16:20 華山 SHC 1 ｜ 06.27 THU 19:00 信義 HYC 11 ★

流雲世事
Drifting Clouds

芬蘭 Finland｜1996｜DCP｜Color｜95min

老夫電車司機、老妻餐廳經理，倆口恩恩愛愛，經濟拮据更要優雅生活。貸款還未還清，老夫就被裁員、老妻被引退，雙雙失業的兩人該何去何從？找到工作又被騙，追討薪資又被揍；可是親愛的，縱使造化弄人，至少我們有一起吃苦的幸福。努力翻身了還是一波三折，精神抖擻卻換來一蹶不振……來到窮途末路，昔日餐廳老闆卻遞出一張機會卡，他們能否守得雲開見月明？

作為「魯蛇三部曲」的首部曲，郭利斯馬基以冷靜節制的攝影，拍出荒誕詼諧的人物刻畫，舉重若輕地回應了九〇年代芬蘭經濟危機，以及對無產階級社會的省思。極簡主義的場景卻不時湧現密碼般的美術設置，片中多位殿堂級演員的撲克臉冷面表演，也讓一眾角色的內心小劇場暗湧翻騰。描寫甘苦人生不忘表彰人性微光，本片是獻給所有正深陷谷底卻願意相信明天的人；只要還剩一口氣，再多絕望仍有希望。

The chilly landscapes of Helsinki are warmed by the gentle humanism and wry humor of Aki Kaurismäki in the first installment of his Finland Trilogy, a deadpan tale of everyday survival in the face of overwhelming obstacles. Misfortune begets misfortune when, in short order, Lauri loses his job as a tram driver and the restaurant where his wife, Ilona, works announces it is closing to make way for a chain. With few job prospects, the two find themselves facing a crisis that tests the strength of their bond.

▶ 推薦人 Guest Curator

姚宏易，曾參與侯孝賢導演多部電影拍攝。執導的紀錄長片《金城小子》曾獲金馬獎最佳紀錄片、台北電影獎百萬首獎等多項獎項肯定，更分別以《地球最後的夜晚》、《刻在你心底的名字》兩度獲得金馬獎最佳攝影。

YAO Hung-i served as Hou Hsiao-hsien's cinematographer on many films. For directing *Hometown Boy*, he won the Golden Horse Award for Best Documentary and the Taipei Film Awards' Grand Prize. He won the Golden Horse Award for Best Cinematography for *Long Day's Journey into Night* and *Your Name Engraved Herein*.

▶ 推薦理由 Guide

拍電影時我們常討論「裝」什麼好料的給觀眾，有時失察裝太多塞太滿了，自己都覺得倒胃口時，一定會打直腰桿向芬蘭導演阿基·郭利斯馬基敬禮，因為他非常清楚地、不被世界變動所左右地，只拿走該拿的料絕不貪心，並淬鍊出屬於他的獨特風味。看他的電影總能提醒自己不要一昧地偏向技巧（矯飾），就像當兵打靶時，要把步槍先歸零一樣。

When making a film, we often talk about what ingredients to "pack" for the audience. But sometimes, when we inadvertently pack too much and disgust even ourselves, we will pay our respects to the great Finnish filmmaker Aki Kaurismäki. This is because he is very assured and unaffected by changes in the world; he only takes necessary ingredients without being greedy, refining his own unique flavor. Watching his films always reminds me not to blindly focus on technique (pretension). It's like how, during military service, we need to first zero our rifles before shooting targets.

DIRECTOR, PRODUCER, SCREENPLAY, EDITOR 阿基・郭利斯馬基 Aki KAURISMÄKI **CINEMATOGRAPHER** Timo SALMINEN **MUSIC** Shelley FISHER **SOUND** Jouko LUMME **CAST** Kati OUTINEN, Kari VÄÄNÄNEN, Elina SALO, Sakari KUOSMANEN **PRINT SOURCE** Finnish Film Foundation

■ 1997 芬蘭國家電影獎最佳影片、導演、劇本、女主角、女配角
 Best Film, Best Direction, Best Script, Best Actress, Best Supporting Actress, Jussi Awards
■ 1996 坎城影展人道精神獎特別提及 Prize of the Ecumenical Jury - Special Mention, Cannes

06.25 TUE 15:40 中山堂 TZH｜**07.01 MON 19:00 信義 HYC 10 ★**

食人錄

Caniba

法國 France｜2017｜DCP｜Color｜91min

佐川一政，一名極具爭議性的傳奇人物。八〇年代初期，他在巴黎殺死一位他愛慕的少女，並將她的肉體當成佳餚，在法國經歷兩年的精神治療後，以自由之身返回日本。回到日本後，他寫書、出版漫畫，將食人的經歷毫不掩飾地描述給外界知道，他也拍攝 A 片、化身食評家。在大眾獵奇的目光下，他被再現成一種東方主義畫像中吃女性的獸。

這部電影是導演雙人組維瑞娜‧帕拉韋爾、呂西安‧卡斯坦因－泰勒在事發 30 多年之後的另種再現。然而，他們對佐川一政的食人慾望不感興趣，攝影機靜靜凝視躺臥著的佐川一政，因病而行動不便的他，只能仰賴弟弟的協助，逐步地經由兄弟倆的互動，輾轉呈現出這位極具爭議的人物成謎的內心世界。

Caniba reflects on the discomfiting significance of cannibalistic desire in human existence through the prism of Issei Sagawa. Rather than taking cover behind facile outrage, or creating a masquerade out of humanity's voyeuristic attraction to the grotesque, as has been the case for portraits of Sagawa to date, it treats cannibalistic desire and acts with the unnerving gravity they deserve. Cannibalism is closer to the human condition than most of us ever suppose, both because it is replete with affinities to sexuality and spirituality and because in our evolutionary history it implicates humanity as a whole.

DIRECTOR, CINEMATOGRAPHER, EDITOR 維瑞娜‧帕拉韋爾 Véréna PARAVEL, 呂西安‧卡斯坦因－泰勒 Lucien CASTAING-TAYLOR **PRODUCER** 維瑞娜‧帕拉韋爾 Véréna PARAVEL, 呂西安‧卡斯坦因－泰勒 Lucien CASTAING-TAYLOR, Valentina NOVATI **SOUND** Bruno EHLINGER **CHARACTER** 佐川一政 SAGAWA Issei, 佐川俊 SAGAWA Jun **PRINT SOURCE** 車庫娛樂股份有限公司 GaragePlay Inc.

▍2017 紐約影展 New York FF
▍2017 多倫多影展 Toronto IFF
▍2017 威尼斯影展地平線單元最佳影片 Best Film, Orizzonti, Venice FF

▶ 推薦人 Guest Curator

許哲嘉，因大學意外接觸紀錄片製作，而開啟個人電影之路。2015 年以原住民醫師徐超斌為主題的紀錄片《沒有終點的旅程》入圍金穗獎，並以耗時五年完成的紀錄片《捕鰻的人》，獲得台北電影獎最佳攝影、紀錄片及百萬首獎肯定。

HSU Che-chia embarked on his filmmaking journey after unexpectedly getting involved in a documentary production during university. In 2015, his documentary *On the Road* was nominated for the Golden Harvest Awards. His 2021 documentary *The Catch* won Best Cinematography, Best Documentary, and the Grand Prize at the Taipei Film Awards.

▶ 推薦理由 Guide

初探電影，一直以攝影為重，聲音為輔，直至偶然經歷電影聲音的後期製作，我的身體、感官及電影之眼便開始有極大轉變。感官人類學的系列影片在內容、攝製、理解與詮釋上，都大大開啟我的電影感官經驗。《食人錄》就是一部如此經典的感官影片，透過探索聲音性、感官性、現場性，去親近犯罪、邊緣、尋常、複雜、弔詭，以及其中的多重關聯性。

In my early explorations of film, I focused on cinematography and considered sound secondary. It wasn't until I worked on sound in post-production that my body, senses, and cinematic perspective changed. Sensory anthropology films have greatly opened up my personal sensory experiences. *Caniba* is such a classic sensory film that touches on crime, marginalization, ordinariness, complexity, paradoxes, and their multiple interconnections through the exploration of sound, sensory experience, and liveness.

他們的凝視之處 便是影像的起點

文──邱予慧（台北電影節 節目專員）

大丈夫 Husbands © 1970 Columbia Pictures Industries, Inc. All Rights Reserved.

▶動態影像發展至今已逾百年，視覺文化如今主導著人們的觀看與感受方式，攝影在其中作為關鍵角色，當概念從技術層面提升至創作與美學風格的建立時，攝影師不僅作為光影的操控者，更是說書人，捕捉光影的選擇決定了他們詮釋故事的方式。而對於敘事的捕捉，背後是無數的技術考量與創意決策。透過敏銳的觀察和技術準備，攝影師在現場必須做出快速而精確的判斷，凝鍊每一幀畫面的情感與訊息。

在電影創作的過程中，攝影是形塑場景氛圍和引導觀眾感受的關鍵元素，除了得在理性的技術處理與感性的創意表達之間找到平衡，從最初概念到成片，都涉及跨領域的密切協作和不間斷的技術調整。這一過程可能始於對作品視覺色調的初步探討，逐步擴展至美術對於質感的影響、造型的改動，再到演員表演系統的異同，最後則是調光工作的完成。每一次的創意發想和技術糾錯，精確地塑造最終影像的呈現。此外，攝影師與不同部門的溝通也是製作過程中不可或缺的一環。舉例來說，前期訪談時我們發現，在與導演的

溝通當中，攝影師通常需要提前進行大量的視覺和構圖預設，也涉及前期廣泛的參考資料收集，這不僅止於技術上的準備，更是對電影藝術核心的理解。而在捕捉表演時，攝影師的角色不僅限於觀察者，更接近參與者，如同舞台上的雙人舞，與演員之間的互動充滿化學反應，每一次光線的調整、鏡頭的選擇，都是對演員表現的直接回應，而演員的表現同時也影響了攝影的判斷與進入。

前期訪談了多位攝影指導，最初我們試圖自他們的工作流程中找到共通的規則與作法，爾後發現在台灣已逐漸體系化的電影產業當中，仍存在著各式的攝影創作取徑，從閱讀劇本、文字轉譯為影像語言、與團隊的溝通，再到現場的技術執行皆大相徑庭。而訪談過程中，也感受到攝影指導們在少有機會合作的前提下，對於其他同業創作者的好奇。故此次「電影正發生」對於電影攝影的重點，聚焦在多種攝影思考歷程與策略，並盡可能多方面地展現攝影的有機性。

進入攝影創作的多種途徑

為回應本次主題，首先策劃了靜態展，展示影像調性與攝影風格迥異的攝影師們的所作所思。觀眾將得以更進一步於此一窺攝影的作業流程，除了如何閱讀劇本、與劇組溝通、選擇鏡頭等等，亦包含了他們的入行歷程及養成。本展覽也提供一條途徑，作為進入「攝影人」私領域的起點，窺探不同背景與歷練的攝影師們，在電影創作中的實驗與實踐。同時，兩日的創作現場則直搗「正發生」的核心，邀請攝影指導陳克勤，以及同樣具有豐富攝影經驗的導演錢翔攜手合作，拋開一切電影製程，從電影攝影的本質為始，觀察攝影師在每個情境下的文本解讀、光影安排與鏡頭選擇，還有與團隊的合作溝通，每次開機前的背後策略為何，最後再扣回展覽核心──「觀看」如何被建構。

於創作現場打開對攝影的想像之後，論壇為本次展覽開啟電影攝影的對話，也作為觀眾對此創作的提問起點，試圖打破大眾對於攝影模式與器材的既定印象。首場內容將看到四至五人組成的小團隊緊密合作，以近似紀錄片的手法捕捉人物情感變化；拋開日新月異的攝影器材，化繁為簡，以手機鏡頭創造影像美學；同時亦將看到攝影指導置身外在條件難度高的底片時期，如何走縱筋骨、精密計算每一次開拍的瞬間。在展現多樣的攝影方式之後，讓擁有文藝片、紀錄片、類型片等多元片型代表作的資深攝影指導們，侃侃道出彼此的執掌鏡頭之路，期望透過漫談與交流，勾勒出台灣電影攝影的發展現況。

從攝影師的目光再觀看

延續以往，今年持續邀請不同創作風格的攝影師選映對他們職涯富含重大意義的電影作品，而有趣的是，此次作品年份跨度近50年，示意著不同時期的影像持續滋養著新的創作能量。其中包含以靈動手持攝影風格見長的包軒鳴，推薦了美國獨立電影先驅約翰‧卡薩維蒂的《大丈夫》（1974），其對於角色與狀態的細緻描摹，以及在劇情中發掘生活的真實肌理也成為包軒鳴日後攝影風格的奠基。此外，攝影風格自由多變，甫獲金馬獎最佳攝影的女性攝影師余靜萍，選擇了瑞典電影大師洛伊‧安德森的《二樓傳來的歌聲》（2000），超現實般的攝影風格為此片定調，以黑色幽默刻劃如同失去靈魂般的角色樣貌及荒誕情節，搭配如詩如畫般的長鏡頭美學，對長期以動／靜態影像作為靈感來源的余靜萍來說，有雙重啟發的作用。同樣有著北歐悲喜劇調性，鏡頭瞄準社會底層的《流雲世事》（1996），由芬蘭名導阿基‧郭利斯馬基執導，則為攝影指導姚宏易所推薦。師承侯孝賢，從助理開始打拼至今已擒下兩座金馬攝影獎座的他，經時間打磨而淬煉出的自然攝影，巧妙與該作品中簡約精準的鏡頭遙相輝映。而在清一色大師之作當中，以前衛大膽風格聞名的導演雙人組維瑞娜‧帕拉韋爾與呂西安‧卡斯坦因－泰勒的舊作《食人錄》（2017）打開廣度。該片失焦的極端特寫鏡頭，讓觀眾浸淫在驚世駭俗的日本食人魔世界當中，由同為紀錄片導演的許哲嘉推薦。曾獲台北電影節百萬首獎與最佳攝影的他，跳脫類型限制，從紀錄片角度觀看攝影如何體現潛藏於生活中的自然質地。

在龐雜且技術門檻極高的攝影世界之前，本次電影正發生試圖匯聚不同攝影師們的經歷與思緒，嘗試以創作角度詮釋該項命題。特別感謝在本次策展過程中，每一位攝影創作者的投入與幫助，引領我們從未知走向一次自由且有機的實驗與交流，為此次的單元定影成像。◆

Where their gaze falls is where the image begins

▶ Motion pictures have developed for more than a century, and visual culture now guides the way people perceive and feel. Cinematography has played a vital role in this. When the concept rises from the technical aspects to the formulation of creative and aesthetic styles, cinematographers become not just manipulators of light and shadow but also storytellers, and their choices in capturing light and shadow determine how they interpret the story. As for capturing the narrative, behind it are countless technical considerations and creative decisions. Through keen observations and technical readiness, cinematographers must make quick and precise judgments on the spot, refining the emotions and messages in each frame.

In the filmmaking process, cinematography is a key element that shapes atmosphere and influences audience emotions. Apart from finding a balance between logical technical decisions and sensible artistic expression, it also involves close interdisciplinary collaboration and constant technical adjustments, from initial concept to final film. This process may start with preliminary discussions on the film's color tone, gradually expanding to the impact of art direction on texture, modifications in styling, to the actors' performance methods, and finally, the completion of color grading. Each creative idea and technical correction contributes to the precise shaping of the final image. Furthermore, communication between the cinematographer and other departments is also integral to the production process. For instance, in initial interviews, we discovered that during communications with the director, the cinematographer often needs to prepare a large number of visual and framing presets in advance. This involves extensive collection of reference materials, not only for technical preparations but also to gain a deeper understanding of the essence of cinematic art. When capturing performances, the role of the cinematographer is not merely that of an observer; it is closer to that of a participant. It is akin to a duet on the dance stage, where interactions with the actors are filled with chemical reactions. Every lighting adjustment and choice of shot is a direct response to the actors' performances. At the same time, the actors' performances also influence the cinematographer's decisions and approach.

We spoke with several cinematographers during initial interviews. In the beginning, we attempted to find common rules and methods in their workflows. However, we discovered that within Taiwan's gradually systematized film industry, there exists all kinds of approaches to cinematographic creation. From reading scripts, converting words into visual language, communicating with the crew, to technical execution on the set, everyone has their own way of doing things. During the interviews, we also sensed the cinematographers' curiosity about their industry colleagues, given the limited opportunities for collaboration. Accordingly, this year's "In Focus" on cinematography zones in on its various thought processes and strategies, showcasing the organic nature of cinematography in as many ways as possible.

The many paths to cinematographic creation

In accordance with this year's theme, a static exhibition was first planned to showcase the thoughts and actions of cinematographers with different imaging tones and styles. Audiences will be able to further glimpse into the cinematographic process, including how to read scripts, communicate with the crew, choose shots, and so forth, as well as how they first entered the industry and their development. This exhibition also provides a pathway, a starting point into the private domains of "cinematographers", delving into the experimentation and practices that cinematographers with different backgrounds and experiences utilize during the filmmaking process. At the same time, the two-day "On-Site" goes straight to the heart of "In Progress" by inviting cinematographer Chen Ko-chin and director Chienn Hsiang, both of whom have rich cinematography experience, to set aside all film production conventions and start from the essence of film photography, observing how cinematographers interpret scripts, arrange light and shadow, and choose shots in each situation, in

Written by Polny CHIU (Taipei Film Festival Program Coordinator) Translated by Howard SHIH

addition to how they communicate with the crew, and the strategies they employ every time before turning on the equipment, before finally taking it back to the core of the exhibition — how "viewing" is constructed.

After opening up the imagination with "On-Site", the talks will initiate a dialogue on cinematography. They serve as a starting point for audiences to ask questions about the creative process, seeking to break down the public's fixed impressions of cinematographic modes and equipment. The first session will see close collaboration between small teams comprising four or five people, who will use documentary-style techniques to capture characters' emotional changes, toss aside their ever-evolving photography equipment, and simplify the complicated by creating aesthetic images using smartphone lenses. At the same time, we will see how cinematographers during the analog film era — where external conditions were more difficult than digital cinematography— navigated the challenges and made meticulous calculations each time before the camera rolled. After showcasing varied approaches to cinematography, seasoned cinematographers with diverse representative works spanning art films, documentaries, and genre films will elaborate on their journeys behind the lens, with the aim of painting a picture of the current landscape of cinematography in Taiwan through casual discussions and exchanges.

Viewing deeper through the eyes of cinematographers

Continuing the tradition of past editions, this year we have invited cinematographers with different styles to select and screen films that have significant meaning in their careers. Interestingly, the films selected this time span nearly 50 years, indicating that images from different eras continue to foster new creative energy. Among them, Jack Pollock, known for his agile handheld camera style, recommended *Husbands* (1970) by American indie film pioneer John Cassavetes, whose meticulous portrayal of characters and their emotional states, as well as his explorations of the true fabric of life,

laid the foundations for Pollock's later cinematographic style. Additionally, the versatile female cinematographer Yu Jing-pin, who recently won the Golden Horse Award for Best Cinematography, chose Roy Andersson's *Songs from the Second Floor* (2000), which employed a surreal cinematographic style to set the tone and used black humor to depict soulless characters and absurd plotlines, coupled with a picturesque long-take aesthetic. For Yu Jing-pin, who has long used moving/still images as a source of inspiration, this was a film that provided double inspiration. Cinematographer Yao Hung-i recommended *Drifting Clouds* (1996), directed by renowned Finnish filmmaker Aki Kaurismäki, a film that also has a Nordic tragicomic tone and focuses its lens on the bottom rungs of society. Mentored by Hou Hsiao-hsien, Yao started as an assistant and has since won two Golden Horse Awards for Best Cinematography. His naturalistic cinematography style refined over time cleverly mirrors the minimalist and precise shots of his recommended film. Also among the uniformly masterful selections is *Caniba* (2017), which highlights the bold, avant-garde style of filmmaking duo of Verena Paravel and Lucien Castaing-Taylor. The film, which uses extreme close-up shots to immerse viewers in the sensationalized and grotesque world of a Japanese cannibal, is the recommendation of fellow documentary director Hsu Chie-chia. A winner of the Grand Prize and Best Cinematography at the Taipei Film Awards, he breaks free from genre restraints to examine how cinematography expresses the natural textures hidden within life from a documentary angle.

Facing the complex and highly technical world of cinematography, this year's "In Progress" aims to bring together the experiences and minds of various cinematographers to illuminate the topic from a creative perspective. Special thanks to each cinematographer for their involvement and assistance in the curation process, guiding us from the unknown towards a free and organic experiment and exchange that serves as the culmination of this segment. ◆

版權資料 PRINT SOURCE

A

A Nia Tero and Upstander Project Production
CHEN Yi-chen 陳怡辰
cat7654321@gmail.com
+886-981-569-974

A Really Happy Film (Taipei) Co., Ltd.
台北双喜電影發行股份有限公司
Lulu JENG 鄭熙穆
carol.jeng@justcreative.studio
+886-2-2321-4807

Activator Co., Ltd.
牽猴子股份有限公司
Steve WANG 王師
stevewang0918@gmail.com
+886-975-391-282

Alpha Violet
Fiorella AGUAYO
festivals@alphaviolet.com
+33-1-4797-3984

An Attitude Production Co., Ltd.
一種態度電影股份有限公司
Ian WU 吳奕言
c091196380@gmail.com
+886-2-2712-2977 #104

An CHU 朱建安
johnsonju0072@gmail.com
+886-926-913-567

Andrew Film Co., Ltd.
東昊影業有限公司
Mike CHANG 張全琛
mike@andrewsfilm.com
+886-2-2741-7684

Applause Entertainment Limited
Taiwan Branch (H.K.)
香港商甲上娛樂有限公司台灣分公司
Joy CHAI 蔡若儀
joy@applause.com.tw
+886-2-2552-1502 #816

Asian Shadows
Maria A. RUGGIERI
maria@chineseshadows.com

B

Be For Films
Linda VENTURINI
festival@beforfilms.com
+32-2-793-3893

BingChi (Shanghai) Pictures Co., Ltd.
並馳（上海）影業有限公司
ZHU Wenhui 朱文慧
zhuwenhui@firstfilm.org.cn
+86-132-613-73617

C

Cai Chang International, Inc.
采昌國際多媒體股份有限公司
ccii@ccii.com.tw
+886-2-2658-8868

Charades
Leonard ALTMANN
leonard@charades.eu
+33-6-4064-6600

Chelsea Entertainment
雀喜娛樂事業有限公司
LIN Pei-ying 林佩穎
cclin0613@gmail.com
+886-2-2765-0380

CHEN Hung 陳浤
jimhung.chen@gmail.com
+886-931-775-653

CHEN Liang-ting 陳亮廷
chennn.clt@gmail.com
+886-4-2535-9862

CHIU Hsiao-tsun 邱孝尊
devine0210@gmail.com
+886-2-2765-1918

Content Digital Film Co., Ltd.
內容物數位電影製作有限公司
LIN I-ju 林誼如
ijulin1120@gmail.com
+886-952-868-893

Coproduction Office
Cecilia PEZZINI
festivals@coproductionoffice.eu
+49-30-3277-7879

D

Diversion
Patitta JITTANONT
festivals@diversion-th.com
+61-431-961217

DRAMA CULTURE COMPANY LIMITED
抓馬文化股份有限公司
Evelyn LEUNG
info@ff-ent.com
+886-2-8797-7818

E

Eagle International Communication Co., Ltd.
鴻聯國際開發股份有限公司
Davy CHANG 張岱瑋
davy@e-muse.con.tw
+886-2-2907-6608

ENGINE STUDIOS LLC
原金國際有限公司
Betty HUANG 黃莉雯
bettyengine@gmail.com
+886-2-2633-3167

F

Festagent
Anna KALININA
submissions@festagent.com
+7-982-746-2331

Film Constellation
Melissa DIMOPULO
melissa@filmconstellation.com
+44-750-226-4075

Films Boutique
HSIAO Wen-chiu
hsiaowen@filmsboutique.com
+49-30-6953-7850
Ruta SVEDKAUSKAITE
ruta@filmsboutique.com
+49-30-6953-7850

Finecut
Saejeong KWAK
sj@finecut.co.kr
+82-2-569-8777

Finnish Film Foundation
Jenni DOMINGO
jenni.domingo@ses.fi
+358-9-622-03032

Flash Forward Entertainment Co., Ltd.
前景娛樂有限公司
CHEN Si-yu 陳思羽
selina@ffe.com.tw
+886-2-2926-2839 #21

Fubon Cultural and Educational
Foundation momo mini Incubator
財團法人富邦文教基金會
兒童節目人才孵育計劃
CHEN Yung-shuang 陳詠雙
kidstv@fubonedu.org.tw
+886-988-106-883

G

GaragePlay Inc.
車庫娛樂股份有限公司
Lynn ZHUANG 莊綵羚
public.video@garageplay.tw
+886-2-2555-5177

Geppetto Film Studio
寓言工作室
Eva WANG 王小茵
31876913.film@gmail.com
+886-955-551-116

H

Hangzhou Dangdang Film Co., Ltd.
杭州當當影業有限公司
LIANG Ying 梁穎
liangplusying@gmail.com
+86-186-140-75857

Homegreen Films Co., Ltd.
汯呄霖電影有限公司
Claude WANG 王雲霖
kumo924097@gmail.com
+886-2-2217-2028

HONG Dong-ren 洪冬人
drpphdr@gmail.com
+886-963-034-319

Hooray Films, Ltd.
好威映象有限公司
Han T. SUN 孫宗瀚
hoorayfilms.tw@gmail.com
+886-2-2368-9212

Hummingbird Production Co., Ltd.
蜂鳥影像有限公司
LAU Kek Huat 廖克發
darllau27@gmail.com
+886-983-856-522

I

INDOX
Luke BRAWLEY
luke@indoxfilms.com
+44-794-644-4839

L

Le Pacte
Eléonore RIEDIN
e.riedin@le-pacte.com
+33-6-3296-6281

Light Year Images
光年映畫有限公司
House WANG 王鴻碩
housewang0625@gmail.com
+886-2-2361-6265

LO Yi-shan 羅苡珊
yishanlo85@gmail.com
+886-975-807-213

Loco Films
Salomé RIZK
international@loco-films.com
+33-6-1590-1819

Lots Home Entertainment Co., Ltd.
樂到家國際娛樂股份有限公司
Ding LI 李家儀
ding2pig@lotshome.com.tw
+886-932-365-512

Lotte Entertainment
Leah CHOI
leahchoi@lotte.net
+82-2-3470-3401

LU Hsiao-wen 陸孝文
lu0938702180@gmail.com
+886-980-702-180

Luxbox
Natacha KAGANSKI
natacha@luxboxfilms.com
+33-6-588-22520
Théophane BÉRENGER
theophane@luxboxfilms.com
+33-6-588-22520

M —————————————————

M-Build
Inkar KARIM
funkymonkeypandagod@gmail.com
+7-778-443-4197

Machi Xcelsior Studios
麻吉砥加電影有限公司
Chris MAI 麥煒灝
chris@machix.studio
+886-2-8978-2908 #16

N —————————————————

Nara International Film Festival
Aiko Flores YOSHIOKA
aikosama@gmail.com
+1-512-772-6351

National Film Institute Hungary
Clara GIRUZZI
clara.giruzzi@nfi.hu
+36-30-536-6839
Katalin VAJDA
kati.vajda@nfi.hu
+36-30-441-4465

Nekojarashi
SUGITA Kyoshi
kyoshisugita@gmail.com
+81-3-6234-9434

NEOPA Inc. x Fictive LLC
TAKATA Satoshi
takata@neopa.jp

Netflix Pte. Ltd.
Vivien TAN
vtan@netflix.com
+65-968-08131

Nicetop Independent Limited
Fruit CHAN 陳果
fruitchan007@gmail.com

O —————————————————

One Cool Pictures Limited
天下一電影發行有限公司
Elly LAI
elly.lai@onecool.com
+852-6072-6255

P —————————————————

Parallax Films
視幻文化
QIAO Jinbiao 喬金彪
festival@parallaxchina.com
+86-139-649-31144

Park Circus
Jack REID BELL
jack@parkcircus.com
+44-141-332-2175

PENG Tzu-hui 彭紫惠
ajourneyinspring@gmail.com
+886-905-752-810

Pep Films LLC
Bennett ELLIOTT
belliottny@gmail.com
+1-732-996-8981

Protagonist Pictures
Katie MCGOVERN
katie@protagonistpictures.com
+44-7-386-679-346

Public Television Service Foundation
財團法人公共電視文化事業基金會
Lynn WU 吳岱穎
pub50718@pts.org.tw
+886-2-2633-2000 #1058
Sunny CHI 紀珊
ptsfestival@gmail.com, sunnychi@pts.org.tw
+886-2-2633-2000 #1116
Thanos 樊牧杰
annoydust@gmail.com
+886-983-058-134
Pamela KO 柯予恆
pamela.ko@pts.org.tw
+886-2-2633-2000

R —————————————————

Red Society Films
紅色製作有限公司
Lon NG 伍嘉麟
redsocietyfilms.tw@gmail.com
+886-2-2736-5388

RISE PICTURES CO., LTD.
嘉揚電影有限公司
Annie CHEN 陳亭均
tinjun222@gmail.com
+886-2-2657-1577
David TANG 唐在揚
tang12345678@gmail.com
+886-2-2657-1577

S —————————————————

Seashore Image Productions
岸上影像有限公司
Isabella 伊莎貝拉
James WANG 王興洪
seashore@seashore-image.com
+886-2-8943-4323

Serendipity Films
綺影映畫有限公司
Hazel WU 吳秀瑩
hazelwu@sfilms.com.tw
+886-2-2369-6958

ShuiMuRen Media Co., Ltd.
水母人文化傳媒有限公司
Ocean CHIN 秦海
filmoceanchin@gmail.com
+886-968-261-625

Sidus
Dowon KIM
dowon.kim@sidus.com
+82-10-6674-6505

Sky Digi Entertainment Co., Ltd.
天馬行空數位有限公司
Tiffany WANG 王婷妮
tiffany_wang@skydigient.com
+886-2-2231-1010

Sony Pictures Releasing Taiwan Corporation
美商索尼影業台灣分公司
Maomao TSENG 曾文郁
maomao_tseng@spe.sony.com
+886-2-6636-4675

Square Eyes
Berry HAHN
berry@squareeyesfilm.com
+44-660-980-5377

Storyage Pictures Co., Ltd.
米倉影業股份有限公司
Christa CHEN 陳嘉妤
arsfilm2004@gmail.com
+886-2-2545-1823

Studio 2 Animation Lab Co., Ltd.
兔子創意股份有限公司
FENG Wei-lun 馮偉倫
allenfeng7295@gmail.com
+886-6-3506-923

Svemirko Audiovisual Art Productions
宇宙子媒體藝術有限公司
WU Fan 吳璠
svemirkofilm@gmail.com
+886-905-135-932

Swallow Wings Films Co., Ltd.
海鵬影業有限公司
Peter WANG 王漢宇
marketing.swallowwings@gmail.com
+886-2-2361-0873

T————————————————————

The Match Factory
Valentina BRONZINI
valentina.bronzini@matchfactory.de
+49-152-284-46066

The Open Reel
Cosimo SANTORO
cs@theopenreel.com
+39-340-494-0351

The Party Film Sales
Théo LIONEL
theo.lionel@thepartysales.com
+33-1-4022-9215

Third Man Entertainment Co.,Ltd.
良人行影業有限公司
CHIANG Hsiu-yen 姜秀燕
clara.chiang@thirdman.com.tw
+886-2-2578-2269 ext 281

Tomorrow Together Capital
合影視有限合夥
Eric CHOU 周增晟
tsengchenchou@gmail.com
+886-919-300-733

Totem Films
Nuria PALENZUELA CAMON
hello@totem-films.com
+33-6-308-47575

TRAN Bich Quân
bqt@dissidenz.com
+33-6-8777-4147

TSAI Chi-min 蔡季珉
chimintsai622@gmail.com
+886-952-704-528

TurnRhino Original Design Studio
旋轉犀牛原創設計工作室
TANG Zhi-zhong 唐治中
Zhizhong813@gmail.com
+886-919-560-847

U————————————————————

UZUMASA, INC
KOBAYASHI Sanshiro
kobayashi@uzumasa-film.com
+81-3-5367-6073

V————————————————————

Volos Films
飛望影像
Jamie CHUANG 莊普因
poupou84728@gmail.com
+886-2-2368-0538

W

Wanin International Visual Enterprise, Ltd.
網銀國際影視股份有限公司
Rosa LO 羅宇廷
rosa.lo@wve.com.tw
+886-2-2791-1880 # 330

WANG Ping-wen 王品文
ajourneyinspring@gmail.com
+886-937-930-810

WestEnd Films
Luca MIANO
luca@westendfilms.com
+44-207-494-8300

WOWOW Inc.
OSAKI Aoi
filmentry@wowow.co.jp
+81-70-2319-0302

X

XIE Zong-min 謝宗旻
kill86116@gmail.com
+886-911-690-901

Y

Your Bros. Filmmaking Group CO.
你哥影視社
LIAO Hsiu-hui 廖修慧
hsiuhsiuway@gmail.com
+886-932-551-242

YU Pei-yi 游珮怡
ens.zaii@gmail.com
+886-905-053-706

影片索引（依筆畫順序排序）

FILM INDEX (Alphabetical Order)

導演索引 DIRECTOR INDEX (Alphabetical Order)

特別感謝 ACKNOWLEDGEMENT

公益財團法人日本台灣交流協會
加拿大駐台北貿易辦事處
台北歌德學院
全美戲院
財團法人桂田文化藝術基金會
荷蘭商開雲亞洲股份有限公司古馳台灣分公司
富邦文教基金會
遠足文化
National Film Institute Hungary - Film Archive
Anke HAHN
Chanel KONG
Clara GIRUZZI
Didi WU
Janus VICTORIA
KIM Young-woo
Lorna TEE
Vanessa-Tatjana BEERLI
九把刀
方美娟
方曉茹
王允瑜
王芃雯
王思靜
王振愷
王湘筠
王蓮琇
王韻婷
包軒鳴
史潔
曲相澐
朱映蓉
朱瑄
佘祖逸
余卜康
余德莎 Theresa HÜMMER
余靜萍
冷彬
吳明憲
吳秉勳

吳采娉　林倢如　張筑悌　陳品叡　楊凱湉　薛克昭
吳青樺　林哲強　張瑋珊　陳奕凱　楊貴媚　謝宏立
吳俊誠　林書宇　張瑜芬　陳宥臻　楊駿閔　謝寧
吳奕倫　林淑惠　張憶潔　陳家達　楊禮蔚　鍾艾
吳璟田　林儀芸　戚耘華　陳振權　葉如芬　鍾定恩
呂洛頡　邱純輔　梁穎　陳婉婷　葉妍伶　顏振發
宋怡嫻　長田真優　莊千慧　陳儀蓁　詹承學　魏琥弦
宋欣穎　侯季然　莊淳淳　陳築均　詹家玟　關本良
李侑穎　姚宏易　莊雅婷　陳韻安　鄒介中　嚴藝文
李芸嬋　姜秀瓊　莊雯媛　陳麒文　廖志峰　蘇意婷
李采恩　施宏儒　許玉如　陳寶旭　廖明毅　蘇意雯
李冠吾　柯孟融　許哲嘉　陳顥升　廖奎鈞
李奕萱　柯貞年　許�îｮ筠　麥汎然　廖庭萱
李柏毅　段羽瞳　許惟珊　傅莉淳　廖翊帆
李致逸　段鍾沂　許鈞婷　彭翊宸　廖慶松
李若綾　洪伯豪　郭子榮　彭緯宸　端木芸珊
李婉榕　洪倩玉　郭佩芸　曾亦歆　劉君宜
李懿麒　韋向謙　郭昱萱　曾英庭　劉芷妤
沈可尚　夏紹虞　郭若琦　曾瀚霆　潘芝諺
辛品嫻　孫以萱　郭若穎　游紀慈　練建宏
冼若瑜　孫恩潔　郭栗蓉　游嘉娜　蔡沛樺
周以文　徐志宏　郭曉慶　湯永聖　蔡佩璇
周侑惠　徐國倫　陳又嘉　湯紫翎　蔡雅霖
周育嫻　徐敏芳　陳天奉　賀秭庭　蔡樸雲
周宥彤　徐譽庭　陳世川　黃怡媗　蔣依潔
周建華　晏靖宜　陳以恆　黃怡綸　蔣詠涵
周璇圃　翁芷薰　陳可軒　黃昕柔　蕭世宏
林子寧　翁瑞鴻　陳幼雯　黃茂昌　蕭翊樺
林心如　馬媽媽　陳向訕　黃韋慈　蕭雅全
林宇威　高炳權　陳伯任　黃凌熙　賴又慈
林孝謙　張三玲　陳伯義　黃敬淇　賴雨柔
林言諾　張全琛　陳克勤　黃敬凱　賴昱達
林佳亨　張宇生　陳君如　黃霖恩　賴衍亦
林佳欣　張克柔　陳汶其　黃鶺榕　賴泰然
林昕媛　張育銨　陳坤苓　塗翔文　錢佳緯
林亭儀　張芷瑜　陳季莘　楊之馨　錢映慈
林信帆　張家瑋　陳芯宜　楊元鈴　錢翔
林冠伶　張庭嘉　陳俊蓉　楊宇澤　龍品辰
林恒青　張媁涵　陳俐吟　楊定樵　龍傑娣

不攔 ——— 就點

Uber Taxi
優步小黃

*所有行程由使用優步網際網路系統之合作車隊派遣車輛

SOTETSU GRAND FRÉSA
TAIPEI XIMEN

GRANDFRESA_TAIPEI_XIMEN

OFFCIAL WEBSITE

ACCESS
One minute's walk from Exit 3 of Ximen Station on the MRT Bannan Line (Blue Line) and MRT Songshan–Xindian Line (Green Line)

ROOM
Out of a total of 200 rooms, 171 rooms can comfortably accommodate three people. Grand twin rooms can accommodate up to 4 persons. There are also 9 Adjoining rooms that can accommodate up to 6 people in pairs.

AMENITY
Face lotion, emulsion, insect repellent stickers and other products are available in the free amenity corner.

FACILITIES
We will help make your stay more comfortable with extensive facilities such as self-service lockers, vending machines, laundry corner (cashless only), and microwave ovens.

MEMBERSHIP PROGRAM
SOTETSU HOTELS CLUB offers a variety of benefits. Benefit in place of 500yen cashback. Get NT$100 convenience store gift card as present.at the hotel. *Guests on day-use plan cannot avail of this benefit.

1. Approx.**20** minutes from **Taipei Songshan Airport** by MRT
A few minutes' walk from **Ximen Station**

2. All guest rooms are spacious,over **30m²**

3. 171 out of 200 guest rooms accommodate **up to 3 guests**

4. Adjoining rooms accommodate **up to 6 guests**

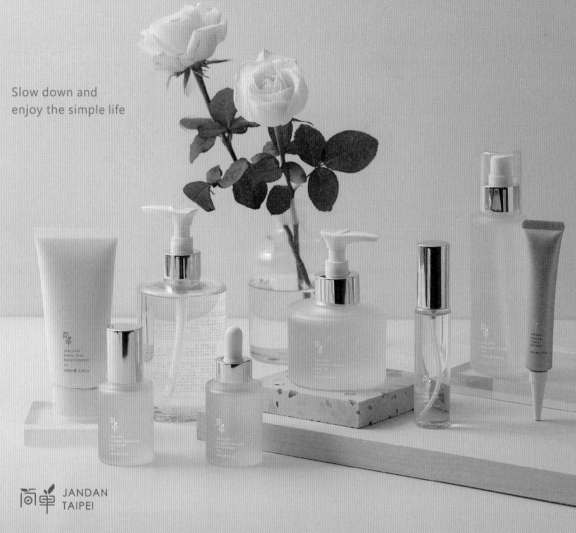

Slow down and
enjoy the simple life

JANDAN
TAIPEI

MIT植萃保養品牌 | 專業安心的敏弱保養

《簡單JAN DAN》從台灣出發，攜手專業皮膚科醫師與保養專家，嚴選品質及效果優異原料；堅持以純素配方打造敏弱、油性、孕婦全膚質試用及有效比例與植萃配方，溫和透明，認真看待每處環節，提倡有意識的保養，為肌膚與生活帶來質樸美好，簡單喜樂。

遵循Clean Beauty純淨保養用料原則，無酒精及動物性成分，選料準則純粹透明，官網上即可檢閱完整成分標示；包裝多採用無染霧透玻璃、白色紙盒，降低環境傷害。

 不含
化學香精　 植萃純素　 拒絕
動物實驗　低敏
溫和配比

TRIPOLOGY

WARRANTY 10 YEAR 年保固

俐落快取
前開式行李箱
開啟嶄新冒險旅程

瞭解▼更多

TRIPOLOGY × *T.H.* TREAS HUNTER

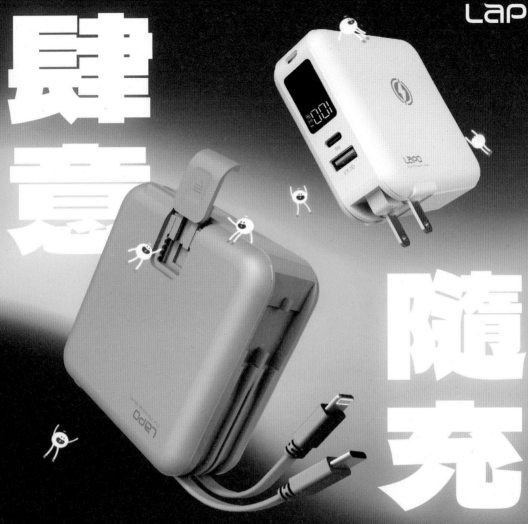

肆意 隨充

LaPO

功能多合一
充電就是這麼直覺簡單

10000mAh
大電量

22.5W
PD超快充

15W
磁吸無線充

X5
自帶2線2孔
最多五台同時充

國內外多項
安全認證

100V-240V
全球通用電壓

官方網站

Facebook

Instagram

Hair Boutique

Flux

—

KÉRASTASE

PARIS

FLUXKERASTASE

環保，也要時尚

立即打造
專屬環保杯

KEEP FILMING FUN

旋轉牧馬
攝影器材
攝助出班

創作者最可靠的夥伴

旋轉牧馬是位於臺北的攝影器材租賃品牌，支持影像創作是旋轉牧馬的重要信念，我們熱愛影像並竭盡所能的與拍片人一起奔馳。

旋轉牧馬 MERRY GO ROUND

專業影視器材租賃・攝影助理技術出班

大安門市　台北市大安區復興南路一段279巷32號　Tel: 02-2325-8665
汀洲門市　台北市中正區金門街17巷8號1樓　Tel: 02-7709-4255

小馬廏 SMAJO

台北活動場地租借・藝文空間・攝影棚

台北市大安區復興南路一段279巷33號1樓 Tel: 02-2325-8100

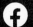 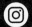

Chill 可麗露

浪漫超Chill

小美 SHAOMEI ®

濃厚巧克力
Dark Chocolate

草莓蛋糕風味
Strawberry Cake Flavor

FamilyMart 熱賣中

定食の彌生軒

一道道料理皆用心以對,充滿日本特有的細緻堅持,
歡迎來到定食的世界。

26ᵗʰ TAIPEI FILM FESTIVAL
台北電影節 ╳ 初耘

初心醬 蒜蒜辣油
酥酥古早油蔥拌麵

初耘｜台北電影節限定禮盒

2024
6.21—7.6

懂

你的啤酒

懂在地，懂天然，懂真實，所以最懂你需要的啤酒；

懂生活，懂人生，所以也懂你。

用一杯啤酒給你應援，讓你有自信，面對不簡單的生活。

Instagram：BeerBellyBrewing.tw

THE YUAN ——————————

時尚咖啡禮品　跨界合作的專業首選

THE YUAN是專精於咖啡領域的品牌，訴求時尚品味與質感生活的傳遞

提供精緻的專業產品，將咖啡美學融入生活中

擅長跨領域合作，曾合作過國際汽車品牌、彩妝保養品等，打造專屬品牌的最佳作品

歡迎企業採購　少量也可客製化

我們提供專精且多元化的咖啡產品，從濾掛咖啡、咖啡豆、精緻禮盒、罐裝咖啡..等眾多品項，皆可提供客製化設計
如有公司行號大量訂購等商業需求，另有商業合作優惠價格，歡迎撥打0905-035-515，洽詢專人服務與報價

官方社群 　領取合作方案

花景

千葉景正
草月流師範

於東京學習草月流日式花藝。在台以美術製片身份參與多部華語圈電影，從經驗中萃取出
「故事」「年代」與「傳統文化」的概念，並將其具象化，進而營造出令人雀躍的氛圍及世界觀。
台北電影節花藝聯盟品牌，台北草月流日式花藝教室。

IG & FB
hanakage.production

職人手熬果醬｜島嶼果乾水｜島嶼果風糖磚

99% 超高回購率
天然補水首選品牌

◎ 2021 經濟部食品獎 特別獎　　◎ 2023 OTOP產品設計獎
◎ 2023-2024 經濟部社創良品年度品牌

補水新選擇　一喝就愛上

citizenM 世民酒店台北北門

■ 地點：台北市中正區中華路一段 3 號
　　（鄰近台北車站和機場捷運 / 步行可至著名購物觀光區西門町）

■ 房間數：267間（共26樓）

關於citizenM世民酒店

citizenM世民酒店以「價格合理的奢華旅宿體驗」為理念，並歡迎目光敏銳、尋找嶄新飯店體驗的新世代國際旅客入住。位於核心地帶的我們期望提供時下旅客奢華享受、時尚設計、先進的智慧設備、以及舒適柔軟的枕頭，並以合理的價格獲得優質的入住體驗。

當現代旅客下榻其他傳統飯店時，常常會為了自己不想要或不需要的服務隱性收費而感到困擾，因此世民酒店正是為了翻轉旅客的體驗而所成立。

我們去蕪存菁，並致力提供現代旅客真正想要和實際需要的住房服務。

THE SINGLETON

蘇格登醇金13年

貴腐甜白酒桶過桶・珍稀如金

THE SINGLETON
13 YEARS
SINGLE GLEN ORD

THE SINGLETON
SINGLE Malt Scotch Whisky
GLEN ORD
DISTILLERY
13
THIRTEEN YEARS
SAUTERNES FINISH

Golden Tresor

TAIPEI
ARTS
FESTIVAL
臺北藝術節

2024 8.2 → 9.8

時間博物館
EMBODYING
THEIRSTORIES

日本｜麿赤兒×法國｜馮莎・夏紐

8.17 ——— 8.18 北藝中心 球劇場

黃金雨 GOLD SHOWER

世界巡迴最終站 封箱演出在臺北
舞踏大師與舞蹈奇才 解放身心的雙人靈魂頌歌

泰國｜維帕亞・阿塔瑪

8.24 ——— 8.25 水源劇場

曼谷公寓 BAAN CULT, MUANG CULT

溫暖詩意 刻畫泰國當代社會樣貌
雙面舞臺 一戲二刷解鎖兩面精彩

TAIPEI ARTS FESTIVAL　TPAC.ORG.TAIPEI/FESTIVAL-TAIPEI　購票請洽 OPENTIX　購票請洽 TAIPEI 臺北市政府　購票請洽 臺北表演藝術中心 TAIPEI PERFORMING ARTS CENTER　廣告

gomaji
懂生活的好麻吉

Gomaji 提供一站式吃喝玩樂的購物
提供多元、優惠、有趣的產品方案，讓
每一位 Gomaji 愛用者，都成為懂過
日子的人！

非載不可

精打細算
APP點數回饋更多

好康優惠
第一手資訊掌握

地圖探索
周邊優惠隨時找

外帶、按摩、泡湯
雙訂模式好方便

❋ 影迷限定優惠 (使用期間:2024.06.21 - 2024.07.06)

於 Gomaji 官方 App 購買任一商品，輸入影迷專屬優惠碼「999-tff24」
不限金額消費，即可抵用 30 元，每人限用一次，限量 500 份。(部分商品不適用)

- -

❋ 新戶限定

首次下載APP
輸入 Gomaji 現賺 $100 點 (1點=1元)
打開 APP 並登入，選擇「賺取點數/輸入優惠碼」，輸入邀請碼即可得點

優格咬了嗎

Cranberry Yogurt

乳酸菌咬咬蔓越莓優格

採用超低溫急速冷凍技術，搭配純淨無添加配方，製作出濃縮五倍，可常溫保存的咬咬優格，完整保留優格營養，幫助維持消化道機能，改變細菌叢生態，讓全家人都安心享受入口即化的微酸果香。

 www.vilson.com
 米森愛有機
 @vilson

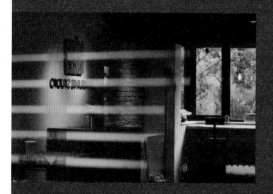

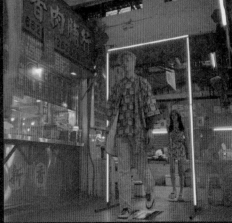

Tetsujin

Post Production

RENO STUDIOS

再現影像

Content Development **Animation**
Content Design **LED Virtual Production**
Visual Effect **Immersive Content**

公益財団法人
日本台湾交流協会
Japan-Taiwan Exchange Association

HP

FACEBOOK

IG

財團法人台北市文化基金會－台北電影節執行團隊
Taipei Film Festival Office, Taipei Culture Foundation

主席	Festival President	易智言	YEE Chih-yen
總監	Director	李亞梅	LI Ya-mei

節目組 Program Team

副理	Assistant Manager	洪健倫	HUNG Jian-luen
資深專員	Senior Coordinator	馬曼容	Pony MA
專員	Coordinator	邱予慧	Polny CHIU
專員	Coordinator	陳雅筠	CHEN Ya-yun
節目助理	Assistant	高偉恆	KAO Wei-heng
接待統籌	Hospitality Senior Coordinator	林郁珣	Iris LIN
接待專員	Hospitality Coordinator	黃瀚生	Hansen HUANG
接待專員	Hospitality Coordinator	林伊湄	Ariel LIN

映演組 Screening Team

統籌	Senior Coordinator	史婉萱	Gracy SHIH
字幕統籌	Subtitling Coordinator	林祐亘	LIN You-hsuan
放映專員	Screening Coordinator	陳彥宇	CHEN Yen-yu
戲院現場專員	Theater Coordinator	蔡文瑄	TSAI Wen-shiuan
戲院現場助理	Theater Assistant	廖翊珊	LIAO I-shan

台北電影獎組 Taipei Film Awards Team

副理	Assistant Manager	陳人岳	CHEN Jen-yue
專員	Coordinator	何嫚馨	HÔ Bān-hing
專員	Coordinator	黃鈴惠	Where HUANG
專員	Coordinator	林昕儒	Lulu LIN
頒獎典禮統籌	Ceremony Senior Coordinator	賴玉蓉	Judy LAI
頒獎典禮執行	Ceremony Execution	何育涵	Lisa HO
頒獎典禮執行	Ceremony Execution	蘇柏仁	SU Po-jen
頒獎典禮執行	Ceremony Execution	柳李萱	Win LIU

行政組 Administration Team

副理	Assistant Manager	林家如	Ruby LIN
專員	Coordinator	陳俐彣	Rita CHEN
助理	Assistant	陳宇愛	Phoebe CHEN
助理	Assistant	吳欣柔	WU Hsin-jou
票務統籌	Ticketing Senior Coordinator	郭美淨	KUO Mei-ching
票務專員	Ticketing Coordinator	李欣穎	LI Xin-ying

行銷組 Marketing & Communications Team

經理	Manager	焦同筠	Sherry CHIAO
資深專員	Senior Coordinator	劉怡廷	Ellie LIU
資深專員	Senior Coordinator	張斯庭	Christine CHANG
設計資深專員	Senior Art Designer	葉雅婷	Judy YEH

活動組 Event Team

經理	Senior Manager	唐乙鑫	TANG Yi-hsin
專員	Coordinator	鄭詠中	Walt ZHENG
專員	Coordinator	李予扉	Yufi LEE
專員	Coordinator	劉俞均	LIU Yu-jyun

媒宣組 Press Team

副理	Assistant Manager	楊絲貽	YANG Szu-yi
專員	Coordinator	呂敏慈	Michelle LYU
資深專員	Senior Coordinator	楊景婷	YANG Ching-ting
社群小編	Social Media Coordinator	林明潔	LIN Ming-chieh
影音統籌	Senior Coordinator	周仲妤	Nikki CHOU
圖像設計	Art Designer	林家安	LIN Jia-an

新導演長片工作坊統籌 New Director Workshop

統籌	Event Team Senior Coordinator	郭曉芬	Fen KUO

諮詢委員 Committee Board

王 師	WANG Shih	柴智屏	Angie CHAI
王耿瑜	WANG Ken-yu	陳明和	CHEN Ming-Ho
余卜康	Ken YU	陳俊蓉	Zoë C.J. CHEN
李耀華	Aileen LI	陳潔瑤	Laha Mebow
林心如	Ruby LIN	陳璽文	Stefano CENTINI
林孝謙	Gavin LIN	傅天余	FU Tien-yu
柯景騰（九把刀）	Giddens KO	賀照緹	HO Chao-ti
		葉如芬	YEH Jufeng

專刊編輯 Editorial Team

總編輯	Editor	林雨靜	LIN Yu-ching
英文編輯	English Editor	石雄皓	Howard SHIH
譯者	Translator	何美瑜	Isabella HO
		劉若瑄	Lorelai LIU
美術設計	Art Design	厚研吾尺	Most of Hou

專刊撰稿 Contributors

艾斯特·法澤卡斯	Eszter FAZEKAS	許耀文	Wen HSU
王文珏	Ariel WANG	陳俊蓉	Zoë C.J. CHEN
王振愷	WANG Jhen-kai	黃柏鈞	George HUANG Po-chun
林伊湄	Ariel LIN	黃瑋儒	Wei HUANG
林姵菁	Lin Pei-jing	黃聖閎	HUANG Sheng-hung
林 昱	LIN Yu	塗翔文	Steven TU
邱予慧	Polny CHIU	廖之綺	Betsy LIAO
侯伯彥	Jimmy HOU	趙正媛	CHAO Cheng-yuan
洪健倫	HUNG Jian-luen	潘信宏	George PAN
孫志熙	SUN Z. C.	蔡曉松	TSAI Hsiao-sung
翁皓怡	Catherine WENG	謝以萱	Ruby HSIEH I-hsuan
馬曼容	Pony MA	謝鎮逸	Yizai SEAH
張婉兒	CHANG Wan-erh	羅心彤	LO Hsing-tung
張硯拓	CHANG Yen-tuo	鐘岳明	Jimmy CHUNG

手冊印刷 Printed by

晶華彩色印刷有限公司

發行日期 Date of Publication

June, 2024

2024 第26屆台北電影節 Taipei Film Festival

WEB	www.taipeiff.taipei
FB	www.facebook.com/TaipeiFilmFestival
Instagram	www.instagram.com/taipeiff/
YouTube	www.youtube.com/TaipeiFilmFestival
E-MAIL	info@taipeiff.org.tw
TEL	02-2308-2966
ADD	10852 台北市萬華區廣州街151號

1999 臺北市民當家熱線

側拍團隊 Behind the Scenes

動態側拍 BTS Video Team

動態攝影	Photographer	桑道仁	Vincent SANG
動態攝影	Photographer	陳柏勝	CHEN Po-sheng
動態攝影	Photographer	陳彥宇	CHEN Yan-yu
動態攝影	Photographer	陳彥安	CHEN Yen-an
動態剪輯	Editor	發記影像設計 劉漢青	OZ Design Co. Raph LIU
影展預告剪輯	Program Trailer Editor	黃靖閔	Kassey C.M. HUANG
影展片花剪輯	Program Teaser Editor	費柏誼	FEI Po-hsuan

平面側拍 BTS Photography Team

平面攝影	Photographer	自由狐攝影工作室	Freefox Photo
平面攝影	Photographer	翁偉中	Will WONG
平面攝影	Photographer	羅紹文	Swen LO
平面攝影	Photographer	蔡玫香	TSAI Mei-hsiang
平面攝影	Photographer	蔡耀徵	Choy TSAI
平面攝影	Photographer	趙豫中	CHAO Yu-chung
平面攝影	Photographer	劉千鈺	LIU Chien-yu
平面攝影	Photographer	吳欣柔	WU Hsin-jou
平面攝影	Photographer	郭守珀	KO Shou-po
平面攝影	Photographer	王玲玉	Alexis WANG

2024 影展大使形象團隊 Ambassador Styling Team

化妝師	Makeup Artist	陳怡俐	CHEN Yi-li
髮型師	Hair Stylist	謝子豪	Jacobs HSIEH
造型師	Stylist	蔡靜瑤	Charlie TSAI
平面攝影	Photographer	三　角	Mr. triangle
攝影助理	Assistant Photographer	施卜元	Mike yuan
攝影助理	Assistant Photographer	許凱傑	HSU Kai-chieh
攝影助理	Assistant Photographer	柳妘儒	LIU Yun-ru
攝影助理	Assistant Photographer	陳泱丞	CHEN Yang-chang

主視覺團隊 Visual Design Team

藝術統籌/	Art Director/	楊士慶	YANG Shi-ching
視覺設計	Visual Design		
3D 動畫	3D Artists	莊煜彬	CHUANG Yu-pin
動態製作	Motion Desgin	唐張崇偉	Tom
字體設計	Type Design	鄭妤柔	Rose ZHENG

形象廣告團隊 Promotional Short Film

形象大使	Ambassador	林柏宏	Austin LIN
導演	Director	傅天余	FU Tien-yu
導演助理	Director's Assistant	李培妏	LEE Pei-yi
製片	Producer	吳嘿兒	Hel WU
製片助理	Production Assistant	曾銘楷	ZENG Ming-kai
攝影指導	Director of Photographer	胡世山	HU Shi-shan
跟焦師	Focus Puller	劉三郎	Saburo LIU
攝影助理	Assistant Photographer	王子禎	WANG Zi-zhen
攝影助理	Assistant Photographer	王思翰	WANG Si-han
燈光指導	Gaffer	林祝祥 (阿閣)	LIN Zu-hsiang
燈光助理	Lighting Technicians	呂鴻昌	LU Hong-chang
燈光助理	Lighting Technicians	李模帥	LI Mo-shuai
燈光助理	Lighting Technicians	楊育鈞	YANG Yu-jun
美術指導	Production Designer	陳炫劭	CHEN Hsuan-shao
美術場務	Grip	許誌峯	HSU Chih-fong
收音師	Production Sound Mixer	許政高	XU Zheng-gao
收音助理	Sound Assistant	黃世鑫	HUANG Shi-xin
藝人經紀	Agency of Austin Lin	賴玟君	Anita LAI
化妝師	Makeup Artist	陳怡俐	CHEN Yi-li
髮型師	Hair Stylist	Nino	Nino
服裝造型	Executive Costume Designer	查理	Charlie
後期製片	Post-production Supervisor	吳嘿兒	Hel WU
剪接指導	Editor	賴詠萱	LAI Yung-hsuan
調光室	Dimmer Room	時間軸影像製作有限公司	Timeline Studio
調光師	Colorist	洪文凱	Kevin HUNG
音樂製作	Music Production	利比多音樂實業有限公司	Libido Music Ltd.
製作統籌	Executive Producer	林泓伸	LIN Hung-shen
音樂總監	Music Director	唐愷韡	TANG Kai-fei
音樂協力	Additional Composer	周家光	CHOU Chia-kuan
音樂協力	Additional Composer	孔書亞	Joshua KUNG
錄音室	Mixing Studio	好多聲音	FORGOOD SOUND
混音師	Mixing Engineer	高勤倫	GAO Qin-lun
混音師	Mixing Engineer	林晉德	LIN Jin-de
後期協力	Post-Production Support	時間軸影像製作有限公司	Timeline Studio
後期協力	Post-Production Support	大鐵人影業有限公司	Tetsujin Post Production
後期協力	Post-Production Support	好多聲音	FORGOOD SOUND
後期協力	Post-Production Support	赫儀聲音製作有限公司	Hzalyzer Sound
後期協力	Post-Production Support	聲匠記號工作室	SoundArtisan#b Studio
場地協力	Filming Location Support	再現影像製作股份有限公司	Reno Studios
場地協力	Filming Location Support	中影股份有限公司	Central Motion Picture Corporation
器材協力	Camera Gear Support	旋轉牧馬有限公司	Merry Go Round Inc.
器材協力	Camera Gear Support	台灣索尼股份有限公司	Sony Taiwan

2024 非常新人形象團隊 Supernova Styling Team

造型指導	Costume Designer	王佳惠	WANG Chia-hui
造型執行	Excutive Costume Designer	顏妙瑻	YEN
造型協力	Styling Assistant	張紘姍	Josanne CHANG
造型協力	Styling Assistant	蔡秉珊	TSAI Ping-shan
造型協力	Styling Assistant	管梅芬	Meigan KUAN
妝化統籌	Makeup Designer	陳怡俐	CHEN Yi-li
化妝師	Makeup Artist	胡欣儀	Ellie HU
化妝師	Makeup Artist	郭理惠	KUO Li-hui
化妝師	Makeup Artist	陳意潔	Jessie CHEN
化妝師	Makeup Artist	劉鳳琪	Kei LIU
髮型團隊	Hairstylist Team	UNDER hair	UNDER hair
髮型師	Hairstylist	莊倖樺	Jojo CHUANG
髮型師	Hairstylist	鄺啟業	Ben KUONG
髮型師	Hairstylist	游翔之	Sean YU
髮型師	Hairstylist	陳心瑩	CHEN Hsin
髮型助理	Hairstylist Assistant	鄭輝煌	Aaron ZHENG
髮型助理	Hairstylist Assistant	何聿橙	Phanes HO
平面攝影	Photographer	謝宏奕	HSIEH Hung-yi
攝影助理	Photographer Assistant	蘇挹德	SU Yi-te
攝影助理	Photographer Assistant	潘彥光	ZEMOK
攝影助理	Photographer Assistant	劉立中	LIU Li-chung
動態製作	Production	寶鳥映畫有限公司	Bird of Paradise Films Ltd.
動態導演	Director	黃靖閔	Kassey C.M. HUANG
攝影	Photographer	李毓琪	LI Yu-chi
攝影	Photographer	游世楓	YOU Shih-fong
攝影	Photographer	周家彤	CHOU Chia-tong
剪輯	Editor	發記影像設計 劉漢青	OZ Design Co. Raph LIU
調光贊助	Digital Colorist Sponsor	意象影像處理(股)公司	i-View Process, Corp.
器材協力	Camera Gear Support	旋轉牧馬有限公司	Merry Go Round Inc.
器材協力	Camera Gear Support	台灣索尼股份有限公司	Sony Taiwan

2024 非常演員形象團隊 Top Talents Production Team

形象照 Photo

平面攝影	Photographer	三 角	Mr.Triangle
攝影助理	Assistant Photographer	施卜元	Mike YUAN
攝影助理	Assistant Photographer	許凱傑	HSU Kai-chieh
攝影助理	Assistant Photographer	柳妘儒	LIU Yun-ru
攝影助理	Assistant Photographer	陳泱丞	CHEN Yang-chang
美術團隊	Visual Designer	一起設計工作室	WHY NOT ADVERTISING

形象影片 Video

製作	Production	寶鳥映畫有限公司	Bird of Paradise Films Ltd.
製作	Production	益鼎傳播文化事業有限公司	E Dien Pictures Ltd.
導演	Director	黃靖閔	Kassey C.M. HUANG
副導 / 表演指導	Assistant Director/ Director of Performance	黃采儀	HUANG Tsai-yi
製片	Production Executive	黃敬涵	HUANG Chin-han
製片助理	Prdouction Assisstant	蔡嚴儀	TSAI Yen-i
美術	Production Designer	羅雲鐘	LO Yun-chung
攝影指導	Director of Photographer	江佩玲	CHIANG Pei-ling
B機攝影師	Photographer	李毓琪	LI Yu-chi
攝影大助	Technical coordinator	游世楓	YOU Shih-fong
攝影大助	Focus Puller	陳韋鈞	Paul CHEN
攝影助理	Assistant Photographer	王子禎	WANG Tzu-chen
攝影助理	Assistant Photographer	尤崇瑋	Way YOU
攝影助理	Assistant Photographer	劉得生	Dennis LIU
攝影助理	Assistant Photographer	錢 琦	Ci CHIEN
燈光	Gaffer	豐玉影業有限公司 王俊豐	Jim WANG
燈光助理	Best Boy	王育彰	Michael WANG
燈光助理	Best Boy	孫試凱	DaKai
燈光助理	Best Boy	陳智暉	CHEN Zhi-hui
燈光助理	Best Boy	郭秉鑫	KUO Bing-xin
收音師	Location Sound Mixer	陳亦偉	Aki CHEN
收音師	Location Sound Mixer	錢 誠	Kurt CHIEN
場務	Grip	陳政翰	Pringle CHEN
調光	Digital Colorist	意象影像處理(股)公司	i-View Process, Corp.
資深調光師	Senior Colorist	王慕鼎(布丁)	Muddy WANG
剪輯	Editor	發記影像設計 劉漢青	OZ Design Co. Raph LIU
調光贊助	Digital Colorist Sponsor	意象影像處理(股)公司	i-View Process, Corp.
攝影器材提供	Camera Equipment	旋轉牧馬有限公司	Merry Go Round Inc.
攝影器材提供	Camera Equipment	台灣索尼股份有限公司	Sony Taiwan
燈光器材提供	Lighting Equipment	豐玉影業有限公司	HU_GAFFER
聲音製作協力	Sound Designer	好多聲音	FORGOOD SOUND
DCP 製作協力	DCP production	大鐵人影製所	Tetsujin Post Prodution
場地協力	Shooting Studio	中影股份有限公司	Central Motion Picture Corporation
英文顧問	Language Consultant	高偉豪	David KAO
英文顧問	Language Consultant	陳紹恩	Morris CHEN
英文譯者	Script Translator	方雨婷	Taylor FINNEY
英文編輯	English Editor	何美瑜	Isabella HO
手冊設計	Brochure Design	姜康哲	CHIANG Kang-che
網站設計	Web Design and Development	蕭宇彤	HSIAO Yu-tung
幕後花絮製作	Behind the Scenes Production	桑道仁	Vincent SANG
特別感謝	Special Thanks	郭憲聰	Tomi KUO
特別感謝	Special Thanks	呂 珽	LU Ting

2024 卓越貢獻獎影片製作團隊 Outstanding Contribution Award Video Production Team

導演	Director	賀照緹	HO Chao-ti
製片	Production Executive	黃琇怡	HUANG Hsiu-yi
攝影｜燈光	Photographer&Gaffer	林皓申	LIN Hao-shen
攝影｜燈光	Photographer&Gaffer	王盈舜	WANG Ying-shun
攝影｜燈光	Photographer&Gaffer	盧元奇	LU Yuan-chi
攝影｜燈光助理	Assistant Photographer	陳彥旭	CHEN Yan-xu
攝影｜燈光助理	Assistant Photographer	許春炫	HUI Chun Yuen
攝影｜燈光助理	Assistant Photographer	張弘樑	ZHANG Hong-jie
剪輯	Editor	蔡宜芬	TSAI Yi-fen
剪輯助理	Editor	蕭郁錡	HSIAO Yu-chi
美術編輯	Graphic Design	林旻錡	LIN Min-chi
後期協力	Post-Production Collaboration	時間軸影像製作有限公司	Timeline Studio
後期協力	Post-Production Collaboration	大鐵人影製所有限公司	Tetsujin Post Production
後期協力	Post-Production Collaboration	好多聲音	FORGOOD SOUND
器材協力	Camera Gear Collaboration	旋轉牧馬有限公司	Merry Go Round Inc.
器材協力	Camera Gear Collaboration	台灣索尼股份有限公司	Sony Taiwan

2024 台北電影獎看板畫作 Taipei Film Awards Billboard Art

繪師	Artist	顏振發	YAN Jhen-fa

台北電影節實習生 Taipei Film Festival Interns

節目組 Program Team
林郁庭　LIN Yu-ting
林淵智　LIN Yuan-chih
張語茹　CHANG Yu-ju
鄭簡勛　CHENG Chien-hsun
楊詠琦　YANG Yung-chi

接待組 Hospitality Team
鄭佩維　CHENG Pei-wei
許紓婕　HSU Yu-jie

台北電影獎組 Taipei Film Awards Team
丁盈瑄　Julia DING
李品佑　Mark LEE
馮仕譯　Brian FENG
黃筠真　Dough HUANG

行銷部 Marketing & Communications Team
涂育誠　TU Yu-cheng
詹景涵　CHAN Ching-han

媒宣組 Press Team
蘇圓圓　SO Yuen-yuen
黃泯榕　HUANG Ming-jung
黃克宣　HUANG Ko-hsuan
周廷芳　CHOU Ting-fang
董珈甄　TUNG Chia-chen
章睿棻　CHANG Rui-fen

活動組 Event Team
劉鈺彤　LIU Yu-tung
何宛錞　HO Wan-chun
魏誠萱　WEI Cheng-hsuan
洪子桓　HUNG Tzu-huan
林芷葳　LIN Chih-wei
陳家益　CHEN Chia-yi
林穎詩　Vincie LIN
吳宜柔　WU Yi-rou
葉卉穎　YEH Hui-ying

2024 第二十六屆台北電影節 節目專刊
TAIPEI FILM FESTIVAL CATALOGUE

Text and illustrations © Taipei Film Festival / Taipei Culture Foundation

出版單位	財團法人台北市文化基金會台北電影節 10852 台北市萬華區廣州街 141 號 2 樓
編輯單位	台北電影節 10852 台北市萬華區廣州街 141 號 2 樓 電話　+886-2-2308-2966 Email　info@taipeiff.org.tw

Published by Taipei Culture Foundation - Taipei Flim Festival

2F, No. 141, Guangzhou St., Taipei City, Taiwan 10852

Planning & Executive by Taipei Film Festival

2F, No. 141, Guangzhou St., Taipei City, Taiwan 10852

Tel: +886-2-2308-2966

Email: info@taipeiff.org.tw

總策劃	李亞梅
總編輯	林雨靜
英文編輯	石雄皓
譯者	石雄皓、何美瑜、董家瑋、劉若瑄
美術設計	厚研吾尺
專刊撰稿	艾斯特・法澤卡斯、王文珏、王振愷 林伊湄、林姵菁、林　昱、邱予慧、侯伯彥 洪健倫、孫志熙、翁皓怡、馬曼容、張婉兒 張硯拓、許耀文、陳俊蓉、黃柏鈞、黃瑋儒 黃聖閎、塗翔文、廖之綺、趙正媛、潘信宏 蔡曉松、謝以萱、謝鎮逸、羅心彤、鐘岳明
法律顧問	財團法人台北市文化基金會管理部
出版日期	2024 年 6 月 初版
印　製	晶華彩色印刷有限公司
定　價	新臺幣 100 元
ISBN	978-626-98693-0-5

Festival Director	LI Ya-mei
Editor	LIN Yu-ching
English Editor	Howard SHIH
Translator	Howard SHIH, Isabella HO, TUNG Chia-wei, Lorelai LIU
Art Design	Most of Hou
Contributors	Eszter FAZEKAS, Ariel WANG, WANG Jhen-kai Ariel LIN, LIN Pei-jing, LIN Yu, Polny CHIU Jimmy HOU, HUNG Jian-luen, SUN Z. C. Catherine WENG, Pony MA, CHANG Wan-erh CHANG Yen-tuo, Wen HSU, Zoë C.J. CHEN George HUANG Po-chun, Wei HUANG, HUANG Sheng-hung Steven TU, Betsy LIAO, CHAO Cheng-yuan, George PAN TSAI Hsiao-sung, Ruby HSIEH I-hsuan, Yizai SEAH LO Hsing-tung, Jimmy CHUNG
Legal Consultant	Taipei Culture Foundation Dept of Management
First Edition	June 2024
NTD	100

Printed in Taiwan

國家圖書館出版品預行編目 (CIP) 資料

台北電影節節目專刊 . 2024 第二十六屆 =
2024 Taipei film festival catalogue/ 台北電影節編輯 . -- 初版 . --
臺北市 : 財團法人台北市文化基金會台北電影節 , 2024.06
272 面 ; 19*24 公分 中英對照
ISBN 978-626-98693-0-5（平裝）
1.CST: 影展
987.066　　113007120

2024台北電影節
影展大使